The Holland Park Circle

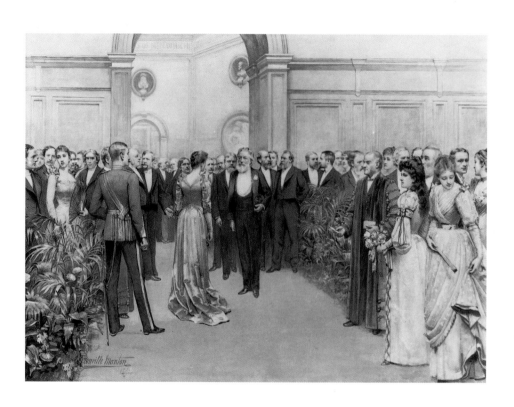

The Holland Park Circle

ARTISTS AND VICTORIAN SOCIETY

Caroline Dakers

Yale University Press New Haven and London

for

Harriet and Madeline

Designed by Kate Gallimore
Set in Joanna MT by Best-set Typesetter Ltd, Hong Kong
Printed in Hong Kong

Library of Congress Cataloging-in-Publication Data
Dakers, Caroline.
 The Holland Park circle: artists and Victorian society / Caroline Dakers.
 p. cm.
 Includes bibliographical references and index.
 ISBN 0-300-08164-2 (cloth: alk. paper)
 1. Art and society—England—London—History—19th century. 2. Artists—
 Homes and haunts—England—London—History—19th century. 3. Artists'
 studios—England—London—History—19th century. 4. Holland Park (London,
 England). 5. London (England)—Buildings, structures, etc. I. Title.
 N72.S6D34 1999
 709 .421 34—dc21 99-16247
 CIP

A catalogue record for this book is available from the British Library.

Frontispiece: G. Grenville Manton, *The Royal Academy Conversazione, 1891*, 1891. National Portrait Gallery, London. Sir Frederic Leighton, President of the Royal Academy receives guests at the annual 'conversazione'. Among the crowd are the actress Ellen Terry, the first wife of George Frederic Watts, Marcus Stone and Edward Burne-Jones.

Endpapers: The South-west sheet, *Stanford's Library Map of London and its Suburbs* London c. 1895.

Contents

Acknowledgements

For lending me invaluable material, reading drafts of the text, and sharing their knowledge of the period, I owe especial thanks to the Earl and Countess of Airlie, John Brandon-Jones, John Christian, Dr Nigel Cross, Sir Hew Hamilton-Dalrymple, the Honourable Simon Howard, Julia Ionides, Susan Meynell, Edward Morris, Pamela Myers, Mary Oliphant, Valentine Prinsep, Dr Christopher Ridgeway, Carrie Starran, the Honourable Charlotte Townshend, the Earl of Wemyss, Stephen Wildman.

Many descendants of the artists, architects and patrons who feature in *The Holland Park Circle* have been most helpful, also the current owners of houses: Don and Shirley Black, Anthony Crane, William Dalrymple, Francis Dineley, Robert Entwhistle, Chloe Green, the Countess of Gowrie, James Hervey-Bathurst, Christopher Ionides, Miriam James, the Marquess of Lothian, Neil and Keith Mason, Polly Morris, Lord Neidpath, Lord Ogilvy, Sophia Ryde, Carlos Sanchez, Gavin Tait, Kate Thirkell, Michael Winner.

The Leverhulme Foundation awarded me a Fellowship which enabled me to take a six month sabbatical from Central Saint Martins College of Art and Design; the Paul Mellon Centre and the Scouloudi Foundation awarded me small grants to assist with the cost of photographs; Central Saint Martins awarded me small grants for travel and materials, also replacement teaching hours so that I could complete the book and curate the accompanying exhibition, Artists at Home, the Holland Park Circle 1850-1900, to be held at the Leighton House Museum. I am most grateful for all their support.

Staff of libraries, art galleries and auction houses, curators of museums and archives, and scholars of the period have generously provided time, information and advice: Ann Anderson, Dr Robin Asleson, Dr Barbara Bryant, David Cockcroft, Alan Crawford, Graham Dobson, Simon Edsor, David Elliott, Caroline Evans, Stuart Evans, Donald Francis, Veronica Franklin-Gould, Julia Findlater, Katerine Gaja, Mireille Galinou, Dr Barbara Dayer Gallati, Oliver Garnett, Dr Mark Girouard, Julian Hartnoll, Guy Holborn, Richard Jefferies, Dr Sheila Kirk, David Kynaston, Dr Jody Lamb, Dr Fiona McCarthy, Kathryn McCord, Janet McLean, Dr Jan Marsh, Peter Nahum, Christopher Newall, Shirley Nicholson, Dr Pamela Gerrish Nunn, Professor Leonee Ormond and Richard Ormond, Linda Parry, Elizabeth Powys, Mark Roberts, Pamela Roberts, Daniel Robbins, Paul Saville, Reena Suleiman, Roger Waine, Bill and Sarah Waters, Dr Timothy Wilcox, Victoria Williams, Christopher Wood, Dr Paul Woudhuysen.

I would like to thank: the Syndics of the Fitzwilliam Museum, Cambridge for permission to publish material from the Burne-Jones Papers; the Hon. Simon Howard for permission to publish material from the Castle Howard Archive; Mary Oliphant for

permission to publish extracts from the letters of Edward Burne-Jones; the National Art Library and Pamela Myers for permission to publish extracts from the letters of Luke Fildes and Henry Woods; the University of Glasgow for permission to publish material from the Whistler Papers; Leighton House Museum and the Royal Borough of Kensington and Chelsea for permission to publish extracts from the letters of Frederic Leighton and the diaries of Linley Sambourne; the Royal Academy for permission to publish material from the diaries of Frederic Leighton; Liverpool Record Office for permission to publish extracts from the diaries of Andrew Kurtz; the Tate Gallery archive and the Watts Gallery for permission to publish extracts from the papers of George Frederic Watts; the Bodleian Library for permission to publish extracts from the papers of John Ruskin and F.G. Stephens; the Dickens House Museum for permission to publish extracts from the memoirs of Marcus Stone; the National Art Library for permission to publish extracts from the letters of the Ionides family, Marcus Stone, Valentine Prinsep, Wiliam Blake Richmond, William Burges and John Hanson Walker; the London Metropolitan Archive and the Ilchester estate for permission to publish extracts from the Holland estate papers; the Royal Geographical Society for permission to publish material from the Lowther papers.

While every effort has been made to trace copyright holders for literary and illustrative material, any further information would be welcomed.

Introduction

At the end of the twentieth century some 10,000 artists are said to work within two miles of Old Street in London's East End. At the bi-annual Whitechapel Open Exhibition maps are obtainable, showing the location of the artists' studios. On open days the public can make their way between warehouses and industrial units to meet the artists and view work in their studio-spaces. The contribution of these, mostly young, artists to the image of 'cool Britannia' is celebrated by middle-aged politicians and glamorised or debunked by art journalists. The elite artists are successful media celebrities, decorating chic restaurants, modelling designer clothes, dining with the Prime Minister.

During the second half of the nineteenth century, the most desirable locations in London for artists' colonies were St John's Wood, Hampstead, Chelsea and Kensington; the most prestigious address was Holland Park, home to the celebrated artists George Frederic Watts and Frederic Leighton. On 'Show Sundays', a few weeks before the opening of the annual Summer Exhibition at the Royal Academy, the public were able to visit artists' studios to view work about to be sent to the Academy or, from 1877, the Grosvenor Gallery; it was also an excuse to see the artists in their domestic environment. Their original work and the reproduction rights commanded high prices; several of the artists were as rich as members of the aristocracy, millionaires by late twentieth-century values.

This study is a history of a unique period in British art, when fashionable artists earned fortunes and exercised unparalleled influence on the artistic sensibilities and tastes of the rich. It describes the relationship between their art and their artistic environment; their carefully designed studio-houses and their carefully cultivated social network of fellow artists and sympathetic patrons. The royal family were patrons, as were some members of the aristocracy, but their main supporters were the newly rich middle classes: industrialists, merchants, bankers, who wanted to buy 'interesting subjects; variety, resemblance to nature; genuineness of the article, and fresh paint'.[1] It was a golden age of patronage, or at any rate of generous merchant buyers driving a burgeoning art market.[2]

> Large fortunes were being made in Birmingham, Manchester and Liverpool; large houses were being built. There was a growing dislike to the mass of spurious 'Old Masters', to the sham Claudes, and doubtful Canalettos, and to the 'furniture pictures' that had been so much in fashion since the days of Sir George Beaumont. The fingers of the picture buyers had been frequently burned over their bargains, and the new order of rich patron that arose refused to have anything to do with them. For the future they would buy at any rate genuine works, the works of living men, with their signatures, properly vouched for, upon them.[3]

The 'living men' who provided works for the rich saw themselves, in turn, as 'cultural legislators, painting enormous canvases, trafficking in great ideas'.[4]

At the centre of the Holland Park Circle – and this study – are the artists' individual studio-houses. Regularly featured in a variety of journals and magazines, the houses played a major role in promoting their work. Visitors to their studios on 'Show Sunday' or for special musical soirées appreciated the rich and ornate interiors made more alluring by the refinement and sensibilities of the artist in residence.

The power of style and packaging – very modern concepts – was nowhere as effective as in the Holland Park Circle, dubbed at the time 'Paradise Row'. The presence of two of the 'Olympians' of the Victorian art world, Watts and Leighton, was an irresistible magnet to press and public.

Readers were provided with glimpses or 'peeps' into the lives and homes of the household names of art. Everything was touched on: the original design of the building; the architect's ability to provide for the specific requirements of an artist; the new technology apparent in the studio fittings; the choice of internal decorations; the artist as collector and connoisseur; his appearance and personality; snippets from his life-story; the listing of patrons or famous models; hints regarding the large prices paid for works and for reproduction rights. Most 'peeps' were lavishly illustrated with photographs of the artist and his (very, very occasionally, her) home, and reproductions of their art. They were not so different to features in The World of Interiors or Elle Decoration, or in the lifestyle sections of the Sunday newspapers. The 'peeps' in the Strand are prototypes for Hello! magazine.

The design of the studio-houses indicated the rising social status of Victorian artists. Throughout the eighteenth and first half of the nineteenth centuries, the majority of artists had occupied modest studios in Newman Street, St Martin's Lane, Long Acre, Leicester Fields and close to the British Museum. The only evidence of artists in residence was the enlarged window to let in extra light:

> Here in England the only external indication we have of a painter's studio is the further disfigurement of the dirty brick fronts of Newman or Berners Street, by increasing the height of a window and making it protrude awkwardly into the limits ordinarily assigned to the floor above. The lower part is shaded with green calico and the windows are dirty.[5]

Throughout the nineteenth century there was an inexorable move westwards not only by artists but also by art establishments.[6] Watts, for example, the 'father' of the Holland Park Circle, occupied a studio in Fitzrovia in the late 1830s; he returned from Italy in 1847 to work first off the Edgware Road, then in Belgravia; in 1851 he was living in Little Holland House on the Holland estate; by the end of the century he owned a house in Melbury Road and a house and studio in the Surrey countryside. The year he settled in Holland Park the Great Exhibition opened in Hyde Park. Six years later the Sheepshanks Gallery opened in Kensington, the first permanent building to form the South Kensington Museum and School of Design.[7] In 1869 the Royal Academy moved from Trafalgar Square to Burlington House in Piccadilly; the Grosvenor Gallery opened in Bond Street in 1877.

These shifts were occurring as London was itself undergoing rapid expansion: the total population in 1800 had been around a million; by 1881 it was 4.5 million. By 1871 a seventh of the total population of England and Wales was living in London, by 1900 a fifth.[8] Kensington was one of the fastest growing areas of London. In 1817, two

years before Queen Victoria was born at Kensington Palace, the population of the borough was 12,000; by 1851 it was over 44,000.

The studio-houses of the Holland Park artists not only reflected the artists' critical and worldly success, they were also significant as examples of nineteenth-century domestic architecture. They were all built of red brick, standing out in a desert of stucco, 'an oasis in this weary waste of building'.[9] They were designed by architects who were regarded as the most imaginative of their time: Philip Webb, George Aitchison, William Burges, Richard Norman Shaw and J.J. Stevenson. Webb's first house had been the Red House designed for William Morris, and almost all his work was for artists or art-lovers. Burges was famous for his elaborate Gothic fantasies for the Marquess of Bute at Cardiff Castle and Castle Coch. Shaw and Stevenson were the major forces behind the 'Queen Anne' movement which would change the architectural style of Kensington and Chelsea.[10]

The first artists' houses were built on land released for building by Lady Holland, widow of Henry Edward Fox, fourth Baron Holland, whose extravagances could not be supported by the Holland estate but whose advisers proposed cashing in on the rapid development of Kensington. Holland House, the Jacobean mansion at the centre of the property, had been famous for its Whig salon since the end of the eighteenth century: Lord Macaulay, a regular guest of the Hollands and a resident of nearby Campden Hill, described it as 'the favourite resort of wits and beauties, of painters and poets, of scholars, philosophers and statesmen'.[11] The various attempts to safeguard the house (fig. 1) and surrounding park provide a continuous background to the evolution of the circle. Even in their financial embarrassment, the Hollands made an unwitting contribution to the lives of artists; the land sales led to the establishment of the colony close to the old mansion and park.

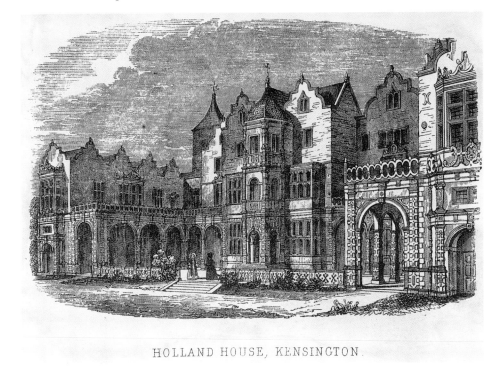

1. Holland House, c. 1840.

HOLLAND HOUSE, KENSINGTON.

Watts and Leighton are the principals of the story. Watts, known to his intimate circle as Signor, was delicate and sensitive, and eschewed both country-house weekends and formal occasions in London. He preferred the solitude of his studio or the company of a select circle of adoring, high born ladies with whom he could discuss death and the after-life. But his reputation among fellow artists was unassailable, founded on his talent to manipulate paint, as much as his ambitious subject matter and his steadfast belief in art as a moral force for good. Throughout his life he managed to balance portrait painting, which paid the bills, with the production of symbolic works (he called them 'suggestive') which found few buyers. To introduce a wider audience to his work, he commissioned a gallery to be added to his house in Melbury Road in which to show a selection of his works which he intended to leave to the nation. The public were graciously welcomed to visit, free of charge, every Sunday.

Leighton was President of the Royal Academy from 1878 until his death in 1896. Handsome, charming, accomplished; patronised by royalty; knighted in 1878; raised to a baronetcy in 1885; the only artist to be made a peer of the realm, he was Colonel-in-Chief of the Artists' Volunteers and the model for Disraeli's Mr Phoebus (in *Lothair*) and Henry James's Lord Mellifont (in 'The Private Life'). Leighton achieved unrivalled social status for a member of the artistic profession. His personal success was nowhere more apparent than in the palace of art he created in Holland Park Road. The Prince of Wales attended his private dinner parties; society anxiously awaited invitations to his musical parties held at the beginning of the London Season. When his studio was open Holland Park Road was 'blocked with carriages and all the great men of the London world flocking to see the artist's work'.[12] Aspiring artists dreamed of building their own studio-houses nearby, as if geographical proximity might bring a share of the honours.

By the 1880s it was the sheer population of artists living around Holland Park that brought the area its artistic prominence. Several became Associates of the Academy soon after investing in property, almost as if the address assisted in their elevation. Certainly the cost of the area and the price and public estimation of their work were related.

> Melbury Road, Kensington, has for some years past been completely converted into a colony of eminent artists and sculptors in general, and R.A.s in particular. Pedestrians seldom pass by that way. It is a corner of London which the birds seem to have singled out as a fitting place for early and impromptu concerts – a Kensington nook . . . altogether an ideal spot for the artist. . . . To think of standing in a garden and being able to throw stones – carefully, of course – on to the green lawns of Sir Frederick [sic] Leighton, Mr Val Prinsep RA., Mr Watts RA., Mr Marcus Stone RA., and Mr Colin Hunter ARA., whilst, from the roof of this particular house [that of Hamo Thornycroft RA] those gifted in aiming straight might pitch a pebble amongst the bushes belonging to Mr Burgess [sic] RA., or Mr Luke Fildes RA.[13]

Some of their patrons acquired houses close by, including the Greek merchant Alexander Ionides, who bought number 1 Holland Park, part of an exclusive development intended to make the Holland estate a tidy profit. The aristocratic artist and collector George Howard, later Earl of Carlisle, commissioned Philip Webb to design a house on land close to Kensington Palace, released by the Crown Estate for residential development.

Unlike the artists associated with Chelsea, in particular Dante Gabriel Rossetti and James McNeill Whistler, the majority who moved to Kensington wanted to be accepted by the establishment. As William Holman Hunt noted, 'a new associate of the

Academy immediately received an accession of demand for his works'. Hunt recalled his disappointment at not being elected in the 1850s, about the time he moved to a studio-house on Campden Hill, overlooking Holland Park: 'had I been distinguished by the badge of Academy favour, I could have counted upon the prejudice against my work by rich collectors being turned into approval and patronage'.[14] The badge of Academy favour also implied particular social status: members were automatically deemed to be gentlemen,[15] and the large sums artists received for their work also meant they could live like gentlemen.

During a period when the average annual income was about £100, many artists were earning in excess of £5,000, the annual income, for example, of a high-court judge. Leighton's income was about £2,500 in 1864, the year he commissioned his house in Holland Park Road; by 1893 his receipts from sales of paintings and investments exceeded £21,000. In 1855 Queen Victoria paid him 600 guineas for the first work he exhibited at the Royal Academy, *Cimabue's Celebrated Madonna is Carried in Procession through the Streets of Florence*; Manchester City Art Gallery paid £6,000 for *Captive Andromache*, exhibited at the Academy in 1888.

The houses commissioned by the artists in Holland Park now sell for several million pounds – a one-bedroom apartment carved out of Marcus Stone's large studio-house sold in 1999 for over £1 million. The first studio-house which Philip Webb designed for Val Prinsep in 1865 cost some £2,000, with a ground rent, payable to the Holland estate, of £28 per annum; Luke Fildes' house in Melbury Road, designed by Shaw in 1875, cost about £4,500 for the first stage; James Jebusa Shannon's house, built next door to Leighton in 1892, cost over £3,500 and the ground rent, payable to the Ilchester estate, was £280 per annum.

This study explores the complex network of taste and influence which distinguishes the circle, moving between the artists' houses – paid for by the art collectors – and the houses of some of their patrons, influenced by the taste of their artist friends and neighbours. Henry James identified the phenomenon in his review of the 1877 'Picture Season': 'the taste for art in England is at bottom a fashion . . . a great fashion. How these people have always needed, in a certain sort of way, to be entertained, what handsome things they have collected about them . . . on what a scale the consumption has always gone on!'[16]

As far as possible I have attempted to create a narrative of the foundation and development of the Holland Park Circle, interspersed with case studies. Because so little remains of both the artists' and their patrons' homes as they were originally conceived and executed, this book describes the decoration and furnishing (where known) in some detail. Such descriptions can only suggest the effects which struck visitors as 'different' and quintessentially 'artistic'. Delicate painted friezes designed by George Aitchison and Albert Moore, elaborate gesso-work by Walter Crane, stencilled ceilings by Morris and Company, all were swept away along with the reputations of their creators.

The collapse in the value of Victorian art was well underway before the end of the century – it is a tale often told. The individual wealth and social status achieved by artists in the Holland Park Circle was only sustained during their lifetimes. Luke Fildes, Marcus Stone, Colin Hunter, the Thornycrofts, Val Prinsep, James Jebusa Shannon, Solomon J. Solomon, Ernest Normand and Henrietta Rae have received little critical

notice since their deaths.[17] Their value at auction has also remained considerably lower than the work of the Pre-Raphaelites, Aesthetes and Symbolists, resurrected in the mid-1960s through a series of ground-breaking exhibitions.[18] Only now are Watts, Leighton and Albert Moore securing some of their former status through re-evaluation and relabelling as aesthetes and modernists.[19]

This book describes their zenith as artists and millionaire-princes in their palaces of art. In many ways, their greatest artistic achievements were the creation of their studio houses in total: decorations, sculptures, paintings, furniture, and even gardens. Only Leighton's house gives the public a glimpse of these now vanished creations. The sale particulars of 49 Prince's Gate, the home of the Liverpool ship-owner Frederick Leyland, sums up the contemporary view of the status of the late-Victorian artist. The Kensington house was auctioned on 17 June 1892, complete with fourteen bedrooms (seven for servants), six reception rooms, including the famous Peacock dining-room designed by Whistler, five dressing rooms and bathrooms.

> The desirable and most convenient situation of this property presents itself equally to the Merchant Prince, Nobleman or Artist, being particularly easy of access to the Parks, Clubs, Albert Hall, Theatres, Galleries and the 'Art Homes of Kensington'.[20]

1

Watts and his Early Patrons: the 1840s

In the spring of 1837 the young painter George Frederic Watts was visited in his studio by a Greek merchant, Alexander Constantine Ionides. Watts was asked to make a copy, for £10, of a portrait of Ionides' father Constantine Ionidis Ipliktzis by Samuel Lane.

According to a descendant of Ionides, Watts had been recommended for the task by Sir Martin Archer Shee, President of the Royal Academy.[1] He had entered the Royal Academy Schools in 1835, though later recalled 'There was no test, no examination of the pupils.'[2] By 1838 he was established in a studio in Clipstone Street, close to Fitzroy Square, an area of London which was popular with both Royal Academicians and ambitious young artists.[3] Three of his paintings were selected for the Royal Academy Summer Exhibition of 1837.

Alexander Ionides was so pleased with the copy that he immediately commissioned Watts to undertake original portraits of the family. The first, also completed in 1837, was a painting of Ionides' wife Euterpe and three of their children. Over the next half-century Watts painted five generations of the family (fig. 2). He wrote to Ionides' son Constantine in 1893: 'As I had given up painting portraits the picture of your little grandchild was done for myself, for the pleasure of painting a fifth generation.'[4] Thomas Armstrong, who visited the Ionides with George du Maurier in the late 1850s, recalled that the portraits were 'for the most part, rather brown and low in tone, done in the careful and laborious manner now called "stodgy" which alone leads to that mastery with the brush for which Watts's later work was so remarkable'.[5] Watts' copy of the Lane portrait was never sent to the Ionides' company office in Constantinople, its intended destination; the family preferred it to the original and invited Watts to paint Ipliktzis' wife to make a pair. 'I recollect as if it were yesterday', Alexander Ionides later wrote to Watts, 'your first visit to my office, when you brought both original and copy, and I said at once to Mr G.F. Cavafy, who was present, that I preferred by far the copy, and that I was going to keep the copy and send the original to Constantinople.'[6]

Watts' father was a carpenter and an unsuccessful manufacturer of musical instruments; he himself was largely self-taught apart from an apprenticeship to the sculptor William Behnes and his brief time at the Royal Academy Schools. 'I received no teaching', he informed Marion Spielmann in an interview for the *Pall Mall Gazette*, 'I visited no painters' studio or *atelier*. Disappointed as to the Royal Academy, it became my habit to haunt the studio of Behnes, but I never studied under him in the ordinary acceptation of the term.'[7] Without private means, portraiture was the only way he could hope to make a living and also to provide for his impecunious father and two half-sisters. As

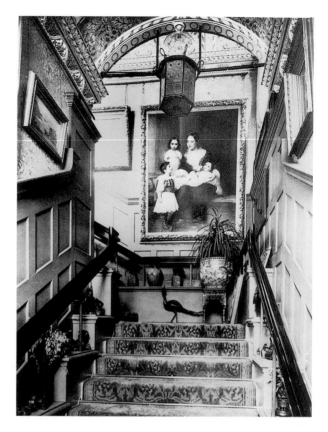

2. The staircase of 1 Holland Park, home from 1864 of Alexander Constantine Ionides. George Frederic Watts' painting of Euterpe Ionides with three of her children hangs on the staircase wall. The house was decorated throughout by Morris & Company (see chapter eight).

Wilfrid Blunt commented, 'for Watts, there was always another Ionides, waiting in the queue to be painted as soon as a financial crisis obliged him to take time off from unprofitable "High Art" and stoop to vulgar but lucrative portraiture'.[8] However, the close relationship Watts maintained with Alexander Ionides and his descendants for over half a century reflected not just the agreeable effect of his portraits, but his ability to attract the affections of families with the means to offer him financial and domestic support.

The Ionides' wealth came from trade, and later from banking. Ipliktzis had first established his name in Manchester in 1815, exporting Lancashire cotton to Greece and Turkey while importing silk, opium, fruit, corn and Egyptian cotton. His son Alexander was born in Constantinople in 1810 and came to England in 1827. In 1837, the year he commissioned Watts, he was established, with his wife Euterpe, at 9 Finsbury Circus in the City of London. He also became a British subject, 'under the very first Act of Parliament of Her Gracious Majesty'[9] and formally adopted an Anglicised spelling of his name, Ionides rather than Ionidis.

The Greek community in London was led by a small number of wealthy and influential merchant and banking families linked by marriage and commercial interests. Pandias Stephen Rallis, whose company was also in Finsbury Circus, regarded himself as the head. He was Greek Consul in London until 1853 when Alexander Ionides succeeded to the position. Families related by marriage to the Ionides included the Cavafys, Cassavettis, Spartalis, Argentis and Lascardis. By mid-century, they virtually controlled

trade between Britain and ports in the Mediterranean and the Black Sea. The *Mark Lane Express* in 1853 described their rapid rise:

> This large and increasing trade is exclusively in the hands of a small body of merchants, all connected together by the ties of nationality, of religion, and in a great measure of kindred. They created this cargo trade, and they probably will keep it to themselves. . . . In 1820, the trade with the Levant, then of small extent, was wholly in the hands of British merchants. In that year, two or three Greek houses were established in London, with moderate capitals and humble pretensions. Their operations, though at first limited, were highly successful, and received rapid development. Other Greek establishments were formed, and gradually the whole of the trade passed away from the British houses into the hands of the Greeks, who realized rapid, and in many instances colossal, fortunes.[10]

In 1840, with both wealth and British citizenship, Alexander and his wife acquired a substantial home on Tulse Hill, at the time a rural location to the south of London. Watts became a regular visitor, painting group and individual portraits of the family while he was fed pastry cakes made from rose leaves. Greek and British customs were engagingly jumbled together at Tulse Hill. Older female members of the family spoke little English. A German guest described Euterpe, who was a year older than Watts, as 'an Athenian, translated into English . . . in her . . . British positively pairs with oriental equilibrium' and admired the children 'with the dark eyes and melodious names', Aglaia, Chariclea, Constantine, Loucas (Luke) and Alexander (Alecco).[11] Watts painted the younger sons in Greek costume seated at the feet of their conventionally clad parents.[12]

Profits from trade were so large that in 1845 the family established the Ionidi Foundation. Generous grants were made to educational and religious establishments in Greece and in London. At the same time, Alexander Ionides began to develop his interest in contemporary British art and design, an interest which spread to all his children. However, the Ionides' pattern of collecting was unusual: it almost always began with a chance personal contact which awakened interest in the painter's work.

Tulse Hill remained the Ionides' home until 1864 when they moved to Holland Park. Their Tulse Hill neighbours included the musicians Figdor Joachim and his nephew Joseph. Elhanan Bicknell, ranked by the *Athenaeum* on his death in 1861 as one of four major British collectors of contemporary art, lived close by at Carlton House, Herne Hill with his third wife, sister of Hablot Browne (Phiz), and Charles Dickens was a member of the circle. Luke Ionides remembered, 'I used to meet Dickens at our friends the Bicknells. I was a youth at the time and found fault with his dress which I considered very loud.'[13]

The Ionides' house was open every Sunday, with dinner served at four o'clock for as many as were present. The cosmopolitan atmosphere, the informality, the unusual beauty of the daughters and their female cousins combined to make Tulse Hill one of the most popular weekend retreats in London, particularly in the late 1850s, for artists, musicians and writers.

The relationship which developed between Watts and Alexander Ionides was the first of the close friendships which sustained and to a large extent controlled Watts' life. For Ionides, his faith in the young artist was justified when Watts, comparatively unknown, succeeded in winning one of the three first prizes of £300 offered in 1843 for cartoons to decorate the new Palace of Westminster with *Caractacus Led in Triumph through*

the *Streets of Rome*.[14] The Roman Emperor Claudius, representative of classical civilisation, is so impressed by the 'barbaric' British chieftain Caractacus' noble spirit that he pardons and releases him. Watts' success with such a subject probably encouraged him to devote the rest of his life to 'the loftiest ambitions and the loftiest ideals'. In the words of his own motto: 'The utmost for the highest'.[15]

According to Luke Ionides, Watts wrote to his father to ask for an allowance of £300 a year for the rest of his life,

> on condition that my father might have all the work he did. My father answered that he would let him have any money he wanted, so that he should not be troubled with the menace of want, but he would enter into no pact of that sort, as the time would come when Watts's earnings would be in thousands – a prophecy which came true.[16]

With the prize money and additional help from Ionides, Watts travelled to Italy, his first trip away from England, to study fresco painting.

During the journey, Watts became acquainted with General Robert Ellice, one-time Governor of Malta, and resident of Florence, and was given a letter of introduction to Henry Edward Fox, fourth Baron Holland, who was British Minister at the Court of Tuscany in Florence (fig. 3). Watts was too shy to make use of the letter but Ellice mentioned his name to Lord Holland, who then tried to locate Watts for himself.

> The young man had made his way there, it is true. But absorbed in his studies and revelling in the artistic treasures by which he found himself surrounded, he might well have returned to England without making the acquaintance of the British Minister – for two months was to be the limit of his stay. But the Fates willed otherwise. A second meeting with General Ellice in the street brought an invitation to dine at the Casa Feroni [home of the Hollands]. This was on October 3 [1843].[17]

Within two weeks of dining with Lord Holland and his wife at the Casa Feroni, Watts was painting his hostess (fig. 4). Lord Holland wrote to his aunt, Caroline Fox at Little Holland House, Kensington:

> Mr Watts seems to me full of genius and favourable ambition, without any of the jealous, niggling, detracting vanity of his brother artists. I have seen a good deal of him, as he has made a beautiful sketch of Augusta in oil. I wish you would mention and recommend him to Lord Lansdowne. I think he will be a great painter in his day.[18]

Lady Holland later recalled: 'I remember perfectly well hearing Lord Holland say, "Why not come here? We have plenty of room, and you must stay till you find quarters you like."'[19] Watts failed to find quarters he liked and remained living under the Hollands' roof in Italy until the spring of 1847, several months after his hosts had returned to London.

Watts was to be the first and only artistic protégé of the Hollands (fig. 5). He was five years younger than Lady Holland and played on his good looks as well as his genius: 'Being young with a profusion of very good hair, a vigorous moustache and imperial, my appearance was not against me. In fine, I was liked.'[20] He was also, in the opinion of Ronald Chapman, a 'great opportunity' for his hostess: 'She had met men of genius before, but none of them had even remotely been of her making. But here was a young man whom she really could patronize. It would be of infinite use to the ambitious painter, and full of allurements for herself.'[21]

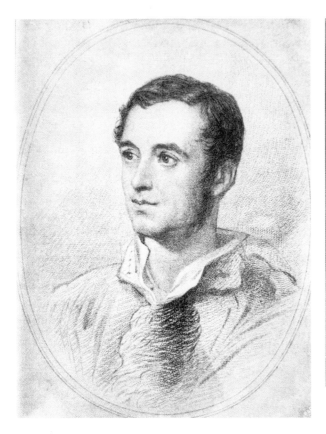

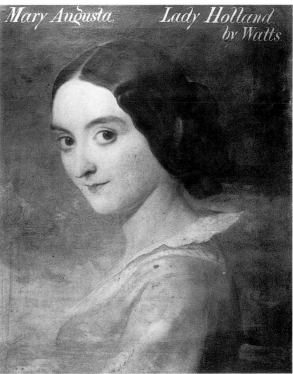

Watts repaid Lord Holland by producing numerous portraits of the many distinguished visitors who passed through Florence: politicians, diplomats, soldiers, European aristocrats and their wives.[22] Watts' skill was in encouraging his subjects to talk in the intimacy of his studio and to appreciate his own conversational and intellectual powers, a skill which he drew on throughout his long career as a portraitist.

His residency with the Hollands was not entirely without friction. Though he recognised that portraiture was likely to be his main source of income, he regarded the form as inferior. Lord Holland pressed him to produce such work, stressing its economic value. He wrote to his mother in London a few months after Watts had settled in:

> I have worried him into painting portraits. . . . He would not paint portraits at first, as he aims at being more than a mere portrait painter, and indeed he has talent for really fine poetical pictures – but who in this age will order them and pay for them, among the few who have sense to hang them up!!? I like him very much, and have seldom if ever known any artist so totally devoid of their usual faults of envy and detraction. He is very clever, well read, and wonderfully quick and intelligent; but I fear he has not the energy and qualities to ensure his prosperity in the world.[23]

Lord Holland's concerns for the future of Watts may have been partly coloured by his own worries about his estate in London. His father had died in 1840, leaving Holland House and its contents to his widow, for her lifetime. She had been extravagant during her husband's life, but after his death she gave increasingly lavish dinner parties at her town house in Mayfair. To help finance her entertainments she began to dispose of

3. George Frederic Watts, *Henry Edward Fox, Fourth Baron Holland* c. 1845. Private collection. The original painting was destroyed when fire damaged part of Holland House in 1871.

4. George Frederic Watts, *Mary Augusta, Lady Holland,* 1843. Private collection.

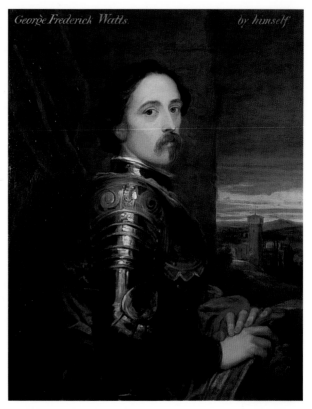

5. George Frederic Watts, *Self-Portrait in Armour*, 1846. Private collection. During a ball given by the Hollands, Watts sketched a suit of armour abandoned by a guest in a room at Casa Feroni. He later painted himself in armour at the Villa Medicea. The Torre di Careggi, a castellated farmhouse close to the villa is in the distance.

paintings from Holland House; she also tried to sell her son, Colonel Charles Fox's house in Addison Road while he was living in it, and drew up plans to build along the entire south front of the park.[24] Action had also begun in Chancery to obtain payment from the Birmingham, Bristol and Thames Junction Railway Company (renamed the West London Railway) for land sold along the western boundary of the estate for the construction of a new line.

Benjamin Haydon, writing to the artist Seymour Kirkup in Florence about the same time, was appalled by the direction of Watts' painting:

> That boy Watts, I understand, is out, and went out, as the great student of the day. Though he came out for Art, for High Art, the first thing the English do is to employ him on *Portrait*! Lord Holland, I understand, has made him paint Lady Holland!! Is this not exquisite? Wherever they go, racing, cricket, trial by jury, fox-hunting, and portraits are the staple commodities first planted or thought of. Blessed be the name of John Bull.[25]

It was easy for Haydon to scorn, but for Watts the patronage of the Hollands – their hospitality and the access they provided to both works of art and the Italian landscape – was vital to his artistic development.

Watts also irritated Lord Holland by his apparent idleness.[26] It is more likely, as Wilfrid Blunt suggested, that Watts spent much of his time assimilating his Italian surroundings, quite simply looking and thinking.[27] He also met other artists working in Florence, including Kirkup and Hiram Powers. As far as Lord Holland was concerned Watts was not even getting down to the study of fresco painting, which was ostensibly the reason for his trip to Italy (fig. 6). 'He is . . . terribly dilatory and indolent, and

will not buckle down to study fresco painting as he ought.'[28] However, Watts completed many landscape sketches and a considerable number of portraits in pencil and oil.

Watts was experimenting with fresco painting for himself, but his early attempts in the courtyard at Casa Feroni were dismal. In December 1843 Lord Holland sought technical advice from his cousin Lord Lansdowne who had commissioned frescos for Bowood House in Wiltshire including *Pilgrims Arriving in Sight of Rome* by Charles Eastlake: 'An artist here has been making several trials with unequal success. Sometimes his labours dry quite spotty and bad, and sometimes tolerably well; but he is not able to discover what (unless it be the changes of the atmosphere) makes this variety.'[29]

During the summer of 1844, Watts began a new fresco in the garden loggia of the Villa Medicea, Careggi (fig. 6). The Hollands retreated annually to the villa in the Val d'Arno to escape the heat of Florence. Watts chose as his subject the murder of the doctor of Lorenzo the Magnificent, thrown down a well for failing to save the life of his patient. He was, as always, provided with lavish facilities; at the villa he worked in a studio 100 feet long, a building in the garden originally designed to shelter lemon trees in winter.

He was also becoming increasingly interested in painting the landscape, especially scenes around Careggi (fig. 5). Lord Ilchester describes them as a 'violent fancy' which 'diverted him from his strict objective', the completion of the fresco of the murder.[30] On a visit to Rome with Lord Holland in August 1844 he painted studies of peasants and bulls in the Campagna. When he completed the oil version, *Peasants of the Roman Campagna* the following year, he sold it for 200 guineas, presumably to the surprise of Lord Holland, who could only view with frustration the uncompleted portraits which

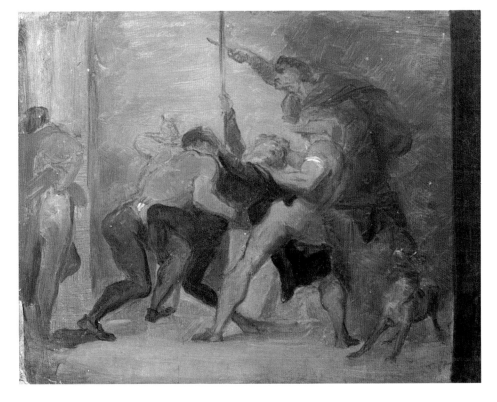

6. George Frederic Watts, sketch for the fresco at the Villa Medicea of the murder of the doctor of Lorenzo the Magnificent, 1844–5. Watts Gallery, Compton, Surrey. The completed fresco survives in an enclosed loggia at the villa.

cluttered up the studio in his house in Florence. There was an argument between patron and artist some time in 1845 when Watts refused to accept payment for a head of Sir Charles Bannerman, the father of one of the members of the British legation:

> I have scoled [sic] and reasoned, and for the time kept him quiet, but he vows he shall return the money and will not paint portraits for gain. I think this foolish. However, I suspect he is just now in the fervor of historical painting, and will not be so unreasonable when the fit of glory and the visions of Michael Angelo shall subside a little.[31]

In May Watts was literally locked out of his bedroom at Casa Feroni, and dispatched to Careggi to work on his own.[32]

Lady Holland was also worrying about Watts, and about the role of the Hollands as perceived by future historians. Was their patronage actually harming Watts?

> I hope our home, wherever it be, may be his home occasionally, under circumstances whenever he likes, but I have a strong and determined wish to break the spell, and make him feel that he is ever a welcome guest but not a constant and *necessary* inmate. I consider this *necessary* for all parties, becoming all parties, and I feel certain it will lead to the ultimate comfort of all parties.[33]

She was no doubt aware of the gossip circulating in Florentine society concerning her intimacy with the artist.[34] At the same time Watts, surrounded by the splendours of Renaissance Florence, living in a Renaissance *palazzo*, was perhaps coming to see his patrons as Medicis, sufficiently wealthy to support his every artistic scheme; his ambition was 'to tread in the steps of the old masters'.[35] Lady Holland continued:

> The world is ever cold and heartless in all its judgments; and I feel unfortunately a strong conviction that Watts's prolonged *séjour* in our house will not be ascribed to its real cause – good-nature and kindness of heart on our side, want of energy, affection and gratitude on his. His idleness will be laid to our door; and we shall be accused of having been the ruin of him, lucky if both of us escape with even so mild a censure.[36]

Many years later Watts expressed only gratefulness towards the Hollands: 'I often wonder when I think of the kindness of those two to me; as I think of that time I see how wonderfully they made me one with them. It pleases me to think what confidence they had in me, talking to me about their most intimate concerns.'[37]

The Dowager Lady Holland died in 1845 and Holland House and the estate became the responsibility of her son. His annual income increased to some £9,000, modest enough by the standards of his class but quite insufficient for settling the debts accrued by previous generations. Land had to be sold, even though Holland House would 'lose its merits as a country place'. Lord Holland consoled himself with the thought that by 'retaining elbow room about it, H.H. may become a fine *town* house, and still be enjoyable'.[38] He resigned his post in June 1846 (he was also dogged by ill health) and left Italy in July.

Watts, however, was invited to remain behind at the Villa Medicea, to be looked after by Lady Holland's friend Caroline Duff-Gordon. A widow, Lady Duff-Gordon already lived in Florence with her two daughters, Georgie and Alice. They agreed to take over the villa until their annual December move south to Rome.

Watts wrote to Ionides explaining his situation in Florence and his decision to pursue art rather than money. With the Hollands gone it was not too difficult to forswear portraiture:

I have been most fortunate & have made great & powerful friends, if I have not made money it has been my own fault with the connection I have made if I applied myself to portrait painting I might carry all before me, but it had always been my ambition to tread in the steps of the old masters, & to endeavour as far as my poor talents will permit to emulate their greatness (nor has the sight of their great works diminished my ardour). This can not be done by painting portraits, therefore I forego the present advantage in the hope of acquiring future fame.[39]

He offered Ionides the opportunity to commission something special, Greek, patriotic: above all, morally uplifting:

cannot you give me a commission to paint a picture to send to Greece? Some patriotic subject! something that shall carry a moral lesson, such as Aristides relinquishing his right to command to Miltiades. Thus those who look upon it may recollect that the true Hero & patriot thinks not of his own honour or advantage & is ever ready to sacrifice his personal feelings & his individual advancement for his country's good, such subjects grandly painted & in a striking manner would not be without their effect upon generous minds.[40]

Forced to introduce the subject of the cost, Watts produces a tortured, meandering, embarrassed diatribe which is worth quoting at length: the style becomes a feature of all his future correspondence dealing with money.

Take advantage of my enthusiasm now: I will paint you an acre of canvass for little more than the cost of the materials, or say, if you are not rich enough yourself get up a subscription among your friends, for two hundred & fifty pounds I will paint an historical picture which shall be worth six times the sum, I cannot say a less price for the materials & models cost a good deal & I have besides my sisters to look after, think of what I say & dont throw away a good opportunity which will not be offered again dont think I offer this because I cannot get occupation. I sold a picture last year containing two half length figures & a couple of bulls heads [*Peasants in the Roman Campagna*] for two hundred guineas, & my price for a single portrait is a hundred guineas, so that you see I offer merely for the sake of gaining honour, & name a sum which will only prevent my being out of pocket.[41]

While waiting for an answer from Ionides, Watts settled into the new regime at the Villa Medicea, entrancing the Duff-Gordons as completely as he had won over the Hollands. Mary Watts' comment suggests something more calculating on the artist's part: 'he was again surrounded by that affectionate care which something in his nature required and compelled'.[42]

He was invited to give the Miss Gordons drawing lessons and a close and intimate relationship developed with Georgie, who was exactly his age, twenty-eight. She wrote in her diary for August 1846: 'We have been most fortunate in finding Mr Watts here, who has fallen into our ways as if we had lived together all our lives and whose painting is a constant interest to us.'[43]

Watts was working on a life-size nude 'Echo' (fig. 7), also a large painting of a scene from Boccaccio depicting a naked Philomena in flight. Such sensuous paintings may have led to a sense of *frisson* among his young admirers.[44]

At the same time his correspondence with Ionides over the Greek commission was becoming heated when it became apparent that potential subscribers wanted to see a preliminary sketch.

I hope it was clearly understood that it was not as a matter of business, or by way of obtaining a commission that I made the proposal, the sum I mentioned was one which upon

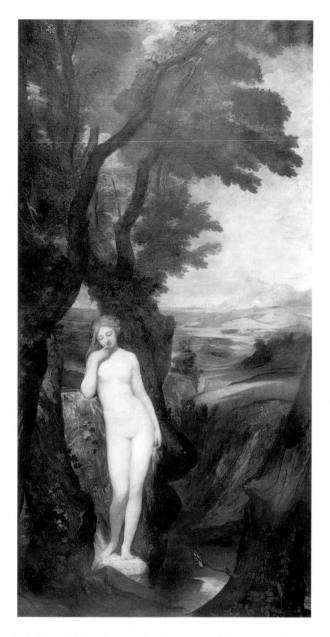

7. George Frederic Watts, *Echo*, 1844–6. On permanent loan to the Watts Gallery, Compton, Surrey.

moderate computation I concluded would barely pay the expenses of Canvass, colours, models . . . or go some way towards defraying the rent of a studio.[45]

He had calculated that 'at least a year of hard work & application would be necessary' to produce a work of quality, but such a sacrifice would be worth making for 'the cause of honour, & for Greece'.

> I would even with the hope of being useful to the birthplace of the Arts & Sciences paint the picture entirely at my own expense, but you are sufficiently acquainted with my circumstances to know that my sisters depend upon my exertions for their subsistence, & I cannot consistently with my duty run into expenses which would oblige me to break into the small sum which I have been labouring to lay aside for them.[46]

The request for a sketch was most galling, 'as if your friends wanted assurance'.

> As to making a sketch the subject is one of the very highest class & would depend entirely upon grandeur of style & treatment, elevation of character correctness of drawing; dignity & justness of expression, purity of design, colour, & sentiment, it is quite impossible to express these qualities in a sketch.[47]

Watts' high opinion of his own worth paid off: Ionides agreed to commission the work himself, his friends refusing to subscribe. He also requested another smaller 'historical' picture for £50. The Greek painting was never completed; Watts also failed to deliver the historical picture.

On 17 November Lady Duff-Gordon moved her daughters to Rome. Georgie recorded in her diary: 'It is an epoch in one's life, to look back to three months of intellectual life, without any bores or social plagues. Yesterday we parted from Mr Watts with the greatest regret.'[48] Watts wrote to her a few weeks later:

> How goes the music? do you ever sing any of our old duetts? I tried the other day the German Duett with a Lady, but although she sang it as well as possible it was quite another thing, and I could not but feel how wonderfully well our voices must have suited each other. I have not touched the clay since your departure. . . . My guitar is consigned to its case and my music is covered with dust. Excepting upon the occasion above mentioned I have not attempted to sing a note. One does nothing alone.[49]

Whether heart-broken or not – the letter is characteristic of Watts' flirtatious epistolary style – he continued his plans to make a visit to Greece to assist in his commission for Ionides. However, the trip was postponed when he was persuaded by Lord Holland to enter the further (fourth) competition for the decoration of the Houses of Parliament. A large oil painting, nearly twenty feet long, of *Alfred Inciting the Saxons to Resist the Danes*, began to take shape in the garden studio. Watts explained to Ionides why he had decided to enter the competition:

> my friends think it incumbent upon me to send a picture to Westminster Hall, where to say nothing of the possibility of getting a prize they tell me it is my duty to appear & as I wish always as far as possible to do what is right I have commenced a picture . . . it is right for the sake of the many good friends I have that I should enter again into the lists with the artists at home, for much is expected of me & many think I am losing my tiara.[50]

Before leaving Italy, Watts spent ten days with the Duff-Gordons in Rome. There were visits to picture galleries and churches, excursions into the countryside and concerts in the evenings, also a visit to the Vatican Museum by moonlight specially arranged for Watts and Georgie. She wrote in her diary after his departure, 'I wish he cd. have stayed a few days more'.[51]

2

Watts at Little Holland House; the Genesis of the Holland Park Circle: the 1850s

Watts intended to spend only a short time in England, making sure his half-sisters were provided for in their new home outside London and entering *Alfred* for the competition for the decoration of the Houses of Parliament. He took temporary lodgings at 48 Cambridge Street, off the Edgware Road, also the address of the artist Charles Couzens, with whom he had been friends since boyhood. He had no studio in which to work but Robert Holford, a wealthy connoisseur and art collector, came to the rescue. They had become acquainted in Florence; now he offered the artist the use of a room in Dorchester House, his brand new mansion on Park Lane.[1]

While Watts worked in his rent-free studio, he resumed his friendship with the Ionides family on Tulse Hill and with the Hollands. A room was reserved for him at Holland House in Kensington, 'whenever he chose to appear',[2] which led to Watts painting yet more portraits for his hosts, including Anthony Panizzi, the Librarian of the British Museum, and François Guizot, the distinguished French historian and statesman. Watts also undertook decorative work at Holland House. His assistance in the restoration of painted panels in the Gilt Room was, according to Mary Watts, a 'labour of love'.[3] It was presumably also some return for all their hospitality.

Watts won one of the £500 first prizes for the Houses of Parliament decorations. However, this success and the continuing support of Holford, Alexander Ionides and the Hollands did not prevent him from suffering intense loneliness and loss of confidence in his work. According to the memoirs of Laura, Lady Troubridge, he had expected to be provided with a permanent home at Holland House but there was a 'difference of opinion, a quarrel'. Perhaps Lady Holland was acting on her misgivings about providing the artist with too much support. On the other hand Lord Ilchester refers, in his history of the Holland family, to a personal rift between Lord and Lady Holland in 1848–9.[4] In such a situation Watts would hardly have been welcome as a permanent resident.

Neither the *Alfred* painting nor the portraits Watts submitted to the Royal Academy in 1848 pleased the critics. Sir Charles Eastlake wrote to Watts on behalf of the Commissioners, who wished him to alter Alfred's legs.

> I was directed to ask whether you would have any objection to do something to the legs of the principal figure in your picture . . . some object also to the flying drapery of the same figure but it is believed that when the left leg is more seen & the other not (apparently) so straight, the upper portion will be improved. The objection, at all events, relates to this figure only & by no means to the whole figure as the head is much admired – no fault of any kind is found with any other part of the work.[5]

Thackeray was more general in his abuse. He published a skit on the artist in *Our Street* ridiculing the scale and subject matter of Watts' work:

> George while at Rome painted . . . a picture of 'Alfred in the Neatherd's Cottage', seventy-two feet by forty-eight – (an idea of the gigantic size and Michael-Angelesque proportions of this picture may be formed, when I state that the mere muffin, of which the outcast King is spoiling the baking, is two feet three in diameter). . . . None of George's pictures sold. He has enough to tapestry Trafalgar Square.[6]

Watts' letters to Georgie Duff-Gordon reveal his 'melancholy and despondency' at this time. He asked her to help him find a wife, a companion who would provide him with 'a real and tangible object for my exertions'.[7] He was depressed by the sight of poverty in the London streets and wrote to Georgie, 'This winter I will paint portraits in order to purchase the luxury of bestowing.'[8] He also produced four melancholy paintings, his only foray into social realism: *Under the Dry Arch*, *Found Drowned*, *The Irish Famine* and *The Song of the Shirt* (also known as *The Seamstress*). The last of these was inspired by Thomas Hood's popular poem, originally published anonymously in *Punch* in 1843, a passionate protest by an overworked and underpaid seamstress. Watts never sold the works; it was as if they represented a poignant moment in his artistic and personal life.

They were executed at a new studio. Building work at Dorchester House forced Watts to move, so in 1849 he joined Charles Couzens at 30 Charles Street in Mayfair, taking his 'muffins' with him. Couzens obligingly helped Watts by copying his portraits to satisfy the demands of the Ionides family.[9] Luke Ionides gives a slightly different interpretation of their relationship: 'Couzens . . . trained by Watts to make replicas of his portraits to be distributed in the family, to which Watts put the finishing touches, which, I fear, were accepted later on as genuine Watts.'[10]

Though to Georgie Duff-Gordon Watts revealed his loneliness and sadness, in the company of his fellow artists he was able to discuss his wilder ideas for a House of Life – to decorate a vast building with 'a history of the progress of man's spirit' – and for a Hall of Fame, to be filled with his portraits of distinguished contemporaries. In such a way his work would be given a national and historical significance far above his fellow artists' run-of-the-mill productions.

The Charles Street studio of Watts and Couzens became a popular place for other artists and writers to meet. By 1850 the Cosmopolitan Club was established. William Holman Hunt, who joined in 1852, commented that Watts' 'artistic and other numerous friends had taken steps to keep together and extend the circle of remarkable men of differing intellectual activities'.[11] Early members included Tom Taylor, dramatist, journalist, art critic and editor of *Punch*, who brought together Watts and the Terry sisters, Kate and Ellen, both actresses; Richard 'Dicky' Doyle, the artist and a contributor to *Punch*; Henry Wyndham Phillips, artist and secretary of the Artists' General Benevolent Institution; James Spedding, civil servant and authority on Francis Bacon; Thomas Hughes, author of *Tom Brown's Schooldays*; Sir Henry Layard the archaeologist; John Ruskin, who championed Watts in *The Stones of Venice* (1851–3) and purchased one of his early unfinished 'muffins', *Michael the Archangel Contending with Satan for the Body of Moses*.[12]

Later members included the novelist Anthony Trollope who described the club in *Phineas Redux* as 'a small club . . . the Universe. . . . It was domiciled in one simple and somewhat mean apartment. It was kept open only one hour before and one hour after midnight. . . . Its attractions were not numerous, consisting chiefly of tobacco and tea.'[13]

As Sir Algernon West recalled, in the early 1870s: 'one of the great walls is covered with a life-size fresco [painted by Watts] taken from a story of Boccaccio's (The Spectre Huntsman), where a nude young woman, as a punishment for having jilted her lover, is pursued by fairies and wild dogs.'[14] Other members included Millais, Leighton, Tennyson and Browning. Watts had by this time shaved off the moustache of which he had been so proud in Florence. A portrait by Couzens reveals a handsome if nervous-looking young man (fig. 8). For a brief moment his appearance was conventional. But the metamorphosis into Signor, the bearded, monk-like sage, was not far off.

He acquired his first pupil at Charles Street, Roddam Spencer Stanhope, grandson of the Earl of Leicester. As a younger son without the responsibility of inheriting estates, Spencer Stanhope decided, while a student at Oxford, to become a professional artist and persuaded Dr Henry Acland, Regius Professor of Medicine and a close friend of

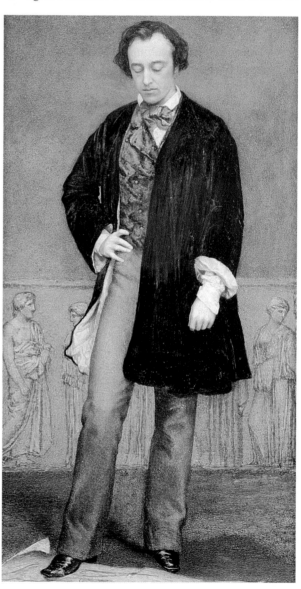

8. Charles Couzens, *George Frederic Watts*, c. 1849. Watts Gallery, Compton, Surrey.

The Holland Park Circle

Ruskin, to recommend him to Watts as a pupil. A letter of his mother's suggests that the reputation of Watts was the deciding factor: 'Roddy is in high force, but doubtful whether he shall go to the Scilly Isles with Mr Cross to study anatomy, or to Oxford during the vacation to study drawing under Watts, the famous Cartoon painter, who only takes pupils by great favour.'[15] The arrangement was confirmed after Lady Elizabeth was reassured as to the morals of Watts:

> We spent the morning at Watts's studio. . . . We were in raptures with the magnificent designs and pictures there and still more with poor Watts himself, who, Eliza declares, is the only person she ever saw who gave her the idea of Genius embodied in human form; and certainly the mind seems completely to have worn away the body, he looks so frail. . . . We made friends directly, as he seems a delightful person, and I thanked him very warmly about Roddy. I am very glad I have seen him and his pictures, which must be the result of a highly religious mind.[16]

Watts continued to frequent Holland House and on one visit Mr Fleming, a friend of the Hollands, proposed introducing the artist to a startlingly beautiful woman who lived close to Charles Street. Watts declined but after a chance sight of her in the street he asked Fleming to organise a meeting.

The woman was Virginia Pattle, who lived at 9 Chesterfield Street with her sister and brother-in-law Sara and Thoby Prinsep. Virginia was, according to contemporary accounts, exceptionally beautiful. Edward Lear, for example, declared her the 'handsomest living woman . . . I think her expression of countenance is one of the most unmitigated goodness I ever contemplated.'[17] Virginia and Sara became regular visitors to the Charles Street studio; Watts in turn was a guest at Chesterfield Street where he painted the walls as well as the family. Spencer Stanhope lent a hand.

When Watts fell seriously ill in 1850, he was nursed at Chesterfield Street. Mary Watts gives a charitable account of events:

> His old enemy of headache and nausea had returned, and so violent were these attacks that, while they lasted, he would be quite motionless for hours, with almost the look and the pallor of death upon his face. This, of course, appealed to the large mother-heart of Mrs Prinsep, with her genius for all sorts of confections in the way of delicate foods, and endowed as she was with untiring energy, especially where nursing was required.[18]

There are different views: 'like a spider she ensnared Watts into her web. Her powerful personality brushed aside any hesitation on his part and he was soon content to allow her to ordain the pattern of his life, which his consenting to come to live with the Prinsep family considerably facilitated.'[19] He remained under their protection for the next twenty-five years.

The Prinseps and the Pattles were both Anglo-Indian families. Sara and Thoby married in Calcutta in 1835: she was almost twenty; he was forty-three, a member of the Indian civil service. Thoby's father John Prinsep had made a fortune in India at the end of the eighteenth century (it was reputed to be some £40,000), chiefly through trade in indigo. In 1802 he had become Member of Parliament for Queenborough, embarrassing the government on Indian affairs, and though he suffered losses later in life, he acquired an appointment in London as bailiff to the court of the borough of Southwark on a comfortable salary of £1,500 per annum. Seven of Prinsep's sons attained official positions of authority in India.[20]

Thoby retired from the civil service in 1843 having risen to the position of Chief Secretary to the Government of India. He returned to England with Sara and their four children, Henry, Valentine, Arthur and Alice, reputedly with capital of £50,000, and an annuity of £1,000 from the East India Company.[21] He failed to gain election to Parliament but in 1850 became a director of the East India Company; in 1858 he was elected one of the seven directors of the newly formed Council of India, retiring in 1874 because of failing eyesight and deafness. Official duties were pursued alongside his scholarly studies. Thoby was an authority on Indian politics, history and culture, on which he published several seminal works, as well as being a notable oriental linguist. This aspect to his character appealed particularly to Watts, who described him as 'an encyclopedia of valuable information on every sort of subject. It was just like turning the pages of a delightful book, and, like it, open if you wanted it and shut when you did not.'[22]

The Pattles, Sara Prinsep's family, were originally from London, but appear in East Indian records early in the eighteenth century; Sara's father James joined the Bengal civil service at the age of fifteen and by the 1840s was the senior member of the Board of Revenue and an important Anglo-Indian resident of Calcutta. Virginia Woolf, his great-granddaughter, chose to recall his more colourful side as 'a gentleman of marked, but doubtful, reputation, who after living a riotous life and earning the title of "the biggest liar in India", finally drank himself to death'[23] In 1811 James Pattle married Adeline de l'Etang, the daughter of a French émigré couple. Of their ten children, seven daughters survived to adulthood: Adeline, Julia Margaret, Sara, Maria, Louisa, Virginia and Sophia. They received a cosmopolitan education in France (their grandmother Mme Thérèse de l'Etang had settled in Versailles after the death of her husband)[24] where they were introduced to Thackeray, the Ritchies and other Anglo-Indian families.

Thackeray became a lifelong friend of the family and appears to have contemplated marriage to at least one of the sisters. On dining with them in Paris in October 1833, he wrote: 'I dine to day with the Pattles & shall meet pretty Theodosia [Sophia] — I wish she had £11325 in the 3 per cts — I would not hesitate above two minutes in popping that question wh was to decide the happiness of my future life.'[25] All of the sisters apart from Virginia and Sophia ('prettier than their sisters', according to Thackeray)[26] were married by the end of the 1830s. There was a dearth of eligible English brides in Calcutta at the time and 'in such a fertile field, the Pattle sisters, all more or less beautiful and interesting, made a sensational success'.[27] All but one of the sisters were also to play some part in the cultural life of Little Holland House, in particular Julia, known as Talent, Sophia and Virginia, known as Beauty. Sara was Dash.

Julia Margaret married a widower, Charles Hay Cameron in 1838, by whom she had six children. Cameron was appointed the first legal member of the Supreme Council of India, 'a position in which according to protocol he and his wife out-ranked socially almost everyone else in British India'.[28] On his retirement in 1848, the Camerons moved to England, settling first at Tunbridge Wells, close to their friend Sir Henry Taylor, civil servant and author of a number of verse dramas, including *Philip van Artevelde*, and later, in 1860, at Freshwater on the Isle of Wight, where Julia Margaret took up photography.

James Pattle died in 1845 and his widow and two unmarried daughters, Sophia and Virginia, accompanied his body to England. There are various lurid stories about the

effects of the journey on the barrel containing Pattle's body and a large quantity of rum (a preservative). Whether the sight of the body bursting forth from the barrel during a storm caused his widow to die of shock is true or false, Adeline Pattle died before reaching England and was buried at sea. The remains of James Pattle were conveyed to the family vault in St Giles', Camberwell, London.

Sophia and Virginia remained with the Prinseps in Chesterfield Street until Sophia was married in 1847 to John Warrender Dalrymple of the Bengal civil service. When Watts was introduced to the Prinseps, Virginia was the only remaining unmarried Pattle. Probably a little in love with her himself, Watts produced a full-length portrait of Virginia which was hung in the Royal Academy Summer Exhibition in 1850. Charles Somers Cocks, Viscount Eastnor apparently fell in love with the image and vowed to marry the original. He proposed after meeting her at the home of Lady Palmerston. Henry Wyndham Phillips remarked at the time that 'her marriage had been a tremendous blow to Watts, who worshipped her in a way that Somers [Eastnor became Earl Somers shortly before the wedding] had never done'.[29]

Though contemporaries admired her beauty and goodness,[30] Virginia was not a conventional choice for the heir to an earldom and estates in Herefordshire, Worcestershire, Surrey and Somers Town, London. Charlotte Canning commented: 'Oh, that she had another name. . . . It will be curious to watch her rise, as I believe she is not yet in good society.'[31] But Eastnor, not a conventional aristocrat, was indifferent 'to public life or worldly success'.[32] According to the biographer of his daughter Lady Henry Somerset, if Eastnor 'had been free to choose a profession he would have been an artist'. His mother, daughter of the Earl of Hardwicke, had no sympathy with her son's inclinations: 'Indeed, the very thought of a gentleman becoming a professional anything was shocking. She impressed upon her son that "it was not considered the thing for a gentleman to draw too well like an artist, a gentleman might do many things pretty well, but nothing too well"'[33] However she was unable to prevent the marriage which Thackeray attended on 2 October 1850. As he noted in his diary: '[Virginia] looked beautiful and has taken possession of Eastnor Castle, and her rank as Princess and reigns to the delight of everybody.'[34]

Though Virginia had left the Prinseps' home, Sara's ambitions as hostess necessitated a larger house. She also wanted a more rural setting. Watts knew that Little Holland House (fig. 9), the dower house of Holland House, was to let.[35] He took Sara and Thoby to view the rambling old farmhouse, they were instantly charmed with it, and signed a twenty-one-year lease with the Hollands on 25 December 1850. They moved in the following January, inviting Watts to join them.

> How Mr Watts came to live there was once picturesquely described to me [wrote Mary Watts] by Mrs. Prinsep: 'He came to stay three days, he stayed thirty years,' she said, with a little descriptive action of her hand; and it seems a pity to destroy such dramatic summing up by mere fact. But Mr. Watts's recollection was different, and he felt certain that the arrangement was made from the first. Perhaps neither memory was quite at fault, the arrangement most likely being proposed at first, but not carried out, and some months later initiated somewhat accidentally.[36]

> Little Holland House. Those three words evoke a picture of an enchanted garden, where it was always Sunday afternoon – afternoons prolonged, on rare red-letter days, into moonlit evenings full of music and delicate delight.[37]

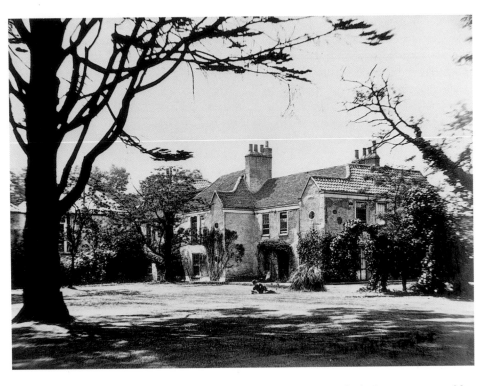

9. Little Holland House.

The salon created by Sara Prinsep at Little Holland House made bohemia respectable, bringing together artists, writers and scientists with politicians, landowners and civil servants: in short, almost anyone who cared, or professed to care, for contemporary culture. Mrs Stirling, niece of Roddam Spencer Stanhope, claimed

> [Sara Prinsep] introduced into her new home a cosmopolitan and liberal spirit to which people of that date were little accustomed. . . . At a time when, it cannot again be too strongly emphasized, genius was tolerated as an eccentricity rather than courted as a divine asset, when an *artist* and a *gentleman* were terms held to be antipodean, men met there on a footing which had the attraction of novelty.[38]

Even those who criticised the preciousness of the salon – George du Maurier was especially barbed – accepted Sara Prinsep's invitations and the opportunity to meet Thackeray, Tennyson, Browning and, above all, Watts. He enthralled both artists and art collectors; 'he taught us values, the beauty of beauty, the joy of joy, the marvel of heroic deeds', wrote one of the Prinseps' granddaughters.[39]

The location and appearance of Little Holland House were part of its charm. In the 1850s it was literally *rus in urbe*, situated on the western side of Holland Park, in Nightingale Lane (fig. 10), a 'strange old-fashioned ramshackle lot of buildings in large grounds';[40] 'the lovely garden that surrounded the house was an enchanted circle separating it from other places' (fig. 11).[41]

It had first been turned into a comfortable home by Caroline Fox, aunt of the fourth Baron Holland. She called it her 'Paradisino',[42] and lived there from 1803 until her death in 1845. She was responsible for merging the adjoining farmhouse into the main building in about 1804; further alterations to the house and the gardens took place in the 1820s. She was so fond of the area that she bought a quarter of an acre of land

The Holland Park Circle

from the estate, on the north side of the present Holland Park Road, 'to build with the assistance of Government a school house with a playground'.[43] At her death she left £3,000 as an endowment for the school; she bequeathed Little Holland House, with an annual rental value of £200, to her nephew.

The charm of the area was evoked by Thackeray's daughter, Anne Thackeray Ritchie in her novel *Old Kensington* (1872–3), set in the early 1850s: 'the hawthorn spread across the fields and market-gardens that lay between Kensington and the river. Lanes ran to Chelsea, to Fulham, to North End, where Richardson once lived and wrote in his garden-house.'[44] The building boom which was to transform the slopes of Campden Hill and virtually surround Holland Park was still a few years distant.

Holland Park was bisected by a public right-of-way which connected the Uxbridge Road (now the Bayswater Road) to the north with Kensington High Street to the south. It provided scenic views of the Holland property:

> Beyond the rail the lawns and fields sloped to where the old arcades and the many roofs and turrets of Holland House rose, with their weather-cocks veering upon the sky. Great trees were spreading their shadows upon the grass. Some cows were trailing across the meadows. . . . [Little Holland House] looked like a farm-house, with its many tiles and chimneys, standing in the sweet old garden fringed with rose-bushes. There were poplar-trees and snowball-trees, and may-flowers in their season, and lilies-of-the-valley growing in the shade. The lawn was dappled with many shadows of sweet things. From the thatched porch you could hear the rural clucking of poultry and the lowing of cattle, and see the sloping roof of a farm-house beyond the elms.[45]

Pauline Trevelyan, who visited in 1854, found it 'all ups and downs and ins and outs'.[46]

The house was also an example of the 'common tradition of honest building',[47] the vernacular architecture that so influenced Philip Webb who would design houses in the area in the 1860s for Valentine Prinsep and the Honourable George Howard. The garden designer Gertrude Jekyll, who visited Little Holland House for the first time in 1867 (and helped Leighton with the plan of his garden), defined vernacular in *Old West*

10. Joshua Rhodes, *A Topical Survey of the Parish of Kensington – with Plans and Elevations* (London, 1766), engraved by George Bickham. Holland House is in the centre, Little Holland House to the south.

11. George Frederic Watts, *The Cedar Tree*, 1868–9, exhibited at the Grosvenor Gallery, 1882, as *The Lawn at Old Little Holland House*. Watts Gallery, Compton, Surrey.

Surrey: 'the local tradition in building . . . the crystallisation of local need, material and ingenuity'.[48]

There are few descriptions of Little Holland House written before it was demolished in 1875. Ellen Twisleton, a member of the Dwight family of Boston and married to an English aristocrat, first visited in 1853 and sent her impressions to her family in America:

> with trees, and flowers, and a beautiful garden – the house was an old farmhouse, and has had another house, as it were, built on to it, so that the rooms are low and large, and wain-scotted, and oddly placed in relation to each other, and then there are long passages, and out you come, again, into rooms where you don't expect them.[49]

She was taken into Watts' studio which had been made by filling up 'a gap between two walls',[50] thus contributing to the unexpected, unorthodox architecture of the house. Later, Watts built another studio on the north-west side of the house, because the first studio proved too sunny during the summer months. By the time Hunt visited for the first time in 1856 'he had two painting-rooms and a third in course of building'.[51]

Laura Troubridge, granddaughter of Sara Prinsep, wrote in her memoirs of 'delicious' Little Holland House, with its 'old-world rooms in that nest of gables' being 'a kind of earthly Paradise . . . a painted ceiling, blue with silver or gold stars, lingers in my memory'.[52] Georgiana Burne-Jones recalled in her memoirs of her husband 'the impression . . . of its low, dimly lighted, richly coloured rooms, dark passages opening into lofty studios filled with the noble works of Watts'.[53] The house presented an aesthetic 'wholeness', in which pictures, furniture, colours and textures blended together. Nothing jarred.

> To eyes accustomed to early Victorian wall-papers and carpets, how describe what was the refreshment and delight of those matted rooms, with cool green walls against which hung paintings glowing with Venetian colour, and the low ceilings, painted a dusk harmonious blue? In the principal drawing-room, where stood the piano, the planetary system was traced in gold upon the deep-blue ceiling. Bedrooms and all were in this scheme of colour, with lattice windows framed with creepers, through which one saw the waving trees . . . the appointments and the furniture of these rooms, and indeed of the whole house, were as fit a setting as the garden itself for what was beautiful and graceful.[54]

In the upper dining-room Watts, with the assistance of Spencer Stanhope, had painted frescos of life-size figures inside the seven or eight arched spaces. Spencer Stanhope wrote to his father: 'if I had my way, paperhangers should hang in their own papers, and all other corrupters of public morals should be treated in the same way. The reason of these observations will be apparent when I tell you what I have been doing at Little Holland House.'[55] Watts was never afraid of a large subject: here he attempted to convey historical periods and philosophical ideas through the human figure, undoubtedly inspired by the stories of his friends the archaeologists Layard and Newton. Ellen Twisleton sent a full description to her Boston family which is worth quoting at length; the impact of the room undoubtedly inspired some visitors to Little Holland House to seek to create a similar effect in their own homes:[56]

> the first is Earth [Virginia, Countess Somers] with the Infant Humanity – a beautiful, womanly figure, stooping over a child in her lap . . . then come two figures of India and Assyria, the one in swathing drapery, and with a half-developed expression to it which is very striking – and the other a reclining, beautiful figure, the very essence of indolent repose – these two are at one end; – on the side wall, where you enter, and in the arches each side of the door, in the first is Greece, and Egypt, which is a wonder – the long, pale, olive-coloured face and straight figure of Egypt, sitting, and Greece of exquisite beauty, a figure studied from one of the Elgin marbles, leaning with one arm on her lap – the next is Persia and Arabia . . . these two are on flat, gold grounds, such as the early Florentines used. At the end of the room opposite come two that surpass the others, one he calls 'the Middle Ages' – two figures, one wrapped in dark, monkish drapery, sitting in a contracted attitude with the face half-covered, the other of exquisite beauty, with an angelic, up-looking face, a broad, ample book on her lap, open, and one hand raised above the book, while with the other she seems moving away masses of cloudy, heavy mist, which press round near her – a figure full of light and expression; in the sister arch to this – is Time unveiling Truth – Truth, a female figure of freshness, and vigour, and beauty, and Time a beautiful graceful angel, which has partly drawn the veil, and is still in motion to withdraw it wholly.[57]

Science and Contemplation filled the remaining wall-spaces.

The scale was large, a deliberate choice of Watts who believed large designs gave dignity to a small apartment. In a letter to Watts written when the house was being

demolished, Sir Henry Taylor recalled these decorations in the dining-room and along the passages '& wondered whether what was on them cd be saved. I know nothing about art as I need not say – but there are none of yr works that have left a more living & lasting impression upon me.'[58]

It helped that Sara and her sisters dressed unconventionally (fig. 12).

> The ladies of Little Holland House . . . had adopted a graceful and beautiful style of dress that seemed inspired by the Italian Renaissance, and was alike admirable in design, colour, and material. These gracefully flowing robes were often made of rare Indian stuffs, and from India . . . came also many of the ornaments they wore: the clustered pearls, the delicate Indian jewels and tinkling sets of gold and silver bangles, having then the added charms of rarity and novelty to English eyes.[59]

Watts had been struck by Virginia's beauty when he first saw her in 'a long grey cloak falling in beautiful lines against her tall figure'. He painted Julia in 1852 in a white dress with an unusually full, loose bodice; he painted Sophia the following year in a flowing dress, restrained at the waist by a simple cord. One of the sisters was recalled by a great-niece as wearing 'a scarlet Turkey twill toga bound with dull gold braid, over an olive-green soft satin under-robe with puffed sleeves, and an Indian shawl trailing over all. . . . They scorned Fashion, wore neither crinoline nor stays, and in long flowing garments designed and made by themselves they walked serenely like goddesses through the London streets.'[60]

Only a few dared to criticise their style. Violet Hunt, for example, described the Pattle hair and complexion as 'nigger'; their dress revealed 'a touch of the tar brush'.[61] Portraits by Watts reveal others happily adopting similar unconventional gowns, although there is no evidence to suggest the dresses were worn outside the studio. Jeannie Nassau Senior, one of Watts' special women-friends and the sister of the writer and social reformer Thomas Hughes, was painted in 1858 wearing an 'artistic gown of luminous stained-glass purplish blue . . . with her golden hair left freely flowing'.[62] When Madeline Wyndham was painted by Watts in 1865 she wore a dress covered in huge sunflowers.

Anne Thackeray Ritchie saw the Pattle sisters as 'unconscious artists, divining beauty and living with it':

> to see one of this sisterhood float into a room with sweeping robes and falling folds was almost an event in itself, and not to be forgotten. They did not in the least trouble themselves about public opinion (their own family was large enough to contain all the elements of interest and criticism). They had unconventional rules for life which excellently suited themselves, and which also interested and stimulated other people.[63]

They cultivated the exotic, making careful use of their Anglo-Indian upbringing and parentage.

> Amongst themselves the sisters talked in Hindustani, and when they met together at one or other of their houses they generally sat up all night in an orgie [sic] of dressmaking, pulling their robes to bits and sewing them up in a new way, or designing and cutting out new clothes, chattering all the time in Hindustani, that seemed to an outsider the language best suited to express their superabundant vitality.[64]

12. Sara Prinsep and her sister
Virginia, Countess Somers.

Their welcome also appeared to strangers to be genuinely warm. Ellen Twisleton found Sara Prinsep's informality more akin to American hospitality: 'I never saw such exuberant cheerfulness and beaming kindheartedness in anyone as her manners express'.[65]

Sunday afternoons 'at home' were particularly informal, weather permitting: 'On those summer Sundays her drawing-room was generally the garden, Indian rugs making patches of colour upon the green, and knots of chairs and chintz-covered couches gathered under the layers of green shade of widespreading trees.'[66] Tea was laid under the trees, there were games of croquet and bowls. In the evening after 'all who were mere visitors departed' there was dinner 'for the more intimate coterie of friends'.[67] Sidney Colvin, Keeper of Prints at the British Museum, recalled the difference between the relaxed atmosphere at Little Holland House and 'that of one of the season's crushes, at which a crowd assembles to jostle and swelter as a matter of fashion or social obligations'.[68]

Few published descriptions of the salon at Little Holland House are critical, and particularly not those written by members of the Prinsep and Pattle families. Some of the artists and writers, however, expressed in letters to friends less favourable views about Sara Prinsep's lion-hunting. Elizabeth Barrett Browning found the 'new fashionable London entertainment' of 1857 intolerable: 'To go there and be quiet would be

13. George Howard, *Alfred, Lord Tennyson*. Castle Howard, Yorkshire.

impossible. People tear us in pieces, Robert and me. And, if by shutting the door, we escaped the class represented by Mrs Prinsep and her peers, we could not refuse to see others who are friends in another sense.'[69] Tennyson was 'invaded by the not-to-be-refused Mrs Prinsep' while staying in another part of London (fig. 13). As Holman Hunt recalled, 'excuses of want of evening dress were all in vain. He was told that he should have a smoking-room to himself and that he should be invited to see no guests but those of his own asking.' On arrival, however, he found the garden full of people: it was a 'gala day'. He retreated to his room until dinner. Even then he was wrong-footed: 'He had expected nothing but a family gathering, but it proved to be a large party correctly attired at a long table.'[70]

The Little Holland House salon was a long way from Murger's *vie de Bohème*,[71] though contemporary commentators freely used the term 'bohemian' to describe the activities of Sara and her sisters – 'a breezy Bohemianism prevailed'.[72] Their hospitality might have been unconventional but it was highly civilised. Thackeray would have recognised the distinction. He liked to pose as a bohemian; he wrote bohemian novels, with sub-plots set in and around Fleet Street and the Strand. However, it was alleged he attended bohemian gatherings 'with a dress-suit packed in a bag, in case he was called to more exalted company'.[73]

Sara Prinsep's hospitality was similar to the elegant Park Lane entertainments of Madame Max Goesler, a major character in Trollope's Palliser novels. Trollope was a frequent visitor to Little Holland House from 1860 onwards.[74] Madame Goesler, like Sara, entertained on a Sunday, as she explained to the ambitious young Member of Parliament Phineas Finn:

> There is a Bohemian flavour of picnic about it which, though it does not come up to the rich gusto of real wickedness, makes one fancy that one is on the border of that delightful region

The Holland Park Circle

in which there is none of the constraint of custom, – where men and women say what they like, and do what they like.[75]

Mrs Stirling was equally enthusiastic about Sunday entertaining at Little Holland House: 'that time of dread, the conventional Sunday of the early Victorian era, was exchanged for the wit of genius, the dreams of the inspired, the thoughts of the profoundest thinkers of the age'[76] Trollope describes Madame Goesler's house as a paragon of taste:

> And everything in that bower was rich and rare; and there was nothing there which annoyed by its rarity or was distasteful by its richness. . . . There were books for reading, and the means of reading them. Two or three gems of English art were hung upon the walls, and could be seen backwards and forwards in the mirrors. And there were precious toys lying here and there about the room, – toys very precious, but placed there not because of their price, but because of their beauty.[77]

The greatest attraction of Little Holland House was its resident artist. Sara Prinsep created the appropriate ambience but Watts' work and his often-expressed ideals drew the celebrities of the day. He played his part to perfection.

His appearance and his conversation evoked a mystical, semi-religious atmosphere of awe. Sophia Dalrymple provided him with the name 'Signor' and everyone used it, even the most sceptical of artists. The artist and landowner Sir John Leslie (who took Bute House on Campden Hill in 1856) brought his fiancée Lady Constance Dawson Damer to meet Watts. She recalled, 'The Signor came out of his studio all spirit and so delicate . . . Signor was the whole object of adoration and care in that house. He seemed to sanctify Little Holland House.'[78] He made a similar impression on Laura Troubridge: 'no one had ever talked to me as he did, taking all the big facts of life and dressing them up in rainbow words like the magical colours on his palette'.[79]

He dressed carefully for the new part. It represented a dramatic change from his earlier roles as artist in residence in Italy and as dapper man about town with his friends in the Cosmopolitan Club at Charles Street. A self-portrait painted in 1853, which hung next to the studio door, shows him in a red robe, looking like a Venetian senator. In a photograph which is dated 1854 by Mrs Barrington he looks more monk-like (fig. 14), by this time sporting a very long beard and bare feet. Sidney Colvin testifies to the natural distinction which had made him so welcome in the homes of the Hollands as well as at Little Holland House:

> It was understood that the main attraction at these receptions [at Little Holland House] was the fame and personality of the great artist Watts. It has always seemed to me a note to the social credit of that day that a man of Watts's undistinguished origin, (his father had been an unsuccessful musical instrument-maker) and of his extreme and perfectly unaffected modesty and simplicity of character, should have been honoured and sought after as he was. It is true that both in looks and bearing he had a natural distinction which must always and in any company have been noticeable. Middle-sized and slightly stooping, he had finely chiselled features and brown eyes of a fine pensive expression. . . . There was about him a total lack of, and indeed incapacity for, any manner of pose or pretension.[80]

The climax of a visit to Little Holland House was undoubtedly an audience in Watts' own studio. Sometimes the door was firmly shut. Dolly Vanborough, heroine of *Old Kensington*, was quite overcome when she was shown inside 'Mr Royal's' sanctuary:

14. George Frederic Watts,
c. 1854.

She followed the servant up an oak passage, and by a long wall, where flying figures were painted. The servant opened a side door into a room with a great window . . . pictures . . . were crowding upon the walls sumptuous and silent. . . . Sweet women's faces lighted with some spiritual grace, poets, soldiers, rulers, and windbags, side by side, each telling their story in a well-known name. There were children too, smiling, and sketches, half done, growing from the canvas, and here and there a dream made into a vision . . . Dolly felt as though she had come with Christian to some mystical house along the way.[81]

Watts' sensitivity and his bouts of illness were not problems for Sara Prinsep; they only increased his romantic elusiveness. She could help to 'guard' his privacy. Georgiana Burne-Jones noticed 'her guiding will through everything, and under all the ease and freedom of the house was a sense of her vigilance'.[82] Mary Watts later wrote, 'Signor's nature, his work, and his health all compelled him to live somewhat apart'.[83] Sara and her family, 'Watts's Holy Family',[84] managed to provide the seclusion Watts craved. Also his financial and domestic worries were largely removed once he settled permanently at Little Holland House. He did not have to maintain his own home or studio; his elaborately simple dietary requirements were carefully prepared in Sara's kitchen;[85] he was able to paint for his own pleasure not for clients (he only accepted

portrait commissions when he required large sums of money, usually to build hous-
es); the appropriate medical attention was always available when he was stricken by
headaches and nausea; Sara and her sisters were also at hand to offer the sympathy he
yearned for. Ronald Chapman asks, 'what would Aunt Sara . . . have done had Watts
been well?'[86] Certainly Sara's ambitions for her Little Holland House salon were assist-
ed by the very particular neuroses of Watts. She was in the powerful position of filter-
ing visits and visitors to Signor. When Watts was too ill to receive anyone, she and her
sisters were adept at providing alternative entertainment.

Holman Hunt could appreciate Watts' situation:

> It was indeed a delight to see a painter of the day with such dream-like opportunities and
> powers of exercising his genius. It was more than a happy combination, for one may safely
> assert that nowhere else in England would it have been possible to enter a house with such
> a singular variety of beautiful persons inhabiting it.[87]

In a letter to the art critic F.G. Stephens, Hunt was less delighted by the effect of so
much pampering on Watts' sportsmanship: 'Watts is hospitable to anyone who lets him
play his own game at croquet and who will abstain from rocketting him when found
in a good position. He once nearly cried and gave up the game when I came upon him
with the rigours of the law in force.'[88] There was no competition within the confines
of his studio. At Little Holland House, Watts' eccentricities were not only accepted by
society but invested with an air of sanctity.

> Of the functions of art in the life of a community no one has ever held a more exalted con-
> ception [than Watts]. He was continually expending his energies and his influence, some-
> times successfully, more often in vain, in the endeavour to be allowed to decorate the wall-
> spaces of public buildings with monumental compositions of high moral, historical, or alle-
> gorical significance.[89]

Watts' obsession throughout the 1850s was the decoration of walls, the bigger the bet-
ter; as Spencer Stanhope announced, 'he has taken up a crusade against bare walls, and
intends painting everything that comes his way'.[90] His crusade can be traced back to
his early attempts at frescos in Italy with the Hollands, followed by his dream of
a House of Life which emerged in the 1840s. During the 1850s he developed more
practical and democratic ideas for making the 'grey North' almost as beautiful as Italy,
believing that Her Majesty's Government should at least be capable of achieving 'the
decoration of all the public buildings, such as town halls, national schools, and even
railway stations'.[91]

Though he failed to persuade the London and North-Western Railway to permit him
to decorate the hall of Euston Station, he was successful with the Benchers of Lincoln's
Inn. They accepted his offer to paint a fresco in their new hall: 'if they will subscribe
to defray the expense of the material, I will give designs and labour'.[92] The subject
was 'Justice: A Hemicycle of Lawgivers'; his intention was to cover, single-handed, a
wall 45 feet wide and 40 feet high. Preparations were made in August 1853; the vast
painting was completed in October 1859.

Meanwhile, and presumably unknown to Lincoln's Inn, between 1855 and 1857
Watts completed the decoration of the dining-room of 7 Carlton House Terrace for
Virginia, Countess Somers. He used the Greek myths to produce nine designs collec-
tively called 'The Elements'. He called on his friends for the loan of their bodies, rather

than professional models. It was cheaper and they were usually flattered. Jeannie Nassau Senior, however, had to be reassured:

> I want to make use of you, don't be frightened, it is but to lend me an elbow. We were talking you know about employing models: I do not, but my work suffers in consequence and I feel that there is a want of conscientiousness in not doing my best . . . so I suppose I shall be obliged to conquer my fastidiousness, but I shall call upon my friends for whatever they can with a perfect sense of propriety . . . so sigh with resignation, but you promised to lend me your hair, and will I am sure lend a hand or an arm occasionally.[93]

Watts was half in love with Jeannie. Her father-in-law William Nassau Senior had written the report on which the 1834 Poor Law was founded and his home on Kensington Gore was a focus for radical politics until his death in 1864. Jeannie was to become the first woman to hold the post of Government Inspector of Workhouses and Pauper Schools. She appears in her brother's novel, *Tom Brown's Schooldays* as Mrs Arthur.

When the Lincoln's Inn fresco was completed, Watts immediately wrote to Jeannie:

> I have this day put the last touches in my fresco at Lincoln's Inn! I dare not call it finished, but it must do. I feel sad at giving it up, for now I cannot cheat myself any longer with the belief that I am going to improve it; alas, for the failure, as it is, for I shall never again have so fine a space.[94]

He also wrote to Lincoln's Inn to apologise for the time it had taken. The delays were forgotten, he was given a celebratory dinner on 25 April 1860 and presented with a cup containing a purse of Russian leather with 500 new sovereigns inside.

While Watts disliked such public demonstrations, the positive response to his work by friends and critics was deeply gratifying. Sir Charles Eastlake, who had found fault with King Alfred's legs over a decade earlier, congratulated him on his 'glorious work, admirably adapted to the place it occupies & the light it receives & perfectly well calculated to produce the best effect of which fresco is capable . . . I feel that nothing can be grander.'[95] Rossetti was impressed, writing to Henry Austin Bruce in October 1859:

> I have indeed seen Watts's fresco and think it by far the finest specimen of the method we have seen among modern ones. The foreground figures and those of the second plane are especially admirable, and do not betray in the least the trammels of fresco. No doubt Watts has overcome the difficulties of his task in the only possible way, that is, by risking much, painting fearlessly, and removing part when necessary.[96]

For the fresco, Watts persuaded members of the Prinsep and Pattle families, friends and acquaintances, all visitors to Little Holland House, to adopt the role of ancient lawgivers. The vast undertaking was consequently an intimate record of the circle gathered around Watts at the time, a 'visual' visitors' book. Among the models were Thoby Prinsep as a druid; Val Prinsep as Servius Tullius, a semi-legendary king of Rome; and Charles Newton as Edward I. Holman Hunt provided the face of King Ina, an early West Saxon king; Tennyson was Minos, King of Crete, the son of Zeus and Minerva.

Before Watts completed the Lincoln's Inn mural, his pupil Spencer Stanhope, and Val Prinsep had been lured away by Rossetti to assist with a rival work, the decoration of the Oxford University Union Debating Room with scenes from Malory's *Morte d'Arthur*.

Rossetti had been introduced to Watts and the Prinseps in 1856 by Hunt, who had himself settled nearby on Campden Hill. Rossetti planned to complete the Oxford decorations during the Long Vacation of 1857 and first recruited Burne-Jones and William Morris. He then went in search of more members for his team at Little Holland House, where he would have seen the work of Watts and Spencer Stanhope. He took Burne-Jones with him: 'You must know these people, Ned; they are remarkable people: you will see a painter there, he paints a queer sort of picture about God and Creation.'[97]

Val Prinsep, the second son of Thoby and Sara, had only just made the decision to leave Haileybury College to take up a career as an artist rather than join the Indian civil service. He recalled Rossetti's visit, also his proposal, which 'fairly took my breath away',[98] that he should undertake one of the panels at Oxford.

> I had not studied with Watts without being well aware of my own deficiencies in drawing – so I told Rossetti that I did not feel strong enough to undertake such work. 'Nonsense', answered Rossetti confidently, 'there's a man I know who has never painted anything – his name is Morris – he has undertaken one of the panels and he will do something very good you may depend – so you had better come!' Rossetti was so friendly and confident that I consented and joined the band at Oxford.[99]

Burne-Jones was equally nervous about meeting the inhabitants of Little Holland House, protesting to Rossetti, 'I am going to a lot of swells, who'll frighten me to death'. Prinsep recalled his first impression of 'the young genius':

> He was a thin, pale-faced man, with high cheek bones and round, very blue, gentle-looking eyes. His hair, straight and without a curl, was apt to stray over his forehead. At that time he was very shy, and, until you came to know him, you might wonder that one said to be so talented should be so silent.[100]

Once in Oxford, Prinsep and Spencer Stanhope, away from their 'master' in Oxford, indulged in student pranks and pursued 'stunners'. Watts, meanwhile, received letters from Ruskin, who was worrying about the influence of Rossetti's medieval excesses on Prinsep:

> I've almost got sickened of all Gothic by Rossetti's clique . . . I will try to get hold of Val this week and have a serious talk with him – I see well enough there's plenty of stuff in him – but the worst of it is that all the fun of these fellows goes straight into their work – one can't get them to be quiet at it – or resist a fancy if it strikes them ever so little a stroke on the bells of their soul – away they go to jingle – jingle – without ever caring what o'clock it is.[101]

Ruskin also wrote to Prinsep: 'I want to come in to town one day especially to see what you are about. When can you be at your studio? . . . I'm tormented . . . about you. . . . Remember me affectionately to your mother.'[102]

Watts did not share Ruskin's fears. As Hunt commented, 'he had the catholicity of interest for other work than his own that all true artists retain'.[103] Watts wrote to Lady Duff-Gordon:

> I have conscientiously abstained from inoculating [Prinsep] with any of my own views or ways of thinking, and have plunged him into the Pre-Raphaelite Styx. I don't mean to say that I held the fine young baby of six feet two by the heels, or wish to imply the power of moulding his opinions at my pleasure; but I found him loitering on the banks and gave him a good shove, and now his gods are Rossetti, Hunt and Millais – to whose elbows more power! I don't know whether you are an admirer of the school – perhaps not. I confess I

rather am, and think they have begun at the right end. The said Master Val, commonly called Buzz by reason of his hair which is this sort of thing [scribble of bristling hair], has made most satisfactory progress, and has distinguished himself by painting a picture at Oxford fourteen feet long with figures ten feet high – 'A muffin'![104]

Watts was aware that Prinsep's interest in medievalism was only shallow: 'the mediae-valism natural to Rossetti was but a mere reflection in the younger mind, not his own natural expression'.[105] Writing in the *Magazine of Art* in 1904, Prinsep agreed: 'at the time we were under the influence of Rossetti's great personality, and, as our minds were filled with thirteenth century traditions, we lived more or less in a world of dreams' (fig. 15).

Watts was not averse to painting medieval pictures himself. He had completed a self-portrait in armour while living with the Hollands in Florence. He recognised in the young Arthur Prinsep the ideal face of a chivalric knight-at-arms[106] and, persuading him not to cut his hair, sketched him on many occasions before he went out to India as a young officer.[107] The depiction of medieval chivalry fitted his definition of 'a great work of high art . . . a noble theme treated in a noble manner, awakening our best and most reverential feelings, touching our generosity, our tenderness, or disposing us generally to seriousness'.[108] He would have been delighted by the impact he made on Mary Seton Tytler when she visited his studio for the first time in 1870: he 'so distinctly suggested to me the days of chivalry that I believe I should not have been surprised if, on another visit, I had found him all clad in shining armour'.[109]

While Watts was attempting a second portrait of Tennyson in 1859 at Little Holland House, the poet was working on the *Idylls of the King*. Watts was asked what he thought

15. Valentine Prinsep, sketches from the late 1850s. Private collection.

36

The Holland Park Circle

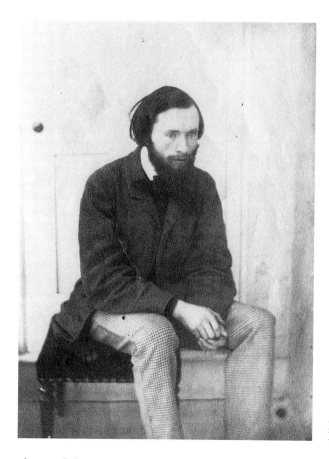

16. Edward Burne-Jones, photographed at Little Holland House, 1858.

about while painting and would have been gratified to find his reply embedded in 'Lancelot and Elaine':

> And all night long his face before her lived,
> As when a painter, poring on a face,
> Divinely thro' all hindrance finds the man
> Behind it, and so paints him that his face,
> The shape and colour of a mind and life,
> Lives for his children, ever at its best
> And fullest.[110]

During the summer of 1858, Burne-Jones was taken seriously ill (fig. 16) and stayed at Little Holland House, nursed by Sara Prinsep. The artistic surroundings, the example of the hard-working Watts and of Tennyson immersed in the world of King Arthur, the presence of the beautiful Sophia Dalrymple (fig. 17), the opportunity to listen to music performed by professionals, all exerted a profound impression on him. Georgiana Burne-Jones described the intoxicating atmosphere in which he was enveloped:

> There, for the first time, he found himself surrounded without any effort of his own by beauty in ordinary life, and no day passed without awakening some admiration or enthusiasm. He had never gone short of love and loving care, but for visible beauty he had literally starved through all his early years.[111]

17. George Frederic Watts, *Sophia Dalrymple*, c. 1853. Watts Gallery, Compton, Surrey.

18. Edward Burne-Jones, *The Kings' Daughters*, 1858–9. Private collection.

From Watts he learned of the discipline involved in the production of art: 'Painting is really a trade; the preparation and tools are so important.'[112] Rossetti had dismissed technique and study; Watts 'compelled me to try and draw better'.[113] He also reinforced Ruskin's advice to Burne-Jones, introducing the young man to the sensuous qualities of Venetian art and encouraging his move away from medievalism and the influence of Rossetti.[114] Watts also helped with Burne-Jones' first commission. He had written to Jeannie Nassau Senior from Bowood about Burne-Jones' talent in connection with a 'painted window'; 'there is at this moment staying at L.H.H. with Val, the very man you want Jones by name, a real . . . genius! really a genius!!!'[115] Then Lord Lansdowne bought a work, a small pen and ink drawing, the *Kings' Daughters*, an idealised vision of Sara Prinsep, her sisters and guests, walking in the garden at Little Holland House.[116]

It is hardly surprising that Georgiana Burne-Jones in her memoirs of her husband chose not to dwell on his susceptibility to the women of Little Holland House. Burne-Jones was deeply affected by Sophia Dalrymple, who lived for most of the time with her sister Sara until her husband retired from India in 1873. Though his name for her was 'Aunty', the book he made for her during 1858 and 1859 suggests he was in love. Harry Prinsep, a nephew of Thoby's, described her impact on the household:

Perhaps we were all round the dinner-table . . . in the lower dining-room – Uncle Thoby thinking about his work, passing his hand over his eyes and silent; Signor not very well and silent; Aunt Sara occupied giving all sorts of directions in a low tone to a servant; the young people awed and silent. Suddenly there was a rustle of silks, a lovely vision appeared – for Aunt Sophie wandered in, dressed in a gown of some rich colour, all full of crinkles . . . before she had been amongst us three minutes, the whole party was laughing and talking.[117]

Burne-Jones was already engaged to Georgiana Macdonald (they married in 1860), but it was Sophia for whom he put together an exquisite collection of poems by Browning, Keats, Tennyson, Rossetti, Edgar Allan Poe and Walter Scott with his own illustrations. The book begins with *Amor*, an early version of a design later worked up for needlework. *The Three Kings' Daughters* is a version of the *Kings' Daughters* (fig. 18). Unrequited, unfulfilled, unsatisfactory love fill the pages. Sophia is both the 'Blessed Damozel' and 'La Belle Dame Sans Merci'. The 'enchanted circle' which separated Little Holland House from 'other places', also separated Burne-Jones from his fiancée and enabled him to engage in a dalliance reminiscent of medieval courtly love. Sophia Dalrymple was the first of a series of unattainable *femmes fatales* who played a significant part in his real and imaginative life.

3

Building for Art in Kensington

Lord Holland died in 1859 leaving no direct heir. His widow, as extravagant as his mother, was left Holland House and estate for her lifetime. She also maintained apartments in Naples and Paris and a house in Mayfair. His attempts to improve the financial health of his property had been only partly successful. The railway line constructed during his father's life had closed after just nine months in operation as passengers failed to materialise and the company collapsed. Plans were drawn up, however, for the construction of over 800 houses to the west of Addison Road and he had entered into an agreement just before his death with William and Francis Radford to build seventy-seven detached villas to the north of Holland House, next to the Uxbridge Road, the estate to be known, confusingly, as 'Holland Park'.[1] Also his ground rents were rising, from £740 in 1849 to a total of £1,700 per annum in 1858, coinciding with the building boom which was beginning to affect the whole borough (fig. 19).

Throughout the 1850s, 1860s and 1870s, much of Kensington and the surrounding area was a vast building site.[2] Wilkie Collins caught the flavour in *Hide and Seek*, first published in 1854.

> Alexander's armies were great makers of conquests; and Napoleon's armies were great makers of conquests; but the modern Guerrilla regiments of the hod, the trowel and the brick-kiln, are the greatest conquerors of all; for they hold the longest the soil that they have once possessed. How mighty the devastation which follows in the wake of these tremendous aggressors, as they march through the kingdom of nature, triumphantly bricklaying beauty wherever they go! What dismantled castle, with the enemy's flag flying over its crumbling walls, ever looked so utterly forlorn as a poor field-fortress of nature, imprisoned on all sides by the walled camp of the enemy, and degraded by a hostile banner of pole and board, with the conqueror's device inscribed on it – 'THIS GROUND TO BE LET ON BUILDING LEASES'?[3]

The *Building News* reported in 1859 hundreds of workmen engaged in building and finishing houses in Kensington, Bayswater and Notting Hill, 'most of which are of a very superior description, and many of them on such a large scale, that they may justly be called town mansions'.[4] When Walter Crane settled in London as a young boy in 1857 he lodged in Shepherd's Bush, just to the west. The outlook was a brickfield, where men were engaged in producing sufficient bricks for the houses which were gradually covering the land eastwards all the way to Hyde Park. 'I began to sketch the shed with the horse going round, the men laying the bricks of London clay in the long rows under straw to dry, and the smoking pile when they were baked, emitting that curious stuffy oven odour which used to permeate the suburbs of London.'[5]

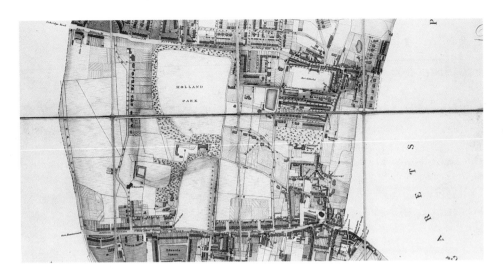

19. Dawes' *Parish Map of Kensington*, 1848.

In January 1862, the minor poet and civil servant Arthur J. Munby recorded in his diary a walk through Kensington

> to see the Exhibition building. When I was here last, some three or four years ago, all this country was a tract of market gardens, with bridleroads between & footpaths, where sweethearts walked for privacy, between Brompton & Kensington. Now, broad streets of lofty houses; and further on, roadways terraced on arches in all directions; the wretched grass of the old fields still visible below, with here & there a doomed tree, where the houses have not yet been begun.[6]

The following year the *Builder* turned its attention to South Kensington: 'westward still the tendency of the town continues to advance . . . [in] the truly noble quarter of South Kensington, [builders have] expended large amounts in ranges of costly mansions flanking the Exhibition, the Prince Albert and the Cromwell Roads'.[7]

The same author, 'Quondam', was getting worried by 1866 as he saw developments 'eating into' Holland Park, 'girdled and regirdled with hideous lines of railway viaducts, horrid with shrieking engines, and veiled in clouds not only of steam but of smoke, London is closing in beyond Kensington and speeding, almost as fast as a snail can crawl, down the western roads.'[8] The railway line through the Holland estate was reopened. As the *Building News* recognised, the conditions which had forced its closure no longer applied: 'As a passenger line it failed ludicrously, not producing even enough to cover its working expenses. What other result could have been anticipated from a line at such a distance as it then was from any human habitation it is difficult to imagine.'[9] It was soon to be surrounded by houses. The new owners, the London and North Western Railway Company, paid Lady Holland £7,860 in 1861 for land on which to lay track and build a station. Addison Road station (now Olympia) opened in 1864.

The Metropolitan Railway was also being extended from Paddington to South Kensington via Bayswater and Notting Hill. Tunnels were excavated under the new houses. Work began on Kensington High Street station in 1865; Notting Hill Gate station opened in 1868. Andrew Kurtz, a Liverpool industrialist and art collector, took the railway from Victoria (he stayed at the Grosvenor Hotel) to visit the South Kensington Museum and artists' studios in Kensington.

The delay is rarely more than two or three minutes as trains succeed one another every seven minutes. The carriages are delightful, clean & comfortable & lighted with gas so that in the cheerful light one hardly realizes that one is underground at all. Five minutes or little more & one arrives at S. Kensington. The neighbourhood here has a very grand appearance all the houses being like little Palaces.[10]

Although the press suggested that noblemen or 'the wealthy and more aristocratic portion of the population of the metropolis'[11] would buy the grander properties in the area, speculators were aiming most of the property at the expanding middle class, by the 1850s a growing and complex social group. The houses were carefully graded by size and features to suit the incomes of the various strata within the class. Collins observed the phenomenon in *Hide and Seek*. He describes the development of a north-western suburb of London with accommodation for 'three distinct subdivisions of the great middle class of our British population'.

> Rents and premises were adapted, in a steeply descending scale, to the means of the middle classes with large incomes, of the middle classes with moderate incomes, and of the middle classes with small incomes. The abodes for the large incomes were called 'mansions', and were fortified strongly against the rest of the suburb by being all built in one wide row, shut in at either end by ornamental gates, and called a 'park'. . . . The hapless small incomes had the very worst end of the whole locality entirely to themselves, and absorbed all the noises and nuisances, just as the large incomes absorbed all the tranquillities and luxuries of suburban existence.[12]

The area developed for Collins' wealthiest middle class corresponds with the 'Holland Park' estate, also the Crown Estate's development on the former kitchen gardens of Kensington Palace. The Queen's Road, dubbed 'Millionaires' Row', joined the Uxbridge Road to the north with Kensington High Street to the south. The *Illustrated London News* forecast the quality of the latter development for 'its great breadth, imposing aspect and the correct taste displayed throughout bids fair to become a most aristocratic neighbourhood'.[13] What the paper did not predict was that most of the residents would belong to the aristocracy of wealth rather than birth: merchants, fundholders, industrialists and businessmen. This was also to be true of the Holland Park estate. And some of the residents would be eager to build up collections of contemporary art, stimulated by the proximity of the South Kensington Museum, the School of Design and artists' studio-houses.

While depressingly uniform stucco houses in various shapes and sizes were being built all over Kensington, Rossetti's Oxford friend Benjamin Woodward, architect of the Debating Hall, designed a completely different house on Campden Hill. Number 15 Upper Phillimore Gardens (fig. 20) was built between 1859 and 1860 for a solicitor, William Shaen. Charles Eastlake noted it in his *History of the Gothic Revival*:

> a curious example of a suburban villa residence treated to a certain extent in a Medieval spirit. The front is of red brick, with stepped gables. A picturesque staircase turret is on the right hand of the building, and a Venetian-looking balcony projects down from one of the windows. It cost 3000£.[14]

Though no artist, Shaen and his wife Emily, daughter of a Manchester silk merchant Henry Winkworth, enjoyed the company of liberal intellectuals and educationalists.[15]

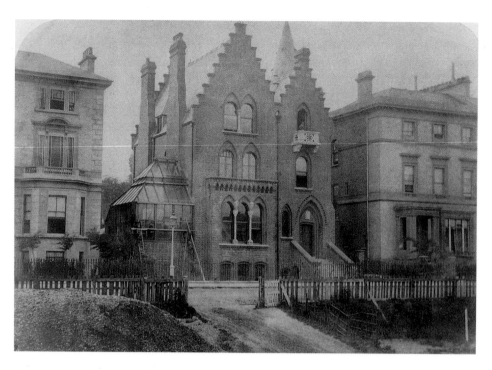

20. 15 Upper Phillimore Gardens, designed by Benjamin Woodward.

Twenty years later, Leighton would attend the musical parties of Emily's brother Stephen, who established himself on Campden Hill and collected paintings and sculpture by his artist-neighbours.

While Woodward's unusual house was being built on Campden Hill, Thackeray decided at virtually the same time to build a mansion for himself a little further to the east on land belonging to the Crown Estate. He also turned his back on the vogue for Italianate villas, instead looking for inspiration to the older houses still surviving in the borough, particularly Kensington Palace, Holland House, Little Holland House, and the houses around Kensington Square including 13 Young Street, the Queen Anne house which he had leased in 1847. Most dated from the seventeenth and eighteenth centuries and all were built of red brick.

Thackeray had become editor of the *Cornhill Magazine* in 1859 on a salary of £1,000 per annum; he was also receiving £350 a month from his publisher George Smith for the serial parts of his novels. His financial position had never been better. He wrote to his mother on 1 October 1859: '3 years more, please the Fates, and the girls will have 8 or 10,000 a piece that I want for them: and we mustn't say a word against filthy lucre, for I see the use and comfort of it every day more and more. What a blessing not to mind about bills!'[16]

He planned to write a history of the reign of Queen Anne and discovered the perfect building in which to be inspired, an old grace-and-favour house at 2 Palace Green, facing the stables of Kensington Palace, and at right angles to the palace and gardens. According to his daughter Anne he also wanted to move to the 'higher ground and gravel soil of Kensington, [so that] he might ward off malaria which, contracted at Rome, had become chronic'.[17] He acquired the house in March 1860 on a repairing lease, writing to George Smith, 'I have taken at last the house on Kensington Palace Green, in which I hope the history of Queen Anne will be written'.[18] *The Four Georges: Sketches of*

Manners, Morals, Court and Town Life was published in the *Cornhill* between July and October 1860.

On acquiring 2 Palace Green (fig. 21) and agreeing to spend £1,400 on repairs, Thackeray discovered the house was too dilapidated to be saved; Frederick Hering, a 'rather dim architect',[19] was supplied with sketches by Thackeray showing what he wanted. A contributor to the April 1860 issue of the *Cornhill Magazine* wrote that the ideal house was 'of red brick, not earlier than 1650, not later than 1750'.[20] Hering did his best to provide Thackeray with a Victorian version in red brick of the favoured Queen Anne style. The builders were Jackson and Graham, specialists in interior decoration. When the house was ready for occupation in March 1862, the cost, including fittings, was over £8,000.[21]

Val Prinsep had taken Anne to the premises of Morris, Marshall and Faulkner, the firm founded in 1861 by Morris, Peter Marshall, Charles Faulkner, Rossetti, Burne-Jones, Ford Madox Brown and Philip Webb. She recalled:

> we came into an empty ground floor room, and Val Prinsep called 'Topsy' very loud, and some one came from above with hair on end and in a nonchalant way began to show me one or two of his curious, and to my uninitiated soul, bewildering treasures. I think Morris said the glasses would stand firm when he put them on the table. I bought two tumblers of which Val Prinsep praised the shape. He and Val wrapped them up in paper, and I came away very amused and interested, with a general impression of sympathetic shyness and shadows and dim green glass.[22]

Thackeray loved the 'reddest house in all the town'; his family called it the 'Palazzo'.[23] However, the final cost was of concern:

> The house is delightful. I have paid 5000 on it in two years out of income – but there's ever so much more to pay I don't know how much. . . . Well upon my word it is one of the nicest houses I have ever seen . . . there is an old green and an old palace and magnificent trees before the window at wh. I write . . . I have the most delightful study, bedroom, and so forth . . . and have a strong idea that in the next world I shan't be a bit better off.[24]

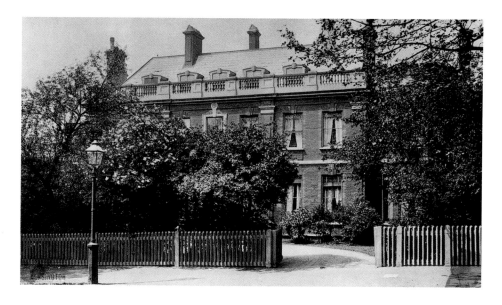

21. 2 Palace Green, designed by Frederic Hering.

As soon as he moved in, he held two nights of private theatricals, which Anne recounted:

> The theatre was put up in the dining-room and the play came to life. . . . Everyone was in
> fun and good humour. . . . A jolly sort of meal in the drawing-room, and then the 2 great
> nights and all the people pouring in . . . I remember standing by Papa when all was over and
> saying goodbye . . . and remember such an odd feeling came over me. I suppose this is the
> summit. I shall never feel so jubilant so grand so wildly important or happy again – It was a
> sort of feeling like Fate knocking at the door.[25]

Anne was right to recognise the house-warming as the 'summit'. Thackeray completed the last part of his novel *Philip* in July; the first part of Anne's first novel *The Story of Elizabeth* appeared in the *Cornhill* in September. But Thackeray's next novel, *Denis Duval* was never finished: he died at Palace Green on Christmas Eve 1863.

By Christmas 1864 Val Prinsep had acquired a plot of land on which to build his own studio-house. His father had agreed to pay; the site was on the Holland estate, close to Little Holland House. The agreement Prinsep entered into with Lady Holland in January 1865 stipulated that he must 'erect and build on the piece or parcel of Ground situate in the Back Road Holland Lane . . . one good proper and substantial messuage or dwellinghouse only' to the value of at least £1,000 – the actual cost of the house in its first stage was just over £2,000[26] – and contract drawings were signed by the builders, Jackson and Shaw, in the same month.[27] Lady Holland granted Prinsep a ninety-nine-year lease, to run from 1864. The ground rent for the first year was a peppercorn, for the second £14, thereafter £28 per annum. The original agreement also stipulated that the house was to be completed by Christmas Day 1865; certainly Prinsep was in occupation before the summer of 1866.

Prinsep approached Philip Webb (fig. 22) to design this, the first studio-house to be built in Holland Park. His choice of architect was obvious. Webb had designed houses, both in red brick, for his friends William Morris and Spencer Stanhope; they also belonged to the same club, the Hogarth, founded in 1858.

Ford Madox Brown, Holman Hunt, Rossetti and Spencer Stanhope were the principal founders of the Hogarth Club which was, according to Hunt, to be 'a meeting-place for artists and amateurs in sympathy with us', where they could 'use the walls for exhibiting our sketches and pictures to members and friendly visitors'.[28] The club survived until 1861 (first at 178 Piccadilly, then 6 Waterloo Place) and the artists, not without some argument, managed to organise four exhibitions.[29]

Of the one hundred members, fifty had to be practising artists. Almost all were outside the Royal Academy and would have regarded themselves as the *avant-garde* of the day. Many were Sara Prinsep's lions, including Watts, Spencer Stanhope and Val Prinsep; Holman Hunt and his companions in Tor Villa, Campden Hill, Robert Martineau and Michael Halliday; Ruskin, Burne-Jones, Rossetti and Frederic Leighton, recently arrived in London and living in Orme Square, Bayswater; Eyre Crowe, a cousin of the Prinseps and Thackeray's secretary; Tennyson and Browning. Watts' patron Lord Lothian, a guest at Little Holland House, was a member; also William Morris and the architect William Burges.[30]

Both Burne-Jones and Prinsep showed their work for the first time at the Hogarth Club. Prinsep, still under the influence of medievalism, illustrated 'The queen was in

22. George Howard, *Philip Webb*.
Castle Howard, Yorkshire.

the parlour, eating bread and honey' (fig. 23) from the rhyme 'Sing a Song of Sixpence'; Burne-Jones hung designs for stained-glass windows, his 'first experience in public life'.[31] Leighton showed his *Study of a Lemon Tree* in which he demonstrated that he could 'outdo the most precise Pre-Raphaelite in artistic truth'.[32] He wrote to Browning early in 1860: 'I am hand-in-glove with all my enemies the pre-Raphaelites'.[33]

Though the Hogarth Club was short-lived, relationships, social and professional, were maintained between several of its members. Seven members, for example, founded Morris, Marshall and Faulkner. And Webb received his first commission in 1859 as an independent architect to design the Red House for Morris and his wife Jane. The house was intended to be a place in which to live and to work; Burne-Jones and Georgiana were meant eventually to join them. A 'lovely plan was made. . . . It was that Morris should add to his house, and Webb made a design for it so beautiful that life seemed to have no more in it to desire.'[34]

Rossetti, in a letter written to Charles Eliot Norton in January 1862, described how the house was viewed by the circle of friends: 'a most noble work in every way, and more a poem than a house . . . an admirable place to live in too'.[35] The Burne-Joneses, Rossetti and his wife Elizabeth Siddal were regular guests, helping to decorate walls, ceilings and furniture.

Even before the Morrises moved into the Red House, Webb was designing the second of his artist's houses, Sandroyd, in Cobham, Surrey, for Spencer Stanhope. In 1859 Spencer Stanhope had married Elizabeth Wyndham-King, granddaughter of the third Earl of Egremont. Sandroyd, unlike the Red House, was designed for a painter and had two studios on the second floor, connected by double doors, also a waiting room, and

a dressing-room for models. It cost approximately £1,860.[36] The location, in the Surrey countryside, was dictated by Spencer Stanhope's chronic asthma. Burne-Jones visited often during the early 1860s, and used the landscape for the background of *The Merciful Knight*, exhibited at the Old Water-Colour Society in 1864. The painting is similar in design to Spencer Stanhope's major work at the time, *I Have Trod the Winepress Alone*.[37]

Both the Red House and Sandroyd were built in the countryside; Prinsep's house in Holland Park was to play an influential role in popularising the 'Queen Anne' style which changed the architectural style of large parts of Kensington and Chelsea in the 1870s and 1880s, not least because the house received much publicity both during and after its construction. Red brick was to become the 'aesthetic' building material; Rossetti hailed Webb as its master:

> With reason is Caesar Augustus renowned
> For of marble he left what of brick he had found.
> But our Mr Nash we must own is a master,
> For he found us of brick and he left us of plaster.
> Now Webb has succeeded in trumping the trick –
> For he found us of plaster and left us of brick.[38]

To begin with Prinsep's house was relatively small and, like Morris' Red House, resembled a red-brick country parsonage, apart from the tell-tale studio windows on the north side. Edward Godwin, writing for the *Building News* in December 1866, thought it 'admirable . . . in beauty of skyline and pleasing arrangement of gabled mass'. Later, the painter and critic Frederic George Stephens described it for his series 'Artists at Home': 'Large, solid, and massive without, and admirably finished in design and execution, its wide and comfortable windows, smooth, dark red brick-work and high-pitched roofs of tiles, are, without being heavy or austere, very sincere and picturesque.'[39]

It was built entirely of red brick with red tiles on the roof, the external woodwork was painted white, the ironwork a dark brown. The servants' quarters were in the base-

24. (above, left)
1 Holland Park Road
(from the north),
designed by Philip Webb
and drawn for the *Building News*, 29 October 1880,
by Maurice B. Adams.

25. (above, right)
1 Holland Park Road,
design for the south
elevation by Philip Webb.

23. (facing page)
Valentine Prinsep, *The Queen was in the Parlour Eating Bread and Honey*, 1859. City Art Gallery, Manchester.

ment, including their sleeping accommodation.[40] With limited resources, Prinsep dispensed with a drawing-room. On the ground floor Webb gave him a 'waiting or garden-room, conveniently placed for visitors, or for business transactions',[41] a dining-room and two bedrooms. The studio, on the first floor, 40 feet by 25 feet, was large enough for entertaining artists and patrons. Prinsep created a drawing-room at 1 Holland Park Road only after the demolition of Little Holland House in 1875 and the departure of his parents to the Isle of Wight.

The studio was the largest room in the house. It covered the whole of the first floor and had its own water closet and model's dressing-room, also a gallery from which Prinsep could work on large paintings. Models and visitors used the same staircase. Morris, Marshall and Faulkner supplied the wallpapers and curtain fabric; the woodwork was painted a dark brown throughout except in the dining-room where dark green walls provided a foil to the blue-and-white china. There, the *Building News* (1880) commented on 'the side cabinets and tables . . . used for the display of many choice works of art, old china, and nick-nackeries, collected in India and from all parts of Europe, as well as from Japan'. The oriental theme was continued with Japanese leather-paper used on the principal room-door panels and for dados.

> Mr Prinsep was one of the earliest to use this material, and obtained it specially from Japan. . . . At that time Japanese leather-paper could only be had in small squares, and so its original quaintness for large surfaces is greatly increased by the varied character and colour which the many small sheets insure – a variety which is almost entirely lost when continuous paper, such as that now imported from Japan, is used.[42]

In the studio the walls were painted salmon red, the coved ceiling was white, the gallery woodwork unvarnished oak. Throughout the house there were old tapestries, 'quiet hangings', some acquired on trips to Italy; also old Chippendale chairs. The atmosphere at this stage in Prinsep's career was comfortable and artistic; it was a bachelor's den rather than a palace of art.

Rossetti, after visiting Prinsep's studio in 1869, expressed his envy of the facilities in a letter written to Janey Morris. He was less flattering about Prinsep's paintings:

> Val's studio filled me with envy as it always does one day that I called there, and the sight of it will I think expedite my movements. I cannot say that the same mean feeling was awakened by his pictures. He has begun one which he calls the *Lion's Mouth*. . . . In the corner a female 'dresser' who has apparently taken the leading lady's part at a moment's notice, is doing something to your knocker in Queen Square, which as I told Val, he had better borrow to paint, as thus one character at least in his picture would be something like the real thing.[43]

Much later, Watts wrote to Madeline Wyndham, friend of both artists, of his disappointment over Prinsep's artistic output: 'with unusual abilities Val has let slip his best opportunities from indolence and indifference' (fig. 26).[44]

Prinsep was a 'weather-cock' as an artist, changing his style from Rossetti-like Pre-Raphaelitism to the subject painting of the St John's Wood Clique, with some attempts at Leightonesque classicism and a little orientalism; he also wrote a novel, plays and memoirs of his trip to India in 1877 to paint the Delhi Durbar. At his death in 1904, the *Art Journal* summed up his contribution as an artist: 'though he himself made no claims to greatness, Mr Prinsep knew all the eminent artists of his time . . . several of them intimately'. His greatest artistic achievement was commissioning Philip Webb to design his house in Holland Park Road.

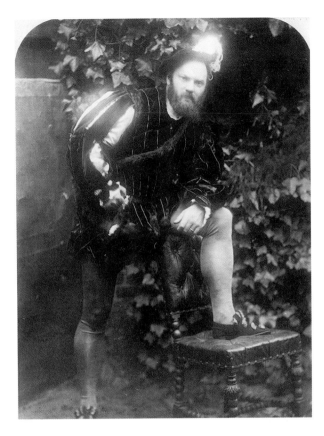

26. Julia Margaret Cameron,
Val Prinsep as Henry VIII, 1874.

While Prinsep was negotiating his agreement with Lady Holland, Burne-Jones, Georgiana and their baby son Philip moved into another red-brick house in Kensington. The plan to live at the Red House had collapsed through lack of funds (in 1865 the Morrises abandoned the house for Queen Square in Bloomsbury). Morris advised the disappointed couple:

> I have been resting and thinking of what you are to do: I really think you must take some sort of house in London – unless indeed you might think of living a little way out and having a studio in town: Stanhope and I might join you in this you know. I don't see how you can do with chambers.[45]

Burne-Jones chose the London option and, according to George du Maurier, began his search in Kensington. He and Georgiana were recovering from the scarlet fever which had struck their family, and from the death of their premature son, Christopher.[46]

> Jones poor fellow has given up all idea of building his house; he has had lots of trouble & not done a stroke of work for 4 months – his wife's confinement & scarlet fever, & his own horrible funk about it have quite knocked him up. He's looking out for a house in Kensington, and Poynter is going to take his room.[47]

Fond memories of Little Holland House may have attracted Burne-Jones back to the area; also the knowledge that Prinsep was building in Holland Park Road. Georgiana recalled earlier visits to the area while they were house-hunting:

The place itself was not strange to us, for once, when seeking rooms, we had gone as far as Kensington and seen its old square lying back undisturbed by the world, with nothing except gardens between it and the narrow High Street. The turnpike through which Edward took me to Little Holland House the first time we went there together had been removed, but the parish church was not yet rebuilt and the whole neighbourhood was quiet and self-contained in comparison with that of Holborn.[48]

Unable to build his own house, Burne-Jones had to make do, taking 41 Kensington Square. 'Our house', wrote Georgiana, 'was on the north side of the square, a great draw-back, because the south light was bad for painting and the only rooms with a north aspect were very small.'[49] However, the house was of red brick, part of Ritchie's *Old Kensington*; as soon as they moved in, the Burne-Joneses ordered blue and green serge from Morris, Marshall and Faulkner, as well as Pomegranate wallpaper and Sussex rush-bottomed chairs. Ruskin gave them a set of Dürer prints and Watts sent Georgiana a sewing-machine, presumably the idea of Sara Prinsep.[50]

Georgiana associated the move to Kensington with loss, not just of their baby but of the contentment she had experienced in their first years of marriage: 'when we turned to look around us something was gone, something had been left behind – and it was our first youth'.[51] Once established in Kensington, Georgiana had to admit their friends 'did not find the distance too far to follow him'. Several were already living close by. The garden was large enough for games of bowls; in the spring 'it was a pretty spot . . . when together with its neighbour-gardens it made a mass of fruit-blossom surrounded by red roofs'.[52] The only problem was the cats: 'This garden is infested with [them] but they haven't got indoors yet, Ned [Burne-Jones] rushes out upon them like a whirlwind from nearly every meal, and hurls sticks and stones at them.'[53]

The wedding of Georgiana's sister Alice Macdonald to the artist John Lockwood Kipling was celebrated at Kensington Square only weeks after the Burne-Joneses moved in. Agnes Macdonald, the third sister stayed for several weeks. In letters home she gives a vivid account of the preparations for the wedding and of the constant presence of the artists, sometimes their wives, who made up the Burne-Joneses' circle. Towards the end of the visit she wrote:

> Oh Louie [the fourth sister], if Providence should ever let us feel able to live in this neighbourhood, there is a complete nest of warm hearts which would welcome us and make our last days better than our first . . . Ned has just applied to have the lease extended to seven years instead of three, for they now intend, all being well, this to be their permanent abode.[54]

Morris called, 'so nice and kind, pleasanter than ever he was I think', and there was an overnight visit to the Red House in return; the painter Frederick Burton, who lived across Kensington High Street in Argyll Road, was a frequent guest, 'wonderfully like Garibaldi'; Rossetti, established since 1862 at Tudor Lodge, Cheyne Walk in Chelsea (another red-brick Queen Anne property), 'spent the evening here . . . the first time for nearly two years. . . . He looks very well, but he's really getting too stout. . . . He brought with him a French artist of great celebrity named Le Gros. . . . He doesn't talk English which is rather a nuisance.'[55]

In 1864 Alphonse Legros had married an English woman, 'pale, handsome'[56] Frances Rosetta Hodgson, and settled in Kensington at 1 Victoria Grove Villas.[57] Edward Poynter, a frequent guest at Kensington Square during Agnes Macdonald's visit, proposed, and married her the following year and they settled at Beaumont Lodge in Shepherd's Bush, just to the west of Holland Park.

The Holland Park Circle

Spencer Stanhope, his asthma no better after moving into Sandroyd, fled to Florence where he spent every winter. During the summer months, however, he returned to London, staying with the Burne-Joneses[58] until he eventually took the Elms, the western half of Little Campden House on Campden Hill (Augustus Egg occupied the eastern half). Charley Collins, brother of Wilkie, was another neighbour. He had been a fellow student of Holman Hunt and Millais at the Royal Academy Schools and after marrying Dickens' daughter Kate in 1860 settled in Kensington. Hunt was himself still living on Campden Hill, at Tor Villa, but in 1866 he set off for the East with his new wife Fanny Waugh.[59]

Val Prinsep was a regular visitor, providing links with his parents' circle at Little Holland House. He offered invitations to Georgiana and Agnes to view his new paintings, on display in his brand new studio; he also began work on a portrait of Philip Burne-Jones. Those who called at 1 Holland Park Road were able to study the progress of the house being built immediately next door to Prinsep, another red-brick studio-house, designed by George Aitchison for the young painter who would become the acknowledged leader of the Holland Park circle of artists: Frederic Leighton.

4

Leighton, Aitchison and 2 Holland Park Road

When Frederic Leighton decided to settle in London in 1859 he was twenty-nine years old and already well known as an exhibitor at the Royal Academy, though still regarded by many members of the art establishment as an outsider. The first painting he submitted to the Academy in 1855 had received unprecedented attention. *Cimabue's Celebrated Madonna is Carried in Procession through the Streets of Florence* had been hung alone on one wall. The critics of the *Athenaeum* and of the *Art Journal* were unanimous in praising the work; Prince Albert was 'enchanted with it', according to Queen Victoria, who paid Leighton's asking price of 600 guineas.[1]

Rossetti recognised the impact of Leighton at the Academy, but also the envy felt by some Royal Academicians towards the young artist who had chosen to study not in London but in Germany and Rome. He wrote to William Allingham: 'The RAs have been gasping for six years for someone to back against Hunt and Millais, and here they have him; a fact which makes some people do the picture injustice in return.'[2]

Leighton was actively disliked by Sir Francis Grant, President of the Royal Academy – 'That Leighton, I can't stand him'[3] – and for several years he received little support from the Academy selection and hanging committees. The critics could also be harsh, comparing each year's submission to the triumph of *Cimabue's Madonna*. In 1856, *The Triumph of Music* was unanimously condemned and consigned by the disappointed artist to 'oblivion during his lifetime in the dark recess of a cellar'.[4] However, he remained determined to succeed in the London art world: 'If I am impressionable I am also obstinate; and, with God's will, I will one day stride over the necks of the penny-a-liners, that they may not have the triumph of having hauled me down before I have had time to be heard.'[5] Leighton continued to submit work to the Royal Academy,[6] and was finally made an Associate in 1864. The same year he acquired a plot of land from Lady Holland on which to build a studio-house next to Val Prinsep and close to Watts at Little Holland House.

During the years before his acceptance by the establishment, Leighton attached himself to several groupings of artists and art enthusiasts; some continued to play a significant role in his life. They provided him with companionship, peer criticism of his work, support in the teeth of Academy slights, as well as valuable introductions to patrons. It was Leighton's growing friendship with Watts and his introduction to both Little Holland House and Holland House that influenced his decision to create his own palace of art in Holland Park.[7]

Watts and Leighton both looked to the classical world and to the Renaissance for inspiration; they shared a belief in the morally uplifting power of art, and in the

seriousness and the responsibility of the artist to society. After Leighton's house was completed, 'scarcely a day passed without a meeting between the two brothers-in-art; and young people coming home from their balls in London would often come across Leighton running in, soon after dawn, to have a few words with Signor before the day's work began.'[8] Their neighbour and biographer Emilia Barrington commented:

> No two characters could have been more dissimilar than those of Watts and Leighton, no two men could have led more different external lives; Leighton's great and varied gifts requiring for their full exercise the whole area of life's stage, Watts' genius demanding seclusion, and days undisturbed by friction with the outer world. Watts' first and great object in life was to preserve his work, and to bequeath it to his country, which he, happily for his country, was enabled to do; Leighton's object was to complete a work as far as industry and his gifts would enable him to complete it, then — as he would say — 'to get rid of it and never see it again; but try to do better next time'![9]

They first met in the spring of 1855 shortly before *Cimabue's Madonna* was hung at the Academy. According to Mary Watts, friends writing to Watts from Rome suggested he call on Leighton, 'a delightful young painter',[10] while he was staying in Montague Square. Apparently they met on the pavement and Watts immediately offered to show Leighton his studio at Little Holland House. Leighton wrote to his mother: 'the studio is at my disposal if I want to paint there . . . Watts is a most marvellous fellow.'[11] They already had acquaintances in common, including Browning and Thackeray. Watts may have known that Thackeray based Clive Newcome, the artist-hero of *The Newcomes*, (1853–5) in part on Leighton.[12]

Watts was generous in his admiration of the younger man: 'Nature got tired when she was in the middle of making me, left off, and went away and made a Leighton.'[13] He noted 'the extraordinary amount of vitality and nervous energy' which Leighton seemed to possess. Leighton commented: 'Don't envy me, envy Signor.'[14] Mary Watts summed up the mutual attraction: 'each seemed to find in the other that which he would above all others have liked to find in himself'.[15] Emilia Barrington later wrote: 'The one was frank, free, courageous; the other almost morbidly self-depreciative, sensitive, and timid. All the same, no two workmen could have had more sympathy with one another in their true aims and aspirations, or more mutual admiration for each other's artistic gifts.'[16]

Another bond was their love of music, manifest in their paintings as well as in their social lives. As a young boy Watts came into contact with music through the unsuccessful attempts of his father to maintain a business as a manufacturer of musical instruments. However, it was in the homes of the Ionides, the Hollands and at Little Holland House that Watts heard musicians with international reputations.[17]

Leighton's musical education was supplied by the soprano Adelaide Sartoris (fig. 28), whom he first met in Rome in 1853. Sixteen years his senior, she became his closest woman friend, a support and inspiration until her death in 1879. From George Aitchison's account of the young artist as he appeared in Rome, Leighton would have been a great attraction in her salon:

> a light-haired, fresh coloured handsome dashing young fellow, with fine manners, who let the most brilliant as well as the wisest saying fall from his lips in his sprightly and animated conversation. In those days he was so gay and lighthearted that, when at friends' studios, he would often break off his conversation to sing a snatch of an Italian ballad or an air from an opera, and would sketch comic idylls on their canvases.[18]

MEN OF THE DAY, No. 46.

"A sacrifice to the Graces."

28. Camille Silvy, *Adelaide Sartoris*.

Adelaide was not without her own attractions, as Leighton's own sister noted in her diary:

> She seems very fond of him, as she might be of a younger brother. . . . She is very stout, high coloured, and has little hair. But the shape of her mouth is very fine, the modulations of her voice in speaking are exquisite. She is a creature who can never age and before whose attractions those of younger and prettier women must always pale.[19]

She was a member of the Kemble theatrical family: her father was the actor, John Kemble; her sister the actress, Fanny. She herself had been one of the leading sopranos of her day, contributing to the revival of Covent Garden, but she gave up her international career in 1842 to marry Edward Sartoris, the son of a French banker. It appears to have been a successful marriage. There is no evidence that Edward minded the gossip about her relationship with Leighton and he allowed her to continue to sing, though only in private.[20]

The descriptions of her homes in Rome, Paris, London and Hampshire provide glimpses of sumptuous artistic interiors brought to life by her presence, a significant influence on Leighton when he came to create his own home in Holland Park. Anne Thackeray Ritchie visited the Roman drawing-room:

27. (facing page) James Tissot, *A Sacrifice to the Graces*, (Frederic Leighton) *Vanity Fair*, 29 June 1872. Private Collection.

all full of a certain mingled atmosphere of flowers and light, and comfort and colour. . . .
Here swinging lamps were lighted up, beautiful things hung on the wall, the music came and
went . . . , a great piano was drawn out and open, the tables were piled with books and
flowers. Mrs Sartoris, the lady of the shrine, dressed in some flowing pearly satin tea-gown,
was sitting by a round table reading . . . from a book of Mr Browning's poems.[21]

Coutts Lindsay's family were less impressed by his description: 'The society you
describe as belonging to Mrs Sartoris doesn't appear to me wholesome or desirable. It's
like some kind of rich food, you think it good but you feel sick after it – more like
onions.'[22]

During the winter of 1855, while Leighton was living in Paris, Watts visited, renewing
his friendship with Leighton and meeting the Sartorises. He wrote to Jeannie Nassau
Senior: 'I have seen a good deal of the Sartoris's and like them much. Their home is a
very pleasant one and nothing could be more amiable than Mrs Sartoris has been to
me, she has often spoken of you and always as I should wish to hear you spoken of.'[23]

The following June, Leighton brought from Paris to London two new paintings *Pan*
and *Venus and Cupid* and was invited by Watts to show them in his studio in Little Holland
House. Watts was impressed by the work:

> I must send you [Jeannie] a few lines to tell you that Leighton's pictures are arrived, and that
> just as I expected so far from being a foil to mine, they make mine by comparison look just
> what I said flat and dim. There are some beautiful things in them evincing a wonderful per-
> ception of natural effects, and power of carrying that away in memory and embodying upon
> canvas.[24]

Leighton was entertained by the Prinseps and the Hollands. He also met Rossetti, 'a
remarkably agreeable and interesting man', and attended a life class in Kensington,
organised by several of the local artists including Holman Hunt, whom 'I like much',[25]
Augustus Egg, W.P. Frith, William Mulready, T.O. Barlow and John Phillip. Val Prinsep
also attended.

The following year Leighton was again in London. At one dinner at Holland House
attended by Leighton, Watts and Prinsep, was Virginia Cerasis, Contessa de Castiglione,
the extraordinary Italian celebrity. Mistress, briefly, of Napoleon III, her beauty was
legendary. 'There has never been another woman . . . in whom immortal Venus, as
deified by the brushstrokes and chisels of the great masters, was more perfectly incar-
nate.'[26] She was immediately attracted to Leighton, whom a friend described at the
time as: 'a youth, with the form and features of a Greek god, not wanting either, the
tower of ambrosial curls of the Apollo, neither vain of person nor of work, yet with a
certain elusiveness about him even then.'[27] Watts was painting the Countess' portrait.
According to Mary Watts, the Countess invited Watts, Leighton and Prinsep into the
studio, where she appeared stark naked, to the astonishment of the three artists.
Presumably they were unaware of her habit of posing for hundreds of photographs for
the photographic firm of Mayer and Pierson, often dressed only in her chemise, some-
times revealing naked legs.[28]

Leighton was again in London in the summer of 1858, having decided he would
make his permanent home in the city. After a final winter in Rome, he returned in the
summer of 1859 and found a studio for himself, not far from Little Holland House.
Number 2 Orme Square was off the Bayswater Road, opposite Kensington Palace

Gardens. Leighton was unsure, however, about the light and the location, writing to his mother: 'I am in great doubt about being able to paint in that studio, and about its having been any use to come over to London without the possibility of a really good *locale*: however, here I am'.[29]

According to the sculptress Harriet Hosmer, Leighton had been thinking of his ideal home for some time.[30] The rented studio was proving far from perfect. In 1863, 'bailiffs entered the house, while he was away, because his landlady Mrs McGedy was behind with her taxes, and they threatened to make off with his furniture'.[31] As a regular guest of Lady Holland, a widow since 1859, he would have been aware of the building activities being initiated to safeguard Holland House; from the Prinseps, at Little Holland House, he would have known, at an early stage, of their son's plans to build a house in Holland Park Road. In the summer of 1864 he wrote to his father:

> I should not leave the place I am in except to build; a mended house would be most unsatisfactory and *temporary*. I feel sure I shall nowhere get standing room for a house for less than £28, still less room for a house and *large garden*. If I find the terms exactly as I expect and my lawyer (Nettleship) satisfied with the title I shall, I think, close the bargain.

He added: 'Gambart [the dealer] has paid the £1050 for "Dante". The "Honeymoon" was bought by a Cornhill dealer yclept Moreby.'[32] Though Leighton's father was to pay him a generous allowance for the rest of his life, his son's success as an artist was assured; 1864 was the year he was accepted by the establishment and made an Associate of the Royal Academy (fig. 30). As Leighton explained to F.G. Stephens, Gambart made the offer for *Dante* after the elections to the Royal Academy were announced:

> As for the A.R.A.ships, I can't well (speaking *quite confidentially*) conceive it a *great* honour now – but it has material advantages as you see with the case of Gambart – I immediately inferred what you say from the fact of his buying my pictures so readily – he who never bought *anything* of mine before.[33]

Leighton's father still needed constant reassurance about the building project:

> As to the possible expense of the house, my dear Papa, you have taken, I assure you, false alarm. I shall indeed devote more to the architectural part of the building than *you* would care to do; but in the first place architecture and more *ornament* are not inseparable, besides, whatever I do I shall undertake *nothing without an estimate*.[34]

His chosen architect was his friend George Aitchison, who had no previous experience of building houses, let alone artists' houses. They had first met in Rome in 1853, when the young architect was on a two-year tour of Italy, France and Switzerland. Aitchison had been articled at the age of sixteen to his father, architect to the St Katherine's Dock Company and the London and Birmingham Railway, then he studied at the Royal Academy and University College.[35]

In Rome he also met Edward Poynter, Alfred Waterhouse and William Burges. Though Burges disliked the architecture of Rome, he was helping Leighton with his massive undertaking, the *Cimabue* painting, designing the candlesticks and draped fabric.[36] Leighton proposed the two architects travel together to Assisi in the summer of 1854; they spent several months exploring towns and villages in Italy and France. Aitchison recalled they planned to 'do no work on fete days, but always take a stroll in

the country. . . . I do not think we ever did; for, before we even reached the suburbs, Burges always espied a by-street that promised to contain some archaeological treasure.'[37] Burges eventually built his own house in Melbury Road close to Leighton; Poynter lived close by in Shepherd's Bush. Waterhouse remained linked to the group, designing the Natural History Museum in South Kensington and a house on Campden Hill for the artist, Edward Sterling.

Returning to London, Aitchison became head clerk and then partner to his father. On his death in 1861, Aitchison succeeded him as architect, designing and surveying warehouses and wharfs, including the tobacco warehouse at the Victoria Docks, with a frontage of 500 feet. In 1864 he designed 59–61 Mark Lane, EC3 for Innes Bros, a property company: 'a handsome example of mid-Victorian commercial architecture, influenced by Ruskin'.[38] Though not unusual visually, beneath the surface 'its bones were entirely of iron. The building's structural principle has been compared to that of a skyscraper.'[39] At the same time he was approached by Leighton to design his house in Holland Park, and the following year his position as architect to the St Katherine's Dock Company was terminated. Work on Leighton's house was to occupy him on and off for over thirty years; otherwise his practice was to be almost entirely devoted to interior design.[40]

Aitchison worked on plans (fig. 29) while Leighton negotiated with Lady Holland for the site. In September 1864 Lady Holland's agent, John Henry Browne, drew up an agreement with the artist.[41] The builders were Messrs Hack and Son; the ninety-nine-year lease, to run from 1864, was granted in April 1866. Leighton was able to move into 2 Holland Park Road a few months later than Prinsep, at the end of 1866. This first stage of building cost about £4,500.

Leighton's house, like Prinsep's, was designed for a bachelor artist, with the possibility of later additions. Red Suffolk bricks were used, with cream Caen stone dressings. The simple Italianate villa was very different to the English country parsonage next door. Leighton's house had closer affinities with the studios he knew in Paris of artists such as Delacroix, Bouguereau and Ary Scheffer: 'the detailing of the cornice, incised with black mastic decorations, the centrally placed studio window (then framed in stone) on the northern elevation, and the elaborate pediment on the eastern gable are neo-Grecian and resemble contemporary Parisian studio-houses'.[42]

The offices were in the basement, and the servants slept on the second floor. By 1871, Leighton employed a butler and valet, Benjamin Kemp as well as Eliza Walton, his housekeeper and Maria Hocking, a young housemaid. He himself occupied a bedroom on the first floor. There was no spare bedroom and one was never added, even when the house was considerably enlarged. By contrast the reception rooms on the ground floor were extensive, with a lofty hall, lit by a large skylight, a breakfast room, a drawing-room and dining-room. Even at this time, comparatively early in his starry career, Leighton was creating a house in which he could perform his public role on a sumptuous stage; his private life required little space.

The *Building News* was ecstatic about Aitchison's design when it described the house on 9 November 1866:

> Full as are the suburbs of London of villas and mansions standing, as the phrase goes, in their own grounds, there is comparatively little good architecture displayed in them. . . . Everywhere the detached and semi-detached villa, the mansion, even the abomination known as a cottage *orné* bears the mark of dull sameness, unless, indeed it breaks out into a

House & Studio of F. Leighton Esqre. A. R. A., Kensington.

G. AITCHISON ESQRE, ARCHT.

29. 2 Holland Park Road, designed by George Aitchison, from *Building News*, 9 November 1866.

wildness of style in which grotesqueness is more noticeable than originality . . . it is seldom that we can allude with pleasure to the erection of an average suburban house. In the present instance, however, we can do so. . . . It is the house of an artist, and it expresses its purpose honestly to the casual passer-by, and no more.

The architect Edward Godwin, however, who had praised Webb's design for Prinsep, was critical, preferring 'informal planning and picturesque massing'.[43]

According to a study of Leighton published only a decade after his death, the artist was involved in every detail of his house:

Every stone, every brick – even the mortar and the cement – no less than all the wood and metal-work passed directly under his personal observation. . . . Often of a morning he used to lean out of a window or from a portion of the scaffold and thereon criticize each course and ornament. His eagle eye at once detected any scrimped work and woe betide the idler! When the time came for him to start for his winter's quarters he bound over Aitchison and all others who were concerned in the building and fitting of the house and studio to carry out his instructions implicitly. These included the minutest directions about the shape, size, and decoration of the furniture, which Aitchison was called upon to design specially [see fig. 30].[44]

Leighton's determination to oversee the building of his house reflected his desire to control every aspect of his life. His friend, the Italian painter Giovanni Costa, testified

as much: 'The whole year was planned out beforehand – the days on which he received visits, those of work; the house in which he would see his few intimate friends, and those in which he would return their visits; even the day and hour for going to see his father.'[45] Any delays to his house-building caused intense anxiety. He wrote to the Honourable George Howard, in 1866:

> Pray excuse my not having answered your question sooner – since I have returned I have been in such a state of turmoil that I have not known which way to turn – I am living at the Charing Cross Hotel and divide my time between servant seeing and furniture hunting – this house has made me lose an infinite amount of time – I hope however soon to get to work again – In about a week I hope to be able to show you a few studies made in Rome.[46]

The interior of Leighton's house was altered over the years; however, the *Building News* of 9 November 1866 provided a full description of the early decorations. The hall was 'paved with tiles in a pattern of almost Grecian severity. . . . The columns . . . of stone. . . . The beams which the columns support are in the Venetian style, and are painted of a peculiar blue, the sunk ornament immediately over the capitals being silvered.. . . The skirting, doors, and architraves throughout the house are painted black, the latter decorated with an incised pattern relieved by a little gilding, the effect of which is very good.'

The influence of the designer Christopher Dresser has been suggested, 'who advocated the use of delicate, stylized natural ornament, of black woodwork and small amounts of strong colour to create an effect of refinement and repose'.[47] Dresser's *The Art of Decorative Design* was published in 1862; he lived at Tower Cressy on Campden Hill from about 1869 until 1882. His writing was addressed to newcomers to the middle classes whom he felt needed to learn about taste.[48]

The drawing-room floor was painted the same 'peculiar blue' as the beams in the hall and covered to within two feet of the skirting with a Persian carpet. Leighton's oil sketch by Delacroix was set into a circular panel in the ceiling of the curved window bay; Corot's *Four Times of Day* were fixed into 'panels wrought in cement, and intended to be fixtures'. There was another large Persian carpet in the dining-room; the ceiling beams and the floor were painted a dull red. There was also a 'a handsome mantelpiece of oak'.[49] Leighton sketched plans for the drawing- and the dining-room showing the arrangements he desired for his ceramics, paintings, furniture and carpets.[50] The studio walls were painted a deep red. The *Building News* considered them

> worthy of notice on account of the appropriateness of all the details and the especial elegance of many of them. To the usual throne for models is added a gallery, so that the artist may be able to get studies of objects at a moderate elevation. The front of this gallery is ornamented with a pierced pattern, and the columns [painted blue] are picturesque in design. The light is controlled by means of a sliding screen which completely closes the skylight when a vertical light is not desired. In the ceiling is a sunburner, and the entire arrangement of the studio and its fittings is as complete as the combined skill of the artist and architect could make it.[51]

Leighton's and Prinsep's houses were built close to Holland Park Road which, according to Leighton, was at the time no better than 'a dirty lane'; opposite were merely the stables and coachhouses of St Mary Abbot's Terrace. The sites for the new houses were taken from farmland belonging to Holland Park Farm, part of the Holland

estate. The tenant, Edmund Tisdall was one of the best-known dairy farmers in the London area.[52] His farmhouse, immediately to the east of Leighton's house, was rebuilt in 1859 and provided accommodation for Tisdall, his wife and four children and several other family members and servants.

Prinsep's neighbour, to the west of his house, was the charity school founded in 1842 'for the education of children of the labouring, manufacturing and other poorer classes of Kensington',[53] by Caroline Fox. By 1871 the schoolmaster was John Howelly, assisted by his sister Jane. Their elderly mother also lived with them. Some of the school children presumably came from the cottages which formed Laura Place, a terrace of two-storey cottages at the east end of Holland Park Road. The occupants included a 'lady-mangler', a police constable, a watchmaker, several milkmen, a bricklayer, a biscuit-baker, two coachmen and a scavenger; most were married with several children. To the west, beyond the school, were livery stables run by Samuel Hough, and Catherine Terrace, comprising four small cottages. The residents included two coachmen, a bricklayer, a laundress, two masons, an unemployed printer and their families.

In the spring of 1867, Leighton's house was opened for the first of his annual music parties.[54] He was made a full Royal Academician in 1869, and the following year he appeared, thinly disguised, as the artist Mr Phoebus, in Disraeli's novel, *Lothair*: 'Mr Phoebus liked pomp and graceful ceremony, and he was of the opinion that great artists should lead a princely life, so that in their manners and method of existence they might furnish models to mankind in general, and elevate the tone and taste of

30. Frederic Leighton, *Golden Hours*, 1864. Private collection. This was the most popular of the paintings Leighton exhibited at the Royal Academy in 1864, the year he was elected an ARA. The decoration of the musical instrument might easily have been designed by Aitchison (see Leonee and Richard Ormond, *Lord Leighton*, 1975). The painting was acquired by the Benzons of Kensington Palace Gardens (see chapter 9).

nations.' (fig. 27)[55] To further his 'princely life', Leighton continued to engage Aitchison to alter his house (see chapter 13) changing the interior decorations and creating additional studio space. The Arab Hall was planned in 1877, a year before Leighton was elected President of the Royal Academy and knighted. It was almost as if artist and architect had anticipated the need for a more exotic setting from which to 'elevate the tone and taste of nations'.

Watts remained at Little Holland House, a short walk away; Prinsep was next door, at 1 Holland Park Road. Until Melbury Road was laid out in 1875, these three artists *were* the Holland Park colony. Even after more artists' houses were built in Holland Park Road and in Melbury Road, Leighton remained head of the colony as well as leader of the Victorian art establishment, positions he maintained with ease until his death in 1896.

5

Artist Comrades: Guns and Glees

Following the outbreak of war between France, Piedmont and Austria in 1859, Britain was gripped by the fear of invasion. There was a nationwide appeal for able-bodied men to join up and between 1859 and 1860 various volunteer corps were founded. A surprising number of artists decided to join, forming the 38th Middlesex (Artists') Rifle Volunteer Corps. When the same corps was renamed the 21st SAS (Artists') Volunteers in 1947, its strength resided in the hallmark of the first volunteers: 'independence and irregularity'.[1]

The artists who continued to be associated with the movement, long after any threat to British security had passed, included Watts, Leighton and Val Prinsep, friends and neighbours in Holland Park; their heartfelt display of patriotism can be seen as a defining characteristic of the Holland Park circle. Leighton and Prinsep wanted to be officers and gentlemen, not simply 'gentlemen of the brush'. They took part in manoeuvres and attended the annual shooting competition on Wimbledon Common alongside the aristocrats, landowners and industrialists in the movement, many of whom they already knew through the Little Holland House circle.

The Volunteers provided a neutral territory, a practice battlefield on which artists and art-lovers met as equals, a 'happy band of brothers', united in their Britishness, even though their opponent was ill-defined. It was another of the numerous Victorian clubs for men; it also provided them with an opportunity to play at being warriors, dressing up in the nineteenth-century equivalent of armour and acting out the scenes of heroism painted by some members of the band to be purchased by their 'brothers'.[2]

Edward Sterling, a student at Cary's School of Art,[3] William Cave Thomas and Henry Wyndham Phillips, were the first to propose that London's artists, musicians and actors formed a defence regiment. As Sir Algernon West, a resident of Kensington at the time, recalled, 'all the town was Volunteer mad'.[4] The initial response was slight when they met together at Phillips' studio, but by May 1860 several artists had enrolled. Phillips held the position of Captain until his death in 1869. Arthur J. Munby recorded in his diary an early meeting with 'Phillips, manly with great black beard, in the chair, behind a long table of rough deal'.[5] Walter Crane was too young to join in 1860 but recalled at least three volunteering from the engraving firm where he was working: 'cartridge belts and plumed shakos were quite common, and hung up alongside ordinary hats and coats, for drills and parades were to be attended after work'.[6]

John Everett Millais also joined, recalling,

The first time I met Frederic Leighton was on the war-path. It was at a meeting of four or five of the original Artist Volunteers, held in my studio at Langham Place, and, if my memory serves me, it was to consider the advisability of adopting the grey cloth which the corps now wears.[7]

Millais had not found it easy to establish his artistic reputation in London after his marriage to Ruskin's wife Effie Gray in 1855 (the Ruskins' marriage had been anulled). While Effie remained living in Scotland he took rooms in Langham Chambers and was a frequent guest at Little Holland House where he was given artistic encouragement by Watts and introduced to the Prinseps' social circle; drilling with the Artists' Rifles also provided him with contact with both artists and potential patrons. *The Black Brunswicker*, exhibited at the Academy in 1861 and appropriately combining the themes of love and war (it depicts the parting of an officer and his fiancée, modelled by Charles Dickens' daughter Kate, before the Battle of Waterloo), brought him critical and popular acclaim. The following year Millais and his wife settled in a large house in Cromwell Place, close to the South Kensington Museum; a lifelong enthusiast of 'manly' sports, Millais remained an active member of the Artists' Rifles. Joseph Comyns Carr, director of the Grosvenor Gallery, recalled that 'it was always, indeed, easier to think of him as one of a happy and careless company during those annual fishing and shooting holidays in which he so greatly delighted, than to picture him a prisoner in a London studio, arduously applying himself to the problems of his art'.[8]

Millais' rescue of Effie from her unconsummated marriage to Ruskin is frequently defined in chivalrous terms;[9] unlike his own marriage, Millais' only attempt to paint such an act was not a success. *The Knight Errant* (fig. 31), shown at the Academy in 1870, is Millais' only painting of a full-length nude. The bound woman, dishevelled and with loosened hair, did not conform to the public's expectations of the innocent virgin, even after Millais replaced her head, originally looking out of the canvas, with the final version, turned modestly away from the viewer.[10] F.G. Stephens thought her 'not over pure in character or refined in expression [but] somewhat feverish-looking, and the carnations of the cheeks appear veiny as in worn faces';[11] she reminded critics of the reality of the naked model rather than an imagined damsel in distress. The motives of the knight, who was not given a reassuring name – chaste Sir Galahad for example – were also unclear.

The young William Blake Richmond, son of the portraitist George Richmond, became honorary secretary of the Artists' Rifles while still a student at the Royal Academy Schools, and a lifelong friend of Prinsep, Watts and Leighton (later in his career he acquired a studio in Holland Park Road). Holman Hunt, Burne-Jones, Morris and Rossetti would appear to have been more unlikely recruits. However, both Hunt and Rossetti were interested in pugilism. Hunt had led a discussion on boxing at his house on Campden Hill, and

communicated the doctrine that it was on account of our ancestors' pugnacity and warlike propensities that England had become great. Now we were degenerating into a generaton of milksops. He and several of the other men were arranging boxing lessons to be taken of a man of the name of Reid [Alec Reid, room manager at the Cambrian, Leicester Square].[12]

Reid's pupils included William Rossetti, Hunt, F.G. Stephens, Spencer Stanhope, George Boyce and Prinsep, whose own physique and taste for pugilism were celebrated by Dante Gabriel Rossetti:

31. John Everett Millais, *The Knight Errant*, 1870. Tate Gallery, London.

There is a big artist named Val,
The roughs' and the prize-fighters' pal:
 The mind of a groom
 And the head of a broom
Were Nature's endowments to Val.[13]

Drilling with the Artists' Rifles took place from 7 to 9a.m. and 4 to 7p.m. in the gardens of Burlington House; from 1868 the Volunteers met at the Arts Club in Hanover Square. Each volunteer was expected to put in eight drills a month of one hour, also to pay a membership fee of one guinea per annum. Not all were willing and they quickly gave up attending drill, others were simply incompetent. Morris was unable to tell his right from his left; Rossetti persistently queried orders. Hunt was notorious for losing the screws of his rifle during lock drill.[14] Even Leighton fell off his horse.[15]

Hunt became 'very diligent at rifle-drill'[16] in time for the Volunteer Review which took place in front of Queen Victoria in Hyde Park on 23 June 1860. The artists, in their smart grey and silver uniforms, their badges engraved with the motto 'Cum Marte Minerva' apparently caused particular excitement among the female spectators: '[a] pleasant murmur . . . fluttered through a standful of ladies when the Artists' Rifles went past: "There's Mr Leighton; there's Mr Millais!"'[17]

Sara Prinsep's excessive attentions did not prevent Watts exercising his passion for riding and hunting. His desire to experience 'action' was genuine enough: 'I wish I

were strong enough to go where deeds of heroism and daring are done, and privations suffered. The aspirations, even with the violence, of an heroic age would have suited me better.'[18] However, his body was barely able to bear the privations encountered sailing to Asia Minor in 1856 on an archaeological expedition. The ship's captain was scathing:

> [Watts] a man of talent and experience but so utterly broken down for fear of his health that he requires all the care and attention of a child: cannot eat this, must not eat that, is the cry with him all day and every day; requires cold baths half a dozen a day, warm water in bottles at his feet every night and such a man they send out to rough it on the coast of Asia Minor.[19]

Though physically weak, Watts frequently painted heroic figures in armour using himself, his first wife and his friends as models,[20] and had first painted a self-portrait in armour in Florence, while staying with the Hollands (fig. 5). Photographs taken in the 1850s show Watts posing in chain-mail and in monk-like garb, as if choosing between opposing roles: soldier or saint. For *The Eve of Peace* (1863) he again presented himself as a knight in armour, though no longer exhibiting the confidence apparent in the Florentine self-portrait: the spiritual depths of the true knight are revealed.

In Arthur Prinsep, Val's brother, Watts found a real soldier with the looks of a chivalrous knight. He used Arthur's head for four versions, painted over half a century, of Sir Galahad, the knight who was sufficiently pure to find the Holy Grail, only to die in ecstasy. The third version Watts presented to Eton College Chapel; a print was given to every boy leaving the school. Watts approved of his own ideal of manly purity being used in such a way: 'I recognize that from several points of view, art would be a most valuable auxiliary in teaching, and no where can lessons that may help form the character of youth of England be more important than in the great schools where statesmen, and soldiers, and leaders of thought receive their first impressions.'[21] Arthur's head is also used in *Aspirations* (1866–87) and for the Red Cross Knight in *Una and the Red Cross Knight* (1869).

Watts' strangest choice for a knight was his first wife Ellen Terry, who posed in armour in *Watchman, What of the Night?* (1864–5). In a letter he wrote to his neighbour Lady Constance Leslie, Watts explained that his intention in proposing marriage to Ellen was to rescue her from the stage. He was the chivalrous knight: the theatre was the dragon.

> Knowing how much you are interested in the Miss Terrys I am going to tell you a thing that will perhaps surprise you. I have determined to remove the youngest from the temptations and abominations of the Stage, give her an education and if she continues to have the affection she now feels for me, marry her. There is a great difference between her age and mine and I shall not think of putting any pressure upon her inclinations, but I think whatever the future brings, I can hardly regret taking the poor child out of her present life and fitting her for a better.

He was, as always, concerned about the opinion of others, and about the financial implications. His own snobbish view of the theatre is obvious:

> I hope in what I have undertaken to do, I shall have the countenance of my friends, for it is no light matter from any point of view. Even the expense will be considerable, for I shall have to compensate her family for the loss of her services. If you and any others, whose opinion may be valued, think well of my object, I would be very glad if you would tell Mrs Prinsep and her family, for you know the prejudice that is against the stage. (I have it myself). Miss

Terry is very young and I do not see the future at all distinctly but giving her a chance of qualifying herself for a good position in true society I do not think I ought to be thought ill of.[22]

The age difference was thirty years; Watts was forty-six, Ellen was sixteen at their marriage at St Barnabas', Kensington, in 1864 (see fig. 58). On hearing of the marriage, Watts' old friend Lady Duff-Gordon wrote in her diary: 'I never heard of any thing so silly in my whole life!!'[23] The 'rescue' was short-lived: Ellen returned to her parents in 1865 before going to live with the architect, Edward Godwin; she returned to the stage after having two children by Godwin. Painting acts of chivalry was not the same as performing such acts, even for members of the Artists' Rifles.[24]

As it happened, the Artists' Rifles saw no active service until 1900 when the architect Robert Edis, who became Colonel after Leighton, led the Corps into the Boer War. However, many of the artists were familiar with the effects of war through the experiences of their families and friends, experiences which informed their paintings as well as their efforts at soldiering. Though Britain was not invaded during the nineteenth century, the period, 'effectively launched and ended by major wars, was a militant, indeed military century';[25] its soldiers were involved in numerous wars, fighting in Africa, India, the Crimea and Afghanistan. Val Prinsep's brothers survived the Indian Mutiny of 1857; Leighton's sister Alexandra was also caught up in the fighting, trapped on her own in Aurangabad. She only just escaped with her life, saved by the intervention of Sheikh Borun Buhk; her husband Captain Sutherland Gordon Orr, suffering from dysentery, died the following year.[26]

Other members of the Little Holland House circle played significant roles in the Volunteer movement; some had also experienced active service. Thomas Hughes, founder with Frederick Denison Maurice and Charles Kingsley of the movement known as 'muscular Christianity', was also concerned with the founding of the Volunteers. He raised and commanded the Working Men's Corps (two companies) largely recruited from the Working Men's College in Red Lion Square where Ruskin, Rossetti, Burne-Jones and Ford Madox Brown had taught in the late 1850s.[27]

Lord Ranelagh was also involved, though he was better known to the artist volunteers as the lover of Annie Miller, Holman Hunt's model and the woman Hunt intended to marry. While Hunt was trying to learn his drill, he was considering threatening Ranelagh with exposure in the courts. The art critic F.G. Stephens was his go-between:

> if you find he [Ranelagh] is instigating her [Annie Miller] to make use of the letters to annoy me – do not hesitate, because black as he is he would rather dread having an account of his behaviour come out – as I should, he would know – rather damage him ever in the eyes of those who hold whore's honor as well as those with whom he is trying to get on with now by virtue of the Volunteer Movement.[28]

Hunt's efforts to educate Annie Miller to a level he deemed suitable for his wife proved unsuccessful; she used the opportunity to find a husband higher up the social scale than an artist, eventually marrying a cousin of Ranelagh.

The Honourable Percy Wyndham was a guest of the Prinseps from the early 1860s, commissioning portraits of himself and his wife Madeline from Leighton and Watts. He had seen active service with the Coldstream Guards before joining the Volunteers. He had joined the Guards straight from Eton and sailed, aged nineteen, to the Crimea as a lieutenant in the lst Battalion. After a gruelling couple of months in Bulgaria, he was fortunate to be invalided home; twelve officers out of the original thirty-five in

his battalion were killed or died of wounds or disease. Both of his sons were soldiers: George went to Egypt in 1885 with the Coldstream Guards; Guy was trapped in Ladysmith during the Boer War. Both were painted by Watts just before they were sent abroad on active service. Though Watts was no fighter, he knew how to address the mothers and fathers of soldiers. He wrote to Madeline on hearing that George had reached Egypt.

> As to Death, my friend Death! you know also what I feel about it, the great power always walks by my side with full consciousness on my part, inevitable but not terrible . . . even while you shrink, and are scared by possibilities you must feel through all, the nobility of your position, giving of your best for your country and helping, through the brave boy, to set the great example to future times . . . none of those out now in Egypt will be unknown or forgotten.[29]

Watts' friend Lord Elcho (they had met in Florence under Lord Holland's roof), was Lieutenant-Colonel of the London Scottish Regiment and a major force behind the Volunteer movement. 'In an age when material interests are too much with us, and the inspiration of the genius of the shop is more potent than that of the god of battles, Lord Elcho may claim to have discharged a function of the highest usefulness by acting as a depository and an embodiment of the latent forces of English militarism.'[30] Though Elcho experienced no active service himself, his son Alfred was to die in 1873 of fever caught in Africa during the Ashanti War; his son Franco died in a shooting accident during the 1870 meeting of the National Rifle Association on Wimbledon Common.

Elcho had a hand in the design of the uniform. 'The principle that guided me was simply this. A soldier is a man-hunter — neither more nor less; and as a deer-stalker chooses the least visible of colours, so ought the soldiers to be clad.'[31] Arthur Munby recorded Leighton as 'broad shouldered, golden bearded, in the newly chosen uniform of the corps; a french grey loose tunic, foraging cap, & trousers, without facings; & belts & gaiters of unblacked leather'.[32]

Elcho also helped to found the National Rifle Association in November 1859, to encourage the practice of rifle-shooting. He persuaded Watts to design a shield — the Elcho shield (fig. 32) — as the prize for an annual competition 'as an encouragement to international small-bore shooting, and also that my name might be perpetuated in connection with the Association and the Volunteers'.[33] Elcho wrote to Watts on 14 January 1860: 'I wish to leave the conception as well as the drawing of our shield entirely to yourself. . . . If you could let me have a rough sketch of your idea of a shield for us, by Thursday morning, as we have a Committee Meeting at twelve, I should feel grateful.'[34] He explained the creation of the shield later to Mary Watts:

> Your dear husband said to me, 'Let it be made in iron, and six feet high'. On this basis we worked, I suggesting the subjects, and he drawing them as they seemed fittest for the shield. The work was entrusted to Elkington, the silversmiths, and the execution was by them given to a Belgian or Frenchman – 'Mainfroid' by name; and when you think that it was *repoussé* out of a solid bit of iron plate, one's admiration is lost in wonder.[35]

The figures on the shield, but not the surrounding decoration, were drawn by Watts, who also suggested that the target known as 'the running man' become part of the Wimbledon programme for the National Rifle Association.[36] When Watts attended the Wimbledon manoeuvres, his appearance, which was hardly military, caused some

70

32. George Frederic Watts, Elcho shield. Private collection.

comment: 'He looked very splendid . . . his beard was worn long, was very silky, and was blown about in a fascinating fashion first over one shoulder and then the other.'[37]

Tennyson supplied a poem, published in *The Times* on 9 May 1859: 'Riflemen Form!'

> There is a sound of thunder afar,
> Storm in the South that darkens the day!
> Storm of battle and thunder of war!
> Well if it do not roll our way.
> Storm, Storm, Riflemen form!
> Ready, be ready against the storm!
> Riflemen, Riflemen, Riflemen form!

Elcho recalled the comradeship which was a feature of the manoeuvres on Wimbledon Common:

> our evening gaieties taking the form of a gathering of 'classes and masses'; soldiers, sailors, volunteers, police, and neighbouring civilians of all grades and cast meeting in good fellowship round the camp fire. . . . To these nightly picturesque festivities, the West End swells of London used to stream down, duchesses included, and I have seen a long string of carriages thus conveying them to our wild Common.[38]

Of all the artists, the most enthusiastic and diligent was Leighton. He became Captain in 1860, Major in 1870 and Lieutenant-Colonel in 1877. William Blake Richmond thought him 'a marvel, so thoroughly did he become a soldier-painter that he learnt his job *au fond* and was hard at the study of Battalion and Company Drill at

Wellington Barracks with the Guards at 5 o'clock on summer mornings'.[39] The sculptor Hamo Thornycroft, who joined later, recalled 'how efficiently he commanded the Volunteer Battalion in the Army Manoeuvres on Dartmoor in 1876, when for a fortnight of almost continuous rain on that wild moorland he kept us all happy and full of respect for him by his fine soldierly example'.[40]

Leighton's ability to command was obvious from his activities with the Artists' Rifles. The year after he became Lieutenant-Colonel he was elected President of the Royal Academy, and knighted.

When Leighton wrote on 12 December 1860 to tell his mother he had become Captain in the Artists' Rifles, he praised the skills of a fellow officer, Arthur Lewis:

> Lewis was at the same time made Captain of the 2nd – his election of course came before mine; he has done three times more for the Corps than I have or could have done . . . as a man of business, and a very clever one, he has entirely organised the bookkeeping department.[41]

Lewis was known already to Leighton, Watts and Prinsep. From about 1859 to 1867 he oganised an all-male, smoky, sometimes rowdy club, first in his rooms in Jermyn Street, then, from 1862 in Moray Lodge, his house on Campden Hill, just to the east of Holland House, where he welcomed artists, musicians, writers, even the Prince of Wales, for music and oysters. His entertainments complemented Leighton's more rarefied musical parties and Sara Prinsep's unashamed lion-hunting at Little Holland House, adding to the allure of Holland Park and Campden Hill. His own professional interests encouraged other wealthy industrialists, merchants and tradesmen to purchase houses in the area and he provided useful contacts for his young friend Arthur Lasenby Liberty, manager of Farmer and Rogers Oriental Warehouse in Regent Street and the future founder of Liberty's.[42] His 'rescue' of Kate Terry from the stage was altogether more successful an affair than Watts' attempt to save her sister Ellen.

Arthur James Lewis had worked in the family business, Lewis & Allenby of Conduit Street and Regent Street, 'By royal warrant silk mercers to Her Majesty Queen Victoria', since he was fifteen. Travelling through Europe with Mr Allenby, the firm's buyer, he learned to value laces and silks, fine velvets and brocades. He was also able to visit museums, old buildings and private galleries which, according to his daughter Kate Terry Gielgud, 'laid the foundations for his love of the arts'.[43]

Though unable to take up art professionally (he spent sixty years with Lewis & Allenby), Lewis attended Friday evening sketching classes at the Langham Chambers, making friends of artists who regarded him as 'an amateur of considerable and varied talent'.[44] He exhibited paintings at the Royal Academy, studied etching and founded the Junior Etching Club which met at the Langham Chambers between 1858 and 1860.[45]

Music was Lewis' other passion: after the disintegration of the Junior Etching Club, he invited fellow enthusiasts to join him on Saturday evenings during the winter months under the direction of Johnnie Foster, alto singer and Gentleman of the Chapel Royal. The amateur musicians called themselves the Jermyn Band;[46] after Lewis' move to Moray Lodge they became the Moray Minstrels. They sang part-songs, glees and madrigals.

The band consisted mostly of artists – friends Lewis made at the Langham

Chambers, but quickly joined, if contemporary memoirs are to be believed, by almost every male artist in London. There were artists associated with Little Holland House, including Watts, Prinsep, Millais, Hunt, Dicky Doyle and Leighton; also all the members of the St John's Wood Clique.[47] After the move to Campden Hill local artists called, including John 'Spanish' Phillip, John Callcott Horsley and Carlo Perugini. In 1865, when Frederick Walker sketched a gathering at Lewis', *Dear Arthur's Round Table*, he included himself, Joe Jopling, W.W. Fenn, Philip Calderon, Leighton, the architect Anthony Salvin, George D. Leslie, Tom Angell, Carl Haag, Michael Halliday, Frederic Sandys, Millais and Prinsep. Lewis wears a crown; Prinsep has won a considerable amount of money. The air is thick with clouds of cigar and pipe smoke.

Writers among the amateur musicians included Thackeray, Dickens, Trollope, George Augustus Sala, Edmund Yates, founder and editor of *The World*, and the *Punch* war correspondents Frank Burnaby and Archibald Forbes. Many other regulars were associated with *Punch*. Marion Spielmann refers to the 'jovial meetings' of the 'merry clan' in his history of *Punch*.[48] Henry Stacy Marks recalled meeting three *Punch* editors at Moray Lodge: Mark Lemon, Tom Taylor and Francis Burnand. 'The artistic staff was well represented by John Leech, with his sensitive and kindly face, by the evergreen John Tenniel, by [Charles] Keene, du Maurier and kindly Sambourne.'[49]

The worlds of *Punch* and Little Holland House might seem an unlikely combination. However, Lewis' musical evenings encouraged participation and also a male 'bonding' which appealed to Leighton, Prinsep and even, on occasion, to Watts. Many of the *Punch* regulars lived nearby, on Campden Hill and in other parts of Kensington. Linley Sambourne would move to a house in Stafford Terrace in 1874.

John Leech's last home was 7 The Terrace, 'a most perfect early Georgian house on the south side of Kensington High Street with its arched wrought iron gate, a paved fore Court, its white wooden pediment and pillared doorway'.[50] 'The garden was well nigh a country garden then, flycatchers and blackbirds used frequently to build there. . . . Indeed, under the weeping ash-tree, where the festive board was spread, all was so cosy and so quiet that you might have heard an "h" drop if a cockney had been present.'[51] He was invited to Little Holland House, and after his death in 1864 his pictures were sold to raise money for his widow. Works were bought by Leighton, Millais and Dickens.

Millais, Walker and Marks drew for *Punch*; even Leighton contributed a drawing of Dorothy Dene to illustrate 'The Schoolmaster Abroad' in 1886.[52] The heyday of the Moray Minstrels coincided with an explosion of quality illustrated magazines. Many of the guests were competing with one another for work not only in *Punch* but also in *Once a Week*, *Good Words*, *Household Words* and the *Cornhill*.[53] Under the editorship of Thackeray, the *Cornhill* serialised George Eliot's *Romola* with illustrations by Leighton.

Until Lewis married in 1867 his evenings appear to have been male-only; there is no record of any woman attending as a guest. The music began at 8.30 or 9p.m., a 'set programme of glees and part-songs performed by the Moray Minstrels'; oysters were served at 11p.m. 'After supper volunteers were invited to amuse the company', there were games of cards, smoking, sometimes charades, the artists dressing up as Old Master paintings.[54]

Usually someone drank too much. 'Marks is the great man at Lewis's this year; last time he got drunk and his humour was terrific.'[55] Smoking was indulged in 'ad libitum,

as one's eyes, hair, and clothes testified the next day'.[56] George du Maurier, loud in his praise of the bachelor life before he himself married, hailed Moray Lodge as a 'splendid bachelor's paradise. . . . All kinds of manly sports on the Sunday afternoon including claret cup & a jolly supper at eight, 20 fellows sat down to it last Sunday, and by Jove the number increased to 40 in no time.'[57] Lewis offered an alternative experience to the Artists' Rifles, intended for lovers of music rather than brothers in arms, though in fact the majority of members belonged to both 'clubs'.

The artists revealed different aspects of their characters on these bachelor occasions. W.W. Fenn confirmed Leighton's clubbable personality:

> Frederick [sic] Leighton was nearly always to be seen . . . laughing and enjoying himself to his heart's content, for, though he could not be said to display any great personal humour, he had the keenest sense of it in others, never failing to express his mirth with the utmost cordiality. We used to say that at Moray Lodge his appearances were like those of a beautiful meteor – in flashes, as it were.[58]

Frederick Walker was given particular help in his career by Lewis; he become a regular Moray Minstrel after he moved to Bayswater in 1863. He designed Lewis' annual invitation card, from 1865 to 1871 (fig. 33). These were elaborate productions: for 1866 'Minerva and Apollo, seated one on either side of a wreathed and massive pedestal, crowned by a shallow vase . . . etched on copper'; for 1867 'a group of musicians and dancers . . . similar to those on an old Etruscan vase'.[59]

Lewis provided Walker with a horse and took him out hunting; the artist was able to use Moray Lodge as the backgrounds to his work. Lewis also furthered Walker's professional career through introductions made in between the glees and madrigals. The art dealer Gambart, for example, met Walker at Lewis' and managed to persuade him to exhibit *Wayfarers* in his gallery rather than at the Royal Academy. 'I'd only got a short distance into the room at first, when Gambart *got at me* (that is the only way I can describe it), and with greeting most tender insisted upon coming to see me'.[60] Lewis also introduced Walker to William Graham, the Liberal MP for Glasgow, a major patron of Burne-Jones and Rossetti, and a trustee of the National Gallery: Graham bought *The Bathers*, *Vagrants* and *Lilies* and entertained Walker in Scotland.

Millais, a fellow volunteer, also shared a love of sport and of Scotland with Lewis, with whom he frequently went shooting. Lewis bought his painting of a soldier in the 42nd Highlanders, *News from Home* (1856); Millais found relief in games of billiards at Moray Lodge when forced to remain in London painting during the shooting season.[61]

In his novel *Trilby* (1894) Du Maurier suggests that Moray Lodge – Mechelen Lodge – was opulent. This was never true, even though the Prince of Wales occasionally called. Lewis entertained in the billiard room,

> the walls of which were decorated with trophies of arms, and coloured versions of sporting subjects by Leech which had appeared in *Punch* as plain woodcuts. The billiard-table, its surface duly protected by a substantial cover, held stores of pipes, cigars, jars of tobacco, and tankards and bottles of liquid refreshments.[62]

One of the last public appearance of the Moray Minstrels was on 29 July 1867, a benefit performance at the Theatre Royal, Manchester for the widow and children of the *Punch* artist Charles H. Bennett. The programme began with *Cox and Box; or, the Long-*

The Moray Minstrels. 1865

ARTHUR J. LEWIS.
AT HOME
MORAY LODGE, CAMPDEN HILL,
KENSINGTON.

SATURDAYS

January 28 | March 25
February 25 | April 29

MUSIC AT 8.30

OYSTERS AT 11.

33. Frederick Walker,
Moray Minstrels'
Invitation Card, 1865.

lost Brothers, a lyrical version of Maddison Morton's *Box and Cox*, written by Francis Burnand with original music by Arthur Sullivan. A photograph survives of the performers. Standing at the back is Arthur Lewis. Though he took no stage part, he was already courting Kate Terry, the elder sister of Ellen (who was only just separated but not yet divorced from Watts). Kate made her final London performance as Juliet on 31 August. On 5 October she appeared at the Prince's Theatre, Manchester as Marie de Fontangers in *Plot and Passion*. In the dressing-room after the performance, Lewis presented her with a gold bracelet inscribed on the outside 'To Kate Terry on her retirement from the stage, from him for whom she leaves it'.[63] She was twenty-three. They were married two weeks later, to the horror of Lewis' mother:

> it needed all Kate's art, her gentle simplicity and prettiness, the exercise of all the Terry charm, and her consent to retirement, to reconcile Jane Lewis, formidable autocrat as she had ever been, to the son who had won the heart of London's leading lady, and proposed to introduce an actress into the family – an actress only twenty-three years old, a slight girl with masses of brown hair, laughing grey eyes and fair skin, sensitive lips, a tip-tilted nose and the long line of chin characteristic of the Terry family. Arthur must have been bewitched, lamented Mrs Lewis to her daughters.[64]

Kate left the stage but she used her contacts and Lewis' wealth to entertain actors, actresses, artists and musicians, as well as some of the art collectors who were moving to the area. Moray Lodge was described by contemporaries in much the same way as Little Holland House:

> one of the few remaining rustic spots in the overbuilt distict between Kensington and

Notting Hill. It is well known in the London world . . . Mrs Lewis' popularity is in a great measure personal to herself. . . . Moray Lodge . . . a central gathering point where widely distinct circles meet on common ground.[65]

Meanwhile a very different salon was being established virtually next door, but led by an aristocratic woman, Blanche Ogilvy, Countess of Airlie, whose aim was to compete with Sara Prinsep.

6

Art and Society on Campden Hill

George Campbell, eighth Duke of Argyll, was the only notable peer apart from the Hollands, to live in the area in the 1850s.[1] He occupied Argyll Lodge, the largest and most lavish of the group of houses on Campden Hill built by John Tasker at the beginning of the century and known, after their illustrious residents, as 'The Dukeries'. It had been enlarged by Sir Jeffry Wyatville for the sixth Duke of Bedford in the 1820s (it was then known as Bedford Lodge); after the Duke's death his wife Georgiana engaged Landseer to help lay out the formal gardens. She had built a drawing-room lined with white and gold chestnut from a château in France,[2] and made Campden Hill 'the resort of the fashionable world'.[3]

The Duke of Argyll acquired the house after the death of the Dowager Duchess in 1853. A keen ornithologist, he was in search of seclusion rather than society:

> It was next to Holland House, and absolutely removed from all noise of traffic. We went to see it, and the first thing I saw out of the late Duke of Bedford's room, was a fine lawn covered with starlings. . . . To my amazement, I saw nut-hatches moving over the trees . . . *The birds settled everything.*[4]

The Duke and Duchess had seven sons and four daughters and maintained a large household in their London home even when they were absent. Their main country seat was Inverary Castle in Scotland. The census for 1861 recorded twenty-six servants at Argyll Lodge; in 1871 there were twenty-four, including the Duke's piper.

The Duke's interests were varied: bird-watching, poetry, religion, politics and science. He served in several Liberal governments, as Postmaster General and Secretary of State for India. A contemporary described his striking bearing:

> His hair was as vividly red as that of his namesake Rob Roy, and was brushed straight back and up from a truly intellectual brow. His manner suggested a combination of the Highland chief with the university Professor. . . . A quality not easily distinguished from arrogance showed itself in the Duke's social bearing. He never seemed to realize that his associates were in any sense his equals.[5]

Many of the guests at Argyll Lodge also attended Sara Prinsep's parties across the park at Little Holland House. Although there is no evidence that the Duke himself ever called on Sara, his portrait was painted by Watts in about 1860. He would have met Thoby Prinsep on a professional footing at the India Office.

The Duchess was less formidable and Holman Hunt recalled her visiting his studio at Tor Villa. She had 'in the most agreeable manner . . . called upon me, and taken a genuine interest in my work'.[6] In 1867, the young artist William Blake Richmond was

34. Thomas Babington Macaulay
seated in the Library of Holly
Lodge.

entertained by the Argylls at Inverary Castle, where he painted the Duke and two of his daughters. He also drew the eldest son John Douglas, Marquess of Lorne. After the marriage of Lorne to Queen Victoria's daughter Princess Louise, Richmond was given further introductions to royal circles.[7]

Tennyson first met the Argylls on Campden Hill while he was staying with the Prinseps in May 1857. The Poet Laureate was summoned to Argyll Lodge to read his poetry in the garden to the Duke and Duchess. A close friendship developed and the Argylls stayed annually with the Tennysons on the Isle of Wight, where the bird-watching was particularly good. Emily noted in her diary in June 1863: 'The Duke sees a Kestrel fly past with a bird & finds the nest of a golden crested wren in the Arbor Vitae.'[8]

The Argylls also admired the historian Thomas Babington Macaulay (fig. 34), himself a friend of Lord Holland, and in 1856 persuaded him to quit the Albany for Holly Lodge, Campden Hill.[9] It was next door to Argyll Lodge, with its own large mature gardens to which Macaulay was deeply attached: 'my little paradise of shrubs and turfs'.

> The sward was graced by two rare and beautiful variegated elms, a noble willow, and a mulberry tree . . . in abundance all that hollies, laurels, and hawthorns, and groves of standard roses, and bowers of lilacs and laburnums could give of shade, scent, and colour . . . [the lawn's] unbroken slope of verdure was worthy of the country house of a lord lieutenant.[10]

Macaulay received the news of his peerage at Holly Lodge on 28 August 1857, the same day he read of the massacre of British men, women and children at Cawnpore during the Indian Mutiny:

> I stayed at home, very sad about India . . . the news is heart-breaking. I went, very low, to dinner, and had hardly begun to eat when a messenger came with a letter from Palmerston. An offer of a peerage . . . God knows that the poor women at Delhi and Cawnpore are more in my thoughts than my coronet.[11]

Macaulay died in December 1859, after just three years' tenancy. The following year, Holly Lodge was acquired by the Earl of Airlie, as an appropriate London residence for his wife and growing family.

Blanche, Countess of Airlie had spent the early years of her marriage based in Scotland, at Cortachy Castle. She stayed with her parents on visits to London or rented accommodation. She moved to Holland Park with the intention of becoming better acquainted

with the artists and writers associated with Watts. Though her own patronage was limited, and she was eventually upstaged by her wealthier and more adventurous sister Rosalind Howard, she played an important part in introducing friends and family to the artists associated with Little Holland House, thereby assisting in the spread of aesthetic ideals among her class. She also contributed to the social cachet of Holland Park. This was at a time when many of her class shared the view of her mother about the neighbourhood: 'I am sorry Blanche should be such a long way off [on Campden Hill] but we shall be able to ride there'.[12]

She was a member of the formidable Stanley family, renowned for their sharp tongues and their assumption of moral and intellectual superiority.[13] Her parents were 'unalterably whiggish in politics'[14] and staunch supporters of Palmerston. The Stanley children were almost all notable individuals, in some cases flouting the traditions of their class and family.

Thackeray had known the Stanleys since he was a young man. Writing to congratulate Lady Stanley on the marriage of Blanche to Lord Airlie in 1851, he commented: 'I hope she will be as happy as a Queen: and I should much prefer her having a house within dinner-distance in London to a castle in Scotland however splendid or ancient.'[15] Cortachy in Angus was certainly not 'dinner-distance' from London and Blanche's ambitions as a hostess were constantly frustrated in Scotland. London, on the other hand, 'is never dull or empty'.[16]

Throughout the 1850s she cultivated the writers and artists whom she had met in her parents' homes: Carlyle, Thackeray and his daughters, Caroline Norton and Richard 'Dicky' Doyle. They enjoyed her hospitality at Cortachy as well as in London. Once established on Campden Hill, Blanche changed the name of her house to Airlie Lodge and began to give 'intellectual' breakfasts reminiscent of Macaulay's. Her sister Rosalind attended a breakfast in June 1863, accompanied by her brother Lyulph. She was enthralled by the company and the conversation:

> I got up at 9 to go to Holly Lodge for breakfast. Blanche had a charming party so very intellectual, that it was a real pleasure to listen. The prestige of Ld. Macaulay's breakfasts in that same house seems to have fallen upon her. There were the Grotes – Arthur Stanley – Jowett – Mme Mole – Sir Coutts Lindsay – Mr Arthur Russell – Lord Dufferin, Lyulph & myself. We sat an hour at breakfast & heard a good deal about Speake's [sic] discovery of the source of the Nile – Then we sat in the garden till 1 o'clock so pleasantly did they all beguile the time with their learned & agreeable talk.

The contrast to 'society' was clear enough to Rosalind. 'Lyulph & I walked home through Rotten Row & dreadfully hot it was, all the world was there as usual dressed very smart & I felt how inferior such society was to the company of the philosophers & learned men whom we had just left if only one could be worthy ever to belong to their set even as a humble listener.'[17] Rosalind, like Macaulay, appreciated a garden 'where one can sit out & read [: it] gives repose & calm to the mind.'[18]

Blanche had asked Watts to paint her husband before she moved to Campden Hill. He finally agreed in 1863: 'I have a sort of recollection that you once asked me to paint a head of Lord Airlie & that I put off the question on the score that I wanted all my time for large pictures'. Claiming to be concerned that Blanche might think his behaviour 'very bad' because he had been 'worried into doing' other portraits, he declared he was all hers:

I want to tell you that I will paint Lord Airlie for you whenever, or if ever you wish it, I am not afraid you will think I am asking for the commission, but think you will understand my object in writing, which is simply to give you a right to claim my service, at any time no matter what I may be doing.[19]

Watts eventually painted Blanche as well as her husband. The portraits were completed in 1866. The lengthy process of persuasion and negotiation, then of sittings at Little Holland House allowed Blanche to become even closer to Watts and on friendly terms with the Prinseps and their guests. Watts, Sara Prinsep and Carlyle all visited Blanche after the birth of her children at Airlie Lodge. ('I had a visit yesterday from Mr Carlyle to my surprise. He came to see the baby [eleven days old] & seemed quite unacquainted with creatures of that size.'[20]) Letters were exchanged concerning the health of Watts and Mrs Prinsep. Blanche was one of the first to be invited by Sara to visit Prinsep in his new home.

Blanche also visited nearby artists' studios, including Hunt's on Campden Hill and Leighton's in Orme Square. She praised Leighton's work, after a studio visit in April 1861, as 'most beautiful & original';[21] presumably this was *Lieder ohne Worte*, generally admired in the studio but badly hung at the Royal Academy. It was Leighton's first 'aesthetic' painting and Blanche revealed herself as a strong supporter of 'advanced' contemporary art.

Leighton introduced Blanche to Adelaide Sartoris, and invitations to Hampshire followed. The first appears to have been on 30 March 1864; during a visit on 3 August, Adelaide was 'singing most beautifully'. In June 1866 Blanche was enjoying 'much pleasant quiet talk' in the company of Adelaide, Leighton and Madeline Wyndham. 'Mrs Sartoris read Medusa – it is so beautiful & she reads so well.'[22] Blanche reciprocated by asking a friend of Adelaide's to one of her garden parties: Mme de Murrieta, 'a *good* little woman, & quite inexpressibly dear to me'.[23] The Murrietas were wealthy Spanish merchants, with houses in Kensington Palace Gardens, Phillimore Gardens and Pembridge Square. They became patrons of Walter Crane and Alfred Stevens.

A visit to Scotland by Leighton, the Sartorises and Val Prinsep in September 1869 was less successful, at least from Blanche's point of view. They stayed at Glen Isla, Lord Airlie's shooting estate.

Mr Leighton shot a very good stag on the 23rd – Mr Sartoris has missed a good deal & is a trial for poor Airlie to have bad shots & yet when the Sartorises were as near as Meikleour [in Perthshire] it was impossible not to ask [them] after all the civility they have shown us. Mrs Sartoris thinks Blanches voice very promising & of unusual extent & she has given her two lessons. [Two days later] Mr Leighton has made one sketch in oils but nothing very beautiful. May Sartoris [her daughter] sketches nicely & I copied a sketch of Mr Leightons in a way to please him . . . Mrs Sartoris stories which she tells are very interesting. Her singing too is still very pleasant in a room. Mr Leighton is not very agreeable & Mr Sartoris is very silent so we are glad they have been all day on the hills.[24]

According to Prinsep, Leighton was no sportsman. On a visit to the Lindsays at Balcarres he 'went through with a partridge shooting party . . . without betraying to the gillies and his fellow-guests his utter ignorance of the sport'.[25] The stag he shot at Glen Isla obviously provided him with a larger target.

Blanche believed her most important artistic relationship to be with Watts. He made her feel special, unique, even though as far as he was concerned she was just one of

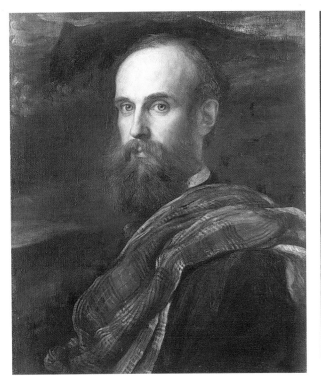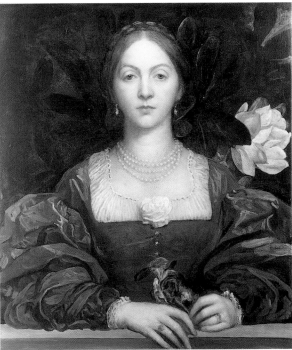

several aristocratic ladies with whom he exchanged views, sometimes over decades, on matters spiritual and temporal. They visited one another in London (though never as much as she wished) and exchanged letters until his death in 1904. The continuity in their friendship probably added to Blanche's status among Watts' admirers; it also reflected her particular taste in art. Lord Airlie, painted by Watts, was, in her eyes, much more than a portrait (fig. 35):

> I have brought Airlie's picture, it is a pleasure to both Clementine [her daughter] & myself – No one knows what a wonderful work of art it is, who has not lived with it. It is so noble & grand & pure & deep all these things so much mystery besides in the wild background. It is like a knight as you say, not a gentleman of the 19th century – & Airlie's qualities are not of this age.[26]

She carefully pasted a letter from Watts on to the back:

> I have finished the picture & got the Frame. You shall have it today if you send me word that you so wish. . . . I hope you will like it. . . . The picture must be hung if possible opposite some dark object or wall as the glass reflects light things to the destruction of the general effect.[27]

Watts was at first dissatisfied with her portrait; he added hands, then graciously refused additional payment. The Airlies were left in no doubt that they had acquired a significant work of art (fig. 36):

> I put in the hands for the benefit of the picture & consequently for my own advantage, so that an additional charge for them is out of the question. . . . I would not if I could help it take a farthing for any thing I can do in the way of Art, feeling that if Art is really great it is

35. (above, left) George Frederic Watts, *David Ogilvy, Earl of Airlie*, 1865–6. Private collection.

36. (above, right) George Frederic Watts, *Blanche Ogilvy, Countess of Airlie*, 1865–6. Private collection.

priceless & if not; that it is worth nothing. As I have no independent means I am obliged to sell my work, but I do not sell my love of Art & if the picture had grown into a whole length through my striving to realise my own objects I could only have taken from you the price of the picture ordered which is 150 gns. The payment I shall most value will be approval.[28]

One hundred and fifty guineas was indeed a low figure. Perhaps in this instance Watts wanted to paint Blanche. Certainly her portrait has a strange enigmatic quality. She added a note of her own to Watts' letter: 'He was so fond & proud of the picture – & when it was hung up at Airlie Lodge Kensington Gladstone said it was the finest woman's portrait in this century.'[29] Blanche was always susceptible to flattery; on the other hand she was mortified when she learned, usually from her sister Rosalind, that she had been criticised by artists she considered her friends (William Morris, for example, thought her a snob).

Watts never ventured north to Cortachy – 'What should I do in the Halls of dazzling light?'[30] – and was often prevented by illness, real and diplomatic, from calling at Airlie Lodge, just half a mile away:

it continues to be so hopelessly wet & chilly that I am afraid to go out to day having some return of a throat infection which I have been suffering from a good deal lately, when I get cold it is such a very serious matter that I hope you will let me defer the pleasure I looked forward to.[31]

Time and again he chose to plead ill health as an excuse rather than claim too much work, though the latter was often the reason for his need to remain in his studio.

However, sufficient contact was maintained between Little Holland House and Airlie Lodge for Watts to know exactly what hung on Blanche's walls; also the identity of her influential friends. In 1871, expressing a wish to paint Disraeli for his Hall of Fame, he appealed to Blanche for an introduction. Disraeli was too busy to get to Little Holland House in July,[32] but wrote to Watts in December: 'If, indeed, I ever find a tranquil hour, & you might deign to think me not unworthy of your pencil, I should be proud, & just-ly proud, of sitting to the greatest Master of our School; & whose genius I have ever admired.'[33] The project dragged on, with Blanche acting as go-between. Either Disraeli was too busy or Watts postponed sittings. Watts wrote to her on 1 January 1875: 'If when you are in town you do see Lord Beaconsfield please tell him that I did wish to paint & indeed do wish to paint him, it cannot be doubted he will stand a conspicuous figure in history.'[34] The painting never materialised: Millais produced the definitive portrait.

For Blanche, the pleasure of being specially noticed and apparently needed by Watts – she described him as Dante – was intense. He suggested her children come to Little Holland House to ride on his old mare, 'she is so good & safe';[35] he borrowed her daughters as models;[36] he wrote to her letters full of self-pity and fear: 'From the moment I found that nothing I could do or be could touch the highest, work & life lost all delight & value, & now I know that the new year must be like the old, & many old ones, what is the use of filling up space in it?'[37] Believing herself 'privy' to his thoughts she was always ready to respond, to support and comfort.[38]

She shared him with Lady Holland, Georgiana Duff-Gordon, Jeannie Nassau Senior, Madeline Wyndham, and with Constance, Marchioness of Lothian and her sisters Adelaide and Gertrude Talbot. Unlike his disastrous few months with Ellen Terry, Watts' relations with all of these ladies appear to have been constant, even intimate, but never sexually threatening. The intimacy remained confined to the studio; the physical side

expressed only in the movement of Watts' paintbrush over the canvas as he created their portraits. The commercial aspects of such portrait commissions were usually handled by their husbands.

Not all women who enjoyed the hospitality offered at Little Holland House were susceptible to Watts' peculiar charm; Blanche's sister Rosalind preferred Burne-Jones and, even more, his wife Georgiana.

Rosalind appreciated visits to Airlie Lodge before she 'came out' in 1863, though her mother, Lady Stanley was less enthusiastic: 'Mamma grudges & counts my visits to you.'[39] Blanche, as her elder sister, offered more freedom than was permissible in Dover Street, there was a large garden, young nephews and nieces to play with, as well as 'intellectual breakfasts'.

She met the Honourable George Howard, her brother Algernon's 'Cambridge friend' on a visit to Oxford, writing in her diary for 16 June 1863, 'He knows a good deal about architecture, so he was a pleasant companion in the cathedral & at the time the study seemed to me so interesting that I determined to take up architecture.'[40] The young couple were struck by the beauty of a stained-glass window in Christ Church Cathedral: St Frideswide, designed by Burne-Jones. The artist and his wife Georgiana would become their closest friends. However, it was through Blanche, living on Campden Hill, that they first became acquainted with a large number of artists and writers, all members of the art world associated with Little Holland House.

In July 1864, just before they were married, Blanche gave a dinner for them which included Watts' friends Lord and Lady Elcho, the Grosvenors (Hugh Grosvenor, to become the first Duke of Westminster, was living at the time in Kensington), and Holman Hunt. When they returned from their honeymoon early in 1865, though living with George's grandparents in Mayfair, they made almost daily visits to Kensington, lunching with Blanche, calling at Little Holland House to meet Watts and the Prinseps; visiting Leighton, Hunt, Millais, Coutts Lindsay, Burne-Jones, Frederick Burton and John 'Spanish' Phillip. Watts, with surprising energy, completed a portrait of Howard in just two months (March to May 1865, thus delaying Blanche's portrait). At the same time Leighton had agreed to paint Rosalind.

Visits further afield were to artists Blanche already knew: Rossetti in Chelsea; Prinsep, who kept a studio in the Mall, Kensington, while his house was being built; the sculptor Thomas Woolner, a favourite of Sara Prinsep's, in Marylebone. Blanche had confused Woolner by sending him live doves rather than the usual dead game: 'a thousand thanks for the doves, which I shall prize as much as doves can be prized; secondly I want to know all the kinds of food I ought to give them? I am afraid of giving them anything that might injure such delicate constitutions.'[41]

The Howards also called on Blanche's neighbours. The Duchess of Argyll was a cousin of George's; so was Charles Manners, sixth Duke of Rutland, a bachelor, who had acquired Bute House on Campden Hill in 1864. The Airlies and the Argylls were not on friendly terms, however. Their families – the Ogilvies and the Campbells – had been at war for centuries. Airlie Castle had been burnt down by the Campbells. The Duke of Argyll's piper was apparently encouraged to play in the grounds of Argyll Lodge when Lord Airlie was at home (presumably playing 'The Campbells Are Coming').

Though heir 'to all the Howard honours in the direct line',[42] including the earldom

of Carlisle, Naworth Castle, Castle Howard, and nearly 79,000 acres, Howard's only ambition was to be an artist. Rosalind expressed her doubts before they were married.

> Mr H. said he wished to become an artist & study in good earnest giving himself up to it; but that his family strongly objected & wished him to go into Parlt. having a prejudice against artists. He says he should be lazy in any other profession & that drawing alone would make him energetic. I don't like the idea at all.[43]

Her doubts surfaced, periodically, throughout their marriage; his situation possibly provided a model for Nick Dormer, hero of Henry James' novel *The Tragic Muse*. James and Howard became acquainted in 1877; *The Tragic Muse* was published in 1890.

The Howards' combined annual income was between £2,000 and £3,000 until the deaths, in quick succession, of Howard's father in 1879 and his uncle Lord Lanerton in 1880. In a letter to Blanche, thanking her for her wedding gift (a tea caddy), Howard revealed their plans to acquire a house in Kensington, though not before 1866:

> Rosalind & I think if we can of going abroad next winter [1865–6], so we should only get a house for the year this next summer, as it would be hardly worth while to settle for so short a time. I suppose that the houses about Kensington wd hardly be let for so short a time so I fear we shall not be neighbours till 66 but I do not give up.[44]

During the spring and autumn of 1865, while Howard was studying at the South Kensington School of Design, the young couple visited exhibitions, called on artists and sat for their portraits. Prinsep took Howard to meet Burne-Jones in his studio; then the Howards called together on the Burne-Joneses at 41 Kensington Square. According to Georgiana Burne-Jones, Mr Howard's gift as a painter of romantic landscape made him welcome in the studio at once, while [we] the two wives drew more slowly, but quite steadily together'.[45]

In June 1866, the Howards began house-hunting in earnest. They made an early call on Prinsep in his new studio-house; Leighton's house was also almost completed. By comparison all the other houses available to buy were not good enough: part of Little Campden House; Thornwood Lodge, next door to Blanche (to be taken by Sir John Fowler the railway engineer the following year); a house in Queensberry Place, Cromwell Road, too much at £6,500; Stoke Lodge in Queen's Gate Gardens – they were 'not pleased with it'. At the same time, Howard fitted in the life class at Heatherley's School of Art; drawing lessons with Burne-Jones and Watts; oil painting lessons with Edward Wild, an artist they met in Italy, and then with Alphonse Legros (fourteen guineas for fourteen lessons).

On 27 October Rosalind noted in her diary 'think about building a house'; on 8 November they called at 'Morris & Webbs furniture place in Queen Sq'; on 27 November they both went back to look at Prinsep's house and the same day inspected a site for building on Palace Green next to Thackeray's old house. Howard immediately called on Philip Webb. Two days later all three met on the plot to discuss the design of a house appropriate for both an aristocrat and an artist. Georgiana Burne-Jones was meanwhile being kept on tenterhooks; on 30 November she wrote to Rosalind: 'I am very anxious to hear about your castle building and so glad you like Mr Webb'.[46] By May the following year, the Howards had sold some stock, bought the plot (for £3,000),[47] finalised plans with Webb and received his estimate, at this stage about £7,000.

The Howards' decision to settle in Kensington not far from the Airlies had implications for the artists who were their neighbours, and for the artists whom they patronised; they reinforced the allure of the area for the discerning members of their class. For Blanche, however, the competition from the Howards was sometimes hard to bear. Though they were limited financially in the first years of their marriage,[48] they shared a love of contemporary art; at least to begin with Rosalind supported her husband's ambitions both as an artist and as a patron. Even before they were established in Palace Green, they were introducing artists to Blanche, rather than the other way round.

Letters between Blanche, Rosalind and their mother record the rivalry of the sisters, sometimes almost fighting over the attentions of their favoured artists. With an artist for a husband, Rosalind could always claim superior and more intimate knowledge of the art world. Blanche's husband preferred the company of animals. His first great passion, gambling on horses, had been replaced, by the mid-1860s, with an enthusiasm for cattle and the challenge of breeding Aberdeen Angus in the United States. He made his first trip to Colorado in 1866, buying land and eventually establishing the Prairie Land and Cattle Company. Apart from agreeing (or not) to pay for Blanche's purchases, he appears to have shown an interest in contemporary art on only two occasions.

He was possibly involved in selecting the society portraitist Henry Weigall to paint full-length portraits of Blanche and himself, before Watts completed his commission.[49] He was also persuaded by Howard to buy a work from Legros, but only because he wanted one of Howard's paintings. Early in 1868 Howard completed *The Lady of Airlie* (fig. 37), a historical reconstruction of an event in the Ogilvy past. Lord Airlie wrote to Howard:

> I went yesterday with Blanche to see your picture at Mr Le Gros [sic]. I think it very good indeed & should like much to buy it if you will let me know what price you are putting on it. Of course it is of more interest to me than to any one else & I should not like to lose it. . . . It will be a great disappointment to both of us if we do not get the picture.[50]

37. George Howard, *The Lady of Airlie*, 1868. Private collection.

38. Alphonse Legros, *Church Interior*, c. 1868. Private collection.

The following day, Howard called at Airlie Lodge, according to Rosalind, 'to say he will sell him his picture if Airlie will order a picture fr. Legros of £100. G. gets £35 for his. He would not ask more.'[51] Airlie agreed, thus obtaining one of the more unusual pictures in his collection (fig. 38).

Blanche's introduction to Edward Poynter was through the Howards. She commissioned a portrait of her own daughter soon after Poynter painted Georgiana Burne-Jones for Rosalind (Poynter also painted Howard's grandmother). She sought advice from her sister about the correct fee: '*Do you think £60 is what we owe him, guineas or pounds?* I think it was what you said. Will you tell me soon, as the picture is finished & I wd like to have it sent home.' Rosalind's reply was curt: 'I can't tell you anything about the price of Poynter's picture – You had better ask him yourself.'[52]

Walter Crane was also approached by Blanche through the Howards. She had presumably seen their purchase, *Hunting Moon*, and wanted a pen and ink drawing of the Pincio, Rome. When Crane appeared to her to be working rather slowly, George reprimanded her: 'If you want to hurry him you had better write yourself. But a highly finished pen drawing price £10 can not be turned out in a day or two by machinery. I shall be delighted to have the drawing if you do not like it.'[53]

Blanche did provide a useful introduction when, in 1875, she took Arthur Balfour to Burne-Jones' studio, independently of the Howards, who regarded Burne-Jones as their particular friend. Balfour had been responsible for a large personal fortune and the Whittingehame estate in Scotland from the age of twenty-one; in 1874 he became

The Holland Park Circle

a Conservative member of Parliament and acquired 4 Carlton Gardens. Blanche, attending a dinner at his London house, found him 'so charming & clever & good'.[54] His visit to Burne-Jones resulted in a commission to ornament his music room. The artist quickly wrote to Howard:

> I have just had a commission I shall like from a young man named Balfour, whom Lady Airlie brought – and he wants pictures to go round a room, some story or another which will be very pleasant work – he is a very delightful and amiable and so young that it is painful – I dined there one day, there were eight at table I think, & I was so much older than anyone that I well might have been their father . . . if you were here we could go and potter over the room and settle what to do – but you are away.[55]

Georgiana noted that 'the subject of the Perseus story was soon agreed upon, and much of the year went in arranging a scheme and making studies for the different pictures'.[56]

The limitation of Blanche's patronage, particularly in comparison with the Howards', is most apparent in her relations with Philip Webb. He was invited to Cortachy Castle in August 1868 to discuss redesigning the library by opening up an adjoining turret. Once in Scotland, however, Webb was presented with the possibility of building the Airlies a brand new castle. Blanche wrote, excitedly, to her mother on 6 August: 'He went over to Airlie Castle yesterday & he thinks the site magnificent and wd like to build – Airlie is bitten with his enthusiasm the result is we are to wait till we know about money before we fix on anything.'[57] Airlie Castle is about fifteen miles from Cortachy: it consisted (and still does) of a late Georgian house attached to the ancient castle which had been burnt by the Campbells in 1640. Cortachy Castle consisted of an older part with a Gothic wing. Webb considered two options – to build at Airlie or at Cortachy – while Blanche explained to Rosalind:

> We have come to no conclusion as to where we build & the doubt is distracting . . . the last idea is having a complete plan of Airlie Castle made & building a portion. The expenses will be very great then, but he [Webb] says it wd be splendid & there is plenty of room on the plateau for a castle. If he build here [at Cortachy] he wished to pull down all except the two towers & the real old building – Airlie is not unwilling to build at Airlie, but we are to take 3 months to consider & then decide . . . Airlie gets on well with him. I think he wd make a fine simple & grand building at Airlie. The stone is of a pleasant colour & he wd respect the old walls building from there inwards.[58]

Webb's letter to the Howards was more careful:

> I found matters in a very uncertain state at Cortachy and I did my best to search into all the propositions and to arrange them plainly before Ld & Lady Airlie for their care-ful consideration – There is nothing worth saving at Cortachy except the original block wh is good and should in no way be seriously altered . . . Airlie is a very fine and enviably Scotch site but would require a large sum to properly build upon.[59]

Webb's work on the library was completed, but his provisional estimates for rebuild-ing Cortachy (£15,000 to £20,000) and at Airlie (£50,000) horrified Lord Airlie. A second set of plans for Cortachy was produced in November 1869 but the estimate had risen to some £40,000. Airlie wrote to Howard enquiring about Webb's record at Palace Green, only to receive a passionate defence of the architect. An attempt was made by the Airlies to reduce the work and the cost to under £25,000 but Webb was

unable or unwilling to agree. When Rosalind saw him on 9 December 1869 he 'looked terribly ill & wretched – I went to Mama afterwards & she said Airlie had thrown up Webb's plans for Cortachy altogether & was to pay him £900.'[60] He destroyed the designs.

Webb may have recommended to the Airlies David Bryce, an architect practising in Scotland. He built a more modest wing at Cortachy. When it was completed, Blanche wrote to Rosalind, 'I wonder if you will like anything in this house. It is so different to what you have done & full of faults which I see tho I do not talk about them.'[61] She might have gained solace if she had been able to read Henry James' notebook entry for December 1881 when he visited her at Cortachy:

Perhaps what struck me as much as anything was my drive, in the gloaming, over from Kirriemuir to Cortachy; though, taking the road afterward by daylight, I saw it was commonplace. In the late Scotch twilight, and the keen air, it was romantic; at least it was romantic to ford the river at the entrance to Cortachy, to drive through the dim avenues and up to the great lighted pile of the castle, where Lady A., hearing my wheels on the gravel (I was late) put her handsome head from a window in the clock-tower, asked if it was I, and wished me a bonny good-evening. I was in a Waverley novel.[62]

7

Howard, Webb and 1 Palace Green

'No more exceptional or attractive young couple gathered about them in those days a more varied company of talents and distinctions whether in art, literature or politics.'[1] Thus Sidney Colvin described George and Rosalind Howard (fig. 39). Theirs was a twenty-five-year partnership of art appreciation and collecting, which ended only with the breakdown of their marriage in the late 1880s.

Though 1 Palace Green was built for the heir to an earldom, Howard's involvement in contemporary art, as both painter and patron, determined its appearance inside and out. In November 1867, his painting *Emilia* was hung at the Dudley Gallery. The Dudley had held its first spring watercolour exhibition in 1865; it was a 'welcome exhibiting space for amateurs who were not members of either of the well-established water colour societies, or known at the Royal Academy'.[2] When *Emilia* was sold (for a modest £25), Howard was in a position to give the money 'to the distress in East London',[3] but Rosalind also noted the significance of the Dudley's recognition (Poynter was on the selection committee, also Tom Taylor) and the sale. She commented, 'I am glad G. has sold Emilia & now he is no longer a mere amateur, for better or worse he has taken his stand amongst the artists'.[4]

The desire of both Howard and Webb to create a modern house which challenged the conventions of the day was tested, even before the foundations were dug, in a battle between Webb and the Commissioners of Woods and Forests. The Commissioners were bitterly opposed to Webb's plan for the red-brick house. (Howard described the Commissioner Sir Charles Gore to his sister-in-law Blanche as 'a man devoid of taste in art'.[5]) Webb's design was completely different to the conservative red-brick Queen Anne style mansion which they had allowed Thackeray to build. They were supported by the establishment architects Thomas Henry Wyatt and Anthony Salvin whom they appointed to report on the proposal.

Though Webb explained to Howard, 'I had endeavoured to keep the artistic impression of the Palace neighbourhood always in mind subject always to the necessity of a modern difference',[6] neither the Commissioners nor their architectural advisers agreed. Sir James Pennethorne found the house 'far inferior to any one on the Estate – it would look most common place – and in my opinion [would] be perfectly hideous'.[7] Just about everything was wrong with the tall, severe-looking four-floored house.

> We are unable to discover what style or period of architecture Mr Webb has sought to adopt. We think the combination of square, circular and segmental forms for the windows and pointed arches for the doors and recesses, unusual and objectionable. . . . We think the pilasters on the upper storey and on the chimney stacks rising from a projecting string course

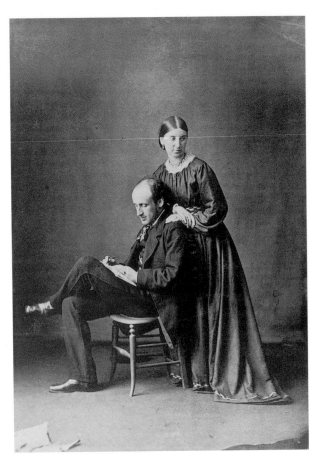

39. George and Rosalind
Howard.

are not satisfactory. They are thin and poor. . . . We regret the necessity . . . of so large a mass
of brickwork without any relief of colour or stone work on its surface.

Webb was forced to defend his professional standing as an architect as well as his
design and the materials he proposed using:

it is not customary for an architect to be forced to explain to a gentleman of the same pro-
fession what he may consider to be the merits of his own work. . . . A well chosen full
coloured red brick, with pure bright red gauged brick mouldings, arches, string courses, cor-
nices &c with the addition of white Portland stone, white sash frames, lead, and grey slates
are in my opinion the very best and most harmoniously coloured materials . . . more espe-
cially in a neighbourhood so happily full of green foliage.

Webb also attacked the 'disgraceful heterogeneous forms and colours' of the houses
which the Commissioners had permitted to be built in Palace Gardens.

I must express my great surprise that you should consider it worthwhile to hinder the erec-
tion of a building which – whatever may be its demerits – possesses some character and orig-
inality, tempered most certainly with reverential attention to the works of acknowledged
masters of the art of architecture and as certainly formed with a wish to avoid adding anoth-
er insult to this irreparably injured neighbourhood.[8]

The Holland Park Circle

The Commissioners relented only after many months of wrangling, Webb finally agreeing to redesign the gable, add more Portland stone dressings and replace the parapet with a cornice. Work began in June 1868, the estimate having risen to £8,806.

Close to Kensington Palace, commissioned by a young aristocratic couple, towering above the neighbouring houses, 1 Palace Green was bound to attract attention (fig. 40).[9] The use of red brick alone contributed to the increasing popularity of the material for town houses and to the reaction against Italianate stucco. It also contributed, together with the red-brick houses of Thackeray and Prinsep, to a wider movement, the development of the new so-called 'Queen Anne style' described by Mark Girouard:

> 'Queen Anne' came with red brick and white-painted sash windows, with curly pedimented gables and delicate brick panels of sunflowers, swags, or cherubs, with small window panes, steep roofs, and curving bay windows, with wooden balconies and little fancy oriels jutting out where one would least expect them. It was a kind of architectural cocktail, with a little genuine Queen Anne in it, a little Dutch, a little Flemish, a squeeze of Robert Adam, a generous dash of Wren, and a touch of François Ier.[10]

It was a style which would dominate the artists' houses to be built in Melbury Road in the 1870s.

W.R. Lethaby, Webb's enthusiastic pupil, described his master's work at 1 Palace Green as exhibiting 'design at once sane and ornamental, the house astonishes me. In our modern way of work nothing so good is to be expected again, for we are not likely to get another man of Webb's power working with his intensity of conviction.'[11]

The site was occupied by an old grace-and-favour house which had to be demolished. Georgiana Burne-Jones wrote to Rosalind on 5 July 1868 that she was 'glad to

40. 1 Palace Green, designed by Philip Webb.

see the old house on your piece of ground quite gone – may we soon see its successor'.[12] By December the new house had reached the ground floor. The Howards sold more of their investments to pay for the building in February 1869; on 5 March Rosalind 'climbed up a ladder to the 2nd floor. It looks quite enchanting – such a charming view from the drawing room of Kensington Palace.'[13] The following month she had an argument with Webb about the window frames 'wch I am not yet converted into liking rather than plate glass'.[14]

On 24 November the Howards were able to show some of their artist friends over all of the house: 'Rossetti admired the house very much'.[15] In December 1869 Howard wrote to his father: 'The house is well on and dry, ready to receive our goods now and us at Christmas. We go there this afternoon to meet Webb and settle about various details – and the painting of the woodwork.'[16] They could begin to entertain the following year.

The Howards began to acquire paintings and drawings while 1 Palace Green was still on Webb's drawing-board, always from artists whom they knew. The final internal appearance of the house not only reflected their taste but also revealed the friendships which they developed with artists over the period of time it was being built. While living in Kensington, the Howards' circle quickly extended beyond the artists and writers they had first met at Little Holland House. Howard's determination to be accepted as a professional artist was taken seriously by the friends who gave him lessons and encouragement. He would have hoped those who regularly attended his 'bachelor' parties – Burne-Jones, Morris, Rossetti, Poynter, Crane, Boyce, Leighton, Legros, Prinsep, Armstrong, Spencer Stanhope – regarded him as their equal rather than their patron.

At the same time, he and Rosalind frequently invited a slightly different list which included women: Browning and his sister Sariana, Matthew Arnold and his wife, Anne Thackeray Ritchie and her husband, Hunt and his second wife. They became particularly close to the Burne-Joneses and, to a slightly lesser degree, the Morrises and the Poynters.

Rosalind did not care for Janey Morris on their first meeting in January 1868: 'she has a fine head with remarkable eyes but is an invalid & seems uninteresting & does not talk enthusiastically on any of Morris' topics of interest'.[17] Further acquaintance revealed to Rosalind the difficulties within the Morrises' marriage, and the tortured relationship between Janey and Rossetti. The Howards entertained Morris, Burne-Jones and their families (also Leighton) at Naworth Castle in Cumbria (the first occasion in 1874), which was available for their use before they inherited it in 1880; Janey and her daughters also stayed at their villa in Italy.

Entries in Rosalind's diary and letters to both her and Howard reveal how much the artists, their wives and children were involved in each other's lives. Rosalind's domain centres on the artists' wives and children: a day in December 1867 is typical. While Howard takes his oil-painting lesson with Legros, Rosalind takes Agnes Poynter for a drive, returns to collect her husband and carries both to the Burne-Joneses in Fulham. Then the Poynters and the Burne-Joneses are whisked away to Legros' studio, where they together proceed to look at 'all G's & Legros' pictures'. A New Year's Eve party at Palace Green, in 1875, brings together Rosalind's mother, brothers, sisters, nephews and nieces with the families of the Burne-Joneses, Poynters, Cranes and Morrises, also Rudyard Kipling, nephew of Georgiana Burne-Jones and Agnes Poynter.

When the Howards were away on their annual visits to Italy, their artist friends kept them informed as to their activities in London. A letter from Burne-Jones, written to Howard in about 1878, is typical:

> This is Sunday – to breakfast came Morris, fresh from the laurels of a successful lecture last night, then came Crane & then [Sidney] Colvin and then to lunch the 2 Grosvenors [Dick and Norman] & [Lord] Stanhope & Balfour, & in the aftn they and many new callers made a garden party, then I went to see Crane's picture – a really beautiful one & full of delight and one I could praise so naturally & fully. . . . [Spencer] Stanhope has been ill for a week & cant send his picture . . . Watts' horse's legs are off [his sculpture], & the body cut in two to be made grander – Leighton has been very pretty to me about sending to Paris (but he! wicked in heart & longs for blood & war & sings Rule Britannia).[18]

When Rosalind visited the studio of Edwin Long (who had painted her portrait before she was married) and Millais in April 1868 she was quite clear about the sort of art she valued:

> It is unfortunate that english artists [i.e. Long] waste so much work & fair ability by choosing wrong subjects. They seem to have no idea of what the real aim of art is, that is beauty & they try instead to amuse the public . . . [Millais' work was] all very second rate & disappointing . . . how very much more he might have done had he not allowed himself to degenerate.[19]

After visiting the Royal Academy exhibition six weeks later (she had a baby in between), she wrote in her diary: 'I had seen most of the pictures in the studios – but had not seen Walker's Gypseys or Mason's Singing girls nor Moore's Azalias in all the celebrated rubbish of the year of the O'Neil & Frith class – Legros' refectory looks splendid also Leighton's Jonathan.'[20]

The Royal Academy exhibition the following year elicited similar responses: the same artists were singled out for notice and praise:

> G[eorge] & I went to the Academy at 9 a.m. & spent 2 hours there very enjoyably. The new rooms are very fine & make all the good pictures look much finer for having plenty of room – Legros Christening is the finest thing there. Walker's Old Gate & Mason's girls dancing are lovely pictures – Watts Orpheus is very beautiful – Leighton's Electra looks best in the Academy – several good landscapes by Frenchmen . . . Moore's 'Quartet' & his Venus have great loveliness of a more delicate nature than anything else in the Gallery.

The 'great many' costume pictures of the St John's Wood Clique were noticed, and Calderon's *Sighing to his Lady's Face* received faint praise: 'a really pretty picture . . . but not with any great force in it'.[21] However the Howards, in common with the Airlies, the Wyndhams, the Lothians and all the other aristocrats who hovered around Little Holland House, do not appear to have bought work by the St John's Wood Clique, nor by any of the artists who moved to Holland Park in the mid-1870s whose allegiance was to the Academy – Luke Fildes, Marcus Stone, Colin Hunter. For these aristocrats beauty always came before 'what amuses the public'.

The Howards were on first name terms with the Burne-Joneses (figs 41, 42) by the summer of 1867, Burne-Jones addressing Howard as 'Dearest George' ('Are you coming on Wednesday to work – all is ready for you to come');[22] Georgiana writing to his wife as 'My dearest Rosalind' ('I am very glad to call you by your pretty name').[23] Howard studied drawing with Burne-Jones, sharing his models Alessandro de Marco

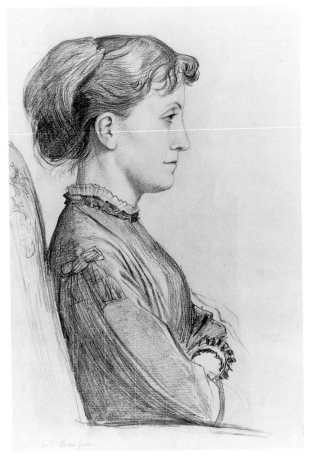

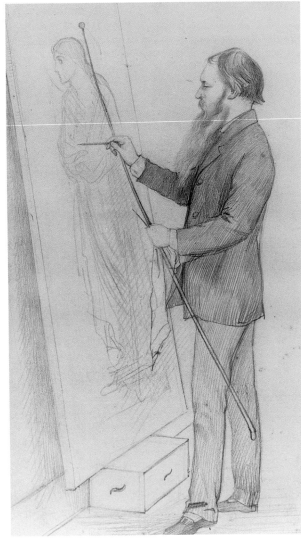

41. (above, left) George
Howard, *Georgiana Burne-
Jones*. Castle Howard,
Yorkshire.

42. (above, right) George
Howard, *Edward Burne-Jones*.
Castle Howard, Yorkshire.

and Colorossi. He also appears to have drawn Rossetti's model and mistress Fanny
Cornforth. He bought his first Burne-Jones painting, a landscape, for £6 10s. at the sale
of the lawyer Anderson Rose; he commissioned Poynter to paint Georgiana for £42 and
Legros to paint Burne-Jones, also for £42; he sat for Burne-Jones' painting of
Theophilus. These were only the beginning of many more commissions, including the
decoration of the dining-room of 1 Palace Green.

In August 1867, however, the Burne-Joneses heard they would have to move from
Kensington Square: the new owner was refusing to extend their lease. They limited
their house-hunting to the immediate area, Georgiana claiming the Howards were part
of the reason: 'we are very anxious not to leave this neighbourhood . . . I am sure you
will believe that one of our chief reasons for wishing to remain in this neighbourhood
is that we may not lose sight of you at all. . . . You have become part of our lives now.'[24]

Robert Martineau (Hunt's former lodger) found a possible property: the Grange,
North End Lane, Fulham. The rent was 'a third more than we had yet paid, rates were

high in Fulham, and the house was bigger than we needed';[25] however, the house could be subdivided (it was originally two), the garden was large, about three-quarters of an acre, with an orchard of apple trees, peaches against the walls and an old mulberry tree. Even in November, once they moved in, 'we found late-blooming monthly roses and a hedge of lavender, whose sweet scent and soft pink and grey colour are inseparably connected in memory with the place and time'.[26] There were further attractions: it had been the home of Samuel Richardson and was some 150 years old; there was a large room on the first floor with east light which would make a suitable studio; also it was 'about a mile up the high road here – so we shall not go out of speaking distance after all'.[27]

Burne-Jones compared it to the ancestral properties his friend would inherit:

> I have just seen the house we have taken, and it is too grand and large and splendid for us: we have no right to such a place . . . the studio is convenient and that conscientiously was the only reason for taking the house: for those 2 months hunting I never once saw a room so good as the one I now have except this one only . . . but I am frightened. It reminds me a good deal of Castle Howard – I should say rather it had the scale of that mansion combined with the more sympathetic aspect of Naworth: it is called the Grange, not moated however . . . there is a madhouse next door which is convenient, for I hate distant removes.[28]

Georgiana looked forward to the time when the Howards would finally move into their new house, when they would 'really come to be our neighbours'. She would 'make light of the distance between the two houses and hope for many a pleasant talk with you [Rosalind] and sight of you then'.[29]

Meanwhile the Howards found themselves caught up in the painful affair between Burne-Jones and Maria Zambaco, niece of Watts' patron Alexander Ionides, which culminated in a public struggle between the two lovers on the Regent's Canal. Howard was probably introduced to members of the Ionides family by Burne-Jones; he visited their houses at least twice while Palace Green was being built and met Maria, whose portrait Burne-Jones had been commissioned to paint. If Howard had any idea that Maria and Burne-Jones were lovers during the course of their affair,[30] he did not tell Rosalind. When she discovered the truth, in the New Year of 1869, she was horrified by 'the awful & deliberate treachery of Mme Z making use of Georgy a whole year & professing such friendship'.[31]

Georgiana's willingness to forgive Burne-Jones, even accepting she was partly to blame, amazed Rosalind, who could only marvel at her fortitude. Rosalind recorded Georgiana's explanation: 'she lacked knowledge of the world & her own guilelessness & strong principle made her trust to others when she should not . . . she still won't admit that Mm Z was deceitful as for E.B.J. she says he takes all the blame on himself & says Mm Z is innocence & truthfulness itself.'[32] Georgiana was convinced 'there is love enough between Edward & me to last out a long life if it is given us'.[33] No wonder Rosalind could write of her: 'she is a good brave woman with such a sad sad story – Her love is the deepest I ever met with.'[34]

The Burne-Joneses were not the only couple known to the Howards experiencing marital difficulties. The relationship between Janey Morris and Rossetti was beginning to threaten the Morrises' marriage, and Morris was himself falling in love with Georgiana Burne-Jones. Perhaps these crises coloured Rosalind's view of the artistic profession. In May 1869 she made a long entry in her diary, expressing grave doubts about her husband's chosen calling:

This aftn I feel very dejected & I am afraid I have dispirited poor George. It is about his art. . . . I think he is getting on but I don't know that he will ever be a really first rate painter & yet I see that daily he is becoming more entirely engrossed by painting. He thinks & talks of nothing else now. He seems to care less about politics. All the friends he seeks out & cares to talk to if they are not artists are people who care to talk art. . . . if I hint . . . at the study of some subject wch will be useful & important to him in late life when he has estates he says it is uninteresting & has nothing to do with art & that he must devote himself to one thing.[35]

Rosalind's doubts about her husband's talents, or her awakening to the true nature of her friends' marriages, did not diminish her fondness for the Burne-Joneses or the Morrises. It undoubtedly strengthened her friendship with Georgiana Burne-Jones, who wrote to her in 1871: 'I am very glad I came to know you when I did, for if it had been left till now I am sure it would never have come to pass – your life is so much more occupied than it was, and I am twice as indisposed to make new friends as I was then.'[36] Perhaps her exposure to artistic infidelities provided her with the fortitude to bear Howard's own infidelity with her sister-in-law Maisie Stanley (Lady Sheffield). She, on the other hand, was able to reject the overtures of the philanderer Wilfrid Scawen Blunt who tried to make love to her soon after Palace Green was completed.

When the *Studio* described the interior of 1 Palace Green in October 1898, the original ideas of the Howards, Webb, Burne-Jones and Morris had been achieved; the collection of paintings, furniture and furnishings was complete.

> Compared with the average Park Lane palace it looks severe and simple; but it is pre-eminently an artist's home, which not only genius has enriched, but good taste has controlled. . . . Even its good taste is not unduly evident, but becomes the more apparent the more closely you observe it. By thus avoiding emphasis of all kinds, the treasures it holds seem but ordinary fittings, until more curious inspection shows many of them to be unique masterpieces. The majority of these are modern – a singularly pleasing exception to the average 'palace' of to-day, which, if it holds masterpieces of any kind, is singularly careful that they shall be of goodly age, hall-marked as it were with official approval of their sterling value.[37]

The extraordinary collaboration between architect, artists and client lasted until early in the 1880s, when Howard inherited Naworth Castle and estate in Cumberland and saw a dramatic rise in his annual income to £18,000. Before 1880, the Howards' income was about £3,000, interest had to be paid on the loan taken out to build the house, and the amount of work which could be undertaken each year was limited. The schoolroom which Webb added in 1874, cost £1,627 8s.9d. in builders' fees alone.

From the first year of their marriage, the Howards chose to spend a large part of their income every year (apart from 1870 when the Franco-Prussian War made European travel difficult) travelling to Italy and living there between three and seven months. As their family grew, they were obliged to take more servants, so the costs rose proportionately (fig. 43). In 1865–6, for example, their seven-month visit cost only £577; they had one small baby. In 1877–8, the same visit cost almost £1,000 but they travelled with seven children and at least six servants. Abroad and in London Rosalind indulged her passion for collecting furniture, Eastern carpets and rugs, exquisite Palampores from the Coramandel coast of South India and oriental ceramics. She also purchased Arts and Crafts pottery from Morris, Marshall & Faulkner (Morris and Company from 1875), William De Morgan and Liberty's.[38]

43. George Howard, extract
from sketch-book, 19 October
1885. Castle Howard, Yorkshire.

The most remarkable decorations were in the dining-room of 1 Palace Green (fig.
44), but they were not completed until the early 1880s, by which time the roses Webb
had planted in the garden were well established, and creepers grew up the red walls.

Burne-Jones first offered on 16 November 1869 to paint a frieze illustrating the
story of Cupid and Psyche (fig. 45) (based on the version in Morris's *Earthly Paradise* of
1868–70), to be executed on twelve canvases around the walls. Two years later the
Howards bought the canvases he required, at a cost of £21 and he began work in his
studio at the Grange. The Howards waited patiently (meanwhile hanging portraits on
the walls), but by 1878 only parts were finished. Burne-Jones had spent much of the
1870s recovering from his affair with Maria Zambaco[39] as well as juggling commis-
sions from William Graham, the Liverpool collector Frederick Leyland, members of the
Ionides family and Howard. Walter Crane was brought in to the project after he and
his wife stayed in Palace Green with their baby for a week or two in 1878. He later
recalled how he tackled the work:

> The canvases – in various stages, some blank, some just commenced, some, in parts, consid-
> erably advanced – were all sent to my new studio [formerly Poynter's] at Beaumont Lodge .
> . . In the treatment I allowed myself considerable freedom, especially in the subjects not
> already commenced or carried far, though I endeavoured to preserve the spirit and feeling of
> the original designs. . . . When I had carried the painting of the frieze as far as I could in the
> studio, the canvases went back to Palace Green, and were put up in position on the wall.
> Burne-Jones then joined me, and we both worked on the frieze, *in situ*, from trestles.[40]

Burne-Jones also worked with Crane in his studio. 'Jones has been over twice & he has
devised a new background for the Gods & goddesses. He made a rough sketch, which

44. 1 Palace Green. Part of the south and west walls of the dining-room, showing the Cupid and Psyche frieze by Edward Burne-Jones and Walter Crane, photographed for *The Studio*, 1898.

I have carried out, of a palace roof & pillars behind the figures, which gives one valuable level & perpendicular lines & works into the pointed form much better than the landscape would have done.'[41]

Morris was engaged to provide further decorations on the walls and ceiling, work which dragged on until 1881. He wrote in December 1879:

I am bound to ask your pardon for having neglected this job; but I did not quite understand what was to be done except the writing [lettering around the walls] (which by the way is a very difficult business): I am now going to set to work to design ornaments for the mould-ings round the pictures, the curved braces of ceiling, and the upper part of the panelling.[42]

45. Edward Burne-Jones, *Cupid Finding Psyche Asleep by a Fountain*, part of the Cupid and Psyche frieze for the dining-room of 1 Palace Green. Birmingham Museum and Art Gallery.

46. Edward Burne-Jones, decoration for organ case (designed by Philip Webb), for Rosalind Howard. Private collection.

He was finally paid £267 in 1882. Meanwhile Burne-Jones realised that the frieze which he and Crane had virtually completed no longer matched Morris' work. He was also unhappy with some of Crane's painting. He engaged Thomas Rooke (the Howards paid Rooke £50), explaining to Howard:

> I am painting *all* the figures *myself* – have redesigned bits of background *all over* & the result is good I think – at least it matches Mr Morris's ceiling now! – they are all much lighter, all the pictures – Rooke has worked between 7 & 8 weeks almost everyday – and some aftns I have worked & most Sundays. I hope Crane wont be hurt – I have had to alter much – I think they were painted in too dry a material for some of the colour wipes off with a dry duster – I think you will think it a very very great improvement. The room looks lighter in everyway & some fair colour I have put into the dresses here & there tells mightily.[43]

The room has been dismantled,[44] and black-and-white photographs convey little impression of what must have been a sumptuous interior. The Howards' dinner guests, most of whom already liked and owned work by Burne-Jones and William Morris, surely would have found difficulty directing their attention away from the walls and ceiling to the pleasures of the table. *The Studio* reported that the room glowed 'like a page of an illuminated missal'.[45] Lethaby, on the other hand, who admired the architecture of 1 Palace Green, wrote of Burne-Jones' work, 'there was no call for national epic, and the artist had to turn himself into a provider of dining-room pictures for men of money'.[46]

The staircase leading up to the first floor was covered with a crimson carpet (manila matting covered the front hall floor); portraits by Watts of Howard and his grandfather Lord Wensleydale hung on the wall. On the landing of the first floor stood an organ. The case was designed by Webb to incorporate a painting by Burne-Jones (fig. 46). Webb explained to Howard on 14 August 1871, 'I took the measurements of the organ-case opening the other day & will order the canvas to be sent to the Grange [Burne-Jones's house]'.[47] Rosalind was delighted with the finished painting. Burne-Jones 'has done a beautiful picture for me in my organ. How good & dear he is, to do that for me. It is most lovely in colour & composition & sentiment. It is a man in red drapery playing an organ.'[48] Moncure Conway, 'the able American who preaches a transcendental theism at the quondam Unitarian Chapel in Finsbury',[49] was impressed by the concept although he identified the subject of the painting incorrectly:

> a charming picture of St. Cecilia playing on her keys. This picture sheds light and beauty around, and shows how much may be done in a house by having such objects brought into the general system of ornamentation adopted in the house. It is hardly enough to bring into the house furniture of a color which is vaguely harmonising with the wall-paper; by a little decoration even the piano, the cabinet, the book-case, may be made to repeat the theme to which the walls have risen.[50]

Georgiana was allowed to play the organ while the Howards were away. In February 1875 she took Frances, daughter of Burne-Jones' patron William Graham, to see it: 'we went to Palace Green the other day, to show the organ to Miss Graham – feeling sure you would have no objection – & oh, how deserted the place looked. The organ was not at all out of tune though.'[51] The same year Burne-Jones began to work on designs of the story of Orpheus and Eurydice for the decorated piano which Graham commissioned and which was completed in 1880, a gift for Frances.

In the drawing-room (on the first floor) the Howards began by hanging Poynter's portrait of Georgiana Burne-Jones, completed in 1869. When Georgiana began to sit to Poynter, Rosalind was disappointed to discover she had changed her hair style. Georgiana was suitably contrite:

> Such had been my incredible promptness, united with my brother-in-laws – that the portrait was already begun, & the hair arranged in curly [sic] wise by the time I got your request about it. However Mr Poynter has managed to effect a compromise & I hope you will like it. It is very dear of you to care for my likeness, & it gives me great pleasure to sit for it for you. I have stipulated that your little locket shall be distinctly visible in it, & though no one will know what that means when we are dead & gone, you & I shall while we live.[52]

Rossetti's striking drawing of Rosalind of 1870 also hung in the drawing-room, together with an oil by Legros, *Psyche* (1868) and two oils by Giovanni Costa, including *Pinewood outside Pisa* (1865). Webb provided careful instructions about the hanging of the pictures in 1869 before the decorations were complete:

> With regard to the hanging of pictures in the drawing room – I should prefer for *appearance* that they should be hung from simple nails driven in just underneath the frieze – and any very large picture with fine cord from the top of room *over* the frieze – it is probable that there would not be many large enough to require this height as the bottom of the frieze is 8 feet from the floor – but at all events you need not hesitate to hang pictures *over* this line and without rods.[53]

The ceiling was painted 'in a simple manner in yellow & white'[54] with a Morris willow pattern frieze. This was kept when, in 1881, Morris' blue Chinese damask was used for curtains and chair covers after his poplin proved unsuitable. He wrote: 'I am sorry that the poplin didn't do. If you should at any time want a damask (that is the weaving makes the pattern not a change of colour) for hanging: I am doing a good one now for St. James Palace, which might suit you'; and a week later, 'the damask can be any colour you choose'.[55] The walls were covered at the same time (1881) with Morris' African marigold chintz. This was chosen after the Howards had decided to hang one of their later Burne-Jones', *Dies Domini* (fig. 47), in the room. Morris and Burne-Jones were both involved in the selection of the appropriate background, Morris writing to Rosalind:

> May I ask what you are going to do about the drawing room at Palace Green? Ned tells me that you are going to keep the Dies Domini there, & want to hang the room accordingly: we dont like to do anything there till the ceiling is made safe: what do you think of hanging a piece of stuff behind it; I could get a colour better suited to it I believe.[56]

Rosalind's boudoir was also on the first floor. To begin with she chose to hang a selection of works by Walter Crane, including *Hunting Moon* and *Mere in Cheshire*. There was a watercolour sketch by Burne-Jones for his early painting *The Merciful Knight* (1863), some of his chalk sketches, and, in 1879, his large painting *The Annunciation* (fig. 48) was added. Like *Dies Domini* in the drawing-room, this painting dictated the final decorations of the room.

The discussions between Burne-Jones, Morris, Rosalind and George Howard reveal a shared interest in 'getting it right'; all believed the painting must dictate the decoration of the entire room. Rosalind's choice of paper, gold sunflowers, was first tried, but the artists realised it was 'fatal' to the picture. Morris wrote to her on 13 December 1879:

> Ned Jones & I went to look at the effect of the gold paper against the picture, & found to our grief that it would not do . . . this morning I find that you suggest leaving the matter till you come up to town: but meanwhile, I, knowing that it would be impossible to get the work done unless we began at once, have set Leach's men at work to forward the job, so that the Drawing Room will be finished next week in the way you wished; & the boudoir has been prepared for final painting & hanging which would now take less than a week to do at any time.[57]

He wrote again after visiting with Burne-Jones:

> Ned & I duly went to Palace Green yesterday & our joint conclusion was that the *best* hanging for the walls of the boudoir would be the enclosed madder-printed cotton: it brings out the greys of the picture better than anything else: also I think it would make a pretty room with the wood-work painted a light blue-green colour like a starling's egg; & if you wanted drapery about it we have beautiful stuffs of shades of red that would brighten all up without fighting with the wall hangings . . . the red stuff 2s per yd yard-wide, which would come to less than the gold sunflower would have done.[58]

Burne-Jones agreed:

> I went this morning to see the room where Morris has hung up a piece of red hanging by the picture – it seemed to go – but of course we cannot tell if you would like it – Georgie told you from me how fatal the gold was to the picture, though it was a pretty paper and

47. Edward Burne-Jones, pastel sketch for *Dies Domini*. Lady Lever Art Gallery. The painting's location is unknown. The composition was taken from a stained glass window design for St Michael and St Mary Magdalene, East Hampstead, 1874

would have brightened your room merrily – still it did destroy with its glitter all the quiet of the picture & took the colour out of it somehow – it looks best when you can see no surrounding at all, but catch a glimpse of it through the doorway, and then it looks like a vision – but I should hate your spirits sacrificed to a pompous & fine effect and there is no need – some colour that will not fight with the tones of the picture is all that is needed – and you will have those cabinets to go one on each side of it, & that will help – the red is a good red – a sort of Indian red colour with no sheen upon it, and it looks rich & handsome – & blue things upon it look lovely – I think you could soon make the room sparkle & gleam brightly – though red takes & would give back much light. There is no red in the picture to be hurt by it. The green tree looks all the greener, and the blue of the wings bluer – and the flesh isn't hurt – nor the white dress turned gray – as the gold paper did for it . . . one day I might paint two solemn single figures to stand one on each side of it and then it would look very nice – as it is, no picture I have ever done will be so kindly placed.[59]

The wall-covering selected was Morris' red iris chintz (total cost £20 13s.). The chairs were covered with Morris' red honeysuckle chintz (54 yards at 6 shillings a yard, 1s. 4d. for the lining). Mrs Root received £3 16s. 6d. for making up the covers. Old English embroidered material covered a table and sofa and formed *portières* over the doors. A white bearskin rug lay in front of the fireplace, which was hidden by Indian silk curtains in the summer.

48. (facing page) Edward Burne-Jones, *The Annunciation*, 1876–9. Lady Lever Art Gallery. The model for the Virgin was Julia Stephen (née Jackson), wife of Sir Leslie Stephen and niece of Sara Prinsep. She gave birth to Vanessa (later the artist Vanessa Bell) on 13 May 1879.

Even before the decorations were completed Rosalind was discussing extending the house with Webb. As if designing a palace of art for aesthetes was not enough, Webb was to be asked to transform 1 Palace Green into a house fit for parliamentarians. Rosalind wrote to him on 3 January 1880 about the possibility of making the house 'a thoroughly good one for the radical party to assemble in for dances & other diversions. Please bear in mind also that I should like the big room to be good for music if there are any special means of securing this end.' She desired more bedrooms, a gymnasi-

The Holland Park Circle

um, a dining-room 45 feet long and a ballroom 60 feet by 25 feet, writing, 'I do not suppose that this addition would be more than was the original cost.'[60]

Webb may have decided her plans were impossible to carry out on the limited site. By November 1881 the Howards were discussing the acquisition of the 'White House', a property behind theirs. Webb was dubious: 'It seems to me that there would be some risk in connecting your house with the "white house" without the Woods & Forests knowing.'[61] However, he inspected the property the following January: 'I went with Neave into the "white house" and found the shell a good substantial building. The tenants – of wh there are a crowd – looked on us as agents of a bloody landlord; and if any of them are Irish, you may expect to have to billet a bullet.'[62]

The Howards dithered throughout 1882 and 1883, looking at other properties in London, including the land on which Baron Grant, the dubious financial speculator, had built his fanciful Kensington Palace: 'a lovely site covered with trees – where a beautiful house & garden could be made on'.[63] But the asking price was £60,000.

It is difficult to believe that Howard would have wanted to abandon Palace Green: was the desire for a larger, grander house linked to Rosalind's political ambitions for her husband? He, meanwhile, was concentrating on the development of a personal style of landscape painting and enjoying participation with Costa, Richmond and Leighton in the founding of the Etruscan School of painting.[64]

Webb continued to work on plans for incorporating the White House (he was also repairing the drawing-room ceiling through much of 1882) but finally lost patience: 'I shd be glad if you would get another genius than myself to add to Palc Green as I'm sure there are many who would give you more satisfaction than I shall. . . . Don't lose the drawings or I'll strike you.'[65] Burne-Jones comforted Rosalind:

> he has rebuffed me lately too. . . . I can't help thinking that if I had what he has, some one utterly devoted to me and caring enough about me to live solitary for my sake that I shouldn't be so very doleful – at least I should like to try – but I am very heartily vexed for both of your sakes – for indeed his work is good – and you have been so faithful about him, both of you that it must hurt.[66]

Further decisions about Palace Green were postponed as the Howards' own relationship deteriorated. Rosalind's violent opposition to Howard's position over Home Rule for Ireland (he opposed Gladstone's 1886 Home Rule Bill) finally drove them to separate establishments. Her mother suggested at the time that she 'should be taken away from your family and placed on a high mountain'.[67] Howard's financial position was also weakening as the agricultural depression affected his newly inherited estates. Throughout the 1880s, his income appeared to be rising: he had been spending large amounts on building works, furniture and paintings for Naworth but he had also been borrowing substantial sums from Coutts Bank. When he inherited the earldom and Castle Howard in 1889 his income rose from almost £33,000 per annum to almost £56,000. However, he had to pay off a debt to Coutts of £10,000 and pay for his daughter Mary's wedding; his expenditure at the end of 1890 was £55,000. The pattern remained the same: though his income was high, his expenses had soared. He was responsible for extensive estates in the north of England, Naworth Castle and the massive pile of Castle Howard, as well as Rosalind's numerous philanthropic concerns. Between 1893 and 1895 his income was £90,000 but his expenditure was £85,000; for the first time he sold family paintings, raising £8,000. The

amount spent on contemporary paintings, furniture and furnishings fell dramatically to only a few hundred pounds.

It was perhaps fortunate that Burne-Jones and Morris died long before George Howard, though they would have been aware of the breakdown of his marriage. When Howard died in 1911, Wilfrid Scawen Blunt commented: 'He was one of the best of men, as well as one of the most domestically tried.'[68] Rosalind sold Palace Green in 1920, moving to 13 Kensington Palace Gardens, 'the most hideous huge gothic mansion on the opposite side, but much higher up than her old house'.[69] Her professed passion for contemporary art and architecture had evaporated along with her friendships with the artists and her affection for her husband.

The Ionides – Patrons in Holland Park

In 1860, Alexander Constantine Ionides was fifty years old, Consul-General for Greece, a director of the Crystal Palace Company; his wife Euterpe was forty-four. He had gradually diversified the family business, moving from exports and imports to merchant banking, and had survived major financial losses brought about by the Crimean War and the Indian Mutiny (in 1866 the collapse of the Bank of London, of which he was a director, was to cost the family more than £120,000). His house on Tulse Hill was still home to three of his children, Luke, Alecco and Chariclea. Ionides' widowed sister Euphrosyne Cassavetti also stayed with the family, together with her surviving children Maria and Alexander.

Alexander's three sons, Constantine, Luke and Alecco, worked for the family firm located at Gracechurch Street in the City of London. Constantine, the eldest, was based for a period in Constantinople where he married Agathonike Fenerli in 1860. Luke had hoped to join the diplomatic service but the Indian Mutiny of 1857 had 'affected the value of stocks which had to be realized to pay for merchandise'. The losses were so severe that he had to 'take to business'.[1] Between 1861 and 1863 he travelled through Italy and Greece to Constantinople, in the company of Alecco and Constantine.

Before becoming a merchant, Alecco spent a period of time in Paris enjoying *la vie bohème* in the Latin Quarter with a group of British artists studying at the atelier of Charles Gleyre: George du Maurier, Thomas Armstrong, Thomas Lamont and Edward Poynter; Whistler was also of the company. When Luke visited Paris in 1855 he was introduced by his brother to his artist friends. Some of their exploits were semi-fictionalised by Du Maurier in *Trilby* (1894). Alecco was 'the Greek':

> a boy of only sixteen, but six feet high, and looking ten years older than he was, and able to smoke even stronger tobacco than Taffy himself, and colour pipes divinely. . . . He was the capitalist of this select circle (and nobly lavish of this capital). He went by the name of Poluphloisboiospaleapologos Petrilopetrolicoconose – for so he was christened by the Laird – because his real name was thought much too long; and much too lovely for the Quartier Latin.[2]

Lamont became 'Sandy, the Laird of Cockpen'. Armstrong provided the inspiration for 'Taffy', also possibly Val Prinsep, whom Du Maurier met later in London at Little Holland House. 'He was a very big young man, fair, with kind but choleric blue eyes, and the muscles of his brawny arms were strong as iron bands.'[3] Poynter was 'Lorrimer . . . the industrious apprentice', already marked out for a career in the art establishment, who 'spent his evenings at home with Handel, Michelangelo and Dante, on the respectable side of the river. . . . he went into good society sometimes, with dress-coat on, and a white tie, and his hair parted in the middle!'[4]

When the artists, in Du Maurier's words, 'transferred their Bohemia to London', they were welcomed by the Ionides at Tulse Hill – 'Paradise'.[5] Whistler introduced the Ionides family to Alphonse Legros and Henri Fantin-Latour, members with him of the Société des Trois, an informal band of friends rather than an artistic movement; he also brought Dante Gabriel Rossetti in about 1862,[6] and Tom Jeckyll the architect and interior designer. Du Maurier took Prinsep for the first time in May 1862: 'my pet giant strong man and best of good fellows'.[7]

The entertainments at Tulse Hill were similar to those of many Victorian households: theatricals, charades, music. But the Ionides, unlike the Little Holland House circle, appeared exotic to many of the artists. Burne-Jones, introduced to the family by Rossetti, thought he had stepped into the *Arabian Nights*. Georgiana recalled:

> Arabian and Persian stories fascinated him so that he gathered a treasure of them in his memory, and loved to talk of them. We had a Greek friend, Mr Luke Ionides, with whom he conversed about them almost every time they met during some thirty years, and neither of them ever grew tired of the subject. That corner of Asia was to him like a far-off country home, for in imagination he lived and travelled there from boyhood.[8]

The Ionides ladies were also renowned among the artists' circle for their beauty and talent. To Du Maurier, they appeared unusually at ease in the company of men:

> The women will sometimes take one's hands in talking to one, or put their arm round the back of one's chair at dinner, and with all this ease and tutoiement, or perhaps on account of it, they are I do believe the most thoroughly well bred and perfect gentlefolks in all England.[9]

Alexander's daughter Aglaia Coronio, he found 'one of the most charming women'. Emma Niendorf, visiting Tulse Hill in 1855, described her: 'poetical appearance, tall, slender, supple figure, pale face, black eyes, proportionate lines, sensitive, quiet, with a dreamful air'.[10] According to Georgiana Burne-Jones, she helped Burne-Jones with 'her perfect taste . . . finding fabrics and arranging dresses for models'. Her warmest friendship was with William Morris, whom she met in about 1869, 'his closest approach to a flirtation'.[11]

Maria Cassavetti was still single and Du Maurier expressed his interest: 'There is a certain beautiful Greek girl of great talent and really wonderful beauty, with a small fortune of her own of 80,000£. She is supposed to be attached by mere obstinacy to a Greek of low birth in Paris.'[12] She married the 'low' Greek, Demetrius Zambaco, doctor to the Greek community in Paris, in 1861, but returned to London five years later with two babies and no husband.

More Greek beauty was provided by the family friends Christine and Marie, the daughters of Michael Spartali (who was to become Consul-General after Alexander Ionides). Armstrong recalled the first sight of them:

> Whistler, Rossetti, du Maurier, Legros, Ridley, and myself were in or on it [the cab]. It seems to me that there were others in that four-wheeler, Poynter perhaps, but I am not sure, and I want to be accurate. The occasion was a memorable one. Then for the first time was revealed to this artistic circle the beauty of two girls, relations or connections of the Ionides family. . . . We were all *à genoux* before them, and of course every one of us burned with a desire to try and paint them.[13]

Swinburne, on seeing Marie for the first time, apparently declared: 'She is so beautiful that I want to sit down and cry.' (fig. 49)[14] In the 1860s she became entangled, against her family's wishes, with Lord Ranelagh, one-time lover of Holman Hunt's model

49. Julia Margaret Cameron,
Marie Spartali.

Annie Miller; in 1864 she became a pupil of Ford Madox Brown and maintained a
career as an artist, marrying the widowed journalist William Stillman in 1871. Rossetti
painted her in 1864 soon after hearing she was Brown's pupil. He wrote to Brown:
'just box her up, and dont let fellows see her, as I mean to have first shy at her in the
way of sitting'.[15] Whistler painted her sister Christine as *La Princesse du pays de porcelaine*;
the painting eventually became the centrepiece of Frederick Leyland's dining-room,
better known as the Peacock Room, at 49 Prince's Gate (see fig. 64).

 Though Whistler was well known to Alecco and Luke Ionides, Watts was respon-
sible for first bringing his work to the attention of their father. *At the Piano* had been
rejected by the Salon in Paris in 1859 but it was well hung at the Royal Academy the
following year – the first picture exhibited by Whistler in England. Watts apparently
declared: 'as far as it went it was the most perfect thing he had ever seen'. And Luke
Ionides wrote: 'I think his praise was what influenced my father when he shortly after-
wards gave Whistler a commission to paint my portrait, also a commission for a pic-
ture, – the well-known "Old Battersea Bridge".'[16] By 1863 Whistler had £300 worth of
orders,[17] from Alexander Ionides, Aglaia Coronio and the Cavafys, an important boost
to his income, which enabled him to settle in London, leasing 7 Lindsey Row (101
Cheyne Walk).[18]

 Whistler and Watts were not the only artists to benefit from the Ionides' patronage;
as Du Maurier wrote, 'they are very *useful acquaintances*'. He drew Luke as 'A cross-legged
Turk' for his first piece in the journal *Once a Week*.[19] In 1861, Alecco paid him six
shillings a week for the use of his spare bed in Newman Street.[20] Legros, though unable

The Holland Park Circle

to complete a portrait of Chariclea after five attempts,[21] painted Alecco in 1864 and became adviser to Constantine when he began to establish his art collection from the late 1860s. Fantin-Latour sold the Ionides and their friends his small copies of Old Masters, his 'bread-and-butter'. They also bought his still lifes and flower paintings. Luke recalled: 'My father bought from him several of his flower paintings which at that time were pounds each, and now fetch many hundreds.'[22] Their patronage of artists and architects was most extensive, however, after they moved to Holland Park.

Alexander Ionides bought the freehold of number 1 Holland Park (fig. 50), for £4,500, in 1864, reputedly using his wife Euterpe's diamonds. He chose the best-sited house of the whole development, although when Philip Webb was engaged to make alterations, he described it as hopeless, 'like a feather-bed – shapeless, and when you pushed it in one direction it stuck out in another'.[23] It backed on to the surviving parkland of Holland House and, as Walter Crane noted: 'its detached situation in garden-ground with the front entrance in an outer wall gave it a certain character'.[24] To begin with, Ionides' neighbour at number 1A was the Holland estate agent, John Henry Browne. In 1869, however, his daughter and son-in-law Aglaia and Theodore Coronio bought Browne's house.

The early residents of Holland Park were mostly merchants, industrialists, fundholders and bankers; several were retired, living off their investments. The sole aristocrat was the fourth Marquess of Londonderry, Frederic William Vane-Tempest-Stewart, at number 3, who was tended by his doctor and six servants until his death in 1872. There was also Count Aguila, who styled himself Royal Prince of Naples in the census return, living at number 33, with his wife, the Countess, and fourteen servants.

The Holland Park development, rather like Little Holland House to the south, was *rus in urbe*, with easy access by railway to the City but also in close proximity to the parkland of Holland House and, a little further east, Kensington Gardens. Several of the first residents remained for the rest of their lives. For Alexander Ionides, the new location

50. View of Holland Park. 1 Holland Park, the home of Alexander Ionides, is on the extreme left.

placed him within walking distance of Watts, Leighton, Prinsep and Burne-Jones. Other merchants and industrialists, less interested in contemporary art, may have chosen to live among their own professional class. The Ionides' part of Holland Park was the first to be built, one road, numbers 1 to 36. The 1871 census reveals neighbours who were successful in a range of interconnected Victorian enterprises. The cotton trade was strongly represented: Demetrio Duarte, a sixty-four-year-old retired cotton merchant from Spain lived at number 6; and there were three Manchester warehousemen, George Routledge at number 8, John Snelgrove (of Marshall and Snelgrove) at number 13 and Thomas Watson at number 31. The Ionides had first settled in Manchester after leaving Greece; Benjamin Whitworth, living at number 11, a general merchant and Justice of the Peace, was born in Manchester. Stanley Perceval, at number 27, was a retired West Indies merchant from Manchester.

One of the most distinguished Mancunians of the nineteenth century was Sir William Fairbairn, who was made a baronet in 1869 for his achievements as an engineer, in particular for his work with Robert Stephenson constructing the Conway and Britannia Bridges. His early career was linked to the cotton industry: he designed machinery for a cotton mill near Manchester. In the 1830s he moved into shipbuilding and in 1839 he visited Constantinople to inspect work by the government and was decorated by the Sultan. He acquired number 9 Holland Park, next door to the Manchester warehouseman George Routledge, when he was far from well (he died in 1874), presumably to gain a London address. His main residence was outside Manchester, but his son Thomas Fairbairn lived in Kensington, at 23 Queen's Gate, until 1868. With so many links it would seem unlikely that Sir William was not known to the Ionides; the Fairbairns were also patrons of contemporary art. Thomas, like Alexander Ionides, was a commissioner of the Great Exhibition. He was also a major patron of Holman Hunt and one of the non-artist members of the Hogarth Club.

There were also East India merchants: George Bullock, at number 2 and John Young, retired, at number 5; an Australian merchant, Richard Gibbs, at number 14; a metal merchant, James Enthorn at number 18 with his wife, ten children and ten servants. Walter Hall at number 12 was only noted as a merchant in the census. He originally came from Scotland as did his neighbour at number 10, Alexander Gordon, a brewer employing '102 men, boys & females' (George Bullock and John Young were also born in Scotland).

The journalist and social commentator, T.H. Escott, observed the merchant class in the second half of the nineteenth century:

> They are industrious, attending closely to business, travelling daily from home to their country houses or offices by 'bus or rail, or even, perhaps, in comfortable brougham or pretentious carriage and pair . . . Greeks and Armenians, Jews, Infidels, and Turks, the stockbrokers, polyglot, of all creeds and nationalities, who have long found the London money market their happiest hunting ground. . . . [Among this group] the same chatter of culture, the same craze for higher aestheticism, prevail. From them issue the great bulk of the crowds that inundate the studios on 'Picture Sundays'.[25]

In addition to their shared culture and professions, Alexander Ionides and his children had a similar taste in architecture, interior design, ceramics and contemporary art, commissioning work from the same artists who were patronised by George Howard

and his aristocratic friends and relations. Unlike the aristocrats, however, the Ionides' relationships with their favourite artists sometimes went beyond friendship: Maria Zambaco and Burne-Jones were lovers; Nellie Ionides married Whistler's brother William (a doctor). Unlike other patrons from their own mercantile backgrounds, they appear not to have sought social acceptability through art collecting. They bought the art that they liked.

Shortly after Alexander and Euterpe acquired 1 Holland Park, Constantine returned from Constantinople with his wife and three young children. He also chose the Holland Park area, apparently settling on 8 Holland Villas Road because it was large enough to accommodate an enormous Turkish carpet which he had purchased just before leaving the East. His son Alec recollected:

> On the way down from the Phanar to embark, my father passed through the Bazaar and saw there a large and beautiful carpet. This excited his idle curiosity to the extent of asking the price. Eighty Turkish pounds was the quotations. 'Nonsense! I will give twenty, not a para more'. 'By the beard of the Prophet' said the vendor, 'Impossible' and my father walked on. Presently he turned to find the vendor at his heel offering him the carpet at his price. Thus it was he came to London with a wife and a large carpet. There, for a while, this investment – the carpet – was a white elephant and a nightmare, for he could find no house within his means to take it in.[26]

Other members of the family followed.

The Coronios were established at 1A Holland Park by 1869, the same year Luke Ionides married Elfrida Bird and moved into 16 Holland Villas Road. Burne-Jones gave a picture, *Hymenaeus* as a wedding present; for the birth of their first child, Burne-Jones, Rossetti and Morris together gave a sixteenth-century Dutch cradle.[27] In 1875, when Luke's family had grown too large for the Holland Villas house, they moved across Holland Park to a house in Upper Phillimore Gardens on Campden Hill.

Their move coincided with a change of ownership at 1 Holland Park: Alexander Ionides retired, eventually moving to Hastings, and the house became the property of Alecco, who married Isabella Sechiari in 1876. Alecco also acquired a country house, Homewood, near Esher.

Alexander's daughter Chariclea was finally allowed to marry the musician Edward Dannreuther in 1871 (he had to earn £1,000 per annum before her father would allow the marriage); they settled at 12 Orme Square, close to Leighton's first London studio. Also in 1871, Euphrosyne Cassavetti, her son Alexander and daughter Maria Zambaco moved to Fairfield Lodge, 6 Addison Road in Holland Park.

Since Whistler had been commissioned by Alexander in 1859 to paint a portrait of Luke, he had found several buyers among the family. In 1868, Alexander bought the plates of his Thames etchings which had not yet been published. He printed 100 sets of the sixteen etchings in 1871, giving a set to each of his children. The following year he bought a Whistler self-portrait from the artist for £50 and gave it to Alecco. Whistler meanwhile made a collection of photographs of the Tanagra figures, the Greek terra-cotta statuettes owned by Alexander. The figures were eventually displayed in the antiquities room of 1 Holland Park where Walter Crane designed 'a sort of temple-like cabinet placed in the position of an "over-mantel" . . . [of] ebony, with gilded recesses to hold the figures'.[28] Whistler's self-portrait was hung in the dining-room (fig. 53).

Constantine Ionides did not acquire work by Whistler, apart from his father's gift of etchings; he took the side of Legros, who had a notorious quarrel with Whistler in 1867. His relationship with Legros led to the acquisition of a unique collection of paintings which was displayed at Holland Villas Road, and finally in a specially designed gallery at Hove. There were several paintings by Legros including *A May Service for Young Women*, also work by French artists Legros knew or liked, including Courbet, Delacroix, Millet and Rodin. The Barbizon painters were represented by Corot, Diaz and Rousseau; Constantine also acquired a work by Degas, *The Ballet Scene from Meyerbeer's Opera 'Roberto Il Diavolo'*. His interest in nineteenth-century French art was unusual among Victorian collectors; it was, however, shared by Leighton, who owned paintings by Corot, Daubigny and Delacroix.

Constantine also collected Italian Renaissance paintings. Rossetti sold him a supposed Botticelli (now school of), writing him a wily letter immediately after Constantine had dined in Cheyne Walk in May 1880:

> I did not enter into the question of the Botticelli portrait yesterday evening, but as you seem to have thoroughly fallen in love with it, and as I shd. prefer your having the refusal, I may mention that I heard just lately from C.F. Murray in Florence that one of his buyers wd be glad to possess it. I answered only a few days ago that my price (shd I sell, which I left Doubtful) wd be 300 guineas. I have not yet heard in reply, but shd prefer, as I say, your housing it if you wish, I am not bound in any way to him.[29]

Rossetti wrote to Janey Morris once the deal was struck: 'The idea of selling pictures you don't have to paint is certainly a very great one.'[30]

The previous year, Rossetti had been commissioned by Constantine to paint *The Day Dream* (fig. 51), based on a drawing of Janey.

> Constantine Ionides looked in with his sister Aglaia on Saturday and commissioned me to paint the drawing over the mantelpiece of you seated in a tree with a book in your lap – the one to which I put the hands last year. This will be a considerable commission, though I must be moderate in these bad times. Terms are not yet settled exactly. Do you know whether Constantine has bought or is buying any pictures of Ned Jones?[31]

Rossetti finally asked for 700 guineas, £200 to be paid in advance: 'As your picture is fully designed & will shortly be on the canvas, I would be obliged if you would kindly make me now an advance of 200£ on its price.'[32] Rossetti was notorious for the length of time he took to complete commissions; at his death in 1882 many pictures were unfinished. Constantine called in January 1880 but was not allowed to see the canvas. In March, Rossetti asked for a further £200, claiming the painting to be 'far advanced & will be beyond question as good a thing as I ever did'.[33] In August, Constantine was at last permitted to see the painting. Rossetti was concerned, however, about how his patron might hang it, writing to Janey Morris: 'There is a white dado – a horrid thing of course for pictures, so I told her [Aglaia] the best thing would be to hang a piece of the silk with which the walls are covered below the base of the picture somewhat like an altar-cloth, and this she said she wd do.'[34]

As well as calling on Rossetti, Constantine was also encouraging Burne-Jones to complete *The Mill* (fig. 52), his other major commission. Burne-Jones took over ten years to finish the work. Finally he wrote in 1881:

> The picture is nearly done – but it may be still a month before it is delivered because of tiresome dryings and anxious finishings – but it is so nearly done that I can promise it very soon

– and if you could send me some money on acct. it would irradiate my life. You will have the green picture at the same time and the mill was to be I think £905. Will you send me £500 and the rest when it is delivered – £500 will be quite enough to pacify the clamorous and smooth my way . . . 1,100 guineas for both pictures.[35]

The 'Three Graces' in the foreground of *The Mill* are Aglaia Coronio, Maria Zambaco and Marie Spartali, dancing to the music of love.

Euphrosyne Cassavetti's commissions of paintings with her daughter Maria as model undoubtedly encouraged and prolonged the affair with Burne-Jones. For Maria's portrait, Burne-Jones depicted her holding open a book with an illustration of his own painting *Chant d'amour*; Cupid's arrow has his name on it. He also painted her as Dante's Beatrice, including part of an Italian sonnet which Rossetti had earlier translated:

With other women I beheld my love: –
Not that the rest were women in mine eyes,
Who only as her shadow seemed to move.

Between 1868 and 1870 he painted for Euphrosyne the first version of the story of Pygmalion and Galatea: Maria provided the face of Galatea, the sculpture with whom the artist falls in love. Her face was also used for Phyllis in *Phyllis and Demophoon*, the painting which led to Burne-Jones' resignation from the Old Water-Colour Society in 1870 (he refused to paint drapery over Demophoon's genitals).

Luke, the least successful in business, was a particular friend of Burne-Jones and a little in love, himself, with Maria Zambaco. Their friendship involved countless night-time 'adventures' which Georgiana Burne-Jones chose to omit from her biography of her husband. Letters from Burne-Jones to Luke are full of plans for 'enjoying the superior charms of manly conversation', meetings at pothouses, visits to plays, discussion about less salubrious dives: 'you don't know what you are saying in suggesting that Portland St., beastly hole – I was sent there by an injudicious friend and shall never get over it.' Burne-Jones particularly enjoyed the daring 'skirt dance' performed by Katie Vaughan which he and Luke saw at the Adelphi and the Gaiety theatres. Their intimate male circle of friends included Swinburne, Richard Burton and Simeon Solomon (until 1873 when Solomon received a suspended sentence for homosexual offences), with whom they shared obscene limericks and a fascination with flagellation and erotica.[36] Luke wrote of Burne-Jones, '[I] never had a better friend, and all the years I knew him we were always in great sympathy and his unfailing kindness remains a memory I cherish.'[37]

Luke's daughter Dorothea described their home at 17 Upper Phillimore Gardens:

Double doors led to the main hall, with marble floor, big fire, Persian rugs . . . the main staircase . . . covered in lovely Persian rugs which, without changing colour, bore our favourite game of tobogganing down on kitchen tea-trays. . . . The left side of the ground floor was all occupied by two drawing rooms with folding doors between; kept open for parties but used, we thought, best of all, for charades and theatricals.[38]

According to Luke, the drawing-room colour scheme was copied by Morris for Burne-Jones' drawing-room at the Grange. Wallpapers were from Morris and Company, also some of the furniture. Their daughter Maisie (drawn by Burne-Jones) married the son of Thomas Woolner, the Pre-Raphaelite sculptor and a favourite guest of Sara Prinsep at Little Holland House. Unlike his brothers, Luke resisted engaging an architect to make

52. Edward Burne-Jones, *The Mill*, 1870–82. Victoria and Albert Museum, London.

alterations to his house (or perhaps his financial situation made it impossible), and never set out to collect paintings and *objets d'art* on the scale which was eventually realised at 1 Holland Park and 8 Holland Villas Road.

Alexander Ionides, possibly at the suggestion of his son Alecco, appears to have initiated the first major work at 1 Holland Park. In about 1870, Whistler's friend the architect Thomas Jeckyll designed an extension comprising a servants' hall in the basement, a billiard room on the ground floor with a morning room above. It was Jeckyll's first important domestic commission and he chose to explore the possibilities of introducing the new fashion for Japanese design into the London home of a Greek merchant. The billiard-room ceilings and walls were framed in oak; the cornice, dado and ceiling panelled with red lacquered Japanese trays; the walls were 'hung all round with Japanese paintings on silk, of the greatest beauty'.[39] There was a high mantel of oak and red lacquer with tiles of red lustre framing the fire, and yellowish-brown leather settees and curtains in shades of light and dark brown.[40]

In the morning room, Jeckyll designed a fireplace with an overmantel inset with panels of red Japanese lacquer, 'admirably suited for a background to the rare red-and-white Nankin vases, which form its principal ornament. In the deep green marble of the mantelpiece are embedded a number of blue-and-white Nankin saucers, with quaint but admirably harmonious effect.'[41] When Alecco married in 1876, Jeckyll designed a suite of bedroom furniture for him, including a wardrobe of ebony and padouk, with Japanese designs in the upper panels of the doors.

Both Alexander and his son Alecco were helped with the acquisition of their treasures by Murray Marks, who established a commercial business importing 'artistic' pieces from Europe and the East but was also, himself, an expert on oriental and Nankeen porcelain, bronze and leather and consequently so much in demand that he became 'intimately concerned in the formation of almost every great collection in London and in Paris'.[42] Rossetti and Whistler were particular friends. Another friend, the architect Richard Norman Shaw, designed the premises he opened in Oxford Street in 1875, 'the first artistic business elevation, in creamy coloured woodwork, which was erected in London in the style of Queen Anne'.[43]

Marks had tried to set up an art firm with the backing of Alexander Ionides to sell

51. (facing page) Dante Gabriel Rossetti, *Day Dream*, 1880, Victoria and Albert Museum, London.

the paintings of Burne-Jones, Rossetti and Watts to collectors (Ionides' purchase of Whistler's etchings was part of the scheme) but the idea was not realised. In 1874, after the billiard room was completed at 1 Holland Park, Marks also recommended Jeckyll and Shaw to Frederick Leyland who already owned works by Whistler, Rossetti and Burne-Jones, and was about to transform the interior of his London house, 49 Prince's Gate, into a 'Venetian palazzo'.

Constantine, meanwhile, was the first Ionides to commission Webb, who designed an extension for 8 Holland Villas Road in 1870 at a cost of £920. The following year, Euphrosyne Cassavetti commissioned Webb to carry out work at Fairfield Lodge which totalled £4,780 and included a 'beautiful studio', presumably for Maria.[44] Her son Alexander, Val Prinsep's solicitor, commissioned further work in 1876. The builders were the Ashby Brothers, who were also working on Prinsep's house in Holland Park Road and the Howards' in Palace Green. When the final bill totalled over £5,000, Alexander Cassavetti protested to Webb, who replied:

> it is not an uncommon thing, I assure you, for Archts clients to be surprised when the final accts come in, as 'till that time, they have, as a rule, hardly realized the amount of things wh have been added to the contract, beyond those things (especially in an altered house) wh could not have been foreseen . . . the staircases better than taken in the contract, to meet your particular wish . . . the additions of bow window in bedroom over east-drawing room, and the wide stone stairs out of new dining-room to garden . . . the great cost of the engineers drainage.[45]

Architects, unlike most artists, had serious labour and material charges which their clients often overlooked, imagining architecture to be a profitable business. Webb himself rarely earned more than £300 per annum.[46]

In 1877 Webb was commissioned by the musicians of the family, Chariclea and Edward Dannreuther, to work on their studio at 12 Orme Square. Dannreuther had founded the London Wagner Society in 1873 and conducted the first Wagner concerts in London. In 1876 Wagner stayed at Orme Square; his sixty-fourth birthday party was held at the house with guests including Robert Browning. Another close friend was Hans Richter, the first conductor of Wagner's Ring Cycle at Bayreuth, in 1876.[47] Morris wallpapers and fabrics filled the 'quaint and old' house; 'nothing can exceed the sympathetic feeling with which these designs harmonize with the style of the halls and rooms'.[48]

Webb was not engaged to work at 1 Holland Park until 1879, after Alecco had taken over responsibility for the house from his father. In conjunction with Morris and Company, he would be occupied with the house for nearly a decade.

Webb first designed a staircase extension at the rear of the house. This comprised a segmentally vaulted porch with wrought-iron gates and grilles; wall and ceiling tiles by William de Morgan; an oak staircase with steeper steps for Alecco's bronze sculptures under the flanking handrails and a mosaic pavement on the main landing with a complicated scroll-patterned central portion in green to match the woodwork. White borders were diapered at intervals in black and orange.

The mosaic floor proved a challenge to its supplier, Joseph Ebner. He wrote with confidence on 2 September 1879: 'I shall be prepared to lay Mosaic for 1, Holland Park as per sketch & measurement supplied for the sum of 60 *Guineas* Nett Cash on completion and undertake to complete the work within 5 weeks from date of receipt

of full size drawings.' By 29 September he needed extra time and money: 'Every nerve is being strained to complete the work by the time appointed.' Finally, on 31 October, he was forced to admit to Webb that mistakes had been made with the design:

> I regret to say that a mistake has unfortunately been made in setting out the patterns, but it is not of so serious a nature as to ruin the design, and I do not think it would be noticed by anybody not thoroughly conversant with the patterns. The cartoons were prepared and out of the house in about a week and this point in the flow of the design seems in the hurry to have been overlooked . . . I will however take particular care to prevent such a mistake in any other work you may favour me with at a future time.[49]

For the dining-room Webb designed the panelling, a sideboard and a fireplace of Purbeck marble with old Persian tiles of hunting scenes (fig. 53). It was Walter Crane's decorations, however, which turned the room into a glittering work of art. Crane himself described his work:

> The room already had a fine Spanish stamped leather on the walls and some charming wood-work designed by Webb. I designed a coffered ceiling in relief, taking the vine as the orna-mental motif, and – thinking of Omar Khayyam – I placed an inverted cylix to serve as a boss at each junction of the panel mouldings. The frieze illustrated *Aesop's Fables* in a series of pan-els, each divided by vertical pilasters panelled with arabesques.
> The ceiling and frieze were, when fixed, covered with silver leaf, and then tinted and toned with various lacquers. Afterwards small designs worked in gesso in low relief, *in situ*, were added as fillings in Mr Webb's panelling at the end of the room and in the fireplace, a long panel above the latter being decorated with a design (also in gesso) emphasising the motif of the vine by a symbolic group framed by an inscription from the quatrains of Omar.[50]

The Ionides 117

54. Walter Crane, model in gesso
for a bell handle produced in
electro silver and copper.

Crane defined gesso as standing 'midway between painting and sculpture'.[51] In his description of his work, however, he gives little indication of the colours of the room. The vine of life on the ceiling was painted in gold on a blue ground; the Spanish leather on the lower walls was 'embossed with a pattern in gold, bronze-green, and a little dark red, on a sea-green ground'.[52] Morris and Company supplied the mahogany dining table inlaid with ebony (£38), the chairs were upholstered in red velvet (£30), matching the curtain fabric (£88) which was also from Morris and Company. Crane designed finger plates for the doors in lacquered gesso, bell pulls and light fittings (fig. 54), and, later, low relief designs in gesso for Webb's wood panelling. Finally, all the surfaces of the walls apart from the mantelpiece and the high dado of Spanish leather, were covered with silver leaf and then tinted and toned with lacquers in various shades, ranging from crimson to pale green and silver.

The result was considered by discerning visitors to be 'gorgeous' yet 'restrained'. 'It would be very hard', wrote Gleeson White in the *Studio*, 'to find another instance of equally elaborate decoration that was so cunningly kept within the proper restraint . . . the result is the reverse of gaudy, and as harmonious as a fine piece of ancient metal with the patina of age upon it'.[53] Lewis Day, writing in the *Art Journal*, declared the colour scheme 'a daring experiment, justified by complete success'; appropriate 'not merely for a room to dine in, but for one in which even a modest man might comfortably live'.[54] Though 1 Holland Park was not open on 'Show Sunday', its decorative schemes were fully covered in journals. Such descriptions, together with black-and-white photographs, are all that remain to convey the layout of the rooms.

The drawing-room and the antiquities room were decorated in 1883; the final costs reached over £1,300. The walls of the antiquities room were covered in 'a gold lac-

quered paper rich in various colours, that at first sight suggests Japan, but proves to be a design of chrysanthemum (by Morris) embossed in silver, overlaid with washes of brilliant transparent lacquer'.[55] The ceiling was painted gold and silver on an ivory ground; the hangings were of grey-greens and blues; the chairs upholstered in grey-green 'Utrecht' velvet, and 'Flower Garden' silk and wool damask. Morris's 'Carbrook' carpet was on the floor.

The drawing-room, with views through to the antiquities room, had walls covered with 'Flower Garden', a jacquard handloom woven silk and wool damask, the colours chosen 'to suggest the beauties of inlaid metal'.[56] The *portière* over the opening between the two rooms was of the same fabric, as were the curtains and valances. The ceiling was covered with a delicate floral design in blues, greens and oranges. On the floor was one of Morris' finest Hammersmith carpets, the 'Holland Park' carpet, with a dark-blue indigo field and a madder-red border. It cost Alecco £113.

Standing on the carpet was a Broadwood grand piano of green-stained oak decorated with swirling patterns in gold and silver gesso by Kate Faulkner. When it was exhibited at an Arts and Crafts exhibition in 1888, it caused Burne-Jones some embarrassment, as he explained to F.G. Stephens:

> on the private view day – I kept taking people up to it & praising it & lauding it to the skies never noticing a label on its top which assigned it to me – so a false impression of my character has gone forth – not for the first time – and an injustice been done to an admirable designer, which matters more.[57]

The majority of the paintings on the wall were by Burne-Jones, including *March Marigold* (1870), *Pan and Psyche* (1869–74) and *Spring* (1884).

Webb returned to 1 Holland Park in 1888, first designing an exercise room complete with its own marble fireplace, to be built in the garden. This appears to have been rejected by the less athletically disposed members of the family in favour of a loggia and smoking room, entered through a glazed door from a landing off the main staircase, and costing £2,000.

> Picture a room, long and high in proportion to its width, lined to a height of eight or nine feet, white marble surrounding panels graduating from a creamy tint to a russet brown, forming a pleasant contrast to the slips of dark green marble that enclose the panels. On the right hand side of the room is a recess, across which runs a frieze, supported by columns of Purbeck marble resting on the floor, with bases of the same material, the caps being of alabaster enriched with simple foliage. Above the broad surfaced moulding forming a coping to the marble, and running round the room, is a range of small windows set in an effective treatment of wood, the far end pierced with a window of circular shape, through which the light falls on the translucent marble. Passing through the door again, and looking down the staircase, is a large circular window at the farther end, following in parallel lines the segmental shaped plaster roof. The sides are panelled in wood and painted green, and from the cornice above springs the barrel ceiling.[58]

The walls of the staircase, the cloakroom and the lobbies were covered in 'Gold Poppy' paper. Paintwork, panelling and stair treads were repaired and an Axminster stair carpet was laid, 'a pleasant harmony in pale greyish-green and cinnamon'. The ceiling was painted with arabesques of gold and other colours upon a white ground (see fig. 2).

The morning room in Jeckyll's extension was also redecorated: Morris carpets of reds and blues, the walls of 'low-toned green' hung with Morris' 'Forest' tapestry (the

animals designed by Webb) and an 'Acanthus' panel of tapestry, also numerous pictures. Lewis Day was overwhelmed by the amount in the room, and yet, like the dining-room, the effect was pleasant, 'cosy' and 'reposeful' (fig. 55):

there is little left bare of pictures and what-nots. This is a room of contrasts, not to say contradictions. A dish of Japanese dragons in raised lacquer is hung as a pendant to one of Spanish lustre, and a Graeco-Roman elephant in bronze is found in close proximity to one in brass, patterned all over with subordinate beasts and ornament in a manner peculiar to Persian Art. Yet it is one of the cosiest and most reposeful rooms in the house. It is here that Mr Ionides finds place for his bookcases, his bureau, and suchlike furniture necessary to personal comfort, all of which are in the English version of the style of 'Louis-Seize'.[59]

Alecco's pleasure in his house was short-lived. He served as Consul-General of Greece between 1884 and 1894 but by 1897 his money had run out. An old friend, Philip Martineau, called and found him 'down on his luck and ill. He was kind and affectionate as ever and we, of course, had of the fat of the land; but it was rather a sad little visit, he being changed so. . . . We did not meet again.'[60] Alecco died in 1898. His widow sold the house in 1908 to the trustees of the Earl of Ilchester; the contents were sold and in the 1920s the decorations were painted over. After German bombs obliterated the house only descriptions remained:

It is one great charm of the whole house that it strikes one unmistakably as a place to live in. It is stored full of beautiful things, but they take their place, and are not, as it were, on exhibition, it has none of the air of a museum. . . . Here everything is so choice that there is not much to choose between them, and nothing asserts itself. One is struck not so much by the richness of it all as by its beauty, and the taste with which, out of elements one would have thought sometimes incongruous, a congruous whole has been evoked.[61]

55. The morning room, 1 Holland Park. The Forest tapestry (now in the Victoria and Albert Museum) hangs on the wall to the left of the fireplace.

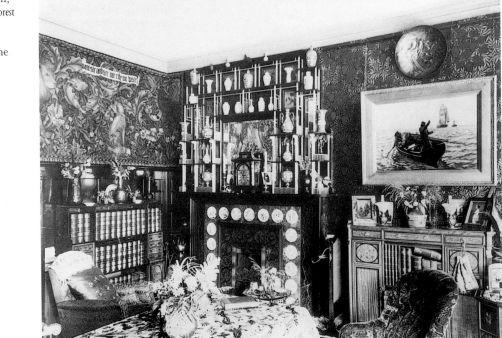

The Holland Park Circle

Meanwhile Alecco's elderly father, Chariclea and Edward Dannreuther had established themselves in Hastings. Alexander had bought two Regency cottages to be turned into one comfortable seaside home, Windycroft.[62] By the time work was completed, in 1891, there were Morris wallpapers throughout, a 'Roman marble mosaic pavement' and light fittings by W.A.S. Benson.

> The front door opened on a Pompeian hall with a mosaic floor. On the left, in a corner, serving for a lamp was an Etruscan tripod. In the dining-room, works of Whistler, Rosa Bonheur and Fantin-Latour adorned the walls, and there was a window seat overlooking the old town in a blue haze of smoke.[63]

Webb's final work for Alexander and his wife was to design the lettering of their gravestones in Hastings cemetery.

Constantine had moved relatively nearby, to 23 Second Avenue, Hove, which, according to his grandson, Bobby Ionides,

> was full of Ionideses, Cavafys, and Rallis when I was born there . . . the Cavafys lived at number ten Fourth Avenue; but the Ionidises weren't nearly so compact a family. They were all over the damned place. Cousins and aunts and uncles busily starting family feuds everywhere; and the head-quarters of all this plot-spinning was at number twenty-three Second Avenue, where my father's parents lived.[64]

Webb was naturally engaged to enlarge the house, adding a picture gallery with a coffered ceiling of two octagons, each with a central lantern in the iron and concrete roof, at a cost of just over £2,000. The gallery had a marble fireplace with embossed and silvered iron jambs; the Morris and Company hangings in silk and in wool were chosen by Webb; Kate Faulkner did some gilding.[65]

Constantine was still buying paintings. At the sale in 1887 of Charles Rickards' collection (Rickards was Watts' most important patron), he bought *The Window Seat* and *Daphne's Bath*, both by Watts.[66] It was Constantine, also, who was responsible for ensuring the Ionides name survived in the public domain. At his death in 1901 he bequeathed 1,138 pictures, drawings and prints to the nation.

> I give free of legacy duty all my pictures, both in oil and water-colours and crayon or coloured chalks . . . and all my etchings drawings and engravings to the South Kensington Museum for the benefit of the nation to be kept there as one separate collection to be called 'The Constantine Alexander Ionides Collection' and not distributed over the Museum or lent for exhibition. And I desire that the said etchings drawings and engravings shall be framed and glazed by and at the expense of the authorities of the Museum so that students there can easily see them.[67]

Items from 1 Holland Park were added: in the Henry Cole Wing of the Victoria and Albert Museum, Kate Faulkner's Broadwood piano stands beneath a selection of paintings from the Ionides Collection. The limited dimensions of the 'Ionides Room' can only hint at the treasures cared for by the museum in perpetuity.

9

The Aesthetic Interior

The houses . . . are those of millionaires. . . . They have preferred that their gold should be transmuted in this world, and into forms that are none the less beautiful for being costly. They are men who occupy a somewhat abnormal position even in wealthy London, and one which admits of a correspondingly rich and even grand environment. They have occasion, and are able, to have rooms which relate them to a large and cultivated world, while they can reserve for domestic privacy apartments that fulfil the want which to others is the only end of a home – a centre amid a busy and weary world for friendship, love, and repose.[1]

The Honourable George Howard was one of the first aristocrats to 'take up' Henry James when the novelist decided to settle in London (he took rooms in Bolton Street, Piccadilly, in December 1876). James attended two garden parties at Argyll Lodge, on Campden Hill, the Duchess of Argyll 'having invited me at the friendly prompting of George Howard. They are very pretty and full of fine folks, some few of whom I knew, and could talk to.'[2] At a dinner party, James was 'rewarded by the presence and by some talk with the adorable Mrs Lyulph Stanley', Howard's mistress.[3] He discovered Sundays were not entirely 'penitential gloom'; he visited Burne-Jones' studio at the Grange, North End Road, where he 'took a fancy to his work, as well as to that of Walter Crane . . . Burne-Jones is a more considerable affair than I had at first supposed, and his things (I think) the strongest English painting since Turner . . . a marvellous mixture of Italy and England'.[4]

Howard took James to Beaumont Lodge, Crane's house in Shepherd's Bush, to meet the artist. Crane recalled: 'He made some remarks in admiration of the artistic treatment of the house and of English houses generally, when Mr Howard said that he must not suppose that they were all like ours, or that artistic feeling was by any means the rule in English interiors.'[5]

Howard was right: houses such as 1 Palace Green and 1 Holland Park were exceptional, their interiors reflecting years of respect and friendship between patron, architect and artists. However, within the circle in which James moved in the late 1870s, he encountered rich men and women with the taste and the means to present their collections of contemporary art, almost always aesthetic, within exquisitely decorated interiors. The *Architect* noted the phenomenon in 1877:

Within the last few years . . . there has been an increasing tendency towards house decoration, not only amongst men of wealth, but also amongst men of taste, and by degrees the services of the best artists have been enlisted in a cause on which the last generation of painters would have looked down, but which was warmly espoused by the greater painters of the Renaissance period. The revival of art furniture, the increasing influence of Japanese

art, as its principles become better understood, and, above all, the rapid development of sociability as well as of social luxury of late years, have all tended in this direction. Artists like Mr Poynter and Mr Leighton have decorated the work of architects like Mr Aitchison and Mr Stevenson, and the happy results may be seen in dozens of houses in the neighbourhood of Hyde Park and Kensington.[6]

From the late 1860s until the late 1880s the 'social luxury' noted in the *Architect* was manifest in an extraordinary coming together of the fine and decorative arts. Some discerning collectors were seeking interiors appropriate for their paintings – by Leighton and his friends George Heming Mason and Giovanni Costa, by Watts, Val Prinsep, Burne-Jones, Rossetti, Whistler, Armstrong and Albert Moore. At the same time several of these artists, along with Aitchison, Crane and Morris and Company, chose to design friezes, panels, tapestries and mosaics, in some cases entire rooms, which perfectly complemented the paintings in their patrons' collections.

Algernon Swinburne, reviewing the Royal Academy exhibition in 1868, placed Whistler, Moore, Watts, Leighton and Rossetti together for their shared 'worship of beauty'.[7] Edward Godwin, reviewing the Royal Academy exhibition of 1869 in the *Architect*, noted that in gallery number two 'the most interesting pictures, from an architect's point of view, are those by Mr Marks, Mr J.F. Lewis, Mr Prinsep and Mr Orchardson, all of which show qualities eminently to be desired in the painters who are to decorate our architecture'. The *Portfolio*, founded in 1870, published a number of articles focusing on the purely decorative qualities of the paintings of Leighton, Moore, Burne-Jones, Watts, Poynter, Frederick Walker and Simeon Solomon.[8] As Helen Smith has explored in her analysis of decorative painting in the domestic interior,

> 'Decorative painting' as a term rapidly changed meaning from diapers and arabesques, through pictorial and figurative mural decoration, to any kind of painting aimed at satisfying the eye (rather than the intellect) when in combination with other objects and features of room decoration.[9]

There was also guidance for those unsure how to achieve the desired aesthetic interior. Christopher Dresser's *Art of Decorative Design* was published in 1862 to exploit the London International Exhibition; his *Principles of Decorative Design*, published in 1873, went through four editions. In his lectures delivered at University College he suggested that ornamentation warranted a higher status than pictorial art and called for an improvement in the status of the designer of 'mere' ornamentation. He reconstructed modern Moorish and Egyptian villas at Alexandra Palace in 1874, providing his guests with scarves, turbans, 'native pipes, cigarettes and delightful coffee . . . served on beautifully-wrought trays'. His students dressed as Moors and Egyptians.[10] As editor of the *Furniture Gazette*, he claimed that the laws of house decoration are

> the laws that govern the bringing together, or the grouping, of objects, for it is not only necessary that everything with which we surround ourselves is beautiful, but also that when brought together the different articles shall produce a harmony of colour and of form and thus make a pleasant whole.[11]

The architect Charles L. Eastlake's essays, first published in the *Cornhill Magazine*, appeared in volume form as *Hints on Household Taste in Furniture, Upholstery and Other Details*, in its third edition by 1872. Rhoda and Agnes Garrett wrote *Suggestions for House Decoration in Painting, Woodwork, and Furniture*, published in 1877: Mrs Haweis, a regular columnist on

Queen magazine, wrote *The Art of Beauty* (1878), *The Art of Decoration* (1881) and *Beautiful Houses* (1882). In *The Art of Decoration* she explained, 'A room is like a picture; it must be composed with equal skill and forethought; but unlike a picture, the arrangement must revolve around to a point which is never stationary, always in motion; therefore the 'keeping' becomes a problem far harder than the colour.'[12]

Among the wealthy collectors who visited Little Holland House, the studio-houses of Leighton and Prinsep, and the Howards' house on Palace Green, Aitchison was the favourite, in demand not as an architect but as an interior designer, sometimes working with Leighton, sometimes with other aesthetic artists. He was particularly sought after for work in London houses, transforming uniform stucco-mansions into unique palaces of art.

None of Aitchison's interiors, apart from Leighton's, survives intact though many of his original exquisite watercolour designs have been preserved. An eccentric bachelor, he lived with his brother William and sisters Fortuna and Kitty a singularly uneventful life in his house in Harley Street. He was a successful establishment figure, becoming ARA in 1881, RA in 1898, President of the RIBA in 1896 and Royal Gold Medallist in 1898. However, he 'refused a knighthood – saying that it would put 20 per cent on all his bills. Every year, in the first week of June, he and William would row up the Thames to Oxford, and at the beginning of September, they would travel to Oxford and row back again.'[13] His ideas appealed to royalty and aristocrats, industrialists and bankers, as well as to wealthy musicians and artists.

Blanche, Countess of Airlie was probably responsible for introducing Madeline and her husband the Honourable Percy Wyndham to Little Holland House in about 1865, although Wyndham's elder brother Henry lived on Campden Hill close to Holland House up until his marriage in 1867; also, Roddam Spencer Stanhope was married to the Wyndhams' cousin Lilla Wyndham-King.

Percy Wyndham was the youngest surviving son of Colonel George Wyndham, first Baron Leconfield of Petworth in Sussex. A hot-tempered aristocrat, he was a traditional Conservative Member of Parliament, passionate about hunting and shooting. Percy's wife Madeline had no fortune of her own but interesting ancestors: she was the granddaughter of Lord Edward Fitzgerald, who had died fighting for Irish freedom from British rule. Both shared the artistic taste of Blanche Airlie and the Howards; they also wanted to know artists personally, inviting them to dinners in London and weekends in the country.

A 'special' relationship between Watts and Madeline was formed in his studio at Little Holland House while he painted her portrait, though there was the usual prevarication over whether he would undertake the commission.[14] For the portrait Madeline wore a striking dress covered with sunflowers (fig. 56), fully in keeping with the preferred fashion of the ladies of Little Holland House. When Henry James saw the painting at the Grosvenor Gallery in 1877 he commented on her 'handsome person . . . dressed in a fashion which will never be wearisome; a simple yet splendid robe, in the taste of no particular period – of all periods'.[15] Though Watts, as usual, turned down invitations to the Wyndhams' country houses – 'I do not know that I shall ever be able to make my way to Wilbury House, to have the pleasure of seeing you at home, and of a gallop over the plains'[16] – he nurtured the familiar quasi-intimate relationship with Madeline which led, inevitably, to further commissions.

124

56. George Frederic Watts, sketch of Mrs Percy Wyndham (Madeline Wyndham) for full-length portrait. Watts Gallery, Compton, Surrey. Wyndham paid Watts £1,000 for the final portrait.

The Wyndhams' appetite for contemporary art was whetted at Little Holland House, and in the nearby homes of Leighton and Prinsep, as was the idea of decorating and furnishing a home to complement an art collection. Even if they had wanted their walls painted by Watts – they would have seen his work for the Earl and Countess of Somers in Carlton House Terrace, for the Hollands at Holland House and for Lord Lansdowne at Bowood – his passion for the medium had waned by the early 1860s. Instead they approached Leighton and Aitchison in 1869 to provide interior decorations for their house in Belgrave Square, the first collaboration by the artist and his architect after the completion of the preliminary stage of Leighton's house in Holland Park Road.

The Wyndhams were already regular guests of Leighton at his musical parties and stayed for weekends of music in Hampshire with Adelaide Sartoris; Wyndham also enjoyed military manoeuvres with Leighton, Watts and Prinsep and was a member of Watts' Cosmopolitan Club. It was hardly surprising that their collecting was strongly influenced by 'Holland Park', in particular Leighton: they acquired work by Corot and Daubigny; and by Leighton's friends Mason (*Evening Hymn*, a study for *The Gander*, *The Swans: Yarrow*) and Costa (*Winter Evening on the Sands near Ardea, Rome*). Gertrude Jekyll sold examples of her embroidery to both Leighton and Madeline.

While Aitchison devised a scheme in blue and Pompeian red stencilling for the staircase and inner hall of their house, as well as a design for the dining-room fireplace, Leighton, who also painted a portrait of Percy, produced five life-size dancing figures *The Cymbalists*, naked and semi-clad, to hang at the top of the grand staircase. Above was a frieze of cormorants, storks and other wild birds painted by Aitchison. The impact of *The Cymbalists* must have been overwhelming for guests walking up the wide stairs to parties in the reception rooms on the first floor.

Henry Wyndham, second Baron Leconfield, was painted by Watts and after inheriting Petworth in 1869 he began to redecorate the mansion using wallpapers from Morris and Company. In 1883 he commissioned Aitchison to complete his London house, 9 Chesterfield Gardens.[17] Aitchison had produced a design for the dining-room in 1880 (he was still working on the interior of the Wyndhams' house), followed by designs for the morning room, for the mosaic pavement and railings in the hall: 'the staircase . . . lined with pavanazzetto [peacock-coloured marble], with a black marble skirting, and the balustrades . . . of Rose du Var capped with Genoa green, and with monolithic shafts of red Devonshire'.[18] Madeline's eldest daughter Mary wrote in her diary: 'went all over his [Uncle Henry's] house; the mosaic pavement & marble stairs are lovely & the frieze in the dining room looks well'.[19] Leighton's protégé William Edward Frank Britten, whom he had befriended at the Royal Academy Schools in the late 1860s, designed the 'Decorative Frieze of Boys and Dolphins' for the morning room, exhibiting it at the Grosvenor Gallery in 1883 prior to hanging it in Chesterfield Gardens.[20]

Percy and Madeline Wyndham were exposed to the work of Webb and Morris and Company at Prinsep's house (Prinsep was a regular guest of theirs in London and the country) and at the Howards'. They dined at 1 Palace Green for the first time in June 1872, no doubt hearing of Burne-Jones' plans for the dining-room. They approached Webb to help re-hang some of their most treasured paintings on the staircase walls at Belgrave Square, and in 1876 Wyndham asked Webb to commission a brand new house, Clouds, in Wiltshire; the interior to be decorated by Webb and Morris and Company.

The relationship between Webb and the Wyndhams was exceptional; the political divide between client and architect was bridged by mutual respect and good humour. Clouds itself, 'a glorified Kate Greenaway affair, all blue and white inside, and all red and green outside', came to be regarded as 'the house of the age',[21] unique not just in appearance and contents, but also in its atmosphere and the nature of the life lived in it. The Wyndhams moved into Clouds in 1885, but neither Leighton nor Watts ever visited; the artist with whom it came to be associated was Burne-Jones, who visited with his wife and children. His paintings, cartoons and drawings hung on the walls. The Wyndhams kept the aesthetic style of Leighton and Aitchison – with the appropriate paintings – for their London home.

The Wyndhams, the Airlies and the Howards were friends of John Douglas, Marquess of Lorne and his wife Princess Louise, daughter of Queen Victoria. Lorne was Howard's cousin, the eldest son of the Duke of Argyll, who lived next door to the Airlies on Campden Hill. After their marriage in 1871, Lorne and the Princess were provided with an apartment in Kensington Palace, close by the Howards.

The Howards were dubious about the success of the marriage. Howard wrote to his father late in 1870:

> The whole matter seems to me to depend on whether the Princess will be willing to sink her rank completely and then whether her mother will allow her to do it. I fear that the almost universal snobbishness of the Briton will make simplicity difficult to her. I fear that Lorne is a little too pliable to stand the certain adulation with the brutality which could be the only way for remaining uncontaminated by it.[22]

The situation was rather more complicated. Princess Louise (fig. 57) was an enthusiastic sculptor (she had been taught, together with her sisters, by Mary Thornycroft) and was already involved with the sculptor Edgar Boehm 'tall, and slim, and wiry, and like a battered soldier',[23] who had given her lessons at the National Art Training School in South Kensington. He had achieved fame in English court circles with his statue of Queen Victoria, unveiled at Windsor Castle in 1869. Later he carved a bust for the Queen of her beloved John Brown. His relationship with Princess Louise was of such concern to the Queen that she deliberately sought out an appropriate husband for her daughter. Agreeing to marry Lorne, the Princess insisted they would live in Kensington Palace, which happened to be close to both Boehm's studio and his home. When the marriage broke down – some biographers claim Lorne's preference was for his own sex – the Princess consoled herself in the company of Boehm.

Both she and Madeline Wyndham were founders in 1872 of the Royal School of Art Needlework, established in Kensington for 'the teaching and giving instruction in ornamental needlework and the supplying of suitable employment for poor gentle-women'.[24] Madeline designed sunflower patterned curtains for Queen Victoria; Princess Louise designed more for Manchester Town Hall. Among the artists giving instruction at the school and supplying designs were Leighton, Val Prinsep, Burne-Jones, Morris, Crane and Aitchison. Princess Louise would also have seen the work of Aitchison at Leighton's and the Wyndhams' houses; in 1874, she and Lorne commissioned Aitchison to design interiors for the apartment at Kensington Palace.

The colour schemes he selected were more sombre than at Belgrave Square, appropriate perhaps for a royal couple living in a seventeenth-century palace: green woodwork and green and red walls in the ante-room; brown woodwork and dull pink walls in the small dining-room; green woodwork and gold walls in the drawing-room; red woodwork and gold walls in the large dining-room.

Princess Louise continued to practise sculpture, working in Boehm's studio. In 1878, shortly after her old teacher Mary Thornycroft moved to Melbury Road, she had a studio built in the grounds of the palace. Godwin was her architect. He explained the task to architectural students:

> I built a studio 17 ft. high and put over it a kind of Mansard roof, with windows looking into the garden. It is about 25 ft square and has an ante-room attached for the Marquis of Lorne,

57. George Howard, *H.R.H.*
Princess Louise. Castle Howard,
Yorkshire.

a little hall, and three entrances. The walls are of red brick, there are green slates on the roof
to match the old house, and few would notice that anything had been added to the old build-
ing. . . . It is admirably suited for a studio, and we managed to put it up for between £600
and £700, including architect's fee. All the light is reflected so as to reduce the horizontal
ceiling as much as possible. This studio seems perfectly satisfactory to the Princess, to Mr
Boehm, the sculptor (for it is a sculptor's studio), and also to myself.[25]

The Princess' relationship with Boehm continued throughout the 1880s; both
exhibited work at the Grosvenor Gallery which opened in 1877. William Blake
Richmond, another of her artist friends, painted a provocative portrait of her in
1880–1 but also noted her unhappiness when she dined with him in Hammersmith.[26]
The circumstances of Boehm's death in his studio in the company of Princess Louise
on 12 December 1890 provided the press with much speculation but Wilfrid Scawen
Blunt's version is now generally believed:[27]

It was during one of these visits [of the Princess to Boehm's studio] that while he was mak-
ing love to her Boehm broke a blood-vessel and died actually in the Princess's arms. There
was nobody else in the studio or anywhere about . . . and the Princess had the courage to take
the key of the studio out of the dead man's pocket, and covered with blood as she was and
locking the door behind her, got a cab and drove to Laking's [the Queen's physician], whom
she found at home and took back with her to the studio. Boehm was dead and they made up

The Holland Park Circle

a story between them to the effect that it had been while lifting or trying to lift one of the Statues that the accident occurred.[28]

The sculptor Alfred Gilbert, who occupied a studio in the same premises, added his weight to their concocted story by taking responsibility for finding the body. Princess Louise championed him for the rest of his turbulent life, providing him with accommodation at Kensington Palace in the 1920s and leading the move to bury his ashes in St Paul's Cathedral.

Like the Wyndhams, the Eustace Smiths were drawn to the possibilities of decorating their home to match their art collection through visits to Little Holland House and to Leighton in Holland Park Road. They were not, however, aristocrats, nor was their wealth from land. Eustace Smith was the sole heir to his family's shipbuilding business on Tyneside; his fortune was reputed to be £60,000 a year.[29] The family seat was Gosforth Park near Newcastle, but Smith established himself in London with his wife Martha Dalrymple, a cousin of Sir John Dalrymple (brother-in-law of Sara Prinsep). Martha was also wealthy, the co-heir to her father's fortune, and strikingly good-looking. She took the name Eustacia and became a regular visitor to Little Holland House.

Their first allegiance was, unsurprisingly, to Watts, and among their first purchases was *Choosing* (fig. 58), one of the portraits he painted of Ellen Terry during their brief marriage. The Smiths' granddaughter Mrs Rawson recalled that Smith

> saw the painting on one of his visits to Watts's studio and at once asked if he could buy it. Watts agreed and my grandfather took out his cheque book and paid for it. . . . Some time later my grandfather received a note from Watts saying he wished to withdraw the picture from his agreement to sell it, and intimating that Ellen had left him and that he was destroying all the paintings and studies he had made of her. My grandfather ordered up his carriage and hurried round to Little Holland House to claim the picture as rightfully his.[30]

The Smiths also bought Watts' *The Wife of Pygmalion* and a version of *Sir Galahad*. Watts painted Eustace Smith in about 1872, the same year he painted Eustacia's lover, the Conservative Member of Parliament Sir Charles Dilke.

Leighton had earlier rejected the commission to paint Dilke: 'What little leisure I have for portraits (which I own to paint unwillingly) is already given away and I have had to refuse to paint even old friends.'[31] However, he was willing to paint Eustacia with whom he appeared, at least to others, to have a close friendship. He became the major artistic influence in their lives after Watts and the Smiths went on to acquire his *Venus Disrobing for the Bath*, *Daedalus and Icarus* and a colour sketch for the *Daphnephoria*, probably a gift. They also bought paintings by Burne-Jones (*Cupid and Psyche*), Rossetti, Millais (*Esther*), Albert Moore (*A Garden*), Mason (*The Harvest Moon* – painted in Watts' studio at Little Holland House), Legros (*Chantres espagnols* and *Blessing the Sea*), and Prinsep (a pencil drawing of Eustacia).

Until 1874, the Smiths lived at 28 Prince's Gardens, close to Kensington Gore. Their collection was virtually complete when they moved around the corner to the larger 52 Prince's Gate, one of Charles Freake's speculative developments in Kensington. When it came to decorating their new home, their friendship with Leighton and the aesthetic nature of their pictures dictated the choice: George Aitchison.

A contemporary described the hall as 'marble, gilded, and spacious'. Above, on the first-floor landing, hung Leighton's portrait of Eustacia. The dining-room was designed

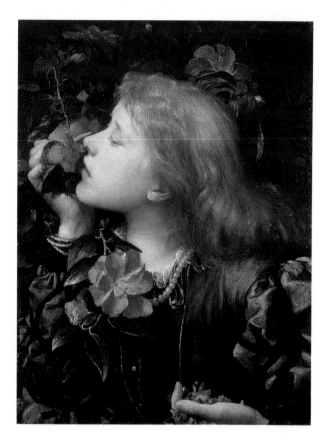

58. George Frederic Watts, *Choosing*, c. 1864. National Portrait Gallery, London. The model, Ellen Terry, wears her wedding dress, designed by Holman Hunt. She chooses between camellias, symbolising worldly vanities, and the small bunch of violets in her hand, symbolising innocence and simplicity.

around two large paintings by Armstrong, *Woman with Lilies* and *Woman with a Tortoise*. Armstrong's friends included Aitchison, Leighton and Howard: a study for his painting of girls in a hayfield hung on Leighton's staircase (so would have been seen by the Smiths); he and Leighton were guests of the Howards at Naworth as well as at Palace Green and after he moved to Campden Hill in 1882 he was invited to make use of Howard's studio. He approved of the way his paintings were hung by the Smiths, on walls which were 'gilded after a slightly indented pattern had been impressed upon them, an entirely new departure which was acknowledged to be a most successful background for both people and pictures'.[32] The dados and the rest of the woodwork in the dining-room were of ebonised wood inlaid with floral motifs in ivory and mother-of-pearl; Leighton designed the frieze.

Aitchison painted the walls of Eustacia's boudoir dull red. He then approached Walter Crane, at this time unknown to him, to design a frieze 'of white cockatoos with lemon and orange crests on a gold ground, connected by fanciful scrollwork in bronze green and red' (fig. 59). Crane had only just designed a frieze of birds and animals for 11 Kensington Palace Gardens, the home of the Spanish merchant José de Murrieta. Poynter lent his studio at Beaumont Lodge for Crane to work on the frieze for the Smiths; this and the Murrietas' commission led to the commission from Leighton and Aitchison to work on the Arab Hall at 2 Holland Park Road (see chapter 13); his gesso-work for the Ionides at 1 Holland Park followed soon after.[33]

In the drawing-room, visitors inevitably noted Leighton's large nude *Venus Disrobing for the Bath* (fig. 60) which was hung, conspicuously, on a wall of dull gold. When the

painting was shown for the first time at the Royal Academy in 1867 it caused a considerable stir, not just because it was the first large-scale nude to appear in the Academy for many years, but because it raised concerns about distinctions between 'the nude' and 'naked'. Leighton's *Venus* was acceptable because, according to the critic F.G. Stephens, 'nakedness is not the leading characteristic of this figure'; she was no 'languid, ferverous and luxurious dame of love' but represented a higher ideal.[34] However, the first owner, Frederick Leyland, had grown tired of the painting and sold it, in 1872, for a mere 175 guineas, whereupon it was snapped up by the Smiths.

Julian Hawthorne, son of the American novelist, recalled the combined impact of the painting and the hostess:

> [Eustacia] was dressed this evening in dark blue silk, open in front, but caught together at the throat by an insolent diamond: one thought, were that clasp to come undone, what an expanse of white loveliness would be revealed! but it held. . . . On your left as you faced the fireplace was a Venus, life size, soft, subtle, and naked, slipping off a sandal with the other foot, ready, that done, to step forward into your arms, apparently, but really, no doubt, into her perfumed bath. She was very beautiful and gently sophisticated: 'In fact', Eustacia spoke in my ear, 'painted by Fred Leighton from a woman well known in society: only the feet,' she added modestly, 'he made from mine; he said no other woman's were unspoilt enough. Of course, Fred and I have been dear friends for ever so long.'[35]

Hawthorne's account was undoubtedly coloured by Eustacia's reputation; her affair with Dilke was well known and did not prevent the marriage of Dilke's brother to her daughter Maye.[36] But when, in 1885, Dilke was named as co-respondent in the divorce of another of the Smiths' daughters, Virginia Crawford, Smith resigned his seat and left

59. George Aitchison, design for Eustacia Smith's boudoir, 52 Prince's Gate (frieze by Walter Crane). British Architectural Library, RIBA, London.

the country. Gosforth Park and the London house were sold and their collection was bought by Alexander Henderson, first Baron Faringdon of Buscot Park. The Smiths eventually returned to England in 1900, commissioning a house in the New Forest from Webb's pupil W.R. Lethaby.

Henry James had been a guest of the Smiths since he first arrived in London. He wrote of their fall: 'queer and dramatic and disagreeable . . . it is . . . by no means without a certain rather low interest if one happens to know (and I have the sorry privilege) most of the people concerned, nearly and remotely in it'.[37] Not only the appearance of the houses but the affairs of their owners would provide material for his fiction.

Eustacia Smith claimed to be intimate with Leighton; letters from Leighton to Stewart Hodgson, who commissioned Aitchison to work on both his London and country houses, indicate that Hodgson was recognised by Leighton himself to be a friend.

Stewart Hodgson was a partner in Baring Brothers and had been a close friend of Leighton since they had joined the Hogarth Club in 1859. He was a near neighbour of the Smiths at 24 Prince's Gardens throughout the 1860s and early 1870s. Leighton painted *Lieder ohne Worte* for him, in 1859–60. Two years later Hodgson bought *The Sisters*, another aesthetic work which F.G. Stephens found 'indescribable by not having any direct incident or tangible subject'.[38]

Like so many of Leighton's admirers, Hodgson bought the work of his friend Mason. A visitor to Leighton's studio at Orme Square in the early 1860s noted that

> he [Leighton] drew the attention of every person who came in away from his own works to show them 'a picture by my friend Mason,' expatiating on all its beauties with eager insistence and the joyous enumeration of its qualities, ending in a subdued change of tone as he added: 'He is in very bad health, poor fellow!'[39]

Hodgson helped Leighton to set up a trust for Mason's widow and children after the artist's early death in 1874; he also lent his works to an exhibition organised at the Burlington Club (Leighton arranged a sale of Mason's sketches at Christie's).

In 1874 Hodgson commissioned the *Daphnephoria* from Leighton for Lythe Hill, his house in Surrey. This was a very large work ($206\frac{3}{4}$ inches long \times 91 inches high), an imaginative re-creation of the triumphal procession held every ninth year in Thebes in honour of Apollo. The procession was led by the Daphnephora or laurel-bearer, a young priest acting the part of Apollo. The painting took over two years, during which time Leighton also worked on his first major sculpture, *Athlete Struggling with a Python*. Hodgson was close enough for Leighton to be honest about the conflicting work and to beg for extra time: 'just write a line and say "give up the statue" or "postpone the Exhibition of the picture" and your dictum shall be final'.[40] Leighton also painted a portrait of Hodgson's daughter Ruth, one of several works he exhibited at the Grosvenor Gallery.

Lythe Hill had been designed by Frederick Pepys Cockerell in 1870 in Tudor Gothic red brick. H. Stacy Marks decorated the entrance hall; in the drawing-room was William Blake Richmond's full-scale fresco in plaster, *The Duties of Women* (Richmond also painted portraits of Hodgson's daughters Mary and Agatha). Cockerell also designed a new house for Hodgson in London, 1–2 South Audley Street, in the Queen Anne style. At Cockerell's death in 1878, Aitchison took over the work and finished both houses.

He completed decorations at Lythe Hill in the drawing-room and in the billiard room, but it was his interior designs for South Audley Street that were particularly striking (fig. 61). He worked with Leighton, Crane and Britten.

Leighton had written to Hodgson to plead Britten's case. He had been most unfortunate with his regular patrons: 'H . . . for whom he had done large pieces, and was about to begin an important picture has died as you know. Hills the great collector of Brighton a staunch friend & "Patron" of his, has gone mad, and a third friend Mr Bethell who had ordered four works of his has also just died – he now finds himself with several works begun on the easel (he is a slow worker) and without a penny to go on till they are finished.'[41] Hodgson was moved to give Britten the commission to paint the frieze of the ante-room.

Leighton himself painted two friezes for the drawing-room, *Music* and *Dance*, though Hodgson had to wait several years. Leighton was again juggling several major undertakings.

> I write to throw myself on your mercy – I have *no excuse* – a promise is a promise you can keep me to it if you desire – I *can by dropping everything else* do your frieze this summer . . . but I had forgotten that if I do nothing to my statue this summer I can't have it cast in bronze (4 months work about) for next R.A. – and all my other work must be done in the winter months – entirely – which is not good for it; and I am thrown back by having to repaint my design for St. Paul's with which I am dissatisfied after seeing it up and I must do something to my fresco S. Kensington or the Dept. can't ask Govt for the money.[42]

Crane (having completed work on Leighton's own Arab Hall) was commissioned to make a further six panels of mosaic. 'There remained four smaller panels to be filled, and for these I designed "Earth", "Air", "Fire", and "Water", as well as two smaller arched panels in recesses of "Stags Drinking" and "A Faun and a Satyr".'[43]

Hodgson's collection, displayed in complementary interiors in London and Surrey, remained intact only for a few years. Hodgson, unlike the Smiths, was not forced to sell up because of a personal scandal; he suffered financially from the crisis of 1890 at Baring's. The bank had speculated unwisely in South America and Russia but was saved through the intervention of the Governor of the Bank of England. However, the partners were liable for all debts. Hodgson,

> least responsible of the partners of the old house, was nevertheless plunged from his riches and beautiful houses at Lythe Hill and in South Audley Street into poverty. His daughter, Ruth, nearly died of a broken heart at having to leave her home and in consequence of the great anxiety they passed through.[44]

All Hodgson's paintings were sold at auction in 1893.

Leighton knew several members of the Lehmann family, whose wide circle of friends spanned art, literature and music; they bought his paintings and commissioned decorative schemes from Aitchison.

Frederick Lehmann was a notable musical connoisseur, his wife Nina, a talented pianist; Henri and Rudolf Lehmann were artists. Leighton had first met Rudolf in Rome in 1854 when he was painted as the poet Lamartine in Rudolf's *Graziella*.[45] Rudolf settled on Campden Hill in 1866 with his wife Amelia, Nina's sister. Eliza, the sister of Rudolf and Frederick, married Ernst Benzon, an art collector who held musical parties at 10 Kensington Palace Gardens and owned *Graziella* as well as Leighton's *Golden Hours*

(see fig. 30), Mason's *Girls Dancing: A Pastoral Symphony* and Legros' *Procession of Monks*. Aitchison designed a decorative scheme for their dining-room in 1871.

Nina and Amelia Lehmann were the children of Robert Chambers, founder of the *Edinburgh Journal*; their aunt was married to W. H. Wills, Dickens' close friend and the sub-editor of *Household Words*, *All the Year Round* and *Daily News*. They were consequently friends of Dickens, of Wilkie and Charley Collins and John Forster. In 1855 Nina and Frederick Lehmann attended a performance of Wilkie Collins's play *The Lighthouse* at Campden House, Kensington:

> Last night . . . dress rehearsal of the play at the pretty little theatre attached to Campden House, Kensington, where it is played tonight for the benefit of the consumption hospital with the original cast. Mrs Collins sat next to me and got every now and then so excited applauding her son Wilkie that I thought the respectable, comely old woman would explode, he all the time looking and acting most muffishly. Nothing could be better than the drama as a drama, but oh, he makes a most unloving and unlovable lover. Dickens and Mark [Lemon] do *not* act, it is the perfecting of *real* nature.[46]

In 1860 Frederick Lehmann was at Wilkie Collins' party, together with Holman Hunt and Augustus Egg, to celebrate the publication of *The Woman in White*, and the same year he attended the wedding of Charley Collins to Dickens' daughter Kate (fig. 62) (Amelia Chambers, not yet married to Rudolf Lehmann, was a bridesmaid). The marriage was not happy: Kate was desperate to escape her 'unhappy home' and Charley, a short time before, was 'trying hard to talk himself into believing that he ought to be married'. Once married, Kate apparently told Dickens that Charley was impotent; she took a series of lovers including Val Prinsep.[47]

When Amelia and Rudolf Lehmann moved to Campden Hill they were close to the Lewises at Moray Lodge. Arthur Lewis' daughter Kate recalled visits to Rudolf's studio 'built out behind the house we children knew well, for he also had four daughters . . . and our Mathilde [the governess] taught them also. We could hear Mrs Lehmann and Liza practising as we passed the drawing-room door, and often voices upstairs

61. George Aitchison, design for the drawing-room, 1–2 South Audley Street (frieze by Frederic Leighton), 4 June 1881. British Architectural Library, RIBA, London.

60. (facing page) Frederic Leighton, *Venus Disrobing for the Bath*, 1866–7. Sotheby's, London.

62. Kate Collins (*née* Dickens) in mourning for Charley Collins, 1873.

would hail us to make some plan.'[48] Amelia wrote novels of little merit under the name Amelia Pain; the artists lived in Melbury Road and the heroines looked like paintings.[49] Rudolf's 'heyday' was 'during the seventies and eighties, when he painted elaborately finished oil portraits, agreeable, life-like, but not very penetrating, nor very exciting from the artistic point of view, of almost everybody who was anybody'.[50] He relied on introductions at the home of his own sister Mrs Benzon in Kensington Palace Gardens, where he met Dickens, Browning and Edward Bulwer-Lytton, who 'evinced much flattering interest in my painting of "Graziella" which nearly filled one side of my sister's dining-room'.[51] His own brother Frederick commissioned a portrait of Wilkie Collins in 1880.

The Benzons, the Lehmanns (both families) and Leighton shared a passion for music and their friends included performers with world-class reputations: the violinist Joseph Joachim; Charles Hallé, pianist and conductor of the Hallé concerts in Manchester; Hallé's second wife, the violinist Wilma Norman-Neruda; the singer Pauline Viardot Garcia. Frederick Lehmann could be critical, however, of Leighton's musical parties.

Leighton's studio looked lovely. Lamps all round and a sunlight from above lighted up his pictures, finished and unfinished. Hallé played a charming suite of Bach and Joe [Joachim] a

Romance of Beethoven, but beside these solos they played two whole sonatas of Beethoven – the two that follow each other in our book in A and C Minor. The latter they began only after 12: it was quite too much music and not the kind of music I love to hear with a lot of men and women knowing about as much of music as my hat. I think they ought to play small salon pieces and give people a chance of talking. O, it was slow, my dear.[52]

He also disliked the division he noticed between the ordinary guests and the 'court' which comprised Adelaide Sartoris, Prinsep and Kate Collins: 'the court never mixed for a moment with those who had not the entrée. The thing is quite too farcical for an observant spectator who does not care a rap for either the fat idol [Adelaide Sartoris] or any of her imbecile attendants.'[53] He wrote to Nina of a dinner he attended with Leighton and Adelaide:

> I do not see so much difference between French and English society. An *amant* seems a recognised social status, and some women get asked to parties with their *amants*, just as others do with their husbands. All right. It's none of my business and does Leighton the greatest credit, for anything more repulsive than this mountain of rolling fat with those spitfire eyes I never saw.[54]

Frederick Lehmann may have disapproved of Leighton's choice of intimate friends, but he liked his house sufficiently to engage Aitchison in 1872 to design the interior of his new home, 15 Berkeley Square. The overall impact of the house left Moncure Conway, author of *Travels in South Kensington*, almost at a loss for words after his visit early in the 1880s:

> Passing down the stairways amid the delicate hues lighting them up at every turn, and through the doorways curtained off from halls by rich Oriental draperies, and finding myself again in the embowered square at the front of the house, I feel conscious of an utter inability to give any reader an adequate conception of the decorations amid which I have invited him to wander in imagination. Let any one who has passed a morning in visiting the interiors of the old Venetian palaces attempt to describe them! . . . The finer secrets of art elude detection, much more explanation, like those of nature.[55]

For the dining-room Albert Moore designed a sideboard inlaid with medallions of ivory animals and fruit; Millais' portrait of Lehmann's daughter hung on the wall; Henry Smallfield, who had worked for William Burges at Cardiff Castle, painted a frieze of flying birds and boughs of blossom. In the drawing-room, Moore painted a 'matchless frieze . . . of peacocks, their long trains in repose'; the fireplace had tiles 'representative of six variations of humming-birds'. There was a Persian carpet, a folding screen of brilliant Japanese silk and watercolours by Turner were hung on the walls. The effects created by Aitchison at Berkeley Square so impressed a visitor in the early 1880s that he thought the completed rooms should be hung on the walls of the Royal Academy.[56]

The collaborations of Aitchison and Leighton, and of Crane and Moore, produced interiors which reflected the aesthetic taste of a discerning group of patrons who valued intimacy with artists above the value of individual works of art. The following section examines two collectors whose London homes were in Kensington but whose ambitions were rather different.

Henry James knew the homes of the Howards, the Airlies and the Wyndhams, Princess Louise and the Marquess of Lorne, Eustace and Eustacia Smith. In his fiction

he developed characters whose personalities were defined by their domestic settings, Mark Ambient, for example, 'The Author of Beltraffio':

> There was genius in his house too I thought when we got there; there was imagination in the carpets and curtains, in the pictures and books, in the garden behind it, where certain old brown walls were muffled in creepers that appeared to me to have been copied from a masterpiece of one of the pre-Raphaelites . . . it was a palace of art, on a slightly reduced scale.[57]

He quickly discovered George Howard was correct in warning him few houses were as tastefully decorated as his own; examples of 'aesthetic misery' can be found scattered through his novels and short stories, Waterbath, for instance, in *The Spoils of Poynton*, with its 'imbecilities of decoration . . . smothered . . . with trumpery ornament and scrap-book art, with strange excrescences and bunchy draperies, with gimcracks that might have been keepsakes for maid-servants and nondescript conveniences that might have been prizes for the blind'.[58]

There was a 'Waterbath' in Kensington, built by the financial speculator Baron Grant, the complete antithesis of the aesthetic palaces of the Howards and the Ionides. His career closely followed that of the speculator Melmotte in Trollope's *The Way We Live Now*.

> Of the certainty of the money in daily use there could be no doubt. There was the house. There was the furniture. There were the carriages, the horses, the servants with the livery coats and powdered heads, and the servants with the black coats and unpowdered heads. There were the gems, and the presents, and all the nice things that money can buy. . . . The tradesmen had learned enough to be quite free of doubt, and in the City Mr Melmotte's name was worth any money, – though his character was perhaps worth but little.[59]

Trollope's novel was first published in 1875 and the death of Melmotte – 'he was able to deliver himself from the indignities and penalties to which the law might have sub-jected him by a dose of prussic acid'[60] – pre-dated the completion of Baron Grant's palatial Kensington House and his almost immediate financial collapse by a couple of years. However, there were many similarities between the dubious Melmotte and Grant, born Abraham Gottheimer, who learned the rudiments of financial speculation in London and Paris,[61] and raised a fortune on joint-stock companies which promised but never delivered huge profits.

In 1872 Grant acquired seven and a half acres of land on the south side of Kensington High Street, between Young Street and Victoria Road, and opposite Palace Green and Kensington Palace. The plot, occupied by Colby House, Old Kensington Bedlam and notorious slums, was 'one of the worst and most squalid neighbourhoods in London'.[62] 'Mr Grant finally got rid of [the slum-dwellers] in April 1873, partly by offering them an easy lease in new industrial dwellings at Notting Hill, and partly by allowing those who went to carry away the wood-work of their houses.'[63]

Kensington House was the largest private residence in London (fig. 63), built at a cost of £50,000, with 100 rooms and a picture gallery 106 feet long. The grounds contained an ice-skating rink and a man-made lake, 'Yet withal there was no sign of that subtlety which may be called taste. . . . The house was designed in such a way that each side matched the other; and if you admired a marble chimney-piece in the western wing you could by opening the intervening doors admire its exact counter-part in the eastern wing.'[64] The paintings for the art gallery were purchased at

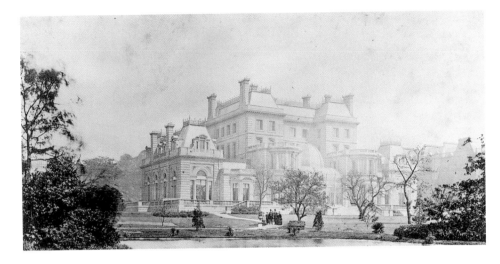

63. Kensington House.

Christie's – Grant was rumoured to have spent £150,000 – none from artists' studios or galleries.

At the same time as his house was being built, Grant was amassing an equally large fortune, some £24 million, through selling shares in joint-stock companies such as the Imperial Bank of China, the Lisbon Steam Tramways Company and the Emma Silver Mine in Nevada.[65] Just like Melmotte, Grant attracted those who wanted to make money for little effort.

> There was a time when all persons speculatively inclined came to believe that Grant held the Philosopher's Stone, that everything he touched turned to gold, but the gold eventually turned out to be nothing but dross. He had a very great following of people who wanted to get rich quickly. In consequence, he had the command of very large sums of money, and thinking his riches had come to stay, he committed great extravagances.[66]

Charles Howell, a dealer in art and artefacts and sometime friend of Whistler, Rossetti and Murray Marks, but with an inclination to lie and steal, was cultivating Grant in 1875. Rossetti was suspicious: 'Howell goes on humbugging as usual. I suppose if he brings Baron Grant (who is the big buyer he talks of) to the studio, he must be let in; but I am writing to H. that I won't have the man brought there unless he is as sure to prove a buyer as Fry was. Moreover, the pictures must be put in proper viewing order before he comes.'[67]

Kensington House was completed in 1876 but rumours were already circulating concerning the true state of Grant's finances. On 8 July, the *Builder* described the house but added, 'many [of our readers] have heard rumours as to the sale of it by the well-known gentleman for whom it has been built'.[68] On 17 August the *London Journal* described Grant as 'a man of amazing enterprise'. 'Enterprise is, however, a comprehensive term. Nothing succeeds like success; but the successful, while they command fulsome praises for often what is little better than a run of luck, may look for black looks, hard names, and bitter language when failures attend their speculations.'[69] Grant was exposed before he could move in; his collection of paintings – by Landseer, Frith, Millais, Calderon, Phillip and Leighton – was sold at Christie's in 1877. Rather than kill himself, Grant retired to Bognor Regis. No buyer could be found for the house.

Everything inside that could be removed, even the staircases, was sold at auction, and the house itself was disposed of for just over £10,000. Within a decade, the largest private house in London had been built, decorated, furnished and finally, in 1882, demolished.

In its place J.J. Stevenson (architect of Colin Hunter's house in Melbury Road) designed the perfectly acceptable red-brick Queen Anne style houses which formed Kensington Court. In 1885 Henry James leased an apartment in the newly built De Vere Gardens close to the site of Baron Grant's folly.

When Prinsep gave a lecture in January 1902 to the students of the Royal Academy he could have been thinking of Frederick Leyland, his father-in-law (Prinsep married Florence Leyland in 1884), the millionaire shipowner from Liverpool who aspired to 'live the life of an old Venetian merchant in modern London'. 'Since [Joshua Reynolds'] time the encouragement of art has fallen to those who have been enriched by trade. The great in the land have other cares, and artists have to seek to please the people instead of the select few.'[70] Leyland was not part of the group who commissioned the decorative work of Aitchison, but though he was an ambitious businessman, he was not a swindler like Grant.

He was influenced in both his collecting and the appearance of his homes by Murray Marks, who helped to acquire many of his paintings, porcelain and furnishings at the same time as he was supplying Alexander Ionides at 1 Holland Park. Marks' friends were Whistler, Rossetti and Burne-Jones, all of whose work Leyland owned (he sold his two paintings by Leighton before embarking on the decoration of his Kensington house). Leyland's reliance on Marks, his desire to compete with other collectors (including the Eustace Smiths, virtually next door at 52 Prince's Gate), and his stormy relationship with Whistler, distinguishes him from other patrons (though they shared many of his aesthetic tastes). After completing the dining-room at Prince's Gate, Thomas Jeckyll went mad and died in an asylum (or so the myth was created) and Whistler was declared bankrupt. The Ionides, the Howards, the Airlies, the Wyndhams, Hodgson, Princess Louise, the Lehmanns and the Smiths (also Burne-Jones and Rossetti's patron, William Graham) were all much more successful at nurturing close relationships with the artists they patronised. The value of individual works was not their primary concern.

Leyland's wealth, like Smith's, came from shipping. However, unlike Smith, who inherited his fortune, Leyland was a self-made millionaire. At the age of fourteen he joined the offices of the Bibby Line, in Liverpool, which had a number of business interests, including running a shipping line in the Mediterranean; by 1864, when he was thirty-three, Leyland was manager of the shipping business, which had moved from sailing to steamship services.[71]

The opening of the Suez Canal in 1869 adversely affected the Bibby Line and Leyland, a junior partner, was keen to use surplus ships on the profitable Atlantic crossing. Bibby 'was getting old and there was no member of the family ready to succeed him' so Leyland bought out the family and set up his own company on 1 January 1873. He wrote to Rossetti shortly before:

> I have been most anxious and worried these last few months in disputes with my partners . . . I have at last carried my point and got quietly rid of them and they leave me in full pos-

session on the 1st January when I shall hoist my own flag and carry on the business in my own name . . . I have succeeded in dictating my own terms.[72]

He was ruthless in commerce, a fact Whistler would discover.[73]

His first London house was 23 Queen's Gate which he acquired in 1867 when he was manager of the Bibby Line. Holman Hunt's patron Thomas Fairbairn had been the previous occupant. He also rented Speke Hall, a half-timbered Elizabethan house outside Liverpool, and carried out extensive restoration work and redecoration, using Morris, Marshall, Faulkner & Co. wallpapers. More Morris papers were used in the London house, Burne-Jones helping with the choice. Leyland also commissioned Burne-Jones to paint six watercolour panels for the dining-room, *The Seasons*, *Day* and *Night*, non-narrative scenes featuring solitary women. Such subject matter characterised many of Leyland's important commissions.[74]

He commissioned Whistler to paint *Six Projects*, a frieze of figures, for Speke or Queen's Gate, though the work was never completed. Whistler was a regular visitor at Speke from 1869 to 1875, painting a portrait of Leyland, *Arrangement in Black: Portrait of F.R. Leyland* and of his wife Frances, *Symphony in Flesh Colour and Pink: Portrait of Mrs Frances Leyland*. He also drew the children, Fanny, Florence, Frederick and Elinor.

After Leyland moved to the larger house in Prince's Gate in 1874, Marks recommended the architect Richard Norman Shaw (who was about to start work on his own business premises in Oxford Street) to transform 'the ugly London house into an Italian palace.'[75] Thomas Jeckyll was to be responsible for the dining-room (fig. 64). Jeckyll brought in Whistler, whose *La Princesse du pays de la porcelaine* was to hang in the dining-room alongside, appropriately, Leyland's collection of porcelain.

Whistler's initial work was successful. He painted seventeen panels on the staircase and hall, the panels 'imitating aventurine lacquer, decorated with delicate sprigs of pale rose and white flowers in the Japanese taste';[76] the walls above were painted a delicate willow green. The dado in the hall was of Dutch metal with gold leaf; above, hung Rossetti's oil of Janey Morris as 'La Pia de' Tolomei' (for which Leyland paid 800 guineas).[77] As visitors ascended the grand staircase, imported from Northumberland House, they could admire Rossetti's *The Loving Cup*, Burne-Jones' watercolour *The Wine of Circe* and on the landing above, three of Albert Moore's paintings of women, *A Venus*, *Sea Gulls* and *Shells*. The house was filled with paintings of beautiful women.

The decoration of the dining-room did not progress as smoothly. Thomas Armstrong recalled events:

> I will write down what little I remember about it. It was in 1876.
>
> Tom Jeckyll . . . designed shelves or étagères with turned spindles or balusters to go round the room. The walls were to be covered with old Spanish or Dutch leather, of which a sufficient number of skins had been found and bought [by Marks].
>
> Jeckyll, who was quite abject in his admiration for Whistler, showed him the leather and asked his opinion as to its suitability. There were pink flowers in the pattern, and Jimmy suggested that these should be repainted with yellow; I think it was described as primrose colour. This alteration was obviously a happy one, having in view the purpose to which the leather was to be put, namely, to be a becoming background to the valuable blue china. When Whistler began to try the effect of repainting the flowers on the leather he found the surface agreeable to work on, and, disregarding the original pattern, he worked all over it and evolved the blue scheme which pleased him so much.

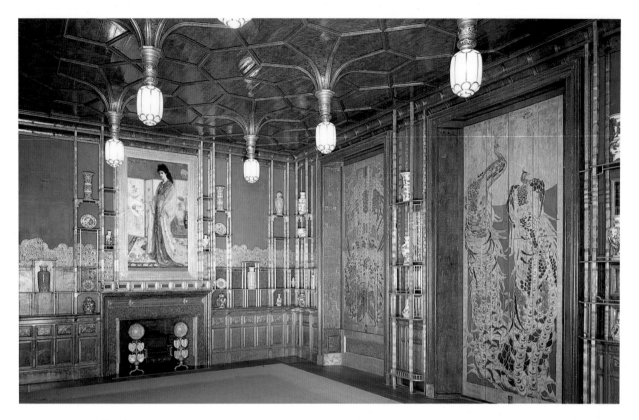

64. The dining-room,
49 Prince's Gate,
designed by Thomas
Jeckyll and James McNeil
Whistler. Freer Gallery of
Art, Smithsonian
Institution, Washington
DC.

... The impression I received on seeing the room was not very favourable, for the colour did not serve as a happy background for people or furniture, and it was fatal to the precious blue china ... the cobalt blue of the pots suffered terribly from juxtaposition with Whistler's paint, made of Prussian or Antwerp blue ... the effect of the embossed pattern which showed through the paint was disturbing and unpleasant.[78]

The peacock design was not spontaneous; Whistler had already offered 'a Peacock Room arrangement' to William Cleverley Alexander, a Quaker bill-broker, who lived at Aubrey House on Campden Hill although this may have been merely a plan for blue and gold decoration. Whistler had painted Alexander's daughter Cicely in 1872–4 and produced designs for the interior of Aubrey House and for furniture after the family moved there in 1874. Alexander rejected Whistler's peacock design, but did allow the artist to paint two rooms in the house, surviving designs suggesting that delicate shades of lilac, yellow and orange were used.[79]

Marks, though disappointed by the effect of Whistler's work on the blue-and-white porcelain, had to admit the beauty of Leyland's dining-room:

No one who has ever dined in the room, or has ever seen it when closed and lit up, can say a word against the almost miraculous beauty of the decorations, which, by artificial light when the shutters which formed an integral part of the scheme were closed; was quite wonderful and entrancing, but it was complete of itself, not a background for porcelain or for anything else.[80]

Leyland, however, was furious, particularly when he discovered Whistler had invited

Princess Louise, the Marquess of Westminster, Mrs Lyulph Stanley and other of his grand friends to visit Prince's Gate in his absence. He refused to pay the 2,000 guineas Whistler demanded (his compromise, an offer of 1,000 *pounds*, was taken as a gross insult), so Whistler altered one of the peacocks to look like Leyland, 'adding feathers so as to suggest a white shirt frill, such as was usually worn by Mr Leyland, and on the ground some shillings, which the peacock was guarding with his claw'.[81] Leyland finally refused Whistler admittance to his house; rumours were circulating of a relationship between his wife and the artist.

> I have accidentally learnt that on Monday last you called at my house and afterwards accompanied Mrs Leyland and my daughter Florence in my carriage to look over Baron Grant's house. . . . I cannot trust myself to speak of the meanness of your thus taking advantage of the weakness of a woman to place her in such a false position before the world – and I write now to tell you that I have strictly forbidden my servants to admit you again.[82]

Whistler retaliated with three satirical portraits of Leyland, *The Gold Scab*, *The Loves of the Lobsters* and *Mount Ararat*. Leyland and his wife divorced, a 'blundering sort of business',[83] thought Rossetti. Shortly after, one of their daughters died in childbirth: 'Poor fellow!'[84] 'They had gone to Italy, whither Leyland escorted his 2 other daughters to join them, and I suppose the whole party were still there at the time of the death.'[85]

Meanwhile Shaw, who had only just finished building studio-houses in Melbury Road (for Luke Fildes and Marcus Stone), and on Campden Hill (for George Boughton), was decorating the drawing-room (fig. 65), which 'was really composed of three charming salons, communicating with each other, and measuring respectively 33 ft., 29 ft., and 32 ft. in length'. The three rooms were separated by two screens, inspired by the rood loft of the Cathedral of Bois-le-Duc, which had been bought by Marks and given to the South Kensington Museum. Shaw designed the screens 'of carved walnut with bars of burnished brass, a combination of wood and metal, giving a richness, lightness, and elegance which no door, however ornate and ornamental, could ever rival'.[86] The paintings were grouped according to period: Leyland had a magnificent collection of early Italian paintings, including four Botticellis depicting scenes from Boccaccio's *Decameron* (Burne-Jones had brought the paintings to his attention), and Old Masters (Whistler had recommended he purchase Velázquez's *El Corregidor di Madrid*). Burne-Jones' seven paintings appeared 'a poetic conception which seems to float in an atmosphere of beauty that fills the spectator with a sort of religious awe, and carries him away from coarse materialism into a region of tenderly ecstatic revery'.[87]

When the writer Julia Cartwright, friend of Burne-Jones and Watts, visited in 1882, she was struck by the contrast between the beauty of the house and the family situation:

> The sad part is that Mr Leyland is separated from his wife and the girls grow up without a mother, caring little for the art and beauty around them and spending £600 a year on dress and not even entering into their father's refined tastes at all – with every opportunity for their self-improvement round them and not caring to learn.[88]

Leyland found consolation with Annie Ellen Wooster in a house designed for him by Shaw at Broadstairs in Kent and called Villette. At his sudden death in 1892 his entire collection was sold to raise capital for the maintenance of their two children. His death also enabled Prinsep to double the size of his house in Holland Park Road, creating

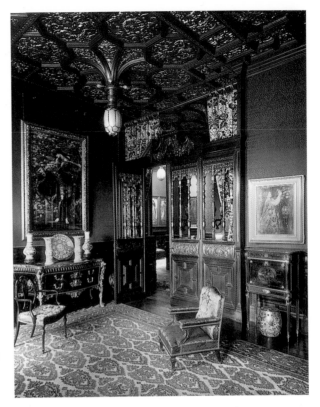

65. The drawing-room,
49 Prince's Gate. Burne-Jones'
The Beguiling of Merlin (now in the
Lady Lever Art Gallery, Port
Sunlight) hangs to the left of the
door; Rossetti's *Monna Rosa*
(*Portrait of Frances Leyland*) is to the
right.

with Webb a sumptuous music room to rival Leighton's Arab Hall next door and the interior of 49 Prince's Gate (see chapter 14).

The Peacock Room was not painted over and now it is fully restored, on display to the public in the National Museum of Art in Washington. Whistler would have been jubilant. He had written to Leyland on 31 October 1876: 'The work just created *alone* remains the fact – and that it happened in the house of this one or that one is merely the anecdote – so that in some future dull Vasari you also may go down to posterity like the man who paid Correggio in pennies!'[89]

The Holland Park Circle

10

The Creation of Melbury Road: 1875

Henry Edward Fox-Strangways, fifth Earl of Ilchester (fig. 66), first dined at Holland House in 1868. The following year he stayed with Lady Holland in Naples, where she 'informed him of her intention to make him heir in Kensington; for closer acquaintance convinced her that he was imbued with the family traditions and that the old house would be safe in his hands'.[1]

Her debts were increasing as she continued to entertain lavishly in London and abroad. Early in 1871 there was a serious fire at Holland House. It began in the sitting-room in the east wing, destroying several of Watts' paintings. Watts, Leighton and Val Prinsep rushed across the park to help. Watts later wrote

> I am grieved to find the picture [of Lord Holland] is destroyed beyond the hope of even employing the canvas.
>
> When the weather is better you will let me have the miniature you spoke of and I will replace the picture but it will not be the same thing, the Duc d'Aumale's picture is also quite ruined.[2]

The same year, a substantial piece of land surrounding the 'Moats' (between Addison Road and the park of Holland House), was bought by a Mr McHenry, who built himself a large house, Oak Lodge. He then offered to buy the whole of the Holland estate from Lady Holland. His approach precipitated her decision to revoke her will and leave the estate to Ilchester outright.

> Lady Holland proposes to make over to Lord Ilchester the whole of the Holland estate immediately, with the entire management of it, reserving to herself for her life the complete possession of the house, gardens and pleasure grounds, in consideration of an annuity to be given by Lord Ilchester during her life, the amount to be agreed on hereafter.
>
> Lord Ilchester cannot grant building leases during Lady Holland's life that would interfere with the beauty and enjoyment of the house, but he will be at liberty to deal with the outlying portions of the estate, as he may please, the land behind the Green Lane and the Little Holland House portion of the estate.[3]

She would receive a large annuity, also the use of the house for the rest of her life; Ilchester would take over the liability for all the mortgages. The papers were signed in January 1874, Robert Driver replacing Browne as the estate manager.

Ilchester was by this time married to Lady Mary Dawson, daughter of the first Earl of Dartrey. Their London home was in Belgrave Square; in May 1874 their son and heir Giles was born. Lady Holland had for once acted wisely: the Ilchester property was concentrated in the West Country: over 30,000 acres mostly in Dorset and Somerset,

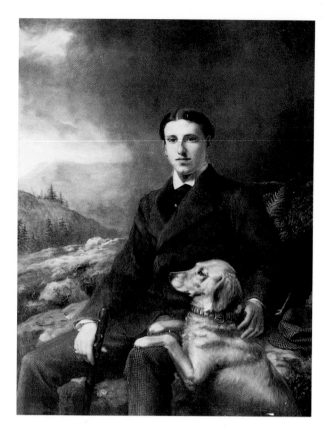

66. H. Graves, *Henry Edward Fox-Strangways, Fifth Earl of Ilchester with Ada*, 1883. Private collection.

with a gross annual value of £43,452.[4] Melbury House, the principal seat, was considerably enlarged in the 1870s in the expectation of a visit from the Queen. The Holland estate was acquired as a long-term investment; for the present it was a millstone around Ilchester's neck.

He was faced with the immediate problem of what new development to undertake to raise money on the property which 'barely paid for the mortgage, interest and other outgoings for which he had made himself responsible, quite irrespective of Lady Holland's large annuity'.[5] He turned his attention to the extensive grounds which surrounded Little Holland House.

Thoby Prinsep's lease was for twenty-one years from Christmas 1850. In 1867 Watts had asked Lady Holland if he could purchase a ten-year extension as he wished to erect a sculpture studio. She had 'pooh-pooh'd the idea that any legal agreement was necessary'[6] and he went ahead with his building project. It seemed a wise investment, as major commissions followed, including the Marquess of Westminster's commission to sculpt his ancestor Hugh Lupus, also the memorial to the Marquess of Lothian for Blickling Church.

However, in 1871, the year the Prinseps' lease ended, Watts heard of McHenry's interest in the estate, and that Lady Holland was being advised 'to sell off that part of Little Holland House garden on which his sculpture studio stood' (it was rumoured she had been offered £40,000 for the site), with the intention of creating a new road – Melbury Road – passing across the northern boundaries of the gardens of Prinsep and Leighton (fig. 67). He was devastated.[7] The statue of Hugh Lupus was hardly

begun. Though he and the Prinseps were allowed to remain on an annual basis, he bought a plot of land at Freshwater on the Isle of Wight on which to build a house. He must at this stage have decided to leave London for good.

Tennyson was apparently the first to suggest that Watts and the Prinseps should come to Freshwater to live near him. He and Emily had moved into Farringford in 1853, buying the Georgian house three years later. However, it was the arrival of Julia Margaret Cameron in 1860 that had transformed Freshwater into Holland-Park-by-the-sea.

Sara Prinsep's sister Julia was by all accounts an extraordinary woman. Anne Thackeray Ritchie, one of the regular visitors to Freshwater, knew her well:

> She played the game of life with such vivid courage and disregard for ordinary rules; she entered into other people's interests with such warm hearted sympathy and determined devotion that, though her subjects may have occasionally rebelled, they generally ended by gratefully succumbing to her rule, laughing and protesting all the time.[8]

She embarrassed the Tennysons with inappropriate and unnecessary presents – legs of mutton, rolls of wallpaper, Indian shawls – and with tiresome requests to take photographs (her daughter Julia Norman gave her her first camera in 1863). Emily described her coming 'across the park looking gorgeous in her violet dress and red cloak, walking over the newly mown grass'.[9] The Tennyson boys Lionel and Hallam became friends of Julia's sons, Charles and Henry.

Julia made the decision to settle at Freshwater. She was visiting the Tennysons in July 1860 and wrote to her husband who was inspecting his coffee estate in Ceylon.

67. Plan of proposed new (Melbury) road through Little Holland House.

68. Julia Margaret Cameron, *Merlin and Vivien*, c. 1874. Charles Hay Cameron is the model for Merlin.

This island might equal your island now for richness of effects – The downs are covered with golden gorse & beneath them the blue hyacinth is so thickly opened that the valleys look as if 'the sky were upbreaking thro the Earth'.... The trees too are luxuriant here – far more flourishing than they usually are by the sea – and Alfred Tennyson's wood may satisfy any forester.[10]

On his return, Cameron agreed to buy two adjacent cottages close to the sea from Mr Jacob Long. A tower was erected between them and the house was renamed Dimbola after their coffee estate.

Watts and the Prinseps were regular guests at Dimbola throughout the 1860s, Watts working on his portraits of Tennyson and his family. He wrote to Emily about painting the boys: 'the price shall be the pride I shall feel in giving pleasure to so great a man as Alfred Tennyson should I happily succeed, and the satisfaction of having done my best with that object should I be so unfortunate as to fail'.[11] The Camerons also built a cottage nearby, in which their friend Benjamin Jowett, Master of Balliol College, Oxford could stay. Julia named it 'The Porch' after the porch where Socrates and Plato spoke to the Athenians. Jowett brought his favourite undergraduates to stay, including Lord Elcho's son Frank Charteris. They were all caught by Julia's camera which offered alternative images to Watts' 'Hall of Fame' portraits. She also produced eerie illustrations to Tennyson's *Idylls of the King*, dressing up relations, local residents and guests, willing or not, in pseudo-medieval costumes (fig. 68).

Thackeray's daughters stayed with the Camerons immediately after the death of their father. Anne wrote to Walter Senior, son of Watts' friend Jeannie Nassau Senior:

It is the funniest place in the world. Everybody is either a genius, or a poet, or a painter, or peculiar in some way; poor Miss Stephens [sister of Leslie] says 'Is there *nobody* commonplace? . . . Mrs Cameron stays up till two o'clock in the morning over her soaking photographs, Jowett's lamp also burns from a casement . . . Mr Prinsep wears a long veil and a high coned hat and quantities of coats. Minny [Anne's sister] goes and reads Froude to him.[12]

To her editor George Smith she wrote: 'it is so heavenly lilac down here'.[13] In 1868 Frederick Walker stayed with Anne to work on illustrations for her novel *From an Island*. He made use of one of Tennyson's rose trees for his watercolour, *Lilies*.[14]

By the time Watts bought his plot of land at Freshwater, in between Dimbola and Farringford, Tennyson had built himself a new house, Aldworth in Hampshire, to which he fled during the summer months. Julia's photographs of the Poet Laureate, particularly the portrait dubbed 'The Dirty Monk', ensured he was instantly recognisable to the tourists who flocked to the island for a glimpse of him. The exhibition of her work at Colnaghi's gallery in 1868 had exacerbated the situation, even though some of the reviews were hardly favourable:

the subjects of many of the portraits are full of interest in themselves and are often noble in form and appearance, a circumstance which gives a value to the exhibition. Not even the distinguished character of some of the heads serves, however, to redeem the result of wilfully imperfect photography from being altogether repulsive – one portrait of the Poet Laureate presents him in the guise which would be sufficient to convict him if he were charged as a rogue and vagabond before any bench of magistrates in the kingdom.[15]

Watts paid for his house by painting portraits as the Prinseps had used up virtually all their capital in unsuccessful attempts to win a seat in Parliament so were reliant on Watts for a home. Also Thoby's health was failing and he was almost blind. The challenge for Watts was considerable: he still disliked painting portraits for money and was now faced with seeing up to three sitters a day. He wrote to his Manchester patron Charles Rickards: 'No one can imagine the intense weariness of my existence as a portrait painter.'[16] To Madeline Wyndham he wrote: 'I am obliged to work from 5 in the morning till 7 at night, and am all day employed upon finishing a lot of pictures – portraits that have gathered upon my hands – so I can only see any friends (unless by engagement) between 2 and 3 or after 6'.[17] Ruskin, writing to him on 1 February 1873 on hearing news of the house-building and his decision to 'adopt' a niece of the Prinseps, Blanche Clogstoun, also expressed concern about Watts' fear that his eyesight might be failing.

Your portraits are so good on points of character – though I think you always err somewhat on the resolvedly grand side – instead of giving people their little weaknesses, (for which we none of us now – nor anybody in the future, should like them a whit the less) – that I wonder you cannot enjoy yourself and feel truly and rightly employed – in making such records of the existing soul-world.

Meanwhile assuredly your first business is to lay by money for the future need, – if it is to come.[18]

Watts was also having to deal with an architect and with builders for the first time in his life. He wrote in some despair to Lady Holland: 'Trouble and expense are before me

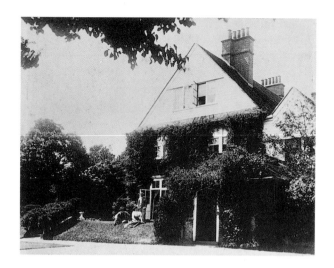

69. The Briary, Freshwater, Isle of Wight, c. 1890.

but the only real misery to me arises from loss of time; and I must hope to live long enough to make that up.'[19]

His chosen architect was, not surprisingly, Philip Webb, who was at the time also working for members of the Ionides family and the Howards; he accepted the brief on 27 February 1872.[20] Building work began in the summer. Laura Troubridge described the house as 'a three-storied building in red and white, half villa, half cottage, yet wholly delightful. . . . Nightingales sang in the copse at the back . . . soft, blustering winds brought the tang of the sea to the garden, which was full of old-fashioned flowers, lavender and sweet geranium, and climbing white and yellow roses.'[21] It was first to be called Myddleton Priory, then the Briary (fig. 69), after the profusion of roses growing in the banks of the drive leading up to the house. There was a great magnolia tree covering the front of the house and two tall cypress trees, reminding Anne Thackeray Ritchie of Italy, at the entrance to the drive.[22] Tennyson, anxiously watching the building operation, wrote to Watts on 27 December 1872, 'Your house here promises to be a very handsome one. Shall we see you here next year?'[23]

Watts' studio, on the ground floor, was 22 feet by 43 feet, double height with a large north window. An area below the gallery could be curtained off to form a private sitting-room and a tall west window enabled the egress of large paintings. Also on the ground floor were the dining-room and drawing-room, and a special invalid's room for Thoby, all three rooms facing south for maximum sunlight. The house was built of local bricks and roof tiles, reflecting the local vernacular; the gables and dormers were covered with white-painted weatherboarding. By roofing the bay windows on the south front with a continuous, deep lean-to, Webb created a veranda, perhaps intentionally reminiscent of India. The rooms had the benefit of south light without the risk of damage to their furnishings. Webb designed a red brick path through the garden so that Thoby could take exercise even though he could hardly see.

The Briary should have been a comparatively straightforward project for Webb; however, he and Watts fell out, providing much gossip for their circle. The fullest explanation for the row is provided in a letter from George Howard to his father, written some time after. Webb, fully aware of Watts' financial burdens, recommended that to save money they dispense with a clerk of works but use a builder 'in whom as he had

The Holland Park Circle

worked for him before, he [Webb] had confidence, while he would inspect the building as much as the distance would allow him to do while the building was going on'.[24] The builder was John Tyerman, who had worked on Sandroyd for Spencer Stanhope and on West House for George Boyce.

Local builders on the Isle of Wight were jealous, one informing Julia Margaret Cameron that work was not being properly done. When Webb travelled to the island 'to examine the charges' he found there was no basis to this allegation and threatened legal action, whereupon 'the local man declared in writing that there was no foundation whatever for the statements that he has made'. All would have been well except that Watts and the Prinseps decided to move in before the plaster was dry and Tyerman had finished the roof: 'of course the walls were damp; they thereupon consulted the local builder . . . [and] Watts on this authority complains very angrily to Webb'. Watts also brought in local workmen, whereupon Webb wrote to him:

> It is with real distress that I find come true, what I could not but have anticipated – The encouragement offered to the interested people in the Isle of Wight to gratify their angry disappointment at the employment by me of a London builder on your house has told . . . I will send for Tyerman, and as carefully as possible put the matter before him to see if there is any probability of his considering himself responsible – Since (as I heard from Tyerman) other workmen than those employed by him have been engaged upon the house.[25]

Webb wrote again on 17 July stating he had sent another architect

> whose professional character wd. be beyond suspicion and who might be considered unprejudiced . . . to visit the works and examine them, in the presence of Tyerman the builder employed by me and the several tradesmen who had been called in without my consent or approval to report upon Tyerman's work.

He enclosed the architect Mr Vinall's report in which Tyerman made it clear he was willing to carry out necessary repairs. 'As soon as these repairs are completed I must beg you to release me from any further interference in a matter wh has been so far from satisfactory to me.'[26]

George Howard summed up the dispute:

> Watts accusation that Webb had not taken proper pains to examine the building is in itself ludicrous, as it is exactly what Webb does do to the smallest & minutest detail. Watts in fact has been made a fool of by a pack of fussy old women who want to direct his house as they did his married arrangements. This however does not justify him in making misstatements to everyone he sees – & which he knows will probably remain uncontradicted as Webb with perhaps an excessive feeling of delicacy & reserve will not speak on the subject.[27]

Meanwhile Burne-Jones gave Rosalind Howard his version of events:

> Watts . . . has worked himself into such a froth that the old Watts is scarcely discernible . . . but I wish it were about something more worth the trouble – I cant think how he can take to heart the loss of money in that way, even if it is loss which I dont know. . . . I am sure he likes the fighting, for he can have nothing mean in him and Webb tells no one anything. I have asked him & he has refused because I know Watts – I have heard of it only through Morris – and Webbs story is clear & perfectly intelligible – even the very valuer that Watts selected to appraise the house valued it at about 700 less than its cost – & you know what valuations are – if your house had been valued as soon as built, some proportionate loss like that would have happened – it always does.[28]

Webb in the end refused to take a fee for either the design of the Briary or his supervision of its construction. So Watts, never less than precise about his own financial recompense, benefited from the sensitivity and fastidious honour of the architect.

While the house was being built, Watts and the Prinseps continued to live at Little Holland House. The move to the Isle of Wight was made in the spring of 1874. George du Maurier visited Freshwater in September, and sent a description of the community to Thomas Armstrong:

> Val was here painting in a box near the beacon – We used to go up there of an afternoon & be very jolly. He has done a very good thing there – downs and sheep. Watts' House is very jolly and he seems very well & happy – Mrs Cameron is without exception the greatest character I ever met; I find her delightful but don't think she would suit as a permanent next door neighbour for the next 30 years or so unless one could now & then get away. . . . She says I have a fine head – (I had always suspected this).[29]

Sara Prinsep had quickly established another seaside version of Little Holland House with a new generation of children clustering around Signor. Mary Seton Tytler (who was to become Watts' second wife) called at the Briary soon after her father acquired a house in Freshwater, an experience she was able to utilise for her biography of the great man:

> With the old furniture, and with the household gods from Little Holland House, which Mrs Prinsep knew so well how to place, the new walls framing these had ceased to look new. Mr Prinsep, now an invalid, was the centre of solicitude . . . At luncheon, Mrs Prinsep, at the head of her table, reigned over her large family party, looking like the wife of a Venetian Doge, transplanted into the nineteenth century, Mr Prinsep seated beside her. On his other side was the beautiful young widow – their niece, Mrs Herbert Duckworth – her hand often resting lovingly on his shoulder. Then the beautiful young wife and her husband, May and Andrew Hichens – not yet married a year; and her sister Anne Prinsep. . . . And there was Signor, with a child on each side, as he could not be parcelled out to the greater number who clamoured to sit by him . . . Afterwards in the big studio, with its serene sense of noble thought, one recalls the painter's light movements to and fro, always intent on work, and yet bearing so courteously with an interruption.[30]

Watts had lost nothing of his ability to play the part. A visitor recalled that he was one of the 'Immortals': 'There was something pathetic to me in the occasional poise of the head, the face so slightly lifted, as we see in the blind, as if in dumb beseeching to the fountain of Eternal Beauty for more power to think his thoughts after him. There is always in his work a window left open to the infinite, the unattainable ideal.'[31]

Watts may have been regarded as 'divine' and 'immortal' but he was also a professional artist who tried to maintain a punishing routine of work. He soon found that living on the Isle of Wight was not conducive to the production of either his symbolical works or the portraits that paid the bills. He needed a base in London and made the decision – an extraordinary one, given his experience with Webb – to build another house.

Before leaving Little Holland House he had agreed with Lady Holland about its poor condition:

The house itself will be of no use, as it is only kept up by constant patching; and, though those who have grown so fond of it as we have would willingly call in the Doctor to keep it going, it is not likely that fresh occupants would do so: indeed the thing would be out of the question.[32]

Lady Holland's legal adviser Edward Cheney expressed a similar view: 'I also went into the Farm yard, and a dirtier or more squalid spot I never saw, even in Ireland. All this being swept away will be an inestimable advantage.'[33]

While plans for the demolition of Little Holland House were being finalised, Watts paid rent up to 31 August 1875 (the Prinseps had left), moving between London and the Isle of Wight. Meanwhile he chose as architect his friend Frederick Pepys Cockerell, and began to look for a suitable plot of land in Holland Park. His friends were anxious to help. Burne-Jones wrote to him from London:

I miss you very much for it has always been a real comfort to run over to Little Holland House & grumble myself out to you . . . [is there] hope of you coming to town presently – always there is your bed room ready. Of the land I can get no news at all – I think the agent has forgotten all about it & when I stir him up invents histories for me of what he has not done in that matter. . . . Is there to be no more Little Holland House? it feels so sad as if one had come to another turn in life.[34]

The plot of land was part of Val Prinsep's garden, the northern half of which would face the new Melbury Road. Prinsep 'had found his garden, and the ground-rent he paid for this, too large'[35] and was happy to sub-let to Watts. The appropriate agreement was drawn up between Ilchester and Prinsep on 15 February 1875; Prinsep became leaseholder of the new house (from 9 November 1876) and liable for ground rent – which Watts presumably paid – of £60 per annum, rising to £120 after two years. Prinsep also took out a mortgage with the Lombardian Benefit Building Society on 3 November 1875 for £928, suggesting he was responsible for part if not all the building costs of the house.[36]

Frederick Pepys Cockerell was on the fringes of the 'Queen Anne' movement. He had designed a town house for Reginald Cholmondeley of Condover Hall, Shropshire which Watts would have seen. Cholmondeley was an amateur artist, and a patron (Watts sculpted his father Sir Thomas Cholmondeley in 1864–7) and assistant to Watts. His house was in Kensington, 37 Palace Gate, and ready for occupation in 1870. Five storeys tall and containing a painting studio, it was built of red brick with yellow stone bands and all manner of architectural styles were evident in its detailing, including a Venetian arch, a Dutch gable, French dormers and *Jacobethan* mullioned windows. Cockerell also designed town and country houses for Stewart Hodgson (see chapter 9).

The building of Watts' house began early in 1875 but Watts remained in Little Holland House for a few more months, overseeing the removal of his work into storage. He bought an iron house, the 'Tin-pot', which was erected in the garden of the new house. This was a special 40-feet-long 'Iron Removable Studio' produced by Bellhouse and Company of Manchester. The standard 14 foot square studio, 'inclusive of stove, papering, painting etc.', cost £60 10s.[37] Watts' was semi-detached; he planned that Burne-Jones would share the studio.

In September he finally left Little Holland House and moved to the Briary. His new London house he called, somewhat confusingly, 'Little Holland House' (it was eventually numbered 6 Melbury Road); it would be ready for occupation in February the fol-

lowing year. Meanwhile, as the demolition of Little Holland House went ahead, his friend Mrs Charles Wylie got into the house to rescue the frescos. He had made no arrangements for their removal. Emilia Barrington, later to become both his neighbour in Melbury Road and his biographer, described how they were saved:

> The surfaces were pasted over with thick brown paper before the walls were touched. The workmen then hacked the plaster away to within an inch or two behind the painting, and cutting out each design from the walls, packed them in wooden crates. . . . When removed from the cases, before touching the brown paper pasted over the surface, tow and plaster soaked in size . . . was squeezed tightly into the loose rubble – the remains of the wall left behind the pictures. This preparation was allowed to harden and become part of the previous ground. Then the exciting process began of washing off the brown paper and gradually seeing the designs emerge.[38]

During the building, Watts was in a constant state of anxiety, particularly when he was stranded on the Isle of Wight. He wrote to Jeannie Nassau Senior on 23 November 1875, 'all my things in London are now in such confusion that I don't know what I have'. And again on 16 January 1876, 'The experience I have had during the building of the house is most disheartening, and has depressed me very much [the workmen's] drunkenness, idleness, and at least so far, dishonesty, is certainly the rule, what is to be done?'[39]

The house had an unusually complicated interior, reflecting the demands of Watts as a painter and sculptor (fig. 70). On the ground floor there was one very large studio 50 feet long, rising up to the first floor, with a north-facing window and viewing gallery. There was also a sculpture studio rising up to the first floor with a gallery from

which to reach huge statues. These were built upon a trolley which ran on rails out to a paved apron, thus enabling Watts to work in the open air. Emilia Barrington described the sculpture studio where 'the conditions in which his work was carried on were delightful to him. . . . The "Hugh Lupus" and "Vital Energy" were both successively mounted on trolleys and run out on rails into his garden, so that for the most part it was in the open air that he worked on them.'[40]

Much of the first-floor space was taken up with the galleried studios, but there were also two bedrooms and a bathroom. The kitchen was in the basement; a sitting-room and third small studio on the ground floor. The *Building News* of 7 October 1881 summed up the house as, 'like its owner, unpretending and mostly devoted to work'. It was not, like Leighton's, designed with a series of reception rooms in which to impress society, nor did it offer Prinsep's bachelor snugness.

Cockerell died in 1878 and George Aitchison was engaged by Watts to finish the house. (Hodgson made the same choice.) He added a large picture gallery (the small studio became a waiting room) 28 feet by 24 feet with a roof of glass so no wall space was lost. Watts had chosen to invite the public, not just society, into his own private exhibition space (but not his house), every Sunday afternoon, for free. Burne-Jones joked about the cost: 'seven hundred and forty eight thousand nine hundred and sixty two pounds eighteen shillings and four pence'.[41]

When Watts settled into the new Little Holland House, Sara Prinsep, overseeing his welfare to the last, provided him with her own housekeeper Emma Grover, and Emma's mother. By May 1876, Watts was ready to return to the grind of portrait painting, to pay off the expenses of the two houses. He wrote to Gladstone, one of the first to resume sittings: 'New Little Holland House, in which you will find me, is about a hundred yards beyond the old place, and is the only house finished in the new road.'[42] A granddaughter of the Prinseps was visiting when Gladstone was being painted. Asked by Watts for her opinion she declared '"I think his ear is awful, like a piece of raw beefsteak" . . . as I repeated, "It's awful!" he said suddenly, half to himself, "Out of the mouths of babes and sucklings cometh forth truth"and altered it far more than he had meant to do.'[43]

Sidney Colvin found that after the traumas of moving, dealing with architects and builders, and the burden of yet more portrait commissions, 'The fine genius [Watts] . . . was of course quite unchanged: his beautiful simplicity of character did but increase with age, his high ambitions both in decorative painting and monumental sculpture continued with increase rather than abatement.'[44] However, Watts was working in the middle of a building site. His house may have been completed, but all around him new houses were rising in Melbury Road. The noise and confusion must have been hard for a man of such extreme sensitivity to bear.

Thoby Prinsep, receiving two watercolour sketches of the old Little Holland House, expressed in verse the sense of loss shared by the circle:

Where now five villas their broad fronts present,
And to the world are offered at a rent, –
Stood heretofore a nest of gables, built
Each to supply a want as it was felt:
And shaded lawns, mowed carefully and rolled,

Provided pastime for the young and old.
Here grew to manhood youths of honoured name,
And here their mentor WATTS achieved his fame.
Well might we elders in our hearts rejoice
That all things prospered in our home of choice.
Thus in long years no little fame accrued
Unto that domicile of structure rude.
Its demolition many much regret,
For there are many who can ne'er forget
The genial spirit in which friends there met.
In lasting memory of days so dear,
A friendly hand has placed these tablets here;
Making the lost loved home to re-appear;
We greet the vision, and suppress the tear.

Julia Margaret Cameron was more optimistic as she completed the poem:

Yet must these precincts lose the fame they won
As of high art, a seat surpassed by none.
Not so, the seed hath struck deep root, and see
Four Studios rising where one used to be
Attracted hither by the master mind
That ever sought through art to elevate mankind.
Still doth the master here pursue this aim
Beneath a roof identical in name
With the demolished home we so deplore,
Spreading its fame yet wider than before.[45]

Melbury Road was to be colonised by a new generation of artists, attracted to the area by the presence of Watts and Leighton even though most had very different views about art to their distinguished neighbours.

11

Stone, Fildes and Shaw: 8 and 11 Melbury Road

For the Ilchester estate Melbury Road was valuable building land; artistic use was not anticipated. However, the first seven properties to be completed were commissioned by artists. The presence of Watts and Leighton, pre-eminent figures in the Victorian art world; the proximity of wealthy patrons; the precedent set by two remarkable studio-houses already completed in Holland Park Road by Aitchison and Webb (for Leighton and Val Prinsep) and another, by Cockerell (for Watts), slowly rising; the availability of generous building plots, some incorporating the garden of old Little Holland House, made Melbury Road irresistible to artists of sufficient means.

Not all the artists were close friends. Their practices were varied – painting, sculpture, architecture – and their houses reflected different professional requirements as well as their own (and their architects') individual taste. Lady Holland objected to the varied styles, but the architectural press and the public who flocked to the area when the studios were open were of a very different opinion. The *Strand Magazine*, reporting a visit to Hamo Thornycroft at 2 Melbury Road in 1893, began: 'it requires but little apology for once again resorting to the immediate neighbourhood of West Kensington. There is no thoroughfare in London more inviting to those in search of all that is interesting, all that is instructive, than the Melbury Road.'[1]

Luke Fildes and Marcus Stone were the first painters to acquire plots. They both chose Richard Norman Shaw for their architect, 'tall, thin and distinguished-looking, quick of mind, easily amused, suave and persuasive with his clients'.[2] Shaw had trained, like Philip Webb, in George Street's architectural practice, and his early clients were artists or art collectors. However, while Webb's clients were almost all associated with Pre-Raphaelitism, with Morris and Company and the aesthetic movement, Shaw's clients represented very different aspects of the Victorian art world;[3] they were solid seekers after Academy recognition. As Escott wrote of Stone, Orchardson and Leslie, they were

> finished and prosperous men of the world in social request everywhere. Each of these, with the polished manner the outcome of prosperity as well as breeding (and better specimens of the intellectual gentlemen of England could not be found), impresses the popular mind with a feeling that art can be an exceedingly paying business; each thus, apart from his work, materially improves the status of his profession.[4]

Stone and Fildes were not Shaw's first artist clients. They benefited from his experience in working for other artists, John Callcott Horsley and Edward Cooke.

Shaw knew Rossetti and Morris and occasionally recommended that his clients use Morris and Company wallpapers, and he was always on friendly terms with Webb,

whom he thought 'a very able man indeed, but with a strong liking for the ugly'.[5] Webb, on the other hand, was no doubt thinking of Shaw when he commented in a letter in 1886 on 'the dilettante-picturesque of the so-called Queen Anne style'.[6] Shaw's partner William Eden Nesfield, with whom he set up offices in 1863 at 30 Argyll Street, was friends with Whistler, Albert Moore, Rossetti and Simeon Solomon, and collected Japanese ceramics. He, himself, designed the commercial premises in Oxford Street of Murray Marks.

John Callcott Horsley, Shaw's first artist client, grew up in London; his family home was 128 Kensington Church Street. However, like several other older Kensington artists, including Richard Redgrave and James Hook, he decided to move to the country-side, acquiring Willesley in Cranbrook, Kent in 1864.[7] Horsley painted imaginative reconstructions of 'ye olde England' (one of his most popular works was *Rent Day at Haddon Hall in the Time of Queen Elizabeth*, exhibited in 1836), so Shaw provided him with an appropriate home, redolent of rural romanticism, with an oak-panelled hall in which to display his paintings and welcome his friends.[8] Fittingly, Horsley became Treasurer of the Royal Academy and led the campaign against students studying from the nude earning him the nickname 'Clothes Horsley'. The armaments manufacturer Sir William Armstrong had bought his painting *Prince Hal* and Lady Armstrong visited Willesley in 1868. The following year Shaw was invited to transform Cragside, the Armstrongs' Northumberland property.

Edward Cooke, the marine painter, moved from Hyde Park Gate to Groombridge in Sussex,[9] where Shaw built him Glen Andred, in the local wealden style, in 1866.[10] Cooke was unable to sever links with London altogether, and in 1871 he commissioned Shaw to design 18 Hyde Park Gate. The house was built of cheap stock bricks, with spacious tall sashes and stone dressings burgeoning into fleur-de-lys. It was the first house Shaw designed in London and marked a new direction in his career – his development of the Queen Anne style. It also brought him different clients, including the Honourable William Lowther, MP and the stockbroker and amateur artist John Postle Heseltine who commissioned houses between 1871 and 1874, to be built close to Cooke's: Lowther Lodge (now the Royal Geographical Society) on Kensington Gore and Heseltine's house, 196 Queen's Gate.

Both Lowther and Heseltine were discerning and wealthy men who entertained the artists whose work hung on their walls. Lowther was married to Charlotte Alice Parke, aunt of George Howard and a talented amateur artist with a reputation for high-mindedness: 'at some of her entertainments it was not easy to tell where society ended and high thinking began'.[11] The Lowthers purchased the Auckland estate on Kensington Gore, two acres of gardens and Eden Lodge, for £36,000. In their new red-brick house, Shaw provided them with a large central hall which was used as a ball-room and an exhibition space for the Royal Amateur Art Association which Alice founded, 'a dignified and artistic setting in which to entertain their elegant friends from the world of politics and society' (fig. 71).[12] Heseltine's house had an engraving studio on the fourth floor. He was a member of the Etching Club and consequently a regular guest of Arthur Lewis at Moray Lodge; he later became a trustee of the National Gallery.

For Fildes and Stone, neither of whom had achieved their Academy ambitions, Shaw appeared to be the best architect, a man who would design the most imposing of studio-houses with appropriate settings for potential patrons.

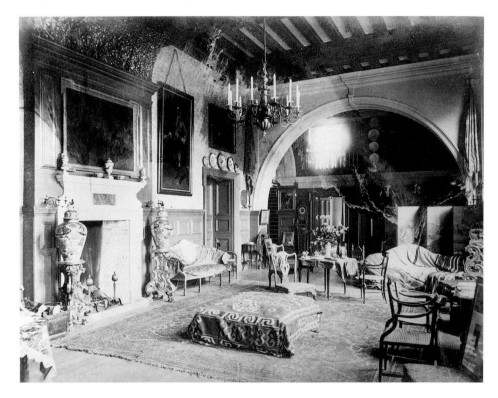

71. Lowther Lodge, Kensington Gore, designed by Richard Norman Shaw.

Though Fildes and Stone knew one another before they were neighbours, their relationship was turbulent, sometimes friendly and supportive, sometimes decidedly competitive. Their houses were built at virtually the same time: Fildes' architectural plans are dated August, Stone's September 1875; building began on Stone's plot in December 1875, on Fildes' plot early in 1876; Stone moved in early in 1877, Fildes in October. Their rivalry is apparent in a letter Fildes wrote to his brother-in-law, the artist Henry Woods in November 1876: 'It [my house] is a long way the most striking and most superior house of the lot. I consider it knocks Stone's to bits tho' of course he wouldn't have that by what I hear he says of his but my opinion is the universal one.'[13]

Marcus Stone's career as an illustrator was launched with the help of Charles Dickens, who had been a close friend of his father. Frank Stone, Augustus Egg and Wilkie Collins had been companions of the novelist during his 'barnstorming theatre days' and were regular callers at his homes in London and on holidays abroad. Frank Stone was a popular genre painter, becoming an Associate of the Academy in 1851, though Marcus recalled only being aware of his profession after the family moved to London in 1850; before then his father had commuted between his London studio and Finchley. 'Although my father was an artist, I saw nothing of him as such until I was ten years of age . . . my father came down only two or three times a week, and we never went to London.'[14]

In 1850 the Stones took Tavistock House in Bloomsbury, but soon gave it up to Dickens' family and moved next door but one. The Stones' and Dickens' children were constantly visiting one another's houses. Stone recalled the novelist's 'love of order and

fitness, his aversion to any neglect of attention, even in details which are frequently not considered at all. . . . In the drawing room his pictures were arranged exactly as they had been in the Devonshire Terrace dining room but as this room was twice the size they had more space between them.'[15] The pictures were of characters from Dickens' novels; he 'surrounded himself with his own imagined world'.[16]

Stone never received any formal training, but began his career by helping his father: 'I was not taught I "picked up" . . . I have never painted with so light a heart as I did when I was a "junior partner".'[17] He mixed with the artists who were friends of his father, Egg, Hunt, Frith, Mulready, John Phillip and Elmore, and in 1856 joined the informal life class they established on Campden Hill (which Leighton briefly attended). It met twice a week in a hired room on Campden Hill; these were 'gatherings for hard work and systematic study, not occasions for gossip and the interchange of studio tittle-tattle'.[18] Stone was stimulated but also appalled by London:

> How strange and wonderful it was, although I came into a new life; a new world in which I have lived ever since, it nevertheless filled me with an awful sense of its drawbacks which I felt acutely, & which I still suffer from in the same way after dwelling in it for sixty years. The darkness, the dirt, the dilapidation, its nauseous sour smoky odours, its mean streets, its hundred square miles of squalor which surround a small centre in which is contained its splendour and opulence.[19]

Silent Pleading, his second painting to be shown at the Academy, depicted poverty in the contemporary world (in a sentimental fashion). A country gentleman restrains a policeman from arresting a tramp who is sheltering from the snow, his small child wrapped in his cloak.

It was hung in 1859, the year Stone's father died. Dickens immediately offered Marcus his help. He wrote to the publisher Thomas Longman:

> I am very anxious to present to you . . . young Mr Marcus Stone, son of poor Frank Stone, who died suddenly but a week ago. . . . He is an admirable draughtsman, has a most dextrous hand, a charming sense of grace and beauty, and a capital power of observation. These qualities in him I know well to my own knowledge. He is, in all things, modest, punctual, and right, and I would answer for him, if it were needful with my head. If you will put anything in his way you will do it a second time, I am certain.[20]

Stone provided illustrations for the *Cornhill*, *GoodWords* and other periodicals throughout the 1860s, and he was also commissioned to supply the designs for Dalziel's woodcuts for the library editions of Dickens' novels. In 1864 Dickens asked him to illustrate his new novel, *Our Mutual Friend*. Phiz – Hablot Knight Browne – was dismayed:

> Marcus is no doubt to do Dickens. I have been a 'good boy', I believe. The plates in hand are all in good time, so that I do not know what's 'up', any more than you. Dickens probably thinks a new hand would give his old puppets a fresh look, or perhaps he does not like my illustrating Trollope neck-and-neck with him – though, by jingo, he need fear no rivalry *there*! Confound all authors and publishers, say I. There is no pleasing one or t'other. I wish I had never had anything to do with the lot.[21]

It would appear that Dickens took little interest in Stone's work.[22] However, Stone provided Dickens with the real-life character for Mr Venus, the taxidermist in *Our Mutual Friend*: 'Marcus . . . came to tell me of an extraordinary trade he had found out, through one of his painting requirements. I immediately went with him to Saint Giles's to look at the place.'[23] Stone, for his part, acknowledged the help Dickens gave: 'It was his

72. Marcus Stone, *Two's Company, Three's None*, 1892. Blackburn Museum and Art Gallery, Lancashire.

example which was always before me which taught me habits of punctuality, diligence, and the like, and it was his example which saved me from the possibility of becoming an idler or dilettante, of which there are too many in all the arts.'[24]

Stone's illustrations for Trollope's novel *He Knew He Was Right* (published 1868–9) were regarded as being more successful.[25] The photoxylography or photo transfer process was used for the first time for work by Trollope. Stone's drawings in black ink were photographed on to the sensitised wood blocks, leaving the originals intact.

Since his father's death, Stone had shown annually at the Royal Academy, realising that although black-and-white drawing might pay the bills for the moment, oil paintings had greater status and would eventually command high prices: 'Black-and-white drawing proved . . . to be a class of Art which had little in it to attract an artist possessed of aspirations as keen as those which were already influencing young Stone.'[26] At the same time, cheap black-and-white reproductions of Stone's paintings would contribute to his popular and commercial success.

In 1860, he had written to William Gimpel: 'I hope that my next picture [*The Sword of the Lord and of Gideon*] will double the value of Silent Pleading. I am working like a horse. Flatou [the dealer] has forbidden me to show to anyone.'[27] Three years later, *On the Road from Waterloo to Paris* received considerable notice when it was hung at the Royal Academy: 'The by-play of history, suggesting rather what might have happened under certain conditions than pretending to present an actual reflection of . . . events'.[28] Rosalind Stanley (to become Rosalind Howard), not yet familiar with the work of Burne-Jones, confessed to liking it: 'There is also a beautiful picture of Stone called "From Waterloo to Paris" showing Napoleon resting in a farmhouse in deep dejection.'[29]

Edward II and his Favourite, Piers Gaveston and *Le Roi est Mort — Vive le Roi* (shown at the Academy in 1872 and 1873) marked the end of his historical subject-pictures. He was gradually moving towards the sentimental, romantic subjects he would concentrate on for the rest of his life and which would be dubbed the 'Stone Age'. Paintings with titles such as *Rejected*, *Waiting at the Gate*, *Bad News*, *A Passing Cloud*, *Two's Company, Three's None* (fig. 72) would pay for a comfortable lifestyle in Melbury Road.

Meanwhile Stone had married and settled in Langham Chambers. The couple remained for six years 'looking for a suitable house, but in vain, and at last we decided to have . . . one built'.[30] The idea to approach Shaw to build the appropriate house in which to live out the 'Stone Age' emerged while Stone was on holiday with Luke Fildes.

Luke Fildes was not from an artistic family. 'I cannot trace any inclination towards painting in the family', he told a reporter for *Strand Magazine* in 1893. Neither was he poor: 'he has never known what it is to be without the wherewithal to furnish the ordinary bread-and-butter of daily life'.[31] He was brought up by his grandmother, a formidable woman, member of the Chartists and President of the Female Reformers of Manchester.[32] She allowed him to attend the School of Art in Chester and then in Warrington, where he met Henry Woods, who was to become his lifelong friend and brother-in-law. After visiting the International Exhibition in South Kensington in 1862 Fildes was determined to study art in London and won a scholarship of £50 per annum to attend the School of Design in South Kensington. He then embarked on a career as an illustrator, working for the same periodicals as Stone, including *Once a Week* and *Good Words*.

When William Luson Thomas decided to found a new journal, the *Graphic*, in 1869, he explained his plans to Fildes. The *Graphic* was to be 'a highly-priced paper, the very best we can get together by the combination of the best writers, artists, engravers and printers. I have you in my eye for many good drawings.'[33] Fildes provided *Homeless and Hungry* (fig. 73) for the first issue (4 December 1869). The sketch was based on personal experience: 'never shall I forget seeing somewhere near the Portland Road, one snowy winter's night, the applicants for admission to a casual ward. It lived in my mind, and as I sat there in my room I tried to reproduce it.'[34] London's Houseless Poor Act of 1864 required those seeking temporary food and shelter to apply at a police station for a ticket of admission to overnight lodgings, called casual wards, in a local workhouse.[35]

Meanwhile, Dickens was looking for an illustrator for his new novel, *Edwin Drood*. Stone was concentrating on oil painting so Dickens had asked his son-in-law Charley Collins to try. Collins, however, was too ill (he died in 1873), as Dickens explained to Frederic Chapman: 'Charles Collins finds that the sitting down to draw, brings back all the worst symptoms of the old illness that occasioned him to leave his old pursuit of painting; and here we are suddenly without an illustrator!'[36] Millais, knowing of Dickens' difficulty, spotted Fildes' drawing in the *Graphic* and drew the attention of the novelist. Fildes, after convincing Dickens he could also draw pretty girls, was given the commission and immediately wrote to Woods, 'It is the turning point in my career.'[37]

Dickens died before *Edwin Drood* was finished, Fildes' commission remained incomplete too. However, he was invited to Gad's Hill after the funeral 'and it was then, while in the house of mourning, I conceived the idea of "The Empty Chair", and at once got my colours from London, and, with their permission, made a water-colour drawing a very faithful record of his library.'[38] *The Empty Chair, Gad's Hill Ninth of June 1870* appeared in the Christmas edition of the *Graphic* and was an instant success. Thousands of copies were sold. The watercolour version was hung at the Academy in 1871. As the *Art Annual* commented when surveying Fildes' career in 1895, 'He knows exactly what will touch his audience, and never was this gift more strongly betrayed than in his drawing of the Empty Chair. . . . Still to be seen in all parts of the country as one of the most treasured pictures.'[39] The source of Fildes' wealth was the combination of the high prices paid

73. Luke Fildes, *Homeless and Hungry*, original sketch for the *Graphic*, 4 December 1869. Forbes Magazine Collection, New York.

for his oil paintings and the fees he received for reproduction rights; the availability and distribution of prints of his works contributed to the popularity and value attached to the originals.

Fildes attributed his decision to become a painter to the death of Dickens. It 'had an extraordinary effect upon me. It seemed as though the cup of happiness had been dashed from my lips. I was tiring of wood-drawing, and being now fairly well off – for my work secured good prices – I determined to become a painter.'[40] His income in 1872 was just over £500.

Fildes took a studio at 22 King Henry's Road, Haverstock Hill (Woods also took a studio in the house) and began work on his first oil painting. He sought Millais' advice on which topic to select, either the casual ward or a sentimental boating trip, *Hours of Idleness*, which had appeared in *Once a Week* in June 1869. Millais recommended the latter. *Fair, Quiet and Sweet Rest* was consequently completed by the spring of 1872, and sold to the dealer McLean for £600 even before Fildes sent it to the Academy. Though it was hung well, *The Times* was critical: 'Do not let him allow his younger friends to persuade him that he has really done much more than give a proof that he can handle brushes and colours deftly and effectively.'[41]

When Fildes submitted *Applicants for Admission to a Casual Ward* to the Academy in 1874 his work was again hung well and the public, if not all the critics, were so enthusiastic that the painting had to be protected by a railing and a policeman. Fildes sought his models in the streets of London, then stood them on brown paper surrounded by disinfectant. One drunkard, 'that fellow with his hands thrust deep into his pockets – was a perfect character. He would not sit to me without a quart pot by his side, which I had to keep continually filled.'[42] To remind his public of his special link with Dickens, he published, in the catalogue, part of a letter written by the novelist after a visit to the Whitechapel Workhouse: 'Dumb, wet, silent horrors! Sphinxes set up against that dead wall, and none likely to be at the pains of solving them until the *general overthrow*.'[43]

While critics debated whether such a subject was suitable for painting – the *Saturday Review* stated that the work was 'too revolting for an art which should seek to please, refine, and elevate'[44] and the *Manchester Courier* declared it 'a chamber-of-horrors style of art'[45] – Fildes already had a purchaser, the wealthy cotton spinner and manufacturer Thomas Taylor, who had bought *Fair, Quiet and Sweet Rest*. Fildes wrote to his grandmother: 'The owner of my first one is anxious to have this one also. They are both the same size, 8 feet. . . . If he buys the one I am now doing he intends sending them both to the Great American Exhibition to be held in 1875. He says "to get me more honours".'[46] Taylor paid £1,250 for the *Casual Ward*. He was only too delighted to hang the work in the art gallery (which he opened to the public on Wednesdays) of his country house, Aston Rowant in Oxfordshire.[47] The sale of one painting brought Fildes a princely sum.[48]

Such success gave Fildes the confidence to propose to Henry Woods' sister Fanny, an artist of some ability in her own right who exhibited at the Dudley Gallery. After marrying in July, they spent the winter months of 1874–5 in Paris with the Stones. The sojourn abroad was not without tensions, as Fildes explained in a letter to Woods:

> It will be often decidedly irksome to be so close to the Stones. They do so love to take possession of us but I shall very plainly give them to understand that we wish to have our own way & not be bothered but on the other hand it will be certainly be more pleasant to Fanny to have someone to go out with in the day. . . . You must notice my doubtful tone about Stone but he and I get on very well when we only see one another occasionally. We are the two most unlikely mortals to be much together. We both hold such different opinions about everything that every day expect a grand flare-up. As it is we defer to one another – I am sure we do – for peace sake.[49]

Laura Stone, older than Fanny, gave advice to her companion, including that she should wear her Titian-red hair tucked away under a hat. 'You are making yourself *conspicuous!*'[50] According to Fildes' son the two men made no attempt to acquaint themselves with the work of French artists, even though the first Exhibition of Impressionists had been taking place.[51] They did, however, discuss their plans to build their own studio-houses.

Stone had his own ideas about his ideal house and drew up plans which he showed to Shaw, 'who was good enough to approve them as a working basis, and I left the whole building of the house in his hands, so that it is his house – architecturally'.[52]

At the time his own work was beginning to develop the style and content with which he would always be associated: 'idyllic compositions full of tender expression, subtle domestic dramas in which Love would always be found playing the leading part'.[53] Though Stone believed the 'best and most valuable art work is done by the man who treats his own period', he considered it 'impossible in England, from what I may call the hourly change of fashion, to paint men and women in the costume of a given year'. Consequently, he selected the 'early days of the century' for his costume, 'while the thoughts and sympathies of the men and women would be sufficiently close to be readily sympathized with by the public'.[54] His decision brought him popularity and wealth, and only praise in the pages of journals such as the *Art Annual* and the *Strand*.[55] Other, more discerning critics gave him the nickname 'Marcus Apollo Belvedere Stone'.

His looks and public manner undoubtedly helped to sell his work: 'sleek, smooth-mannered, habited with extreme care, wonderfully well-looking, and with no more of the artist in his appearance than is indicated by a certain picturesqueness in his "tout-

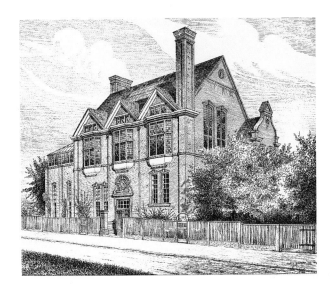

74. 8 Melbury Road, designed
by Richard Norman Shaw,
drawn by Maurice B. Adams for
the *Building News*, 30 April 1880.

ensemble".'[56] The *Art Annual* went further, emphasising a manliness not normally asso-
ciated with an artist.

> Tall, athletic, and in the prime of life, he is possessed of an appearance quite appropriate to
> the stately proportions of his rooms. His vigorous personality, which unites with a distinct-
> ly artistic picturesqueness a certain military uprightness of carriage, is obviously an accom-
> paniment of an equally vigorous mind. The suggestion of alertness and close observation,
> which is given by his keen glance and shrewd expression, is borne out by the physical char-
> acter of his well-knit frame. He looks like a man who could hold his own in any difficulty,
> who would, in fact, be better to have as an ally than as an opponent.[57]

Like one of Samuel Smiles' heroes, he knew all about hard work: 'Surrounded though
he is with all the evidences of his own success, he has remained modestly aware of the
necessity for keeping, in his artistic practice, a constant watch upon himself, and he
never forgets to what a life of endless endeavour a painter is committed to the very end
of his days.'[58]

The plot on which Shaw was to build Stone's house (fig. 74) was on the south side
of Melbury Road, immediately next to Watts. The estate granted Stone a ninety-nine-
year lease from 1875 at an annual rent of £90;[59] the builder, W.H. Lascelles, was fre-
quently used by Shaw. The house was placed right on Melbury Road (from where the
studio windows are clearly visible) so that an expanse of lawns and shrubberies, dot-
ted with mature trees, stretched south to Leighton's gardens, providing 'just the back-
grounds in which he [Stone] delights'.[60]

The house was built of red brick, with Shaw's characteristic tall, narrow sash win-
dows. Shaw placed the family rooms, Laura's domain, on the ground floor, a drawing-
room and dining-room, three bedrooms and a dressing-room. The servants slept and
worked in the basement (by 1881 the Stones, who were childless, employed a cook, a
personal maid and a housemaid). There was a lift from the basement to the first floor,
where the studio was situated, also a back staircase by which models reached the studio.

The first commentary on the house is provided by the *Building News*, in 1880, which
characterised the house as possessing 'the spirit of an Old English home'. The drawing-
room was 'quaint', with its recessed fireplace and barrel-vaulted ceiling; the location

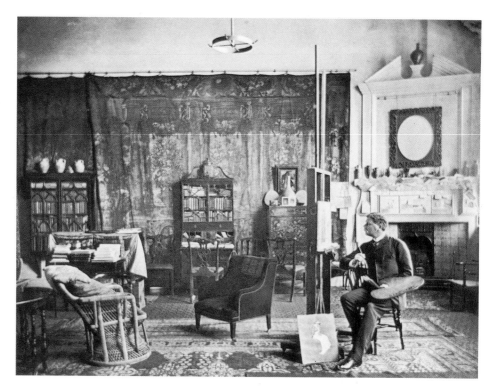

of the garden door, through a curtained lobby, was 'picturesque'. The walls were hung with 'a very pretty, stone-coloured, small-patterned paper, the woodwork and hangings being of a similar shade. . . . The ceiling is enriched by Japanese stamped wall-paper, in gold and brown, and a massive brass, old-shaped candelabrum is suspended from the centre'.[61] As a contrast, the dining-room walls were salmon red.

The studio occupied the whole of the first floor (fig. 75). Light was of paramount importance to Stone, who claimed to be 'the first to build a studio for the painting of outdoor effects'.[62] A contemporary describes how the studio worked:

> The north wall is occupied by three large oriel windows reaching up to the top of the wall, and each is surmounted by a dormer window extending nearly up to the ceiling. The wide piers of walling that intervene between these windows are sufficient to separate the floods of light into three distinct masses, so that the space in front of each window receives a direct light undisturbed by that from the next. The result of this disposition of light is that the painter can stand at any window, and place his model at any other window, with the certainty of having a full light both upon his canvas and upon the model. When one considers that there is a distance of thirty-seven feet from the edge of the window near the fireplace to the opposite edge of the farthest window, and that this painter claims that a picture should be treated with true perspective effect, then the advantages of his long side-lighted studio will be appreciated. But these advantages are not limited to the four walls of the room, for large folding doors in the east wall open into a glass house, which enable the painter to place his model sixty feet away from his canvas. At this distance he can paint garden and other outdoor subjects, being himself indoors – that is to say, with his work under the same condition of light as it would be when hung in a room or picture gallery, for a picture painted in the open air is found to be out of key when framed and hung indoors.[63]

The woodwork in the studio was painted white, 'any other colour being, in the opinion of Mr Stone, more than likely to influence the painter in the tone of his colourings in an injurious degree';[64] the walls were hung with tapestries and hangings which the reporter from *Strand Magazine*, seated on a chair belonging to the Chairman of the Hell-fire Club, identified as 'pre-Shakespearian'. He also spotted an early eighteenth-century looking-glass and a 400-year-old piece of turquoise crackleware. By the early 1890s, Stone could boast, 'there is nothing in the room that does not represent a certain period'; the *Art Annual* praised the effect of the room 'in which it is imperative that there should be no jarring note or discordant touch'. Just outside the studio was an enormous wardrobe, some 12 to 14 feet long, in which Stone kept the costumes worn by his models, their passage to an earlier, romantic age.

Fildes' house, on the opposite side of Melbury Road to Stone's, was larger and cost more to build. He could afford to be extravagant because, soon after Shaw had accepted the work, Fildes' grandmother died leaving him all her property. At the same time, *Betty* (orginally called *The Milkmaid* and really a portrait of his wife Fanny), was such a popular exhibit at the Academy Show of 1875 that it was chosen by the *Illustrated London News* for reproduction in colour as a Christmas supplement. His plot was the finest in Melbury Road, as Shaw pointed out: 'I do most heartily congratulate you on having got that bit – and I feel quite certain you will *never* regret it. What is £20 or £25 a year, in comparison to such a delicious site, *absolutely nothing*.'[65] The garden had originally been part of the grounds of Little Holland House. Fildes' son (and biographer) recalled

> towering elms, a noble acacia, oak, sycamore, and the finest white-blossoming may-tree, as tall as the house, that ever was seen. A many-buttressed wall of great age was the eastern boundary, and on the other side of it was the country lane . . . leading up to the stables of Holland House. On the far side of the lane there were more towering elms and a bank which was a mass of wild-flowers in spring and summer.[66]

House-building progressed slowly. Fildes' decision to move the studio to the first floor delayed the completion of the plans; the close proximity of the house to be built by William Burges, the architect of Cardiff Castle, on the plot immediately to the west, raised concerns about boundaries. On 23 March 1876, Shaw wrote to Fildes with the news that the ground on the site of his house was

> bitter bad – a lot of it *soft* slushy clay – and the rest hard treacherous clay. . . . if it is any consolation to you Burges is worse – he is now putting in beds of concrete that are too astonishing but then I suppose he is going in for a fortress . . . I think we could do with 18″ thick under the Eastern half of the house – but it must be 2′6″ under the western half – the side next to Burges.[67]

Fildes would have to find an extra £120. 'The worst of it is I see no possible way out of it – So I must ask you to go and look at it yourself on Monday – when your picture is off your hands and mind.'

The picture Shaw was referring to was probably *The Widower*, to be hung at the Royal Academy in 1876. It was to be another resounding success, the *Morning Post* writing, 'the man who could view the picture without emotion would not be a desirable person to know'.[68] *The Widower* had been inspired by the sight of one of the models for *The Casuals*, 'a rough-looking fellow' taking care of his child when they retired behind a screen to

rest. 'The child had fallen asleep, and there was this great, rough fellow, possibly with only a copper or two in the world, caressing his child, watching it lovingly and smoothing its curls with his hand.'[69] The 'Widower' went on to help lay bricks for the new house.

When Shaw wrote to Fildes on 6 June to explain progress, Fildes and Fanny had gone away to Venice. *The Widower* was sold, again to Thomas Taylor, for £1,890. Fildes noted that his income for the year up to 1 April 1876 (he was thirty-three years old) totalled £3,327 5s. 5d., all from the sale of paintings apart from just over £100 interest from investments, and £30 earned by Fanny's sales. His expenditure was £1,217 2s.9d.[70] Fildes' friend Linley Sambourne, the *Punch* artist, had married in 1874 on an income of about £2,000 per annum, made up from his earnings from *Punch*, his wife's marriage allowance and his private income of £650. He could not, however, afford to build his own studio-house in Holland Park, but took an eighty-nine-year lease, for £2,000, on a tall, stuccoed house in Stafford Terrace on Campden Hill. His prospects were secure – he continued to work for *Punch* all his life – but he was not in the same league as oil painters with ambitions to become Academicians.[71]

Shaw could only envy Fildes and his wife the 'sunny south'.

> . . . you will find your brickwork better than Stone's but please don't tell him *so* your being built in the summer is all pointed as it goes on but his being done in winter & spring is dirty – and has all to be messed about. . . . We shall be up to the level of the studio – when you come back, or even higher. . . . I wish you would not write about Venice and your happiness – it is very unkind of you – for it makes me entirely discontented.[72]

Returning to England, Fildes was able to inform Woods that progress was finally being made: 'The house is getting on first rate, not quickly, but well. It is roofed-in and begins to look a most imposing structure certainly the best looking and largest of the lot.'[73] He allowed himself the luxury of thinking about appropriate 'treasures' to display inside and called on Woods for assistance:

> I think I can spare enough [money] for anything you may buy for me in Venice in the dish way but I don't know those dishes with the inlaid malachite stones. Are you sure they are old ones & not made up for the modern market? because brass dishes with inlaid stones are new to me. I am a little in doubt about the hanging lamp, for, as you know, the hall in the new house is very low but it would probably do for the stair-case some where – If you have already bought it well & good but if you have not have another look at it – If well worth the money bring it – You may buy me anything you like, particularly if you could get Coleman's judgment for it, but I don't care to go above £10 or so as money will be very tight for some time.[74]

Fildes' concerns about money were linked to the threat of war between Turkey and Russia; regular purchasers of paintings were holding back. He told Woods the effects were 'already being felt at the "Dudley" [Gallery] & elsewhere . . . Fanny's two pictures [painted by her] are hung there and well but she has heard nothing about them.' Fanny was also eight months pregnant.

The Fildes finally moved in the autumn of 1877 (fig. 76). In June Woods had been asked to get calico for the windows 'for it is most necessary that they should be covered this weather as . . . the house is drying much too quickly'. When Fildes paid Shaw in October, the architect promptly replied: 'I have just a moment to acknowledge receipt of your cheque [for £226 10s.] – and to thank you very much – you are an

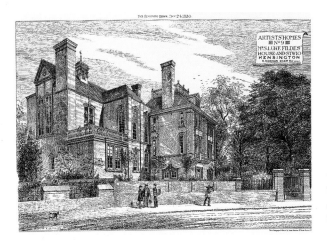

76. 11 Melbury Road, designed
by Richard Norman Shaw,
drawn by Maurice B. Adams for
the *Building News*, 24 December
1880.

awful prompt payer – I should like to be your Butcher & Baker as well as architect.'[75]
The initial cost of the house was approximately £4,500.

When the *Strand Magazine* interviewed Fildes in 1893, his home was described as
being 'that of the artist – everything has its own artistic place and corner; nothing fails
to harmonize, nothing comes short of gaining the effect wanted'. The furniture was
predominantly Sheraton, 'with a mingling of Venetian and Flemish black-framed mir-
rors, Hispano-Mauresque pottery, Venetian brass and copper-ware and touches of
Rossetti and Whistler in blue-and-white Nankin and Delft'.[76] The drawing-room was
white and gold, the furniture covered in 'plush of a glorious blue'; the dining-room
walls were Indian red. Wallpapers by Morris and Company and Walter Crane were hung
in the children's rooms. Whereas Stone's house reflected his romantic paintings, set in
an idealised version of the early nineteenth century, Fildes' suggested affluence, com-
fort and respectability. Neither continued to paint the social realist scenes with which
they had begun their successful careers.

The approach to the studio was designed to impress (fig. 77), much as in Leighton's
house. Visitors entered a hall with walls encrusted with crimson and gold and hung
with engravings after Joshua Reynolds. Passing through crimson curtains, they entered
an inner hall with 'a magnificent pear-wood cabinet of Italian workmanship', then
ascended the gentle stairs taking in brass plates, paintings from the Italian Renaissance
as well as examples of eighteenth- and nineteenth-century British artists, tapestries and
choice pieces of furniture.

The studio was initially 43 feet long and 24 feet wide. It was situated on the north
side of the house, but had windows on all four sides, as well as a series of top-lights.
Fildes could control the light with blinds of 'dense moleskin stuff . . . hung on a dou-
ble series of cords and pulleys, so that they may either be drawn up from the bottom
or lowered from the top of the windows. . . . The skylights are shut by running shut-
ters, and the whole contrivances in this respect are so complete that total darkness
would be the result if all the blinds were closed.'[77] For Fildes, however, the light was
never right: a winter studio was added in 1880, alterations were made to the main
windows in 1881 and a glass studio (with a nursery below) was added in 1885.

The reporter for the *Strand Magazine* provides some idea of what the main studio
looked like by the early 1890s (fig. 78), allowing for the necessary gush:

Stone, Fildes and Shaw 169

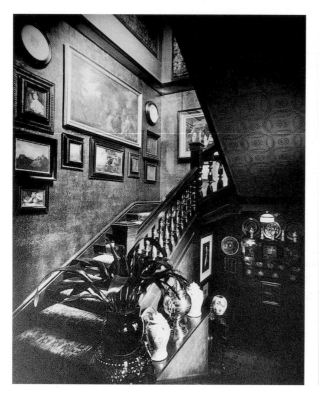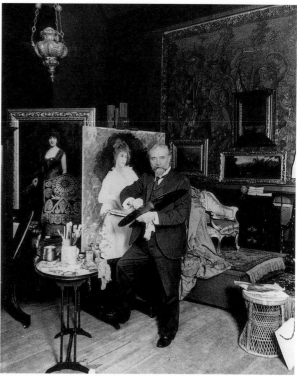

77. (above, left) The staircase, 11 Melbury Road. 'The main staircase affords a graceful approach to the studio. The long narrow windows give height and dignity, while the easy rise of the stairs themselves leaves nothing to be desired' (*Building News*, 17 December 1880).

78. (above, right) Luke Fildes in his studio, 11 Melbury Road. The portrait to the far left is of Fanny Fildes.

the work-room of a man who has painted with a truer touch of humanity than any artist of recent years. It is a grand studio, subdued in colour, yet withal relieved by numerous bright touches. . . . There are a dozen unfinished canvases about. The walls are lined with the works of intimate friends and engravings of the artist's own labours . . . all the component parts of a painter's work-room – the great gilt and crimson chairs, the Florentine couches and tables, elaborately inlaid, together with the model's 'throne' – are all picturesquely arranged upon the rugs which cover the floor.[78]

Meanwhile, Fildes' triumph at finally moving into his new house was marred by the news that Stone had been elected Associate of the Royal Academy. He would have to wait another two years. Worse was to follow. On Christmas Day 1877, just after his first birthday, the Fildes' son Philip died. The diligent attendance of Dr Murray was to provide the inspiration for Fildes' most famous painting, *The Doctor*.

The Thornycrofts, Burges, Hunter and Moore: 2, 9 and 14 Melbury Road and 1 Holland Lane

In October 1876 Fildes wrote to Henry Woods on the changing appearance of Melbury Road: 'All the other houses have gone on apace and the road looks quite crowded.'[1] He could watch the progress of Colin Hunter's house immediately opposite his own.

Hunter was the fourth painter to commission a house in Melbury Road. He was born in Glasgow in 1841 and worked as a clerk from the age of fifteen to nineteen. Meanwhile he taught himself to paint: 'oil colours and hog tools were cheap, and he had used them to make elaborate copies of engravings and other workers in the flat that came in his way'.[2] After a visit to London in 1860 he determined to take up painting professionally and studied with a landscape artist, Milne Donald, in Helensburgh, before spending a brief period at Bonnat's atelier in Paris.[3] His first painting to be hung at the Royal Academy was *Taking in the Nets*, in 1868; *Morning Trawlers* and *Sailing Free* attracted attention in 1872. Thereafter, Hunter specialised in the sea and sailors, occasionally landscapes, always the 'strong, honest study from reality':[4] they sold at between £300 and £500 (see fig. 80).

He was sufficiently wealthy by 1876 (he was living in Carlton Hill, Maida Vale) to commission a brand new studio-house in Melbury Road for himself, his wife and family. He acquired a plot on the bend of Melbury Road just before it turned south to join Kensington High Street; Fildes was immediately opposite; two plots separated him from Stone, one to be occupied by the Convent des Dames Augustines du Sacré Cœur de Marie, the other by a boarding-school for young ladies.[5]

Hunter's architect was J.J. Stevenson, a fellow Glaswegian. Stevenson's father had founded a chemical works on the banks of the Tyne at Jarrow and made a considerable fortune. Stevenson was destined to be a minister of the Scottish Free Church but after studying theology in Germany he decided to become an architect. He worked with David Bryce in Edinburgh and George Gilbert Scott in London, then, in 1868, set up on his own after being left a share in the Jarrow chemical works. He had the time and money to write a two-volume *House Architecture* (eventually published in 1880) and to design and build his own house in Kensington, confusingly named the Red House (like William Morris's house), on a sufficiently lavish scale 'to demonstrate his ideas and advertise his abilities'.[6]

Stevenson was as deeply involved as Shaw in the Queen Anne movement in architecture, though he has remained less well known. The Red House was within sight of Kensington Palace, and built, not of stucco, but of exposed brown stock bricks with red-brick dressings. Unlike Webb's houses for Prinsep and Howard, Stevenson's was quickly copied.

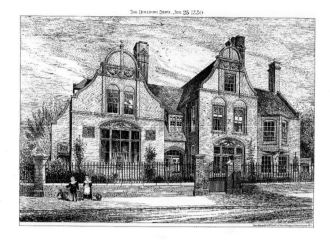

79. Lugar Lodge, 14 Melbury
Road, designed by J.J. Stevenson,
drawn by Maurice B. Adams for
the *Building News*, 25 June 1880.

> The '*Red House*' with its handsome russet *facade* and niche holding a *Nankeen* vase, has been so
> continually parodied by cheap builders possessed by the idea that red brick, a blue pot, and
> a fat sunflower in the window are all that is necessary to be fashionably aesthetic and *Queen
> Anne*, that it is a mercy the original house still stands to point a wholesome moral.[7]

Morris wallpapers were used throughout, a frieze of dancing nymphs brightened the
hall, colours were predominantly blues, greens and yellows. There were paintings and
drawings by Hunter himself, Orchardson, MacWhirter and Rossetti, an 'aesthetic mix-
ture of periods and places'.[8]

In 1873, Stevenson was approached by Henry Francis Makins to build a house
in Palace Gate, Kensington. Makins' brother, Colonel William Makins also liked
Stevenson's work. As Chairman of the Cadogan and Hans Place Estate Company, he
was able to commission a number of houses throughout Kensington and Chelsea.
Colonel Makins also asked Stevenson to build him a house on Exhibition Road: for
him red-brick 'Queen Anne' had become the only style in which to live and to build.

Hunter approached Stevenson in 1876, and tenders for the work were received in
August. The lowest, £4,594, was from J. Tyerman of the Walworth Road, the builder of
Webb's Sandroyd, of West House and most recently of the Briary in the Isle of Wight.
Lugar Lodge (fig. 79), as it was called, was colourful inside and out. It was built of red
brick, with red tiles covering the roof, the window frames were painted white and the
doors 'a dark bronze green'.[9] The street frontage was dominated by two large project-
ing bays crowned by elaborate gables containing the dining-room and the studio.

Inside, the hall and staircase walls were painted salmon red, the woodwork was very
dark green and the ceilings blue. Greens and blues predominated in the dining-room,
appropriate enough for a painter of seascapes, the walls covered with dark green and
gold tapestry fabric, the ceiling greenish blue and even the woodwork bronzy green.
The drawing-room had sienna-coloured walls, a frieze of green gold and a ceiling of
sky blue. There were Morris and Company fabrics of greenish blue and white, the
woodwork was lemony white and the grand piano black.

The studio was different to Fildes' and Stone's: it was on the ground floor and rather
dark. Hunter mostly worked during the summer months away from London in
Cornwall and the Hebrides, sometimes spending weeks at sea trying to capture partic-
ular scenes in paint (fig. 80); unlike his neighbours he was not reliant, in London, on

80. Colin Hunter, *A Sea View*, 1879. Guildhall Art Gallery, Corporation of London.

live models. The walls were painted in a 'brick-red', the woodwork was chocolate brown, the ceiling timbers of oak, stained like walnut; the gallery and staircase were constructed of walnut and the south windows were covered with a hanging of old tapestry. A glasshouse attached to the studio at the southern end provided additional light during the winter months. It contained Hunter's 'props', including sou'westers and smocks – a contrast to Stone's delicate muslin dresses and Fildes' Venetian treasures. Just like Fildes and Stone, however, Hunter's move to Melbury Road was followed by further Academy recognition. Two years after he had moved into Lugar Lodge, Hunter's *Their Only Harvest* was bought by the Chantrey Bequest (he was paid £735 for the painting); in 1881 he sold *The Mussel Gatherers* to Fildes' wealthy German patron, G.C. Schwabe; he was elected an Associate of the Academy in 1884 the year that he sold *The Herring Market at Sea* to Manchester City Art Gallery.

Hunter and his family became close friends of the Fildes. There was less contact between Fildes and his immediate next-door neighbour, the architect William Burges, even though the Tower House was only a few feet away from his own property.

> Mr Burges believes in 13th-century-Gothic, he has always believed in it, and he acts conscientiously up to the faith which he professes. . . . The house which [he] has erected for himself in Melbury-road, Holland-park . . . is intended as a model modern house of moderately large size in the 13th-century style built to show what may be done for 19th-century everyday wants.[10]

William 'Billy' Burges (fig. 81) was almost fifty when, in the summer of 1875, he acquired a plot of land in Melbury Road immediately to the west of Fildes. Tower House was to be the realisation, according to his lifelong friend Edward Godwin, of his 'long day-dream';[11] it was also a 'pledge to the spirit of Gothic in an area given over to Queen Anne'.[12]

Leighton, Prinsep, Fildes, Stone and Hunter had all commissioned their houses when relatively young and in anticipation of artistic and financial success. Burges had

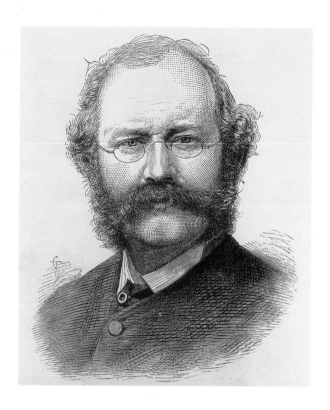

81. William Burges.

completed all his designs, though not all were fully realised, when he began to build Tower House. Though he was not a Royal Academician (he was elected an Associate in 1881), his work for the Marquess of Bute at Cardiff Castle (begun 1865) and Castell Coch (begun 1875) had brought him fame. He designed one other town house, Park House in Cardiff, for John McConnochie, chief engineer to the Bute Docks and employed by Burges' own father William Burges, of the civil engineering firm Walker, Burges and Cooper. Regarded now as 'the finest Victorian house in Cardiff', Park House was built in a 'vigorous gothic of vaguely thirteenth century French form'.[13]

Burges had always been addicted to the medieval age. When he stayed in Rome in 1853, he met Aitchison, Leighton and Poynter. A few days after Burges' death in 1881, Aitchison wrote to F.G. Stephens of their touring Italy and France together in 1854: 'he was the most accomplished 13th century architect England had, rivalling in minute, accurate & extensive knowledge Viollet le Duc himself . . . full of inspiration & in my opinion has not left his equal'.[14] But he never came to appreciate the High Renaissance, he hated the baroque and he called the Queen Anne movement of the 1870s a mere fashion, which 'like other fashions . . . will have its day. I do not call it "Queen Anne" art, for, unfortunately, I see no art in it at all.'[15] It was a 'negro-language . . . he had been brought up in the thirteenth-century belief, and in that belief he intended to die'.[16] In response, Hunter's architect Stevenson described the Gothic style as 'the artistic expression of an obsolete mode of construction'. The Queen Anne style had 'the merit of truthfulness; it is the outcome of our common wants picturesquely expressed'.[17]

Burges made several journeys through Europe and into Turkey. His biographer J. Mordaunt Crook describes the 'tug of distant places: the ancient world, the dark ages, the Far East',[18] all of which appeared in his fanciful designs. He himself wrote: 'all

174

architects should travel, but more especially the art-architect; to him it is absolutely necessary to see how various art problems have been resolved in different ages by different men'.[19] In 1856 he was in Italy with Poynter; he later helped the young artist by commissioning decorative painting and stained glass, including work on his own furniture. Burges' interest in painted furniture coincided with Holman Hunt's attempts to make furniture in the Egyptian style for his home on Campden Hill; also with the efforts of Morris, Webb, Rossetti and Burne-Jones to make pieces appropriate for the Red House. Nothing approached the scale, quality and imagination of Burges' pieces. The Great Bookcase, for example, made between 1859 and 1862 and eventually placed in the library at Tower House, was designed to hold his art books. It was decorated by fourteen artists, including Poynter, Henry Holiday, Simeon Solomon, Rossetti, Albert Moore, Stacy Marks and Burne-Jones with paintings representing pagan and Christian art.

The artists were also Burges' friends. He was immensely sociable, 'one of those rich men who never have any ready money',[20] a member of many clubs (ranging from the establishment Athenaeum to the scurrilous Judge and Jury), a rat-hunter and opium addict, owner of a number of characterful dogs and parrots. Leighton, Prinsep and Moore, neighbours in Holland Park, had known him for years through the Hogarth Club, the Arts Club and in the Artists' Rifles. He was nearly expelled from the Arts Club for stamping on members' hats in a drunken frenzy.[21]

From 1858, Burges occupied six rooms on the second floor of 15 Buckingham Street, off the Strand, a seventeenth-century house overlooking the Thames. George Boyce lived immediately above him. Throughout the 1860s the rooms were gradually filled with objects found and made, and the walls and ceilings were covered with elaborate designs. Edmund Gosse described taking tea with Burges: 'He used to give the quaintest little teaparties . . . the meal served in beaten gold, the cream poured out of a single onyx, and the tea strictured in its descent on account of real rubies in the pot.'[22] Godwin recalled his first visit to Buckingham Street: 'I introduced myself; he was hospitable, poured wine into a silver goblet of his own design, and placed bread on the table. With few words on either side we ate and drank, and thus began a friendship which was more intimate and sincere than any friendship of my life.'[23] Burges often stayed with Godwin and Ellen Terry in their country retreat; after his death, Godwin wrote, as a tribute, a description of Tower House for the Art Journal. It began:

> Do you desire to make an inkstand? Take a Chinese bronze elephant incense-burner, with dumpy legs that are hardly more than feet, remove the pierced howdah-like cover, and in its place put a low circular tower of green porcelain, domed with a *cloisonné* cup reversed, and crowned with a japanese *netzuki*. Combine these things with metal mouldings and machicolated parapets fashioned after the manner of the thirteenth century; arrange the ivory finial, the dome and tower so that each may turn on a pillar at the back, uncovering receptacles for matches, red ink, and black; mount the whole on a slab of marble and suspend chains, and rings, and seals from tusks and trappings, and you have the inkstand Burges had made for himself, which occupied the centre of his writing table all the years I knew him, and reminds me of him more than anything he ever achieved.[24]

Burges began looking for a site on which to build his house in 1875; he also began his 'own house drawings'.[25] He rejected plots in Victoria Road, Kensington and in Bayswater. According to the *Architect* 'he had, after mature consideration, selected as the most suitable site a plot in Melbury Road . . . This plot had the advantage of including

82. William Burges,
Centaur and Theseus, design
for inner hall, Tower
House, 9 Melbury Road.
British Architectural
Library, RIBA, London.

within its boundaries space sufficient for a convenient garden at the back, in which stood some stately trees belonging originally to the park.'[26] The trees, like those in Fildes' garden, were originally in the grounds of Little Holland House. An agreement was concluded with the Earl of Ilchester in December 1875 and building began the following year. The contractors were Ashby Brothers of Kingsland Road and the basic cost was estimated to be £6,000. This presumably rose when Burges encountered the treacherous clay which also held up Shaw and Fildes. The ground rent was £100 per annum.[27]

The house was unfinished when students from the Architectural Association visited in April 1877; they were 'much entertained and astonished at the singularly archaic and massive character of the ceilings, doorways, and chimney pieces, and the ultra-mediaevalism displayed. . . . The doors have, we presume, been hung on the wrong sides, as it is at present impossible to get fairly into the lavatory for the purpose of closing its door. The gas-bracket also is in awkward propinquity with one's head.'[28]

By the time Mrs Haweis of *Queen* magazine visited, Burges was dead but the house was 'a treat to the eye and a lesson to the mind. Beauty is to be seen compatible with comfort; and we mourn as we remember how many wealthy nobles spend as much or more on building and decoration, without attaining any considerable effect at all.'[29] (See figs 82, 83.) The outside of the house was comparatively plain, apart from the circular staircase tower built of red bricks, with Bath stone dressings and green slates from Cumberland. Burges took considerable trouble with the garden at the back of the house. The flowerbeds were raised, 'planned according to those pleasances depicted in mediaeval romances; beds of scarlet tulips, bordered with stone fencing'.[30] Large marble seats were ranged round a mosaic-paved terrace, with a marble statue of a boy with

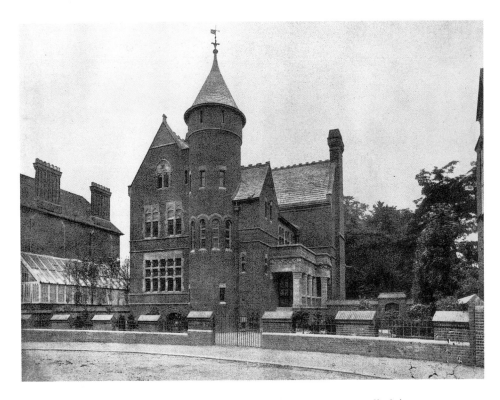

83. The Tower House, 9 Melbury Road, designed by William Burges. Photograph by Bedford Lemere.

a hawk by Nicholls in a flower-fountain at the centre. Godwin recalled: 'Here on a summer's afternoon, Burges would delight to give tea to a few friends, who lounged on the marble seats or sat on Persian rugs and embroidered cushions round the pearl-inlaid table, brilliant with tea service composed of things precious, rare, and quaint.'[31]

The first hint of the treasures within was the front door, covered in bronze, its moulded panels filled with figures, which sent Mrs Haweis' spirit 'straightway to Florence and Ghiberti'.[32] She forgot to ring the bell on discovering the letter-box designed as Mercury 'attired in a tunic powdered with letters'.[33] Five doors opened off the hall, each marked with its appropriate symbol: 'One door leading to the garden has a flower, the main door a great key, the dining-room door the sign of good cheer, the library door the sign of learning, the drawing-room that of love – to which the room is fancifully dedicated.'[34] Every room had its own iconography: on the ground floor, the entrance hall was time; the dining-room, Chaucer's *House of Fame*; the library, literature and the liberal arts; the drawing-room, love, its fortunes and misfortunes; on the first floor, Burges' bedroom was the sea and its inhabitants; the guest bedroom, the earth and its production.[35] Every room was a 'jewel-box or receptacle for Burges' bizarre collection of objets d'art . . . strange and barbarously splendid . . . saturated with his passion for colour, sheen and mystery'.[36]

In the dining-room, Burges was concerned about unpleasant cooking smells (the kitchens were in the basement), so covered the walls, up to a height of six feet, with Devonshire marble, and above this a frieze of glazed picture tiles. The ceiling panels were of enamelled iron, blazoned with symbols of the universe. Cabinets contained the 'precious drinking-vessels which those who have had the privilege of dining with Mr *Burges* know the pleasure (and pain) of handling. Cups of jade, knife-handles, goblets

of silver and rock-crystal set with gems and quaint work, cameos, pearls, turquoise — cups such as that which *Glaucus* gave to the gambler *Clodius*, antique mother-o'-pearl flagons with a long pedigree and full of beauty.'[37]

The library, a 'blaze of gold and colour', had a mantelpiece sculptured as the Tower of Babel; the walls were lined with closed bookcases and the furnishings included braided velvet curtains and Anatolian rugs. The drawing-room ceiling was painted with medieval Cupid figures; the walls were covered with mythical lovers; the chimney-piece portrayed Chaucer's *Romaunt of the Rose*. Then,

> up a narrow winding stair of stone, lighted with coloured windows and protected by soft curtains, we reach the bedrooms. What bedrooms! The guest chamber is made of fire and flowers . . . the bed, toilet-table, washstand, cabinets, are all plain gold. The shutters are plain gold. The windows glow with colours such as the *Alhambra* has. Through *Moorish* trellis-work these colours shine. . . . What is not pure gold is crystal.[38]

Burges' own bedroom was scarlet, the ceiling 'studded with tiny convex mirrors set in stars of gilded lead, and designed to reflect the candlelight like stars in a midnight sky', the mermaid chimneypiece 'iridescent with silver and gold'.[39] On the floor above, Burges created day and night nurseries, even though he was not married and had no children.

Burges was an 'art-architect'; he had no need of north light so there was no conventional artist's studio within Tower House. He worked in the library, perching a colza oil lamp (burning rape-seed oil) among his papers. But even the oil lamps were sumptuously decorated. No other architect, as Mordaunt Crook sums up, 'produced such a bizarre expression of his own ego'. The house and everything in it left Lethaby gasping: 'massive, learned, glittering, amazing'.[40]

Burges first slept in Tower House on 5 March 1878. Soon after, the painter William Blake Richmond and a friend were given a tour of the house. On seeing Burges' blood-red bed, carved with lions, its bedstead decorated with a painting by Henry Holiday of the Sleeping Beauty, Richmond turned pale and when pressed by his companion, replied, 'Well if you must know, as we stood there, I saw Burges lying dead upon his bed. I looked again and he was still there – dead.'[41] On 20 April 1881 Burges was indeed dead, the decorations to his 'day-dream' still unfinished.

Number 2 Melbury Road could not have been more different: it was designed for a family of sculptors and painters. When it was completed in May 1877, not one but six artists moved in, all members of the Thornycroft family.

The senior members were Thomas and Mary, both sculptors. Thomas, who had been a pupil in the Regent's Park studio of Mary's father, the sculptor John Francis, married Mary in 1840. She was the more successful of the partnership, receiving commissions from four generations of the royal family and occupying an apartment in Windsor Castle. She taught all the princesses how to model, inspiring Princess Louise with the ambition to be a sculptor. Thomas designed the 'Commerce' section of the Albert Memorial, but his major work *Boadicea and her Daughters*, by Westminster Bridge, was not erected until after his death.

By 1859, the Thornycrofts lived at 21 Wilton Place off Belgrave Square. Alyce, the eldest surviving daughter was, according to her niece Elfrida, 'highly emotional and romantic and in manner rather stately and severe'.[42] She exhibited her first sculpture,

Ophelia at the Brook, at the Academy in 1864; she also painted portraits in the style of Watts. Helen, also a painter and sculptor, was accepted at the Royal Academy Schools when only fourteen years old, but was declared too young – Landseer apparently exclaimed 'Send her back to the nursery!'[43] – and had to wait another two years to take up her place. She later became known for her watercolours of flowers and landscapes and she was Vice-President of the Society of Women Artists. Theresa studied at the Academy and was a pupil of Ford Madox Brown at 37 Fitzroy Square, together with Brown's daughters Lucy and Catherine, and Nellie Epps.

Hamo had been sent away as a young child to an uncle in Cheshire, with the intention that he would become a farmer, his parents considering this a more lucrative occupation than sculpture. Though Hamo was deeply attached to nature and the countryside, his vocation was art and he returned to London, in 1863, to attend University College School. In 1869 he was accepted into the Royal Academy Schools.

Only John and Frances Thornycroft resisted art. John, the eldest surviving child, took up engineering, founding the boatbuilding works J.I. Thornycroft and Company at Chiswick. He built high-speed launches and torpedo boats, the latter designed to carry the newly invented Whitehead torpedo. He was knighted in 1902; his sister Frances married his partner, John Donaldson.

At Wilton Place, the family of artists disappeared into their respective studios during daylight hours; evenings, however, were often devoted to music. They were enthusiastic musicians and members of a glee club which met regularly at the house under the leadership of the architect John Belcher. Close friends of the Thornycrofts, who shared their musical evenings, included Theresa's teacher Ford Madox Brown, his daughters and their circle: Lucy married William Michael Rossetti in 1874; Catherine married the musician Franz Hueffer (their son was Ford Madox Ford). Helen and Theresa Thornycroft attended the wedding reception of their friend Ellen (Nellie) Epps to Edmund Gosse. Nellie's sister Laura had married Alma-Tadema four years before.

Hamo was meanwhile getting to know Leighton, an 'inspiring master', at the Royal Academy Schools.

> Besides doing much for the school of sculpture, till then much neglected, he started a custom of giving a certain time to the study of drapery on the living model. His knowledge in this department and his excellent method were a new method in the training at the schools, and soon had a salutary effect upon the work done by the students. . . . There can be no doubt whatever that the rapid advance made in the art of sculpture during the last thirty years was to a considerable extent due to the sympathy and the interest which Leighton gave to it.[44]

Leighton also invited the students back to his studio. 'He had promised to criticise the designs we had made from Morris's 'Life and Death of Jason'. This he did most admirably, it seemed to me, and most sympathetically, devoting considerable time to each; and I came away encouraged and a sworn devotee of the great man.[45] So much so, that in 1872 Hamo joined the Artists' Rifles: Leighton was by this time Major, Prinsep his Captain. Hamo was particularly impressed by Leighton's leadership.

> His wonderful knowledge of the Red Book of Infantry Drill and the decision of his word of command made it very easy for the men in the ranks to obey him and the quickness of eye with which he detected any error of movement frequently saved the ranks from getting into confusion, and soon the Artists' Corps became, under his command, one of the best in London.[46]

Hamo was a good shot himself and won a prize of a watercolour for making the highest score on the 600 yards range. He displayed a drawing in the hall of 2 Melbury Road of himself and his friends in the Artists' Rifles, which reminded a reporter from the *Strand Magazine* that 'he and Sir Frederick [*sic*] had the biggest heads in the corps, and there was always a great difficulty in getting the regulation helmets to fit'.[47] In his studio he kept his helmet, surmounted by a red flag which once decorated his father's yacht. After moving to Melbury Road, he became close friends with Henry Woods, also in the Artists' Rifles. Fildes' son recalled,

> [They] were alike as two peas, [and] were always posted conspicuously at the foot of the stairs when the 'Artists' mounted the Guard of Honour at the Royal Academy on Banquet night. The Prince of Wales became used to seeing the pair of them and would pause to remark upon their soldierly bearing.[48]

In 1875, Hamo won the Royal Academy's biennial Gold Medal for the Best Work of Sculpture on a given theme, to be an 'imaginary composition in the round [of] a warrior bearing a wounded youth from battle'.[49] At the same time, he and his father were working on a commission for a statue of Lord Mayo, the fee to be £5,000. The whole family was also working on the 'Poets' Memorial' fountain for Park Lane, for a similar fee. With 'six practising artists in the family, three of whom were sculptors, there was no longer room enough at Wilton Place'. Hamo wrote in his diary in October: 'Began to make plans for a house at Kensington.'[50] His choice of location must have reflected his respect for Leighton and for Watts, whose marble sculpture *Clytie* he would have seen at the Royal Academy in 1867, as much as his own ambitions.

A double plot was purchased to the west of Watts' house. The family's plan was to build a dissimilar semi-detached pair of houses, living in number 2 but building an additional series of studios alongside the west wall. Number 4, designed as a studio-house, would be let or sold for income. Their singing friend John Belcher, who had designed the pedestal for the *Poets' Memorial*, was approached, though Hamo drew up the original plans. Belcher 'gave them much help with the elevations and saved us from making an ugly building'.[51]

The builders were Messrs Adamson and Son of Turnham Green, who gave notice in March 1876 to the district surveyor of their intention to build two houses and a studio for 'Mr Thornicroft' (*sic*).[52] Number 2 was named Moreton House after Little Moreton Hall, Congleton in Cheshire which the family had tenanted during the eighteenth century. A huge projecting chimney stack accentuated the division between numbers 2 and 4 (fig. 84).

There is little information about the internal decorations of the domestic rooms, beyond that they were considered 'unaffected'. The dining-room overlooked Melbury Road. It contained family portraits, including Wirgman's painting of Mary 'in the act of modelling the Princess Louise as a child, with her pet dog Rover by her side',[53] and drawings by Alfred Stevens. The main entrance of Moreton House was at the side, and led to the studio complex as well as the domestic rooms. As all the Thornycrofts were artists, the series of studios and workshops were the centre of the house. There was no need for a boudoir – the Thornycroft women were in their studios. During daylight hours the domestic interior was left to the cook and the housemaid.

The studio complex ran alongside the main house and garden stretching south nearly all the way to Holland Park Road. A small vestibule led to the main gallery in which

84. 2 (Moreton House) and 4 Melbury Road, designed by John Belcher, drawn by Maurice B. Adams for the *Building News*, 27 May 1881. The north window of Helen, Alyce and Theresa's studio can be seen on the far right above the main entrance of Moreton House.

completed works in marble or bronze were displayed. It was also used as an extra drawing-room. Mary's studio, which was also used as a music room, was next, reached through folding doors 'beautifully stippled in viridian green'.[54] In the corner under a glass case was a model of Nelson's funeral car, carved in jet by her father and, according to Hamo,

> the beginning of our family as sculptors. My grandfather went to see Nelson's funeral. The wonderful car impressed him. As soon as he returned to Norfolk he went along the sea-shore, picked up the jet and carved this. Mr Vernon saw it, and immediately sent him to Chantrey's studio.[55]

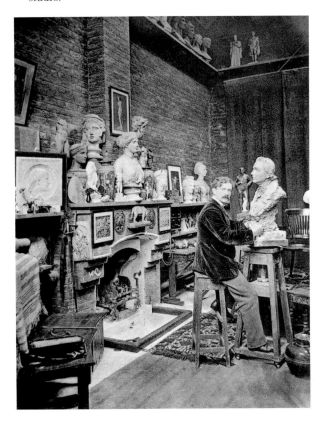

85. Hamo Thornycroft in his studio, 2 Melbury Road, photographed by J.P. Mayall for F.G. Stephens, *Artists at Home* (1884).

Immediately above was the painting room used by Helen, Alyce and Theresa, with a large window for north light.

A 'glass-inclosed passage brimming over with flowers' connected Mary's studio with the sculpture studio beyond, where large clay figures were set up. A wide doorway gave access to the garden where work was carried out in fine weather. 'Here [was] the great turn-table on which the statues are placed, in order that their creator may "consider" them under various atmospheric conditions. It is worked by means of hydraulics, and can be raised fourteen feet. It runs in and out of the studio on metal lines.'[56]

Beyond the sculpture studio was a modelling room where Hamo worked on small sketches in wax (fig. 85). It was lit with north and east skylights and, his daughter Elfrida recalled,

> it was always warm and comfortable with massive hot-water pipes and a fire burning brightly in the open grate. Its walls were painted Pompeian red and dark plush curtains were arranged behind the works in various stages of completion. There was an all-pervading smell of clay. On the cornice of a cupboard were the words of Michelangelo: 'Disegna e non perdere tempo!' while over the fireplace stood the Greek bust known as the *Oxford fragment*, to which Hamo would lift his eyes from his own work in order, as he put it, 'to see how bad it was'.[57]

At the farthest end was a low outer room or alcove opening on to the garden. Above was a balcony where it was possible to model in the open air.

> Around its cement cornice [Hamo] sketched a little frieze depicting the various stages in making a statue: first, the Artist's inspiration as he gazes ardently into the fire, then as he matures his idea under the influence of music, meditates on it by the light of the moon, and at dawn begins to model. The technical processes that follow were illustrated up to the final carving in marble. Lastly the sculptor is shown, his work done, enjoying his recreation: shooting, fishing, playing tennis or drawing musical sounds from his violin.[58]

Alongside the whole complex of interconnecting studios was a series of spaces for storing marble and clay and for carrying out rough-hewing and the carving of pedestals. Elfrida recalled 'great cellars filled with clay kept moist under linen shrouds', also 'a charming wash-place where the small round hand basin and lavatory bowl were of blue Delft china set in mahogany'.[59] The reporter from the *Strand Magazine* commented on the 'workmanlike' nature of this area:

> In the outer yard a workman is chipping away at a small frieze, and in close proximity others are busily engaged on a colossal statue. . . . Great blocks of marble are resting against the wall. . . . A workman is sawing away at a huge piece of the product of Carrara. . . . He can only cut some eight inches a day. . . . The hammers, points, drills – of all sizes – and claws . . . lie in a state of utter *olla podrida* about the stone floor.[60]

Generations of the Smith family worked as assistants. Elfrida recalled 'in later years this was Jim who always wore spectacles when carving and kept handy an instrument of his own devising: a loop of his own hair attached to a matchstick, with which to remove any speck of marble from his eyeballs'.[61]

The Thornycrofts moved into Moreton House in May 1877 and held a party for a hundred friends. Meanwhile their adjoining property, number 4, was acquired by Elizabeth Bagehot, the recently widowed wife of Walter Bagehot, editor of the *Economist*, her sister Emilia and brother-in-law Russell Barrington. Emilia was an amateur painter and already knew Watts, who had told her about the house. To some of her neighbours

she was a snoop (Watts' second wife Mary blocked up the gate which had connected their gardens); however, her snooping paid off for she was to become the biographer of both Watts and Leighton and eventually the driving force behind the campaign to save Leighton's house for the nation. Julia Cartwright visited in 1880:

> The Barringtons' house, or rather Mrs Bagehot's, is quite a sight. Full of lovely Morris hangings, De Morgan-lustred tiles and Persian tiled tables, papers and ceilings designed by Walter Crane. A sideboard of Morris charmed me and I was glad to find our willow–pattern carpet used as a hanging and my dear rush chairs, and there are velvet hangings over every door and sofa, and photos all about. The garden is so nice, and overlooking Watts' and Leighton's new homes.[62]

Belcher remained close to the Thornycrofts. His portrait bust was completed by Hamo in 1881, he built a house in Chiswick Mall for Hamo's engineer brother John and both he and Hamo were founder members of the Art Workers' Guild which held some early meetings in Hamo's studio. After winning a competition in 1889 to design the headquarters of the Institute of Chartered Accountants in Moorgate he commissioned Hamo to design a twelve-panel frieze, 140 feet long, for the outside. Almost all the figures in the panels were in contemporary dress, most of them wearing the working clothes of their trade. Mary Thornycroft is depicted in *Railways* meeting her daughter Alyce who holds a Gladstone bag; in *Commerce* Hamo's wife Agatha holds a roll of cloth; *Building* includes portraits of Belcher and Hamo, Hamo's assistants Jim Smith (the stonemason) and George Hardie (the carver).[63]

His new neighbours were quick to offer advice, often conflicting. While Leighton and Burges had different opinions about *Lot's Wife*, Leighton and Watts disagreed about the faults of *Stepping Stones*. Hamo later remarked, 'Never take advice in art unless you agree with it.'[66] He was discovering the hazards of living in close proximity to artists who were friends but also rivals.

When Melbury Road was laid out, the cows of Holland Farm still grazed on land belonging to the Ilchester estate. Fildes' son recalled how 'Every day at milking time, with mooings and tinkling of bells, cows came along the lane and through the gates by the side entrance of no. 11 and into Melbury Road, and then down to Tunks and Tisdall's Dairy in the High Road.'[67] The dairy, which included cowstalls and a shop, was newly built in 1875, designed by William Boutcher. It was on the island site formed by Melbury Road, Holland Lane and Kensington High Street, of red brick with a curved gable at the Kensington High Street end to harmonise with the nearby lodges to Holland Park. Opposite the dairy at 1 Holland Lane was the red-brick studio built in 1877 for the painter Albert Moore, with two complementary Dutch gables.

Moore would appear to be the most unlikely artist to choose to live in Holland Park. He preferred to live alone, according to his pupil Walford Graham Robertson, 'absorbed in his work, knowing and caring little about the outside world'.[68] While the cows were being milked just across the lane, he immersed himself in his personal landscape, working slowly and painstakingly to produce dreamlike paintings of languorous

86. Sydney Prior Hall, *Albert Moore*, 1887. National Portrait Gallery, London.

women (Robertson called them, disparagingly, 'Graeco-West Kensington young women'),[69] reclining, reading, dreaming, or asleep, draped in and over sumptuous fabrics within interiors which could have been designed for the more 'aesthetically' inclined members of the Holland Park circle.

Moore had links with Kensington, however, which went back to 1855 when he lived with his mother in Kensington Square and attended the grammar school; two of his brothers settled in the borough. Much of his early work had been decorative, particularly in collaboration with his friend the architect William Eden Nesfield; in 1872 he designed the peacock frieze for George Aitchison who was decorating the house in Berkeley Square of Leighton's friend Frederick Lehmann. Leighton himself had become a friend through defending the hanging of Moore's *Venus* at the Royal Academy in 1869.

Albert Moore (fig. 86), like Hamo Thornycroft, belonged to a family of artists. His father William had begun his career painting decorations for japanned goods in Birmingham but eventually became established in York as a portrait painter. John Collingham, 'Col', was the first son to move to London, attending the Royal Academy Schools in 1850; Henry enrolled at the Royal Academy in 1853. Meanwhile their father had died, poisoned by lead and vermilion after using his thumb as a stump for pastel work. In 1855 his widow moved to London, to Kensington Square, together with fourteen-year-old Albert who attended Kensington Grammar School. In 1858 Albert enrolled at the Royal Academy Schools.

Moore's particular friends at the Academy, with whom he founded a sketching club, were Simeon Solomon, Henry Holiday, William Blake Richmond, Frederick Walker and

Marcus Stone. He also remained close to his brothers. Col mostly lived in Italy, sending landscapes of Rome and the Campagna to the Royal Academy, but by the mid-1870s he was settled at 8 Kensington Square, a 'charming eighteenth-century house', and Richmond was among his circle of friends.[70] Henry became famous for his seascapes, showing work at the Academy every year from 1853 until his death in 1895. His home was also in Kensington, 4 Sheffield Terrace on Campden Hill.

Moore frequently moved studios throughout the 1860s and early 1870s, though

87. (above, left) Albert Moore, *A Reader*, c. 1877. City Art Gallery, Manchester.

88. (above, right) Albert Moore, *Birds of the Air*, c. 1878. City Art Gallery, Manchester.

always remaining in the area of Fitzrovia, Soho or Holborn. His first commissions were for decorative work, tiles, wallpapers and fabrics, in collaboration with Nesfield, whom Solomon described as 'a fat, jolly, hearty fellow, genuinely good natured, very fond of smoking and, I deeply grieve to say, of women'.[71] Solomon's preference was for men. In 1863, Moore produced wall-paintings for the kitchen and dairy at Combe Abbey, the country house near Coventry which Nesfield enlarged for the Earl of Craven; between 1864 and 1868 he designed sculpted chimneypieces and a frieze of sunflowers for Cloverley Hall, in Shropshire, designed by Nesfield for a Liverpool banker, J.P. Heywood. Nesfield, together with Burges, Webb and Godwin, moved 'in the same overlapping circles' as Moore, Rossetti, Morris, Burne-Jones and Whistler, sharing a 'dislike of the society into which they had been born'.[72]

Moore's paintings also began to develop purely decorative qualities (figs 87, 88). *Azaleas*, which was shown at the Academy in 1868, was his first large-scale independent painting of a classical figure without any allegorical or biblical subject. Swinburne's review placed Moore at the forefront of the aesthetic movement.

> His painting is to artists what the verse of Théophile Gautier is to poets; the faultless and secure expression of an exclusive worship of things formally beautiful. That contents them; they leave to others the labours and the joys of thought or passion. The outlines of their work are pure, decisive, distinct; its colour is of the full sunlight. This picture of *Azaleas* is as good a type as needs be of their manner of work. . . . The melody of colour, the symphony of form is complete: one more beautiful thing is achieved, one more delight is born into the world; and its meaning is beauty; and its reason for being is to be.[73]

Moore was already friends with Whistler, who defended him against Rossetti's accusation that he was boring, 'a dull dog . . . best avoided'.[74] Their style and subject matter were so close at the time that Whistler wondered whether his own reputation would be damaged. Both had been commissioned by Frederick Leyland, who had bought Moore's *A Venus* in 1869. While Whistler was painting the *Six Projects* he saw sketches for Moore's *Shells* and *Sea-Gulls* at Leyland's house. Nesfield was appealed to, Whistler writing to Moore,

> you should go with Billy Nesfield down to my place and together look at the sketch in question (it is hanging up on the wall in the studio) . . . of four girls careering along the sea shore, one with parasol . . . [Nesfield to decide whether] we may each paint our picture without harming each other in the opinion of those who do not understand us.[75]

Connections were inevitable between artists and writers exploring the possibilities inherent in 'art for art's sake'. Moore's *Shells* was like Leighton's *Greek Girls Picking up Pebbles by the Sea*, shown at the Academy in 1871; Moore's *A Musician*, Whistler's series of Nocturnes, and the literature of Swinburne and Pater, explored connections between art and music which interested both Leighton and Watts.

In 1877, Moore decided to move to Holland Park, to a studio he apparently designed himself. Godwin described the studio in a lecture given to the Architectural Association:

> Mr Albert Moore has acted upon the principle of endeavouring to get rid of every right angle, and to reflect as much light as possible. He has designed his own building – I presume at a much greater cost than if an architect had been called in. The walls and ceilings of this studio are cut about in a most remarkable manner, so that when you go in you think you've got

The Studio & Residence of albert moore R.A. 1 Holland Lane

89. Ernest Stamp, *1 Holland Lane,*
1938. Museum of London.

inside one of those many-sided figures used for mathematical demonstrations of angles and prisms. It has, indeed, numerous sides, is very dodgy and well worthy of consideration by every artist.[76]

A 1938 sketch of the building, which no longer exists, shows a one-floor structure in the Queen Anne style (fig. 89). Robertson provides more detail:

> Its accommodation consisting of two huge studios, a sitting-room with nothing to sit upon in it, a bedroom and, I suppose, a kitchen. [Moore's] constant companion was Fritz, a dachs-hund of depressed appearance reported by models to live entirely upon sardines and oranges. . . . The great embitterment of [Fritz's] life was cats. Cats pervaded the whole house; vague-ly, unofficially, holding no recognised position, they swarmed in the studios and passages, were born abruptly in coal-scuttles, expired unpleasantly behind canvases, making the place no home for an honest dog and taking, as it were, the very sardines out of his mouth. . . . There were also the spiders and their cobwebs, the dust, the leaks in the pipes, and other like phenomena. . . . Nothing in the way of papering, painting or white-washing was ever done in the house, and even of ordinary dusting I saw no sign, nor was anything ever mended.[77]

When Robertson visited with Whistler, they found Moore surrounded by jugs placed to catch the drips from the ceiling. Though he employed a housekeeper, Elizabeth Collier, he had no interest in playing the 'gentleman-artist'; he was the only bohemi-an in Holland Park.

13

The Leighton Ascendancy

Mr Phoebus was an eminent host. It delighted him to see people pleased, and pleased under his influence. He had a belief, not without foundation, that everything was done better under his roof than under that of any other person.[1]

Leighton? That man's doing a fine job as your president. Stands well with royalty. Distinguished appearance. Makes a first class speech. Good linguist. No mean musician − (pause for reflection) − paints a little, sculpts a little.[2]

Leighton was not a passive spectator as the houses of Watts, Fildes, Stone, Hunter and Burges were being built in Melbury Road, Stone's literally at the bottom of his garden. There was scarcely a year up to his death in 1896 when Aitchison was not carrying out some addition or alteration at 2 Holland Park Road: between 1865 and 1895 Leighton's payments to him through Coutts Bank amounted to around £3,500; Leighton died owing him £60. In Aitchison he had found a friend with the ability to turn his fantasies into realities; for Aitchison, Leighton must have been the ideal client, an artist sufficiently wealthy to commission a 'palace of delights'.[3] In a lecture given in 1895, Aitchison described his ideal buildings:

The ground of the cornices will shine with eternal colours, the piers will be enriched with sparkling panels, and friezes of gold will run the length of our buildings; monuments will be of marble and enamel and mosaics will make all admire colour and movement. This will not be false and paltry luxury; it will be opulence, it will be sincerity.[4]

Leighton's studio had first been enlarged in 1869, following his election as a full Royal Academician. He had reassured the supportive critic F.G. Stephens on 3 July 1868: 'I won't paint worse for being a R.A.'[5] As if to match his artistic elevation, the original north window was replaced by a taller, iron-framed, double-glazed one, the gallery was moved and rebuilt further to the west and an extension was built out on the east side 'for some big canvases', including *Hercules Wrestling with Death for the Body of Alcestis*, 106 inches long, exhibited at the Academy in 1871, and Stewart Hodgson's *Daphnephoria*, $206\frac{3}{4}$ inches long × 91 inches high. Aitchison designed a pair of stained-glass windows of 'Moorish' design which were set into the eastern wall, the first 'orientalist' feature in the house. The studio annexe was the first of several rooms beyond rooms, private and intimate spaces designed for an artist who was thought by many to have no private life.

Major additions to the house were begun during the 1870s; perhaps Leighton was motivated by the activities of his 'rivals' in Melbury Road. Richard Norman Shaw was also designing a house on Campden Hill for George Boughton, a house in Hampstead

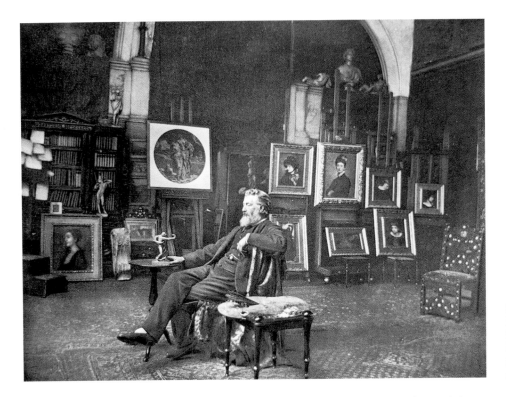

90. Frederic Leighton in his studio at 2 Holland Park Road, photographed by J.P. Mayall for F.G. Stephens, *Artists at Home* (1884).

for Edwin Long (confident of his financial position after the success of *The Babylonian Marriage Market*), and in the Harrow Weald for Frederick Goodall. Millais' Renaissance-style mansion, designed by Philip Hardwick, was rising in Palace Gate, close to Kensington Palace. And Aitchison was working with Lawrence Alma-Tadema on Townshend House, Regent's Park. The house had been badly damaged in 1874 when a cargo of gunpowder carried on a barge on the nearby Regent's Canal exploded. Over the years, Alma-Tadema created a series of rooms with different themes: a Gothic library, a Japanese painting-room, a Spanish boudoir.

The external appearance of Leighton's house as seen from the street was little altered (fig. 91): 'thoroughly comfortable and substantial . . . with a thick screen of plane trees',[6] its plainness was thought to be a deliberate blind 'for what lies beyond'.[7] The front door was moved to the right-hand side of the façade, visitors entering an entrance hall (formerly the breakfast room) 'of calm tone – stone-colour wall, hung with a few drawings'.[8] To the west of the entrance hall, Aitchison added a library or study (Mrs Haweis, writing in gushing terms for *Queen* magazine in 1882, referred to it as a 'pleas-ant den or writing-room'): drawings by Alphonse Legros and Alfred Stevens hung on the walls, and 'choice specimens of mediaeval ware fill odd corners'.[9] From the study, Leighton could spy on visitors and, if he wished, retreat, undetected, to his studio on the first floor (fig. 90). Access to the house was controlled by Kemp, a formidable manservant, 'of impressive appearance', as one visitor recalled: 'just the type of servant one would expect.. . . Some of [Leighton's] urbanity had shed itself on his attendant. Sir Frederic was at home but only receives by appointment and at certain hours.'[10]

The inner hall gave access, as before, to the dining-room and drawing-room; also, up the stone staircase, to the studio. Aitchison's extension to the west created a dramatic

91. 2 Holland Park Road,
designed by George Aitchison,
the *Building News*, 1 October
1880.

vista along a wide corridor, or 'Hall of Narcissus', to the Arab Hall (also known as the Damascus Room) beyond: 'hall opens out of hall, reviving now antique, now mediae-val, now *Renascence* [sic] *Italy*, from *Florence* to *Rome*, down through regal *Naples*, on to *Cairo* itself; and yet it is not *Rome*, nor *Sicily*, nor *Egypt*, but a memory, a vision seen through modern eyes.'[11] This was hardly the 'little addition' Leighton was reported to have admitted he was building, 'for the sake of something beautiful to look at once in a while'.[12]

On a basic level, Aitchison provided Leighton with walls, alcoves, shelves and furni-ture on which to display his increasing collection of tiles, porcelain, furniture, fabrics and costumes, pictures and sculpture, furnishing him 'with a design that would be suited to their employment'.[13] Leighton had begun collecting before the first stage of his house was completed. In 1867, for example, during a trip to Rhodes and Lindos, he wrote to his father: 'Through the assistance of Mr Bileith (our consul) I had an opportunity, which could never present itself again, of buying a number of beautiful specimens of old Persian *faience* (Lindos ware), chiefly plates, which will make a delightful addition to my collection of Eastern china and pottery.'[14]

The first design for the Arab Hall was completed on 19 July 1877. Aitchison based the design on the reception hall of the Sicilio-Norman palace of La Zisa, or Palace of Delights, in Palermo. The walls were covered by tiled panels from Persia and Syria, framed by patterned borders, and a frieze containing verses from the Koran, taken from a hill temple at Sind, was placed over the entrance wall. Aitchison later explained,

> During his visits to Rhodes, to Cairo, and Damascus, [Leighton] made a large collection of
> lovely Saracenic tiles, and had besides bought two inscriptions, one of the most delicate
> colour and beautiful design, and the other sixteen feet long and strikingly magnificent,
> besides getting some panels, stained glass, and lattice-work from Damascus afterwards.[15]

Leighton's trips to Asia Minor, to Constantinople, Rhodes, Lindos and Egypt also pro-vided him with scenery he would use repeatedly in his major paintings, in particular the coastline of Asia Minor as seen from Rhodes: 'that marvellous blue coast across the seas, that looks as if it could enclose nothing behind its crested rocks but the Gardens of the Hesperides';[16] also the colours and atmosphere of Egypt. Leighton had travelled up the Nile in 1868 in style through the intervention of the Prince of Wales, who

persuaded the Viceroy Ismail Pasha to provide the artist with a steamer, a French chef and an Italian waiter.[17]

> I sat in the long gloaming enjoying the soft, warm, supple air, and watching the tints gradually change and die round the sweep of the horizon, and across the immense mirror of the Nile as broad as a lake. It was enchanting to watch the subtle gradations by which the tawny orange trees that glowed like embers in the west, passed through strange golden browns to uncertain gloomy violet, and finally to the hot indigo of the eastern sky where some lingering after-glow still flushed the dusky hills; and still more enchanting to watch the same tones on the unruffled expanse of the water, slightly tempered by its colour and subdued to greater mystery. A solemn peace was over everything. Occasionally a boat drifted slowly past with outspread wings, in colour like an opal or lapis lazuli, and then vanished. It was a thing to remember.[18]

In 1869, when Leighton accompanied Adelaide Sartoris to Vichy for a cure, he first met Richard and Isobel Burton, and Algernon Swinburne. Both Burton and Swinburne were recovering from drinking bouts. Swinburne wrote home about Adelaide: 'I found it was worth while playing the pretty to the old lady, as she plays and sings to me in private by the hour, and her touch and her voice are like a young woman's. But – they have sent her here to get down her fat.'[19] Leighton and Burton were immediately attracted to one another; Burton's experiences fighting in and exploring Africa were in vivid contrast to Leighton's drilling with the Artists' Rifles. Burton was famous for his journey in disguise to the forbidden places of the Hejaz, an account of which he published in 1855 as a *Personal Narrative of a Pilgrimage to El-Medinah and Meccah*, and for his fierce controversy in 1864 with John Hanning Speke over the location of the source of the Nile. Blanche Airlie's son-in-law Bertie Mitford wrote of Burton: '[he] was the only man I knew who could fire the old fashioned elephant-gun from his shoulder without a rest; his powers of endurance were simply marvellous, and he could drink brandy with a heroism that would have satisfied Dr Johnson.'[20] Wilfrid Scawen Blunt, however, described him as a 'wild animal' and a 'caged beast'. His ten-volume translation of the *Arabian Nights* (1885–8) with 'abstrusive and often supernumerary footnotes add up to an encyclopaedia of curious sexual lore'.[21]

It was through Burton's knowledge of and contacts in the East that Leighton was able to acquire so many tiles for his house. From Damascus, where he was British Consul, Burton wrote to Leighton on 22 March 1871:

> I am quite as willing to have a house pulled down for you now as when at Vichy, but the difficulty is to find a house with tiles. The *bric-a-brac* sellers have quite learned their value, and demand extravagant sums for poor articles. Of course you want good old specimens, and these are waxing very rare. . . . The fact is, it is a work of patience. My wife and I will keep a sharp look-out for you, and buy up as many as we can find which seem to answer your description. If native inscriptions – white or blue, for instance – are to be had, I shall secure them, but not if imperfect. Some clearing away of rubbish is expected at Damascus; the Englishman who superintends is a friend of mine, and I shall not neglect to get from him as much as possible.[22]

Burton, however, left Damascus in 1872 'under a cloud'. During his brief sojourn in England he was painted by Leighton, who ignored his pleas, 'Don't make me ugly, don't there's a good fellow', by choosing to paint the profile which exposed the savage scar on his cheek (fig. 92). Leighton visited Damascus in 1873, painting the

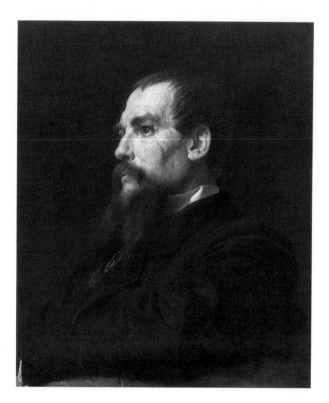

92. Frederic Leighton, *Sir Richard Burton*, 1875. National Portrait Gallery, London.

Burtons' old house and making contact, through Burton, with a missionary, the Reverend William Wright who helped him find textiles and Syrian pottery.[23]

Burton was next posted to Trieste, writing to Leighton on 13 July 1876,

> One word to say that the tiles are packed, and will be sent by the first London steamer — opportunities are rare here. Some are perfect, many are broken; but they will make a bit of mosaic after a little trimming, and illustrate the difference between Syriac and Sindi. They are taken from the tomb (Moslem) of Sakhar, on the Indus. I can give you analysis of glaze if you want it; but I fancy you don't care for analyses. The yellow colour is by far the rarest and least durable apparently. The blues are the favourites and the best.[24]

At the same time Leighton approached Sir Caspar Purdon Clarke who had been commissioned to acquire objects for the South Kensington Museum during a visit to Damascus.

> Before I started Leighton asked me, if I went to Damascus, to go to certain houses and try to effect the purchase of certain tiles. I had no difficulty in finding my market, for Leighton, with his customary precision, had accurately indicated every point about the dwellings concerned, and their treasures. I returned with a precious load, and in it some large family tiles, the two finest of which are built into the sides of the alcove of the Arab Hall. Leighton made no difficulty about the price, and insisted upon paying double what I had given. He never spoke of picking things up cheap, and scouted the idea of 'bargains in Art objects'.[25]

The Arab Hall was not simply a re-creation using bits and pieces from the East, but 'a remarkable homage to the arts of the East all [of which] serve to counteract the materialism of the typical Victorian interior' (figs 93, 94).[26] Mrs Andrew Lang, visiting Leighton in 1884 for the *Art Journal* commented:

The Holland Park Circle

There is about the whole hall the peculiar sense of repose and stateliness, of colour and solemnity, characteristic of the true East – or characteristic of it before Western nations threw their pebbles into the lake, and caused a series of ever-widening circles and disturbances. In those Oriental lands things have a knack of arranging themselves, and harmonizing without any external effort; or at any rate, without any such effort being apparent to the observer. This quality . . . strikes one on looking at the Arab hall. It has not been invented all at once, and planned in black and white on paper. It has grown bit by bit, as one thing after another was collected, therefore there lies about it an atmosphere of rest that can never belong to the hasty creation of a day.[27]

Leighton commissioned friends to provide complementary parts so the finished room can be seen as a unique interpretation of the East through the eyes of late Victorian artists. Aitchison designed the copper and cast-iron gasolier suspended from the ceiling; William de Morgan was responsible for devising the arrangement of tiles throughout the house, not just in the Arab Hall, and for making replacements for broken or missing portions.[28]

De Morgan also made the peacock-blue tiles in the 'Hall of Narcissus' which surrounded more Eastern tiles. This hall or ante-chamber was named after a bronze statuette of Narcissus which stood on a plinth in the centre, a reproduction of a statue in the Naples Museum. The floor of the hall was covered in black-and-white mosaic inlaid

93. George Aitchison, first design for the Arab Hall, 2 Holland Park Road, 19 July 1877. British Architectural Library, RIBA, London.

with a pattern of stylised leaves and lilies which 'casts up shimmering reflected lights upon the greeny-silver ceiling, like water itself'.[29]

The stylised alabaster capitals of the marble colonnettes in the Arab Hall were designed by Aitchison and carved by Princess Louise's teacher and friend, Edgar Boehm; Randolph Caldecott carved the naturalistic birds and foliage in the stone capitals of the Caserta marble columns (receiving 10 guineas in 1880). Caldecott was known for his painting of decorative panels, but in 1873 he had learned to model clay from the sculptor Dalou in exchange for English lessons.

Leighton showed Walter Crane a photograph of the mosaic frieze at La Zisa and asked him to design something suitable for the Arab Hall. Crane was an appropriate choice; his illustrations to *Ali Baba and the Forty Thieves* (published in 1873), anticipated the ideas of Aitchison and Leighton at 2 Holland Park Road. When he sent Leighton small-scale sketches of his mosaic, Leighton advised him to 'Cleave to the Sphinx & Eagle, they are *delightful*. I don't like the Duck-women – bye the bye – what do you say to making the circle in the returns *starry* heavens instead of another sun and moon?'[30] The 'Duck-women' were Crane's attempts at Sirens. The mosaics were made in Venice by Salviati's and the Murano Glass Company, an exuberant arabesque pattern with birds, animals, serpents and medallions but no 'duck-women'. Crane was paid a total of £336 between 1880 and 1883. Leighton also intended the dome to be covered with mosaics by Crane and Burne-Jones, 'when he was able to afford it', but it remained simply painted gold.[31]

There was no pretence that Leighton's house, any more than his 'oriental' paintings, was an accurate representation of the East; both, however, reflected his love of the colours, the textures, the light and the atmosphere he encountered on his travels. A painting such as *Portions of the Interior of the Grand Mosque of Damascus* (1873–5) is full of inaccuracies: two Muslim men pray in different directions, the faces of the girls are uncovered and they are walking across the mosque's main floor.[32] The Grand Mosque, however, is recorded in meticulous detail. Though Leighton owned a sketch of Ingres' *Odalisque*, he never indulged in the orientalist excesses of other Victorian and French artists. Explorations of the harem, of slavery and the juxtaposition of captive women (black and white) and dominant (black) men were staple; for example *The Bitter Draught of Slavery*, painted by his neighbour Ernest Normand and exhibited at the Academy in 1885 (fig. 106).

When Vernon Lee visited 2 Holland Park Road in 1883, her observations were waspish. She declared the house

> quite the 8th wonder of the world, including a Moorish cupola palace, with a fountain, all lined with precious Persian tiles and mosaics by Walter Crane, as good almost as a Ravenna church; Sir Frederick [sic] is a mixture of the Olympian Jove & a head waiter, a superb decorator & a superb piece of decoration, paints poor pictures, of the correctest idealism, of orange tawny naked women against indigo skies.[33]

T.H. Escott, writing in *Society in London* (1886) was hardly kinder:

> a Greek god in a frock coat. His are the hyacinthine locks, thinned indeed by years, but still with something celestial in their flow; his that glossy hue which as seen on his moustache or beard, may come from the liquid dew of Castaly or Rowlands' Macassar Oil. His voice is lutelike, and his language a mosaic of sentiments not so much rare in themselves, as set in

phrases which are miracles of the aesthetic imagination. . . . It is rather Ambrosia in syllables; it is Leightonese.[34]

Leighton and his house appeared to many to be dedicated to an overweening public life; descriptions of the interior of the house, of Show Sundays in his studio, of musical parties at which the performers were musicians of international reputation, visits by members of the royal family reinforced the impression. Crane, always an admirer, recalled 'the courteous and princely way in which he received his guests on these occasions, and the crushes he had at his studio.'[35]

Percy and Madeline Wyndham were regular guests at his musical parties, bringing their daughter Mary when she was old enough to be launched into society. She noted in her diary for 26 March 1879: 'Mamma, Papa & I went to Sir Frederic Leighton's concert it was so nice, Joachim, Patti [Alfredo Piatti, Italian cellist] Henschell & Mlle Janotta [Nathalie Janotha, Polish pianist] all played beautifully.'[36] The following week the Wyndhams attended a concert at Adelaide Sartoris' home with Leighton, presumably, in attendance. In 1881, Mary Wyndham was again at Leighton's house for a concert. The Arab Hall was not quite completed:

> We lunched dressed & went to Sir Frederic Leighton's: Joachim played, Piatti & Madame Schumann. . . . Mrs Grant, wife of the [US] President's son is a most curious looking woman with a peacock feather hat & rosebud jacket, pink stockings & emerald shoes, the Mills were there . . . Violet Lindsay, the Burne-Jones, Mr Watts, Prinsep, Millais & loads of interesting & amusing people. Jacky Aitchison was very keen about the dome that he has decorated, it is lovely, the persian tiles & coloured windows.[37]

The musicians who happily performed year after year for Leighton were also his friends, and some his neighbours. Joseph Joachim stayed with his uncle in Phillimore Gardens, Campden Hill, when visiting London. Charles Hallé, Joachim's regular partner in violin and piano music, settled on Campden Hill, at 1 South Villas, with his second wife, the violinist Wilma Norman Neruda. After his death, she moved to a house in the Holland Park development. And the baritone singer and conductor Georg Henschel lived in Bedford Gardens, also on Campden Hill. Leighton's appreciation of their talent, and his passion for music is evident in private letters. After one of his first parties, in April 1871, he wrote to his sister:

> To me perhaps the most striking thing of the evening was Joachim's playing of Bach's 'Chaconne' up in my gallery. I was at the other end of the room, and the effect from the distance of the dark figure in the uncertain light up there, and barely relieved from the gold background and dark recess, struck me as one of the most poetic and fascinating things that I remember. At the opposite end of the room in the apse was a blazing crimson rhododendron tree, which looked glorious where it reached up into the golden semi-dome. Madame Viardot [Pauline Viardot-Garcia, mezzo-soprano] sang the 'Divinites du Styx', from the 'Alcestis', quite magnificently, and then, later in the evening, a composition of her own in which I delight – a Spanish-Arab ditty, with a sort of intermittent mandoline scraping accompaniment. It is the complaint of some forsaken woman, and wanders and quavers in a doleful sort of way that calls up to me in a startling manner visions and memories of Cadiz and Cordova, and sunny distant lands that smell of jasmine.[38]

A letter to Joachim survives, written on 20 March 1875: 'It will be long indeed before I forget the impression made on me by that strange, fiery stirring composition which I heard yesterday for the first time and which has given me a greater idea of the extra-

ordinary power of Brahms than anything I had heard of his before.'[39]

Burne-Jones, increasingly reluctant to attend public events (his wife and children spent weekends as guests in country houses while he remained behind painting), was always willing to go to Leighton's annual musical parties. During the 1880s, he rented a studio on Campden Hill to work on his vast painting of *Arthur in Avalon*, commissioned by George Howard. He wrote to Watts in the spring of 1888, 'We all went to Leighton's music a week ago. All the ancient friends were there, but all looking a bit more ancient – it is my one musical delight in the year.'[40]

For those who shared Leighton's passion for music the house was rich in places in which to sit, to linger and to listen. Mrs Haweis, for example, noticed how in the inner hall 'beneath the hollow of the stairs a creamy ceiled nook forms itself, occupied by a sofa. The cream is starred with gold, and on either hand stand fine old specimens of early *Italian* inlaying, in stained woods and ivory in wood, forming a soft cedar-like background.'[41] Progressing up the stairs to the studio she found a 'fair divan of dainty colours, laid on that great cassone raised up as aforesaid, which makes a pleasant break in the line of balustrade. There *Juno* might rest on her way to *Apelle's* studio, her own peacock at her right hand as she sate.'[42] Mrs Lang was struck by the small painting-room, accessible from the studio, 'a little antechamber which has a raised divan, looking through a screen of old Cairo wood-work into the Arab hall below. In the centre of this screen is a Persian pot of beautiful design and colour, while the sides of the alcove have panels of blue and white Persian tiles.'[43]

The alcoves and divans, sofas, tapestries and Persian carpets reflected Leighton's own slumberous sensual paintings, from the early *Lieder ohne Worte* of 1861, *Golden Hours* (1864, fig. 30) and *Mother and Child (Cherries)* of 1865 to *Summer Moon* (1872), *Idyll* (1881), *The Garden of the Hesperides* (1892) and *Flaming June* (1895). These have to be seen not simply as inventions in the studio but reflections of the house itself, its design, contents and atmosphere:

> one can only stand and listen to the splashing of the fountain falling beneath the golden dome at the far end of the court, and conjure up recollections of the fairest of scenes and grandest of palaces described in the Arabian Nights. We are in Kensington; but as one stands there it would not come as the least surprise if the court were suddenly crowded with the most beautiful of Eastern women reclining on the softest of silken cushions in the niches in the corners; if the wildest and most fascinating dancers of the Arabian Nights were to come tripping in, and to the sound of the sweetest of strains glide across the smooth plaques.[44]

Though Leighton's father continued to provide him with financial support, his own income steadily increased from the moment he decided to live in Holland Park: receipts from the sale of paintings totalled £2,619 in 1864; £6,405 in 1878 and £21,799 – the highest – in 1893. *The Bath of Psyche* (fig. 97) was sold for £1,000; *Wedded* was sold for £1,500; *Captive Andromache* for £6,000. He bought shares with any surplus, investing heavily in railway projects. For his musical entertainments and dinner parties, food was supplied by Fortnum and Mason, flowers were bought, and good wine and cigars. His butler Kemp's wages were over £200 per annum; stabling in Pembroke Mews, close by, amounted to £55 per annum; his bills for dining at the Athenaeum, his favourite club, were some £300 per annum.

He also spent large amounts supporting his artist friends. Crane praised his generosity:

94. The Arab Hall, Leighton House Museum (formerly 2 Holland Park Road).

In spite of his grand manner . . . Leighton was most kind-hearted, and one of the things that will always be remembered by those who knew him was the willingness and good-nature with which he would take the trouble to look at and give friendly advice about young and unknown artists' and students' work.[45]

Julia Cartwright, attending a reception at his house in 1882, was impressed by his readiness to switch from his 'splendid manner' as President of the Royal Academy, 'talking French and Italian by turn to his guests', to listening to a young artist 'who had come to borrow some background for a picture'.[46]

John Hanson Walker was one of the young artists he befriended. Leighton noticed him in his father's shop in Bath – close to Dr Leighton's home in the Circus – and used him as a model, possibly for the face of the girl in *Lieder ohne Worte*, also for *Duett* exhibited at the Academy in 1862, and *Rustic Music*. Walker was keen to become an artist and was encouraged by Leighton, ten years his senior, to attend the Bath School of Art and Heatherley's School in London before applying to the Royal Academy Schools. Leighton was also supportive when Walker decided to marry, painting his wife as a present and standing as godfather to their first child – Frederick. He appears not to have minded Walker using their friendship to further his career, sitting to Walker for his portrait in 1877. Walker also used his name to sell his work: 'I beg to say that I still have the companion picture to 'Luck' having put it by for next year's Academy Exhibition. Should your friend like to purchase it I would take seventy guineas for it altho my friend Mr Leighton says I ought not to take a farthing less than eighty.'[47] When Walker went to the United States of America, Leighton provided him with an introduction to the millionaire Henry G. Marquand, the creator and director of the Metropolitan Museum of Art. Leighton, Alma-Tadema and Poynter had embellished the music salon of his Madison Avenue mansion in 1884.

Dear Johnnie . . . I was very glad to get your letter . . . I am glad that Mr Marquand has made you welcome in his house, which I understand is very beautiful. I know his Vandyke well; it belonged to an acquaintance of mine, Lord Methuen, who has a number of beautiful things at Corsham. . . . The Turner also I know, a rare favourite of mine. But of the Rembrandt I know nothing. I am glad, too, you thought my ceiling looked well. I hope he has introduced a little gold in the rafters to bind the paintings to the ceiling itself.[48]

Leighton was careful not to offer support where it might cause him embarrassment; like several of his protégés, Walker was not greatly talented. Leighton had to explain he was not the appropriate candidate for the position of Curator at the Royal Academy Schools (annual salary £200).

I am in great difficulty as to what I can do for you in the matter of the Curatorship. If it were only a question of testifying to your character, zeal, industry, etc., etc., I should have real pleasure in giving you that testimony in the highest and fullest degree. But, my dear Johnny, if I am not very much mistaken, the Curator is expected when required *to advise and direct the pupils*, and I cannot in candour conceal from you that your age and experience do not appear to me yet to qualify you for that part of the duties. . . . You must not be angry with me, Johnny; you know I have always spoken the plain truth to you, and am always too glad to think of you obtaining some post that should relieve you from all immediate pecuniary care.[49]

Walker was most successful during the 1880s, when he lived at Vicarage Gate, Kensington and was earning between £1,000 and £2,000 per annum, mostly for portraits. Other close friends were the Sambournes, on Campden Hill: his daughter Maud was bridesmaid at the wedding of Maud Sambourne (after whom she was named); his daughter May married Frank Romer, grandson of Mark Lemon, editor of *Punch*. After Leighton's death, his grand patrons faded away.[50]

Leighton recognised the talent of the young sculptor Alfred Gilbert, offering him, in 1882, £100 for a bronze in any style and subject. The result was *Icarus*, 'arguably the most beautiful work in bronze of the whole nineteenth century by an English artist' (fig. 95).[51] It was shown at the Academy in 1884, thereafter greeting visitors in the entrance hall to Leighton's house. Leighton had painted Icarus in 1869; Gilbert, equally ambitious, commented on the subject: 'it flashed across me that I was very ambitious: why not Icarus with his desire for flight'.[52]

Gilbert had admired Leighton since attending the Royal Academy Schools; Leighton's statue *Athlete Struggling with a Python* of 1877 was a major influence on the new generation of sculptors, including Gilbert and Hamo Thornycroft, who formed the 'New Sculpture' movement. He was 'an overwhelming force in changing the very nature of sculpture in England between 1880 and 1900. By encouraging young sculptors, by seeking out and championing men like Thornycroft and Gilbert, by a policy of

95. Alfred Gilbert, *Icarus*, 1884. National Museum of Wales, Cardiff.

steamrolling into the Royal Academy sculptors of real distinction, he raised the whole level of the medium in England out of its aimless, Mid-Victorian drift.'[53]

Holman Hunt, writing from Jerusalem in 1876 to F.G. Stephens, was forced to recognise Leighton's pre-eminence, however reluctantly:

> I am jealous of Leighton in his completion of his statue – it will be I am sure a very superior piece of sculpture and I hope that it will induce other *artists* to take to the Art and lead patrons to understand what a much better prospect the country would have in sculpture if it were pursued by painters or by people who at least had learnt to draw instead of the superior mechanics who now drive the trade of disfiguring Gods east with caricatures of its greatest men.[54]

Leighton continued to help Gilbert, introducing his work to his own patrons, Stewart Hodgson and Henry Marquand.[55] At the 1889 International Exhibition in Paris, Leighton's *Sluggard* was exhibited alongside Gilbert's *Icarus*, *Perseus Arming*, *An Offering to Hymen* and *Study of a Head*, also Hamo Thornycroft's *Teucer* and *Mower*. Luke Fildes had bought Gilbert's *Study of a Head* on the day the Academy opened in 1883. It was so popular that a railing had to be installed to keep back the crowds.

The sculptors shared a conviction that 'the expression of an artist's inner self must be more vital to sculpture than acquired style or refinement of taste'.[56] After Leighton's death, at the meeting held to discuss how to preserve his house, Gilbert was hardly able to speak. 'I can only say that all I know, and all the little I have been able to do as a sculptor, I owe to Leighton.'[57]

Many of the works in Leighton's collection – to be seen by visitors to his house – were gifts. There was his neighbour on Campden Hill, George Boughton's *Winter Morning, after Frost*, also two works by Albert Moore, *A Pastoral* and *Dahlias in a Vase* and G.F. Watts' *Venus*. Millais gave him *Shelling Peas* (RA, 1889) in return for a sculpture of Leighton's he had admired, *Needless Alarms*. Alma-Tadema gave him *The Corner of the Studio*; John Singer Sargent gave him a sketch for the ceiling of the Public Library, Boston, a reflection of Leighton's own contribution to wall-decoration.

Leighton also bought works by his contemporaries: Thomas Armstrong's *Summer Evening*, Herkomer's *The Steps of a Church*, Edgar Barclay's *Geese* (RA, 1869), George Clausen's *A Hilly Landscape*, Van Haanen's *Head of a Venetian Girl* (1883) and *Venetian Girl*, George Boyce's Egyptian landscapes, drawings and paintings by Legros, J.E. Hodgson's *Sheep Shearing*, several drawings by Burne-Jones, Simeon Solomon, Mortimer Mempes, Walter Crane, Aubrey Beardsley and Charles Ricketts.[58] French works included Delacroix' sketch for a ceiling in the Louvre and the same artist's *Sleeping Figure*, a pencil study by Ingres for *The Odalisque*, Corot's *Morning*, *Noon*, *Evening* and *Night* and landscapes by Daubigny. Old Masters included works by Giorgione, Paris Bordone, Schiavone and Tintoretto.

The final work of Aitchison for the house was the 'silk room', created to display some of Leighton's pictures. The wall was knocked through from the small painting-room (with the zenana alcove) on to the open terrace above the library. The terrace was then enclosed to form a picture gallery with a glass dome above and the external parapet decorated with an ornamental cresting similar to that of the Great Mosque at Cordoba.[59] Aitchison devised decorations: 'black marble pilasters and monolithic columns of pavonazzetto [peacock-coloured marble] with bases and carved capitals of black Numidian marble, and a dolphin frieze'.[60] The walls were hung with a 'warm faced leaf-green silk', but the frieze of dolphins, gold, blue and grey, was still unpainted at the time of Leighton's death.[61]

Leighton gave some artists gifts of money as well as buying their work. He had met Charles Perugini, a 'young and attractive Italian artist of sixteen', in Rome in 1854; by 1860 Perugini was living in London and a member of the Artists' Rifles. From 1871 until 1888, during which time he married Kate Collins and settled in St Alban's Grove, Kensington, Leighton paid him over £2,100. His paintings were similar to Leighton's – female models posed with decorative accessories – and he may have helped Leighton as a studio assistant.[62] Leighton also supported George Heming Mason financially, as well as encouraging friends to buy his work, and, after his death, he established a trust fund for his widow Mary. Leighton's generosity was known only to his closest friends, the details locked away in his account at Coutts Bank.

The contrast between Leighton's public and private personae inspired Henry James to consider a 'little tale'

> founded on the idea of F.L. and R.B. [Frederic Leighton and Robert Browning] . . . the idea of rolling into one story the little conceit of the private identity of a personage suggested by F.L., and that of a personage suggested by R.B., is of course a rank fantasy, but as such may it not be made amusing and pretty? It must be very brief – very light – very vivid. Lord Mellefont is the public *performer* – the man whose whole personality goes forth so in representation and aspect and sonority and phraseology and accomplishment and frontage that there is absolutely – but I *see* it: begin it – begin it.[63]

Transformed into the 'extraordinarily first' Lord Mellifont, Leighton was 'all public and had no corresponding private life'. James, himself, wrote of Leighton, 'I have never known a man so long & so little'.[64]

The artists to whom he offered financial support may have felt they knew something of the private Leighton, as may those who attended private parties at his house.

> After a dinner party at which Sir E. Burne-Jones, Mr Whistler, Mr Albert Moore and many others were present, I recollect how when we were smoking and drinking coffee in this hall, somebody, excitedly discoursing, stepped unaware right in to the fountain. Two large Japanese gold tench, whose somnolent existence was now for the first time made interesting, dashed about looking for an exit, and there was a general noise of splashing and laughter.[65]

As host to fellow artists 'he was most genial, all reserve being thrown off';[66] he had also been able to relax at Arthur Lewis' gatherings of the Moray Minstrels.

James fantasised that when alone, Lord Mellifont ceased to exist; in reality, Leighton's life, apparently so public, was organised around a series of private experiences. He usually travelled unaccompanied, often for several months of the year, through Europe, the Near East and North Africa. And for five days a week, Kemp protected him from visitors in his London home.

> 'Not a sound reaches me here, save the singing of the birds,' said Sir Frederick [sic] Leighton, as we stood for a moment in the garden of his beautiful house . . . there was nothing whatever to disturb one's thoughts on this day of sunshine, when the flowers about the lawn were looking their brightest and best, the great trees and tiny trailing ivy greener to-day than ever before.[67]

James gave Lord Mellifont a wife in his short story; Leighton never married and the general opinion of contemporaries and biographers is that he probably had no sexual relationship with a woman, or, for that matter, a man. Prinsep, Watts and Leighton's

sisters would probably be the only ones to know the truth. There are no surviving letters between Leighton and Prinsep, and few letters between Leighton and Watts dating from before 1880. When Mary Seton Watts was collecting material for her biography of her husband (Watts married her in 1886), Leighton's sister Augusta sent her a bundle of letters, with a covering note: 'I have not read them & if they should contain any references to Lord Leighton's affaire I am sure you would not publish without allowing me to see them'.[68] What could the 'affaire' be?

Gossip focused on Leighton's relationship with Adelaide Sartoris, the older married woman (she died in 1879), and later on his favourite model Ada Alice Pullan, twenty-nine years his junior, who took the name Dorothy Dene when she began lessons as an actress under his 'protection'. Whatever the physical nature of his relationship with Adelaide, it caused no scandal.[69] Dorothy Dene was another matter: she was a model and posed in the nude. A reviewer of *The Bath of Psyche* could not resist dwelling on her identity (fig. 96): 'Psyche's contour is perfect and her form is deliciously rounded. The exquisite pearly fairness of the skin must ever make this rendering of the amorous deity the standard of colour as of modelling . . . Dorothy Dene, Leighton's favourite model, here displays her charms for the admiration of mankind.'[70] Leighton insisted to his sisters his position was honourable: 'On the only thing that matters, you are *absolutely assured, if you believe in my honour*. If you hear these rumours again, meet them with a flat, ungarnished denial.'[71]

In her biography of Leighton, his neighbour Emilia Barrington proposed she had 'discovered' Dorothy, 'a young girl with a lovely white face' standing at the door of one of the Holland Park Road studios (built on the site of Miss Fox's school and next door to Val Prinsep). 'She told me that she had recently lost her mother, her father had deserted his family of five girls and two boys, and she and her elder brother were left to support them.'[72]

The artist employing Dorothy would have been Herbert Schmalz, who had lived at 5, the Studios, Holland Park Road since 1880 (see chapter 15). Dorothy and her sisters became regular models for several artists in the Holland Park area: Schmalz, Leighton, Watts and Emilia Barrington. Isabel ('Lena Dene') modelled for Leighton's *The Light of the Harem* and *Sister's Kiss* (1880) when she was only thirteen years old; Dorothy first appeared in *Bianca* and *Viola* (1881). Henrietta ('Hetty Dene') modelled for *Farewell* and Edith modelled *Memories*, both in 1883. The same year the family moved to respectable Clapham, presumably with Leighton's financial help as over £400 was paid to Thomas, the head of the family. Leighton also assisted the sisters' ambitions to become actresses, paying Thomas regular monthly payments totalling £300 in 1884, the year Dorothy attended Mrs Glyn's dramatic lessons.

In 1886, Dorothy and her younger sisters moved to a flat close to Holland Park Road. Dorothy's stage début had been the previous year but she achieved little success in the theatre; her forte was as the inspiration for some of Leighton's last, greatest paintings, including *The Last Watch of Hero* (1887), *The Bath of Psyche* (c. 1890), *Perseus and Andromeda* (1891), *The Garden of the Hesperides* (1892) and *Flaming June* (1895).

Whatever their relationship, at his death he left her £5,000; also £5,000 in trust. She was summoned to his deathbed by his sisters and reputedly said, 'If I have or ever will do anything worth doing, I owe it all to you – everything I owe to you.'[73]

The secrets of Leighton's private life become more complicated with the puzzle of the identity of Lily Mason (fig. 97), another major beneficiary at his death. She was not a relation of his close friend the artist George Heming Mason, or Mason's widow Mary. However, she received £1,450 from his sisters (who administered his estate) to be placed in her account in the London and South West Bank of Brixton. When Leighton's sister Augusta drew up her own will in 1917 she left a further £1,000 to Lily. If Lily should die in Augusta's lifetime, the money was to pass to her son Frederick James George Mason (fig. 98), who also received under the terms of the will the considerable sum of £3,420 in his own right. In addition Fred was left a watch and a gold ring mounted with diamonds.

So who was Lily, and who was Fred? Lily was born Louisa Wilhelmina Spence on 23 March 1845 at 3 Lupton's Fold, North Leeds. Her father was a dyer. By 1872 Lily was living in London with Frederick Mason, commercial traveller, and their two daughters, Ninny and Jenny. On 16 September 1872 she received two guineas from Leighton, probably for modelling (the going rate was one shilling an hour). She continued to receive similar sums until early 1875. Leighton was working on the monochrome cartoon and colour sketches for The Arts of Industry as Applied to Peace, the second of his enormous frescos commissioned for the South Court of the South Kensington Museum. Many models were required. A similar 'cast of thousands' was required for The Daphnephoria. Lily could be in either painting, somewhere lost in the crowd. In 1875 she would have been thirty years old; Leighton was forty-five.

Some time between 11 October and 23 October 1875 Fred Mason was born.[74] From February the same year Leighton's payments to Lily and her husband had increased in size. There is, however, no discernible pattern to the payments until 1879. From 1879 to 1883, the Masons received three or four annual payments of between £90 and £100; from the end of 1883 to 1890 they received two or three annual payments of £65; from 1890 until Leighton's death they received two or three annual payments of about £50. In addition, the Masons received many small amounts plus a few large amounts: the largest, in August 1884, of £600. By his death, the Masons had received a total of at least £9,000.

Within the Mason family, Leighton was known as Fred's 'Godpapa'; his sister Augusta was 'Grandma Matt'. A letter survives from Leighton, written early in 1885: 'Dear Lil, Thank you vy much for the pretty little locket & your good wishes on my 54th birthday – also the sweet mite whom thank & kiss from his old godpa – I am glad you like the drawing – it is the original sketch of an engraved picture called Daydreams. In haste Your affec Godpapa.'[75] From November 1892 to November 1893 Fred was sent abroad to study German and science at the Hohere Schule Dissen: a career in manufacturing had been chosen for him. The same year Leighton paid the family a total of £675.

Personal contact between the Leighton family and the Masons appears to have increased rather than decreased after Leighton's death: it was public and devoid of patronage. Lily died on Armistice Day 1918. When Fred died in 1953 at St Mary Abbot's Hospital, Kensington, his surviving children were surprised to discover he had left a small fortune. He had shared few stories with them about Lily and his 'Godpapa' Leighton, even though the artist's set of Shakespeare, with a book-plate designed by Robert Anning Bell, was in the bookcase, and a few sketches hung on the walls. But after his death the children began to share information. His daughter Jessie Cecilia,

96. Frederic Leighton, *The Bath of Psyche*,
c. 1890. Tate Gallery, London.

The Holland Park Circle

wife of the historian Sir Charles Petrie, visited Leighton House with her brother
Frederic Charles Mason (Fred had given his son the same Christian name as Leighton).
Then Frederic took his sons Neil and Keith Leighton Mason, independently, to St Paul's
Cathedral, to visit the artist's tomb. Keith, who was about fourteen years old, remem-
bers descending to the crypt and standing in front of the tomb. 'This,' said his father,
'is your great-grandfather.'

Surviving photographs of Fred show a marked similarity to Leighton. Was Fred
Leighton's son? Could he be the little boy in *Elisha Raising the Son of the Shunamite Woman*
(1881) or in *And the Sea Gave Up the Dead Which Were In It* (1882–4), both dealing with
themes of death and resurrection? Or is it possible that Leighton was just a godfather?
We know that he was perceived as and regarded himself as 'Godpapa' to Fred. This could
perhaps be the full extent of his relationship. His other godchildren, however, were rela-
tions or the children of his closest artist-friends, including Val Prinsep and Giovanni
Costa. It is hard to explain why he should be godfather to the son of a commercial trav-
eller and a model. The term 'Godfather' has often covered a multitude of sins.

The evidence of the Masons' shared anecdotes and their letters and photographs,
combined with the financial evidence at Coutts and in Augusta Matthews' will, surely
points to one conclusion. Leighton was, or believed himself to be, the father of Fred
Mason. This is certainly what the Mason family believe.

14

Prinsep, Webb and 1 Holland Park Road

Val Prinsep probably knew more about Leighton's private life than anyone: he was one of his most intimate friends, and claimed to be 'the only man with whom Leighton ever travelled or with whom he lunched at his club.'[1] He was given money by Leighton, a total of £790, between 1880 and 1884. Later, he wrote of Leighton, 'There never was a man . . . who so unsparingly devoted himself to the advancement of his profession and the welfare of his less fortunate brethren'.[2] He was also one of Leighton's few critics, earning a reputation of being hard to please.

> Leighton used to recount an instance of this. . . . [He] had completed the modelling of a statuette, which has as its subject an athlete struggling in the coils of a snake. Being satisfied with the effect produced, he showed it to his friends. They all pronounced it grand. . . . After having achieved so great a success among his other artistic friends and meeting with such unanimous praise, Leighton 'greatly daring', determined to show it to Val Prinsep. The stern critic gazed at it for some minutes, unable apparently to find objection to the work. Sir Frederick [sic], seeing that he had made a favourable impression on the redoubtable Val, awaited with no small feeling of confidence the result of his friend's contemplation. Silence reigned supreme for some few moments; then at last the Oracle spoke. 'The *snake's* wrong, *any* way'.[3]

While Leighton was embellishing 2 Holland Park Road, Prinsep also embarked on alterations to his modest house. Work began in 1877, following an invitation by Lord Lytton, Viceroy of India, for Prinsep to paint the Delhi Imperial Assemblage to celebrate Queen Victoria's accession to the title of Empress of India.

Prinsep had been commissioned two years before by the India Office to paint Lord Lawrence, Governor-General of India; the picture was to hang in Government House, Calcutta. Whether through the Prinsep family connection with India (Thoby was a friend of the Viceroy) or Watts' friendship with Lawrence (he included him in the Lincoln's Inn fresco and painted his portrait in 1862), the commission led to the much more exciting offer to travel to India to paint the Durbar. Prinsep was paid £5,000 for the painting in addition to all other expenses, which amounted to a further £1,000. He sailed for India on 11 November 1876.

Within official circles he was not regarded as the best artist for the work. Charlotte Knollys wrote to the Viceroy on 23 October: 'I am afraid he will not represent very ably the artistic talent of England & this I believe is the general opinion here'.[4] Perhaps it helped that he lived next to Leighton and that his work was liked by the Prince of Wales, who visited his studio on several occasions.[5] The Prinseps were also familiar with India; as Prinsep noted: 'the climate and its evil effects on the constitution of a person not inured to it were much to be dreaded . . . I had the advantage of

belonging to what is called an Indian family . . . although I left Calcutta at an early age'.[6] Nevertheless, the task was formidable.

> Officially armed, he traversed the country far and near, taking the portraits of the native royalties, princes, ministers, and others. He travelled from Bombay to Allahbad, to Cashmere, to Madras, and Mysore, and thus, much hampered by etiquette, the hideousness of Western accessories, and routine, he collected materials for the work of thirty feet long, which now hangs in Buckingham Palace.[7]

Luke Fildes (whose own house in Melbury Road was nearing completion) assumed that he would be knighted, writing to Henry Woods shortly before Prinsep left for India, 'It will be a very fine thing for him and his reputation. He may eventually become Sir Val Prinsep in consequence.'[8]

He made good use of the opportunity, bringing back dozens of sketches of natives and the landscape. After the Assemblage was over he travelled all over the country to paint portraits of those who had taken part: he also painted their garments: 'Some of the rajahs were not exactly complaisant, and others very difficult of access. Occasionally, Mr Prinsep couldn't wait to complete a sketch, so he would take away with him the prince's uniform – in many cases a very costly dress indeed.'[9] The official painting contained nearly 160 recognisable portraits.

Prinsep wrote a lively account of the visit, *Imperial India. An Artist's Journals*, published in 1879, the first of his literary efforts.

> Oh, horror! what have I to paint? A kind of thing that outdoes the Crystal Palace in 'hideosity'. It has been designed by an engineer, and is all iron, gold, red, blue, and white. The dais for the chiefs is 200 yards across, and the Viceroy's dais is right in the middle, and is a kind of scarlet temple 80 feet high. Never was there such Brummagem ornament, or more atrocious taste.[10]

As soon as he received the commission, Prinsep approached Philip Webb to make alterations to his house. Like Leighton's it expanded both in anticipation and on receipt of rewards, social and financial. Webb's challenge was to provide Prinsep with more space for painting, for entertaining and for sleeping. On the street side, he threw an arch over the area below, creating a second studio linked to the first by double doors. This would be large enough to accommodate the 27-feet-long canvas which Prinsep worked on in three sections. Webb also turned the roof space into bedrooms, thereby releasing the spare bedroom for use as a dining-room. The original dining-room was transformed into a drawing-room, giving Prinsep more scope for prestigious entertaining.

Webb's estimate for the work was £800–£850;[11] a tender of £730 was accepted from Messrs Ashby on 20 February 1877. Webb was forced to write a contrite letter to the Ilchesters' agent Robert Driver on 22 March:

> it was simple inadvertence on my part that the right & proper notice & inspection of the plans were omitted to be laid before you before the work was begun. I can only acct. for the omission by the pressure of the business, for Mr Prinsep, having gone to India, left me but too short time in wh to carry out the work during his absence. . . . My clerk brings with him the plans, and on his return with them a tracing shall be made for you at once.[12]

Driver signed the plans four days later.

Work was completed in time for Prinsep's return at the beginning of 1878, and

99. Valentine Prinsep, *A Nautch Girl*, 1878. The Royal Collection. In Prinsep's *Imperial India* (1879), the model is identified as Begoo, a Kashmiree Nautch girl: 'Of moral sentiment they were entirely innocent, but they would never permit anyone to drink out of their cup or smoke from their hookah, and they always went about with these two utensils, for smoke and tea are the two things necessary to a Kashmiree' (p. 228).

shortly after, the Prince of Wales called to see his Indian paintings. All the sketches were taken to Windsor

> in a van – forty kit-kats and more than as many smaller sketches. They were ranged all round against chairs and things in the White Drawing-room, overflowing into the Green Drawing-room. Mr Prinsep himself acted as *cicerone*, and his interview with Her Majesty lasted nearly an hour.[13]

The Queen liked the portraits though she wrote in her journal, 'the landscape ones are hardly as good'.[14] The Prince of Wales preferred Prinsep's paintings of women which he 'worked up' for the Academy, buying *A Nautch Girl* (fig. 99) for 280 guineas and *The Roum-i-Sultana* (RA, 1879). The latter depicted an imaginary reconstruction of the European wife of Akbar reading in her pavilion at the Emperor's palace as she is fanned by a native servant.

Further Indian pictures appeared on the walls of the Academy: straightforward observations of the scenery such as *The Taj Mahal* (1877), *Bathing Ghats at Benares* (1883), *Afternoon Gossips on the Banks of the Ganges* (1885), *The Lake at Udaipur* and *The Garden of the Taj*; also more fanciful orientalist creations, *At the Golden Gate* (1882) (fig. 100), *Miriam, the Slave* (Grosvenor Gallery, 1883), *Ayesha* (bought by the Chantrey Bequest for £300 and inspired by Rider Haggard) and *The Fisherman and Jinn* (1895) from *The Arabian Nights*.

But the huge Durbar painting was not received particularly well either at the Academy of 1880, or by the Queen. *Vanity Fair* called it 'that Eastern monstrosity'.[15] Andrew Kurtz, the Liverpool industrialist and patron of Leighton, noted in his diary

after visiting the Academy: 'a glaring display of colour on a most prosaic & quite ugly scene. I have no doubt but it is a correct rendering of the ceremony, it is quite in character with the pretentious business, but such things don't belong to the realms of Art at all.'[16] Twenty-seven feet long, 13 feet high, with an oak frame costing £300, the whole thing weighed, according to the *Strand*, two or three tons. Fourteen men were required to remove it to the Academy 'in a folded shape'. At Buckingham Palace it was hung in the Princesses' Corridor and consequently not seen by visitors. It was eventually moved, in 1901, to the Banqueting Room at St James's Palace and hung over the doors, lofty, but inaccessible.[17] Prinsep was elected an Associate of the Academy in 1879, but never knighted.

Prinsep became friends with Frederick Leyland and his daughter Florence in the early 1880s; his marriage to Florence took place on 28 July 1884. Mary Wyndham, recently married to Hugo, Lord Elcho (the son of Watts' friend who had become Earl of Wemyss in 1883), was invited with her parents, Percy and Madeline Wyndham (for many years patrons of Prinsep). Prinsep was forty-six years old, Florence twenty-four (fig. 122).

> Went to Val's wedding drove Papa on to Princes Gate. Beautiful house, beautiful pictures wedding banquet at 1.30 Mr Somers Cocks, Mr Millais I sat between. Sir F Leighton was best man, the bride looked very nice Mr Poynter & Mr Watts & Mr B.J. & Phil [Burne-Jones] & many others were there.[18]

In September the newly-weds stayed with the Wyndhams at Wilbury House in Wiltshire. Madeline wrote to her daughter with the details:

> We have a very jolly party here. The Eddie Bourkes and Mr & Mrs Val Mr Dick [Grosvenor] and our own two boys – they make such a row & laugh till all is blue . . . Mrs Val is very nice Very quiet & rather pretty but has rather a common voice to sound Percy likes her very much I think and dear dear old Val is as happy as the day is long happy down to the ground beaming.[19]

As well as enjoying Florence's income (reputed to be £10,000 per annum), Prinsep was made a director of the board of Leyland's shipping company; he was also 'on the board of directors of the Ellernan Lines, Limited, the City Line, Limited, and the Debenture Securities Investment Company, Limited'.[20] By 1890 the couple had acquired a seaside property at Pevensey in Sussex, ideal for family holidays with their three sons; also an apartment in Venice where they could entertain friends and neighbours from London, including Leighton, Fildes and Woods, who wrote to his brother-in-law:

> A large party of us including Leighton dined at the Palazzo Rezzonico the other night . . . boxes at the Goldini afterwards to hear Zago. The President [Leighton] . . . with the Prinseps and myself stopped for a very broad laughable farce afterwards. The Prinseps have been at Bain in every possible opportunity. I am afraid she is very fond of beer.[21]

Woods wrote again on 29 October: 'Val and family are at the Palazzo Rezzonico . . . and I am very glad. They are a thoroughly good pair, and I see a good deal of them. She is not a flatterer.' Prinsep sent paintings to the Academy similar in style and subject matter to the Venetian works of Woods and Fildes.

The decision to enlarge their London house was taken after the death of Florence's father. The intended work was extensive: the estimate for alterations to the old house was over £2,000; the new block was to cost almost £6,500, virtually doubling the size

100. Valentine Prinsep, *At the Golden Gate*, 1882. City Art Gallery, Manchester.

of the property. It would eventually extend almost to Leighton's Arab Hall and northwards along the border with his garden. The ground floor was given over to entertaining, with a spacious hall, two drawing-rooms, a dining-room and music room; the services were below, with a large billiard room immediately beneath the music room. There were four bedrooms and a bathroom on the first floor, another four bedrooms and an ironing room on the second floor.

Webb was working at the same time on Standen, a substantial house in the Sussex Weald, commissioned by James Beale, a solicitor who lived at 32 Holland Park, immediately opposite the Ionides' house. Beale's choice of architect – he chose Morris and Company for his decorations – could have been the result of seeing 1 Holland Park, Prinsep's own house (fig. 101) or the Howards' at Palace Green.

The builders appointed by Webb for Prinsep were C.W. Bovis and Company. Mr Fuller was appointed foreman.[22] Work began in the summer of 1892. The new wing was to be a solid structure (like all Webb's work), the floors constructed of iron beams set in concrete.[23] In October the Prinseps moved out of the old part of the house so that alterations could commence. In spring 1893 they were in Paris, Prinsep writing to Fildes, 'I shall be over again at the end of the month to see after my portrait, all I shall have for the R.A., & shall make a round of the studios on Show Sunday'.[24] While staying at the Grosvenor Hotel in June he was sent Webb's design for the 'initial & date

101. Philip Webb, front
and side elevations of 1
Holland Park Road, 14
September 1892 (cf. figs
24 and 25). British
Architectural Library,
RIBA, London.

escutcheon' to be placed on the west wall of the new block. The couple finally returned to Holland Park in the late autumn to 'the largest and one of the most beautiful of the four or five small palaces that have been built in London by modern artists'.[25] When the *Strand* reporter visited in 1896, he highlighted the fortuitous combination of wealth and artistic taste:

> Mr Prinsep is a Royal Academician and a man of great wealth. Either of these two conditions would ordinarily result in a man having a house beautiful externally and internally; the union of the two in Mr Prinsep, however, results in a sumptuously appointed palace replete with all that wealth can purchase and high artistic feeling dictate.[26]

The entrance porch features in a painting by Prinsep of his wife and two sons, *A Family Portrait*; within, the hall had a dado covered in Japan paper, the floor was of marble, 'parmazetta – Spanish Malaya and Alpine Green', one inch thick, covering 726 square feet and costing £246.[27] The house was lit with electricity; speaking tubes connected the inner door of the entrance to the studio, and the butler's pantry, next to the dining-room, to the kitchen below stairs. The two drawing-rooms were known as the Tapestry Room and the White Room. In the Tapestry Room, named after the wall-hangings, were sketches by Leighton, Millais and Burne-Jones. Alfred Gilbert's bronze bust of one of Prinsep's sons was displayed in the White Room. Both rooms were filled with Italian furniture, cassoni, carvings and fine pieces of porcelain.

Webb designed spectacular ceilings and friezes for the dining-room and music rooms, where the floors were of solid oak ('Daffys flooring'). The high oak dado surrounding the music room was lacquered a dull gold; the ceiling was crossed by heavy beams divided by panels decorated with designs

> by Mr Prinsep, in which tones of subdued gold predominate. The beams support chandeliers of rock crystal, the chairs and couches, covered with Beauvais tapestry, are of the Louis XV

period, and old Persian carpets cover the polished floor. French cabinets and clocks of the eighteenth century, rare Chinese pottery and sixteenth century Venetian wood-carvings take their places together harmoniously in the music-room, on whose walls, covered with silk hangings of pinkish red, are many pictures ancient and modern.[28]

The fireplace was of Cuban mahogany and Belgian fossil granite with a mantelpiece designed by Webb and carved by Laurance Turner. Below, the billiard room had an oak floor (the bedroom floors were parquet); a lavatory was positioned close by. De Morgan tiles were used throughout the house, Webb listing possible designs and colours in his notebook: 'Boston', with 'ground green stalks & leaves & bright blue flowers'; 'Anemone leaf' with a turqoise ground or a white ground; 'Cyprus', with purple flowers and dark green leaves.[29]

At the sale of his father-in-law's collection of paintings and china he bought one painting he had admired since a young man living at Little Holland House, Millais' *The Eve of St Agnes*. It cost him 2,000 guineas and was hung in the music room. He wrote immediately to Millais:

> It was a great pleasure to me, my dear old chap, to be able to purchase your picture. There is not an artist who has failed to urge me to do so. For the professions sake I am glad your picture is in the hands of one of the craft, for it is essentially a painter's picture. After all, what do the public and the critics know about the matter? Nothing! The worst is, they think they do, and hence comes the success of many a commonplace work and the comparative neglect of what is full of genius. I've got the genius bit, and am delighted.[30]

After Leighton's death, Prinsep attended the sale of the contents of his house. He bought paintings, including Mason's *Grapes in a Basket*, Herkomer's *The Steps of a Church*, Giorgione's *The Resurrection*, and many studies by Leighton; pieces of china and porcelain from Persia, Japan, China and Rhodes. From Leighton's own studio he acquired a lay figure of a child and an ebonised chair and stool of Greek design.

Leyland's money provided Prinsep with a luxurious, richly furnished home and the opportunity to travel abroad whenever and wherever he desired. It also removed the necessity for Prinsep to sell his paintings, a situation unique among the Holland Park artists. Prinsep had always been subsidised by his parents; after Thoby Prinsep's death Leighton provided some financial support, factors which contributed to Prinsep's failure to find a personal artistic style. However, he always regarded himself first and foremost as an artist; even when a very wealthy man, he regularly submitted a painting to the Royal Academy. The only room in his home which was left little changed, apart from a fresh coat of paint (Webb described Prinsep's choice as 'a bad sandy red') and improved ventilation, was his studio.

> The studio has none of the richness of furnishing and decoration that mark the principal rooms of the house proper, such as the music-room and the tapestry-room. It looks what it is, a work-room, and its principal adornments are a few paintings by Mr Prinsep himself and some studies by Leighton, his life-long friend. One of the Leightons, a study in oil of a child with a background of sea and coast, is a memento of a holiday the two artists spent together in Ireland.[31]

15

The Studios of Holland Park

Leighton's public profile as President of the Royal Academy and leader of the art establishment, friend of the Prince of Wales and gracious host at well-publicised musical parties held in his exotic home inevitably attracted younger artists to Holland Park.[1] They worked in very different styles and subject matter but shared a determination to acquire almost any sort of space which could be used as a studio and which was close to the President. Accommodation intended for horses and stable-boys was adapted for ambitious but poor painters and sculptors. Building speculators were quick to follow, erecting purpose-built studio blocks, some with live-in accommodation, for artists with slightly more money. By the end of the century Kensington offered a range of accommodation, from recently converted stables to oriental palaces, for artists at almost any point in their professional career and personal life, whether married with a large family or seeking retreat from family responsibilities; whether single or in a clandestine relationship.

Tradespeople still living in Holland Park Road benefited from the influx of artists, including Mrs Caroline White, 'clear starcher' who provided the 'gentlemen of the brush' with their clean shirts. She lived in a small cottage with window-boxes filled with nasturtiums and geraniums; her best customer was Leighton, naturally: ''e is a gentleman, 'e wears three clean shirts a day, and I wash 'em'.[2]

The motley collection of stables and mews dwellings opposite Leighton was the first to be colonised; here rents were a modest £40 per annum.[3] John Butler Yeats, father of Jack and William, took a studio in 1880 before returning to Ireland; so did the sculptor Giovanni Battista Amendola. The painter Tristram Ellis rented a studio for over ten years.

The only artist who achieved a national reputation was Solomon J. Solomon, who took a studio in 1887. He has the distinction of painting one of the most violent rape scenes of the century, his 1886 *Ajax and Cassandra*, showing Ajax abducting Cassandra from the temple of Athene. He regularly tackled subject matter which included death and violence laced with eroticism, including the 1887 *Samson* (fig. 102), a vast canvas depicting the moment Samson's hair is cut, a bare-breasted Delilah watching from the side. Solomon's younger brother Philip modelled for Samson; Therese Abdullah, the daughter of Sir Albert Sassoon's cook, provided the head of Delilah; an Italian, Madeleine Fiorida, modelled Delilah's body. In *Niobe*, shown at the Academy the following year, more bare-breasted girls, alive and dead, fill a canvas over ten feet high and six feet wide. Solomon was elected an Associate of the Academy in 1896 and full Academician in 1906, the second Jew to be accepted. After marrying in 1897, he

102. Solomon J. Solomon, *Samson*, 1887. Walker Art Gallery, Liverpool.

moved to larger premises in St John's Wood. By then, no building plots remained undeveloped in Holland Park.[4]

Solomon's choice of scenes from the Bible and the classics links him to his neighbours Leighton, Watts and Prinsep. His preference for moments of violence, often involving women (as both victims and perpetrators), was shared by two other artists who moved to Holland Park Road in the 1880s, Herbert Schmalz and Ernest Normand. They acquired studios in the only purpose-built block of studios to be built in the road.[5]

The block known as the Studios, Holland Park Road, was erected immediately next to Val Prinsep's house. The charity school established in 1842 by Caroline Fox on land immediately to the west of Prinsep was taken over by the London School Board in 1876. A new site was found and the original school was sold at auction in 1877 for £2,650.[6] William Willett, a builder from Hove, acquired the property and applied to the council for permission to build a group of six two-storey studio residences arranged round a courtyard with an arched entrance and numbered, confusingly, 3, 5, 7, and 2, 4, 6 (numbers 3 and 2 adjoining the road) (fig. 103). The north side of the property backed on to the garden of 4 Melbury Road and Emilia Barrington erected her own garden studio against the end wall of the new development. The riding school remained immediately to the west until the turn of the century. The leaseholders paid ground rent of £18 per annum; their tenants, if they sub-let, paid rent of approximately £90 per annum and had to contribute £1 per annum to the maintenance and lighting of the courtyard.[7]

103. The Studios, Holland Park Road (Val Prinsep's house, 1 Holland Park Road, is in the distance).

The Holland Park Circle

Willett gambled on sufficient artists, probably bachelors or without large families, desiring generous studios at a reasonable cost, extremely close to the residence of the President of the Royal Academy. The first studio to be occupied, probably the first to be completed, was number 3, to be known as Rowsley House, adjoining Prinsep's garden and fronting Holland Park Road. James Arbuthnot Goldingham, his wife Ellen and their 'general domestic' were the residents. They were joined soon after by William Robert Symonds in number 7, who specialised in sentimental genre scenes, often of children and their pets. Both Goldingham and Symonds were upstaged by the flamboyant Herbert Schmalz, ambitious, single and a follower of Leighton, who became neighbour to both, moving into number 5 in 1880.

Schmalz was born near Newcastle, his father a successful merchant and German Consul. He studied at the Royal Academy Schools with Frank Dicksee and Alfred Gilbert and made his début at the Academy in 1879 with *I Cannot Mind My Wheel, Mother!* Leighton and Alma-Tadema were impressed by the young man's work and visited his studio in Newman Street. Tom Taylor gave him a good notice in *The Times*.

The following year, after showing *For Ever*, a love scene in a medieval setting, at the Academy, Schmalz moved into his Holland Park studio and became practically a neighbour of Leighton. He was not averse to using gimmicks for publicity acquiring a boarhound weighing fourteen stone which he named Sultan Achmet. During private views at the Grosvenor Gallery he chained the animal in the entrance hall, thus indicating his presence in the gallery. He also included the dog in a large classical painting of the men and women of Athens trooping to propitiate 'Blind bow God', letting it be known, however, that he 'was very much exercised as to the suitability of Sultan's clipped ears for representation in a classical subject, till he came upon a statue of Meleager, the boar-hunter, which showed his hounds with similar peculiarity'.[8]

Schmalz was fortunate to receive the accolade of a large publication devoted to his work in 1911, before his reputation had entirely vanished. His appreciative biographer Trevor Blakemore wrote defensively:

> If a statesman, general, or pro-consul benefits and pleases the public, he is duly praised by his fellows in such profession; but if the artist contrives by beauty or human interest to win the appreciation of the public, there is something more than a suspicion among his fellow artists, first, that he is stealing a march on them by advertisement, and, secondly, that art which is generally admired must be bad.[9]

Schmalz's interpretation of his subject matter now raises questions of taste, though contemporary views were apparently different. The theme of binding and chaining women was common in the nineteenth century.[10] A conservative journal such as the *Strand Magazine* was able to deal comfortably with *Christianae and Leones* (fig. 104), shown at the Academy in 1888, to the extent of providing details for the reader of Schmalz' use of his fifteen-year-old female model.

> No one can fail to notice how the bonds which bind the girl to the post seem to cut into the soft flesh of her arms. This was realized absolutely by the model, for Mr Schmalz had a post erected in his studio and bound the girl to it exactly as represented. Within the limited area of the panel it will be noticed how the whole spirit of the large picture has been retained, even the mark in the foreground of the chariot-wheel, which has thrown to one side the thigh and shin-bone of some long dead-and-gone martyr who had perished for the sake of her faith.[11]

104. Herbert Schmalz, *Christianae and Leones*, 1888.

Schmalz may have been responsible for introducing Leighton to his favourite model Dorothy Dene. Like Leighton and Watts, he engaged several members of the family as models and in 1889 he married Edith. She modelled for *Dream of Yesterday*, exhibited at the Grosvenor the same year. Working in the style of Leighton brought financial rewards, and in 1893 Schmalz and Edith moved from the Holland Park Road studio to a substantial house, number 49 Addison Road. John Simpson built a large adjoining studio for £1,187. The move followed a successful visit by Schmalz to the Holy Land which he wrote up for the *Art Journal*, never one to scorn self-publicity: 'Having decided to paint a picture of the events following the culmination of the World-Tragedy [the Crucifixion], I desired keenly to visit the Holy City.'[12]

After Leighton's death, Dorothy Dene continued to model for her brother-in-law. *Love is Blind*, exhibited in 1898, presents a disturbing scene: Dorothy, blindfolded, crawling towards a satyr with the face of Schmalz. The accompanying legend reads, 'Maidenhood, blindfolded by innocence, knows not that beneath the godlike mask there lurks the soul of a satyr'. Blakemore provided further explanation:

A young girl, her eyes shrouded, is kneeling in front of a sundial, stretching eagerly towards the pure, beautiful mask of a Greek god's face. Crouching behind and holding this before him is a shrivelled monster with leering evil eyes and the mouth of a Silenus, who writhes with impure satisfaction at the girl's approach.[13]

216 *The Holland Park Circle*

Recent research has suggested that Dorothy may have been Schmalz's lover. In 1899 she died of pelvic peritonitis, blood poisoning, rectal prolapse and dropsy, a massive pelvic infection which could have been caused by an abortion. She was only forty years old.[14]

William Blake Richmond was already a successful portraitist when he took number 6 in the block in 1882. He was seeking additional studio space away from his wife and six children in Hammersmith (where he also had a studio), and close to his friends Leighton and Val Prinsep. His biographer repeats the story that by the 1890s, Richmond was conducting an affair with Edith Finch, one of his favourite models and a talented musician. Meanwhile, his wife Clara suffered 'shattering headaches. . . . Unshared responsibility, worry over money, over her children and their future, often prostrated her.'[15]

Richmond found himself among congenial neighbours; he shared a passion for the classical world not just with Leighton and Watts, but also with Schmalz at number 5 and Ernest Normand and Henrietta Rae living at number 3, from 1886. When he attempted a large sulpture of *The Arcadian Shepherd* he was able to borrow Watts' old iron studio, still erected in the garden of 6 Melbury Road and just over the wall from his own studio. Richmond wrote to Watts on 10 December 1888:

> I am expecting to get over the day work of my statue soon now and have the thing cast, but I have no where big enough to work the finish by in the plaster. I wonder whether you could lend me the big iron studio or a corner of it for a little while. I would promise to make no mess nor move or touch anything.[16]

Richmond had also discovered, like Watts, that only portrait painting provided a regular source of income. Several portraits with local connections were possibly completed in the Holland Park Road studio, including Lady Mary Carr-Glyn, commissioned by the parishioners of Kensington as a gift to their vicar, the Reverend Edward Carr-Glyn, to commemorate their wedding; portraits of members of the Stanley, Bell, Ogilvy and Howard families; portraits with 'Greek' connections including Luke Ionides and his wife Elfrida and Lisa Stillman, daughter of Marie Spartali Stillman; Burne-Jones' daughter Margaret; portraits of the Rawlinson family, art collectors living on Campden Hill; and of Prinsep's wife Florence.[17]

Richmond, like Schmalz, developed a close relationship with his favourite model, the Italian Gaetano Meo, who modelled for several artists in or associated with the Holland Park colony: he can be spotted in the boat in Fildes' early painting *Fair Quiet and Sweet Rest*, also in Leighton's fresco for the South Kensington Museum, *The Arts of War*. He provided the face of God in Burne-Jones' *Dies Domini*, acquired by the Howards for 1 Palace Green (fig. 47); his whole body inspired Hamo Thornycroft's *The Mower*. Meo became Richmond's studio assistant, receiving a gift of an easel from Burne-Jones' lover, Maria Zambaco, and for ten years led the team of workmen laying the mosaics in St Paul's Cathedral. He went on to decorate the Peacock House in Addison Road for Sir Ernest Debenham; his daughter ran off with Edward Gordon Craig, son of Ellen Terry and her lover Edward Godwin.[18]

Ernest Normand and Henrietta Rae met as students at the Royal Academy Schools, married in 1884 and moved from a studio in Wright's Lane, Kensington to number 3 Rowsley House, in the Holland Park Road Studios the following year. Their

marriage coincided with their joint success at the Royal Academy: Normand's *A Palace, yet a Prison* was sold for 300 guineas; Rae, who had begun exhibiting at the Academy in 1880 with *Chloe*, a self-portrait, exhibited her first major figure painting, *Lancelot and Elaine*.

Rae, rather than her husband, featured in a book-length study in 1905 by Arthur Fish who stressed, albeit grudgingly, her exceptional position as a woman artist: 'in spite of her sex she is an artist, and a successful artist, too'.[19] Though an increasing number of women were entering the profession (the census reveals 548 women artists in 1852 and over 1,000 in 1871),[20] the first women students had only been accepted by the Royal Academy Schools since 1860; they were excluded from the life class until the 1890s. Rae's decision to concentrate on the nude and her ability to remain unabashed by hostile criticism distinguished her from contemporary women artists (fig. 105). In 1885, for example, two of her nudes were hung at the Academy, *Ariadne Deserted by Theseus* and *A Bacchante*. Fish records her strategy in dealing with attacks from the public:

> The bid for success was a bold one; for a woman painter to submit two studies from the nude . . . and have them accepted was quite out of the usual . . . they attracted a certain amount of adverse criticism from that irresponsible section of the public which sees in this class of subject nothing but impropriety or indecency. One of these self-constituted guardians of artists' and the public's morals wrote to Mrs Normand . . . implored her 'to pause upon the brink'. . . . When the letter reached her she was rejoicing in the presence of her infant son, who had been born shortly after the opening of the exhibition. The letter was shown to the doctor . . . he made the suggestion that the artist should reply to the letter and

state that she had recently given birth to a son 'who came into the world entirely naked', which fact seemed to suggest to her that there was no impropriety in representing the human form as it was created.[21]

Rae's situation as wife and mother strengthened her position; on a practical level she could paint nude models alongside her husband. She was also an able strategist with her own painting, producing for the 1886 Academy the uncontroversial *Love's Young Dream* which Marcus Stone declared 'Charming! Charming!'[22] At the 1887 Academy she showed only four paintings, two of which were nudes, *A Naiad* and *Eurydice Sinking Back to Hades*. The *Echo* commented: 'It is not an exhibition at which the British matron will be shocked, for, with two exceptions painted by a British matron herself, there is hardly a nude figure on the walls.'[23] Normand, meanwhile, was producing, without critical comment, paintings such as *The Bitter Draught of Slavery* (fig. 106) (RA, 1885), a 'provocative representation of female subjection and male indifference'.[24] His skill at judging the financial rewards from painting erotic subjects may have been developed while he worked in commerce (attending St Martin's School of Art in the evenings) before being accepted for the Academy Schools.[25]

Prinsep was apparently the first to welcome the artist couple to the colony; their acceptance by the 'innermost circle of the Holland Park coterie of which Lord Leighton was the centre'[26] was, however, to bring as many problems as pleasures.

> Each Sunday the Prinseps' lawn was devoted to tennis, tea, and talk, to which came all the artistic celebrities of the adjacent Melbury Road. . . . At Prinsep's suggestion they made a formal call upon Lord Leighton . . . most warmly welcomed. . . . A frequent visitor to their studio he was ready with advice, criticism, and practical demonstration to assist them in their work.[27]

Leighton apparently persuaded both Normand and Rae to try painting using his method, meticulously planning each stage of their work; he was disappointed that

106. Ernest Normand, *The Bitter Draught of Slavery*, 1885. Cartwright Hall Gallery, Bradford.

the outcomes were without merit. Watts was more helpful, discovering a flaw in the foreshortening of the figure of Zephyrus in Rae's *Zephyrus Wooing Flora* (RA, 1888), and drawing a complete foreshortened skeleton over the figure on the canvas.

Normand helped Leighton by making a bow of a 'peculiar build' for the boy model to hold in *Hit*; he also tried to make a clay model (at Leighton's suggestion) for Rae's painting of the *Death of Procris* (RA, 1889) as the position demanded of the model placed too great a strain on his back and arm:

> he set to work to model the 'Procris' . . . [but] nearly all the members of the coterie felt bound to have a finger in the clay, and it became a question as to whom the credit was to go for the construction of the figure. Each, of course, laid claim to the good points as they were developed, but when it was creditably finished, and the cast made, Mr Normand decided definitely that it was his, and that to him alone belonged the glory.[28]

Normand was somewhat deflated when the sculptor Onslow Ford declared he would have produced the clay model in a day and a half. The gardener of Holland House kept Rae supplied daily with nut saplings cut in the park for Cephalus to force his way through.

Prinsep interfered with the progress of Rae's painting *Ophelia*, offering endless advice on the position of Claudius' head.

> At last one morning Sir Frederic Leighton came into the studio, and, after inspecting the very latest change of position, made an observation, stopping any further alterations which might have continued to take place. 'Why do you keep altering the picture and following every fresh suggestion? The only place you *haven't* had his head is – on the floor. No, it won't do! Pose it as *you* wish, and then keep it so.'[29]

Ophelia was shown at the Academy in 1890 and bought by the Walker Art Gallery in Liverpool. The same year the Normands decided to let their studio-house and spend time studying at the Atelier Julian in Paris.

They returned late in 1890 imbued with the Impressionist approach to landscape and, to Leighton's horror, Rae sent *La Cigale*, lacking 'edge', to the Academy. Leighton had given his views on Impressionism shortly before in an interview published in the *Pall Mall Budget*: 'an impressionist must not forget it is the deep-sinking and not the fugitive impressions which are the best . . . originality and eccentricity are not the same things'.[30] Rae's painting was later exhibited at the International Exhibition in Paris (in 1899) where it found a buyer.

The studio-house was becoming too small by 1893, when a daughter was born to the Normands, so they moved to Norwood, where Normand's father offered to build them a special studio in the garden of his house.

> The removal meant the severance of many pleasant associations, and the discontinuance of the critical visits of their academic neighbours and friends. As a matter of fact, the latter objection was one of the strongest appeals in favour of the removal. . . . Mr and Mrs Normand felt that they would now like to 'run alone', and paint their pictures free from external influence. . . . They felt that the influence of Kensington was becoming stronger than was good for them, and that it would be better for them to shake it off before it fettered them in mannerisms.[31]

Rae had become so incensed by Prinsep's incessant interference that she had thrown his hat on her stove; on another occasion she threw it out of the window.[32] The

larger studio in Norwood also provided Normand with the space in which to complete the enormous *Bondage*, a tableau of bound women offered for sale, inspired by a visit to Morocco in 1891.[33]

Later Rae outlined what she owed to Leighton:

> To Leighton, perhaps, I owe the deepest debt of gratitude. His dominating personality from the outset exercised on my impressionable nature a most wonderful and permanent influence, and to his fostering care I attribute the development of any powers of design I may possess. His criticisms, though severe, and at times almost scathing, always left me with the feeling that he expected me some day to do good work, and the very persistence with which for years he superintended our productions, especially in the early stages of composition and design, was in itself a compliment. To use one of his own expressions, one felt one was work-ing 'in an atmosphere of sympathy'.[34]

In 1899 she returned to Holland Park to borrow Watts' studio to paint the portrait of Lord Dufferin. The couple remained in touch with the colony; the support of Leighton, in particular, as President of the Royal Academy, was of great importance. In 1893 Rae was invited to serve on the Hanging Committee at the Liverpool Autumn Exhibition, the first time a woman had achieved the distinction at a major public exhibition.[35] In 1899 she was invited to paint one of the murals decorating the Royal Exchange; Leighton had painted another.

Rae was not the only woman artist within Holland Park. Hamo Thornycroft's mother and sisters were sculpting and painting in Melbury Road; the Montalba sisters, friends of Fildes, Woods and the Alexanders at Aubrey House, maintained a studio on Campden Hill but worked mostly in Venice, sending paintings to the Academy and the Grosvenor Gallery. Henrietta Montalba had studied at the National Art Training School in South Kensington and was a pupil of Dalou, from whom she learned to sculpt in terracotta. She was a friend of Princess Louise (who painted her portrait) and the Marquess of Lorne, exhibiting a head of the Marquess at the Grosvenor Gallery in 1880. Kate Perugini (daughter of Dickens, widow of Charley Collins), painted with her husband at their Kensington studio and sent portraits to the Academy. Eleanor Fortescue-Brickdale took a small studio opposite Leighton's house at the end of the century.

Roddam Spencer Stanhope's niece Evelyn Pickering was further afield, living in Chelsea with her husband William de Morgan. Burne-Jones' lover Maria Zambaco was also practising in Chelsea and from a studio next to his on Campden Hill, after studying sculpture under Alphonse Legros at the Slade; she sent work to the Academy, the New Gallery and the Paris Salon in the 1880s.

The other woman artist with whom the established colony – in particular Leighton – developed a close relationship was Louisa Starr (fig. 107). She had been one of the first women to attend the Royal Academy Schools in 1862, aged only sixteen, and was a contemporary of Helen Thornycroft. In 1865 she won the first medal ever awarded to a woman for her copy of Murillo's *The Beggars*; two years later she won the Gold Medal and a £60 scholarship. By the time she married her cousin Francesco Enrico Canziani in 1882 she was earning between £300 and £400 a year from her work (his income was between £500 and £600).

Her speciality was portraiture, though she also painted genre subjects. *Hardly Earned*, for example, a painting of an exhausted governess exhibited at the Academy in 1875,

107. Louisa Starr and her
daughter Estella Canziani.

the year after Fildes' *Applicants for Admission to a Casual Ward*, caused a considerable stir. The *Times*' critic, unable or unwilling to recognise the appropriateness of the subject matter for a professional woman artist, was dubious: 'some may call the wet boots, which have been dragged off the stockinged feet, a step just over the line which separates the sad from the squalid'.[36]

The Canzianis first lived in Russell Square near the British Museum, Louisa using the drawing-room as her studio. In 1886, however, according to her daughter Estella, Louisa had a dream of her ideal home. Soon after,

> driving in Kensington Palace Gardens, she saw a board up, 'House to Let', and recognised the house and the surroundings of her dream, she telegraphed to my father, who had reached Paris on his way to Italy: 'Found a house, come back,' and he returned. She said, 'We must be at the office early,' and they were there at ten minutes to nine a.m. At five minutes to nine a gentleman arrived. When the door was opened at nine they were asked, 'Who came first?' The gentleman bowed and stood aside, and my parents were told, 'The house is yours'. The artist who lost the house by five minutes is Mr Millar, who then took Fred Walker's house and studio in St Petersburg Place.[37]

Number 3 Palace Green was immediately next to Thackeray's house, and next door but one to the Howards'. It had originally been two cottages incorporating the laundry for Kensington Palace. The old copper for boiling the washing stood in the gardener's

shed. The Clerk of Works at the palace had converted the cottages into a single property; the Canzianis added a studio to the courtyard of the old laundry. The property was leasehold and the Canzianis were strictly forbidden to boil tripe or make soap. The location, like Melbury Road, was still, in the late 1880s, surprisingly rural.

> Palace Green had fields and plane trees with low sweeping branches on each side of the road . . . there was also a passage, with high walls each side leading to Church Street, and snapdragons and wallflowers grew wild on these walls. . . . Every morning cows came down Kensington Palace Gardens and the milkmaids carried milk about London in pails hanging from a wooden yoke on their shoulders. They wore black bonnets with a little white cap inside, a plaid shawl, skirt, and coloured apron, and they called 'Milk oh!'[38]

Like Henrietta Rae, Louisa Starr was entirely committed to her career as an artist. Estella (who also became an artist and was taught by William Blake Richmond), was born in 1887; when she was old enough her mother gave her a copy of Samuel Smiles' *Self Help* to read. 'I also grew up to realize', she recalled, 'that my mother was a very busy professional woman, always occupied by her portraits, that work of any kind must not be interrupted, except out of necessity.'[39] The Canzianis' particular friends among the colony appear to have been their neighbours the Howards, Leighton and Prinsep, also Walter Crane in Holland Street (where he moved in 1892) and Millais at Palace Gate; all the Holland Park artists were visited once a year on Show Sunday.

Leighton enjoyed social visits to Palace Green, often playing with Estella. 'My remembrance of him was always of something big and friendly, with a soft black or brown velvet coat, and a nice long curl for me to hold on to when he danced me up to the ceiling or when he took me for rides. He showed me the stuffed peacock at the foot of the stairs, with its gorgeous coloured tail and throat, and also the beautiful tiles on the staircase, and the Arab Hall.'[40]

The Last Victorian Artists' Houses in Holland Park

Lady Holland died in 1889. Lord and Lady Ilchester took possession of Holland House only after extensive building works were completed. The architect Robert Edis, a friend of Webb and Morris and Colonel of the Artists' Rifles, supervised the work.[1] The Ilchesters intended Holland House to be a centre, once more, for entertaining and patronage. Masked balls had become fashionable, 'the ladies alone being disguised, until at a certain hour all masks were removed', so a new room, the Swannery, was built on the flat roof of the kitchen to serve as a ballroom.[2] Lord Ilchester planned a Japanese garden while his wife planted roses, there were lawn tennis and cricket matches, 'intimate tea parties on the North Lawns' and dinners.[3] The neighbourhood artists were not forgotten. Watts received a letter from Lady Ilchester asking to visit his studio. He played 'hard to get', as usual:

> I am obliged to live by rule, & take what is called my dinner very exactly at half past 6, it is only a matter of a quarter of an hour or twenty minutes at most so that at 7 as I never go out I am always at liberty, any time then that it may happen to be convenient to you & as you are so near it is hardly worth while to make an engagement at 7 you will find me very much pleased indeed to be honoured by a visit. Of course if you can fix a day it will be best.[4]

Watts was not to paint the Ilchesters. Instead the family commissioned work from relatively minor artists, Edward Hughes, Ellis Roberts, the Honourable H. Graves, before seeking out a newcomer to Holland Park, the American portraitist James Jebusa Shannon who, at the turn of the century, was regarded as a rival to John Singer Sargent.[5]

After provincial art training in Ontario, Shannon arrived in London in 1878 at the age of sixteen to attend the National Art Training School in South Kensington. His father was a building contractor for railroads and bridges so the South Kensington 'utilitarian approach to the arts probably appealed' to him; the school was dedicated 'to teaching industrial and commercial design and preparing young men and women for careers as art instructors'.[6] The head of the school at the time was Edward Poynter, whose own studies in Paris in Gleyre's atelier led him to emphasise drawing and painting directly from the model. Shannon was consequently 'part of the first generation of artists to be trained in England by artists schooled in France'.[7] Poynter was regarded as the greatest academic draughtsman of his day.

Shannon was noticed by Poynter, who recommended the young man paint a portrait for Queen Victoria of the Honourable Horatia Stopford, Queen's Woman of the

Bedchamber, the fee to be fifteen guineas. The Queen commanded the portrait be shown at the Royal Academy in 1881, then commissioned a second, this time for forty-two guineas. The news of Shannon's success was reported back home in the *St Catherines Press*:

> J.J. Shannon, a young gentleman of 18 years of age, from this city, has been studying art in England for the past 2 years. He has recently informed his father, Mr.P. Shannon, that he has been chosen to paint several portraits ordered by Her Majesty, Queen Victoria. He has also had the high honour of winning the gold medal in the annual competition of all the art schools in the United Kingdom.[8]

With such patronage and the support of Poynter, also the incentive to earn his own living (his father had suffered severe financial reversals), Shannon decided to remain in London. He settled first in Chelsea. George Percy Jacomb-Hood recalled, 'occupying a studio in Manresa Road, Chelsea, I was one of a little colony which included J.J. Shannon, H. La Thangue, Havard Thomas, William Llewellyn, Frank Short, F. Brangwyn, and Fred Pomery.' Together they founded the Chelsea Arts Club:

> The ground floor and basement of a house next-door to the Town Hall, and the studio at the back of it, in the tenancy of a jovial and talented Scots painter, 'Jimmie' Christie, were rented. . . . The studio formed a mess-room for meals, and the room upstairs was for newspapers, chess, and general sociability.[9]

Association with the Manresa Road artists placed Shannon among the stylistic innovators in British art, a perception that was strengthened by his participation, along with George Clausen and Stanhope Forbes, in the founding, in 1886, of the New English Art Club.[10] However, within two years, Shannon was established in Kensington, with a studio in Alfred Place and a house in Phillimore Gardens.

Marriage in 1886 to Florence Mary Cartwright, a student at the Royal School of Art Needlework, and the birth of their daughter Kitty the following year, called for a steady income only realisable through portrait commissions, although in 1888 *Myrrah*, exhibited at the Grosvenor Gallery, was bought by Peak Frean's for £500 to use on their biscuit tins. Shannon's decision to seek more salubrious premises also reflected the social position of his patrons, in particular the family of the Duke of Rutland.

Shannon was first invited, in 1888, to paint Violet Manners, Marchioness of Granby, daughter-in-law of the Duke, after she had seen *Myrrah* at the Grosvenor. Violet was a talented artist and a cousin of Coutts Lindsay, founder of the Grosvenor Gallery; Watts painted her portrait in 1879. She had married Henry Manners, Marquess of Granby, in 1882 and used a studio in the grounds of Bute House, the Rutlands' house on Campden Hill. Her delicate portraits were exhibited at the Grosvenor, the New Gallery and at the Royal Academy. Shannon painted Violet on several occasions, also her husband and their children. Violet was a member of the aristocratic circle known as the Souls. Other Souls included Mary, Lady Elcho, the daughter of Percy and Madeline Wyndham, and her intimate friend the Conservative MP Arthur Balfour, who had commissioned Burne-Jones in 1875 to decorate his music room. Balfour wrote to Mary on 1 August 1888:

> I went to see Ly Granby this evening. She is full of the picture or pictures (for there seem to be more than one) which Shannon is doing of her. She appears to have set the fashion for Ly [de] Grey is being done by him too. Lord Pembroke does not approve of Ly Granby's choice

of an artist – for as he explained to Ly de Grey [his sister] 'Shannon cannot deal with Ly Granby's style, what he does best is a vulgar face – *like yours!*'[11]

Violet's daughter Lady Diana Cooper was painted on several occasions. She had no recollection of posing at the age of two,

> but another painting, when I was eight, I well remember, and the huge studio in Holland Park, Shannon himself, whom everyone loved, darting backwards and forwards with palette and mahlstick, delicious smells of paint and turps, a mirror behind the painter in which I could watch the picture grow, while my mother's gentle voice read aloud stories of musicians.[12]

In 1891 Shannon had been a founder member of the Society of Portrait Painters together with Solomon J. Solomon. In 1892 he had acquired a plot in Holland Park Road opposite Solomon and next to Leighton, and proceeded to build a studio-house on a scale appropriate to his position as portrait painter to the aristocracy.

Shannon's plot included the surviving farmhouse of the Holland estate. In 1889, the leaseholder Edmund Charles Tisdall had drawn up an agreement with Lord Ilchester to build an artist's house on his land, presumably speculating on attracting an artist to such a salubrious spot next door to Leighton. He commissioned the architect W.G. Hunt of Kensington Crescent to draw up plans: the house was to be substantial, red brick and in the appropriate Queen Anne style. Tisdall died before the project materialised but his daughter Ethel acquired another licence in November 1892 to build an artist's residence. Shannon was sufficiently confident of his earnings to enter into an agreement with Ethel to rebuild the farmhouse and add a studio at a cost of at least £3,500. He acquired the remaining sixty-year lease, agreeing to pay ground rent of £280. Prinsep's original ground rent, agreed nearly thirty years before with Lady Holland, had been only £28.

The architect, W.E.F. Brown, designed an unusual building consisting of two distinct parts, the rebuilt farmhouse to the west and the studio to the east, each with a separate entrance (fig. 108). The material was orange brick; the style Dutch revival, reflecting Shannon's love of Holland where he took his wife and daughter each year for painting holidays. An ornate Flemish gable, intended to unite the domestic and studio halves, dominated the front of the property.

108. Ernest Stamp, 3 Holland Park Road viewed from the south (the inscription by Stamp is incorrect). Museum of London.

The Residence of Val Prinsep RA, and afterwards, J.J.Shannon RA, Holland Park Rd, Kensington.

The Holland Park Circle

109. James Jebusa Shannon, *The Purple Stocking*. South African National Gallery, Cape Town.

The domestic half, Florence and Kitty's domain, had a doorway 'acquired' from a seventeenth-century Venetian palace; inside was a seventeenth-century Italian staircase complete with minstrels' gallery. There was an 'old pickled oak drawing-room'. The dining-room was also panelled 'and painted a wonderful dark blue which, when the sun slanted in through the open window, lit up into a burning blue; [there was] old Dutch furniture and old blue delft china; an old Dutch ship hanging from the ceiling'.[13] The 'large, low Venetian sitting-room looking out on the front garden [was] furnished with painted Italian furniture and china and wonderful bits of old silver'.[14]

Shannon's half contained an 'enormous and lofty'[15] studio 40 feet long with a 25-foot-high window at the northern end overlooking the garden. There were tapestries hanging on the walls and antique furniture artfully arranged to make visitors feel 'at home'. The American artist Karl Anderson recorded his impression of a visit just before the First World War but after Shannon had extended the studio to the north-east:

His studios were filled with uncompleted portraits of England's fairest women and American beauties. The working studio is furnished entirely by these canvases, and another studio is built, he says, for no other purpose than to house a wonderful Venetian ceiling, brought from Venice two years ago. . . . This studio is very sumptuously furnished in rich draperies and rare antique furniture. An old balcony, also obtained in Italy, looks over the house of the late George Watts and Sir Frederick [sic] Leighton. The house is low and rambling, a confusion of halls, of steps up and treasures. Over the mantel in the large living room hangs a wonderful Tintoretto; near it a virile sketch by a modern, unknown painter.[16]

The investment in the property would appear to have been worthwhile; in 1897 Shannon was made an Associate of the Royal Academy.

His election was regarded at the time as the legacy of Leighton's attempts to bring younger modernist artists within the establishment. The move had begun in 1887, the year Leighton bought John Singer Sargent's *Carnation, Lily, Lily, Rose* for the Chantrey Bequest.

> We knew it was all the doing of the President, who entertained a high admiration for the powers of the young artist; but that he found a majority at his back was evident, and was the best of good news for us who wished to see the Academy abreast of the times. . . . Reforms were soon after introduced . . . and many of those artists who, by virtue of their methods or artistic conceptions, would have been held revolutionaries a few years since, now claim the privileges of Burlington House and Messrs Abbey, Clausen, Stanhope Forbes, Arthur Hacker, S.J. Solomon, Swan, and Shannon are all of them of the body.[17]

Shannon's election was preceded by a one-man show at the Fine Art Society in which he showed his non-commissioned figure paintings, including many intimate studies of friends, his wife and daughter. *Jungle Tales*, for example, painted in 1895, depicted Kitty and the daughter of an artist friend listening to Florence reading Kipling's stories. *The Purple Stocking* (fig. 109) was a bust-length image of Kitty in profile, her head framed by a wall-mounted copper plate 'that functions as a conceptual halo'.[18]

However much Shannon may have wished to broaden his work, election to the Academy confirmed his reputation as a portraitist. Like Watts, the source of his income came from producing the work he valued the least.

> A genius for portraiture, delightful and enviable as it may seem to others, is not a gift without alloy. . . . But if a man has the heart of an artist, and the desire to express his sense of beauty of the visible world, the fate that compels him to paint portraits . . . to the almost entire exclusion of more imaginative work, is apt to become almost unbearable.[19]

He was made a full Academician in 1909 and in 1910 became President of the Royal Society of British Portrait Painters. He travelled frequently to the United States to fulfil portrait commissions from prominent families in New York, Boston and Newport. His work completed, he could indulge in gambling in Monte Carlo – his 'little flutters'[20] – touring Spain in his Rolls-Royce, playing amateur tournament tennis at German spas, and giving costume balls in Holland Park Road. He was knighted in 1922.

Like Leighton, Prinsep and Fildes, Shannon was a consummate host; his sociable personality undoubtedly led to lucrative portrait commissions. The artist Jacomb-Hood recalled his skills:

> I was once staying with friends in Hertfordshire with Shannon who was painting our host's portrait. After tea he would give the children Uncle Remus' tales of 'Brer Rabbit' in the real 'darkie' dialect, and I have never heard anything more artistic and delightful. It is unnecessary to say that the two small boys worshipped him. I recall the time when, one evening, we dressed up for dinner, Shannon, with long black hair cut from the tail of one of the cart-horses, and feathers from the tails of the turkeys, a blanket from his bed, and brown-paper moccasins, made himself into a perfect Red Indian. As the footman was handing the vegetables, he emitted a piercing war-whoop which nearly caused disaster and dropped dishes.[21]

He also contributed to the Holland Park circle's round of festivities, setting off fireworks in his garden on 5 November and on the last night of the Henley Regatta.

Kitty recalled her first party held in the studio:

> It started at four, with tea. We had the use of both studios. The party ended at about 5 a.m. Artists and many theatrical people and masses of children. . . . My father was a genius at parties . . . I can see him driving four beautiful children with collars of gold-and-silver bells, and reins of gaily-coloured ribbons. He was always well dressed; blue-black hair and grass-green eyes. . . . First-class at reciting, he recited 'The Wreck of the Hesperus' as an American, as Tree, and as Irving.[22]

Shannon rarely surprised either his admirers or the wider London art world. In 1902, however, he showed at the Academy his portrait of the popular illustrator Phil May, who had been a neighbour in Holland Park. May's fondness for alcohol was common knowledge; instead of indulging in 'the flattering insincerity of his usual style',[23] Shannon chose to provide insight into May's private nature. Jacomb-Hood recalled:

> I only came across Phil May occasionally, and sometimes when he was not 'quite himself'. I remember him at his best when Shannon gave a children's party, and Phil May, as much of a child as any of them, was sitting on the floor with the little people around him, telling them absurd and amusing stories. The children worshipped him. He said to me once, 'You see this nose of mine? I wish I now had all the money it's cost me to colour it.' J.J. Shannon's portrait of him in a hunting coat was a masterpiece, terrible in its unsparing truth.[24]

D.S. McColl, usually a fierce critic of the artist, appreciated the 'close reading of character'. Gone was the usual

> sentimental complaisance, an eagerness to support any pretension of the sitter to beauty, fashion, saintliness that overshoots the mark and dulls his vision. . . . There has been an arrangement that the humorous bohemian shall stand up in a hunting coat with the dignity of a country squire posing for county history. And the pattern of the picture, head, coat, hands, hat and cigar (a concession), is excellent. But the expression, hesitating between an actor's impulse to look the part, and apprehension that he may be taken seriously and laughed at, and a lurking sense of blague gives the whole thing another turn. And Mr. Shannon, intent on the interesting face before him, has painted it better than anything I remember from his hand.[25]

May had taken a small studio on the south side of Holland Park Road from about 1892, moving in 1896, after his election to the staff of *Punch*, to Rowsley House (Number 3, The Studios), formerly the home of Normand and Rae (fig. 110). His Sunday receptions in his studio brought the usual mixture of artists, writers, singers and actors but with the addition of anyone he had happened to befriend in the public houses of London. A barrel of whisky situated permanently at one end of the studio encouraged the latter to frequent Holland Park Road, to the horror of more sedate neighbours. His artist friends ceased to bring their wives; his own long-suffering wife Lilian stood guard on the studio gallery trying to prevent his drawings being stolen. Within a year of Shannon completing his portrait May was dead of phthisis and cirrhosis of the liver.

While Shannon's house was being built, Walford Graham Robertson, painter, designer, book illustrator and playwright, was negotiating to acquire a building plot from the Ilchesters for his studio-house.[26]

Robertson's paintings and plays are now considered of little consequence; he is best known for his memoirs, *Time Was*, his friendship with Albert Moore, his striking pose

110. Phil and Lilian May in 3
The Studios (Rowsley House),
Holland Park Road.

as the young man about town in Sargent's portrait of 1893, and for his support of the
talented artist Arthur Melville.

He was provided by his parents with an adequate private income. His mother, Marion
Greatorex, lived in Rutland Gate, Knightsbridge, and together they acquired a country
property, Sandhills in Surrey. A visit in the early 1870s when still a young boy to the stu-
dio of Walter Crane at Beaumont Lodge left a lasting impression: 'My first studio. I can
remember the impression perfectly. It seemed very large and rather dark, a dim cathedral
fit for the celebration of strange rites. It was very dirty. . . . Then through the dusty gloom
pictures began to appear. In one the *Three Sirens*, lightly linked together, paced rhythmically
on yellow sands. . . . In another *Venus*.'[27] Albert Moore was persuaded to allow Robertson
to work in his studio in Holland Lane in about 1879 before the boy was dispatched to
Eton; he returned for a further two years after completing his schooling.

Robertson began to collect paintings, including Crane's *Sirens*, Whistler's *Rose Corder*
and *Valparaiso*, also works by Rossetti, Moore, John Singer Sargent and William Blake; by
the early 1890s he was refusing to lend the Whistlers: 'I much regret that I cannot com-
ply with your request to allow my picture "Valparaiso" by Mr Whistler to go to the
Chicago Exhibition. During the short time I have owned it I have already lent it to exhi-
bitions at Paris & Munich as well as to your own collection of Mr Whistler's works';
'Miss Corder was away all last summer at the International and she is so pleased to get
home & rest & we are all so comfortable together'.[28] He showed his own paintings at
the New Gallery and, in 1891, at the inaugural exhibition of the Society of Portrait
Painters. His first studio was in Warwick Studios, on the south side of Kensington
High Street opposite Melbury Road. Burne-Jones' son Philip was a neighbour, also the
enamellist Alexander Fisher.

The plot Robertson acquired from the Ilchesters was on the east side of Melbury
Road, almost opposite the turning to Holland Park Road. He was granted a ninety-year
lease in June 1893; the annual ground rent was £125 for the first two years, rising to
£250. The architect chosen by Robertson was a painter, Robert Dudley Oliver; the
house he designed was quite odd (fig. 111).

The façade was reproduction seventeenth century; however the rear, which was
higher than the front to accommodate the double-height studio, was in the Elizabethan
style with a large bay window overlooking the garden rising through the ground and

The Holland Park Circle

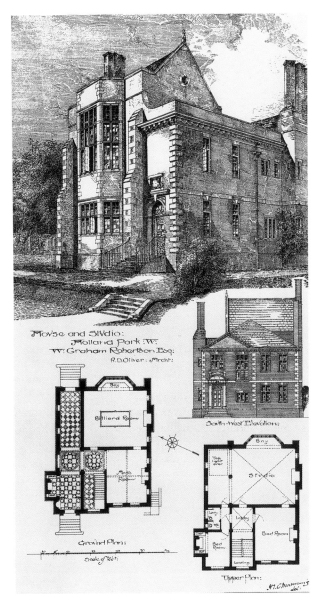

Movse and Stvdio:
Holland Park W:
W: Graham Robertson Esq:
R.D.Oliver: Archt:

Billiard Room

Bay

Ante Room

Ground Plan:

Scale of feet:

South-West Elevation:

Studio

Bay

Top light over

Lobby

W.C

Bed Room

Bed Room

Landing

Upper Plan:

111. 13 Melbury Road,
designed by R.D. Oliver, 1892.

first floors and flanked by buttresses. Inside, the ground floor contained a grand hall-way stretching from the front to the back of the house, an ante-room and, at the back, a billiard room; the studio and two bedrooms were situated on the first floor. There were no traditional reception rooms (Robertson acquired a house in Argyll Road, just north of Kensington High Street, for more conventional entertaining). Visitors to the studio enjoyed the proportions of the hall before being ushered upstairs; artist friends gathered around the billiard table.[29]

No sooner had Robertson's studio-house been begun than the Ilchesters agreed to release another plot, immediately to the south, to the engineer Sir Alexander Meadows

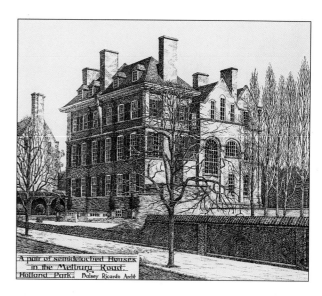

112. 15 and 17 Melbury Road, designed by Halsey Ricardo, 7 July 1894.

Rendel. His father, also an engineer, had lived at 10 Kensington Palace Gardens until his early death in 1856;[30] his brother Stuart (later Lord Rendel) lived at 16 Kensington Palace Gardens. Though Sir Alexander was not an artist – his achievements included the Royal Albert Dock, and railways and bridges in India – his choice of architect, Halsey Ricardo (in fact, Sir Alexander's son-in-law), introduced a fresh direction to the architecture in Holland Park (fig. 112). Ricardo fits into the line of individual, talented figures – Philip Webb, George Aitchison, Richard Norman Shaw, William Burges, J.J. Stevenson, John Belcher – who made the colony unique.

For Rendel, Ricardo designed a pair of semi-detached houses (numbers 15 and 17) faced in distinctive ox-blood-red glazed bricks. He explained his choice of material in the *Builder* in July 1894:

> An endeavour has been made in building these houses, to recognize and accept the present conditions of house-building in London – more especially as regards the dirt and the impurities of the atmosphere. They are faced externally throughout with salt-glazed bricks, which, being of fire-clay vitrified at a high temperature, may be looked upon as proof against the disintegrating forces of the London air. In the case of the usual brick house – whilst the brick and stone are ageing and weathering, the woodwork is periodically being renewed (in effect) by repainting – and the acquired harmony of the whole is constantly being dislocated by this renewal; but with these houses, every time the external woodwork is recoloured the bricks can be washed down and the original effect – for what it is worth – maintained.

Ricardo's ideals were presumably in tune with his father-in-law's, whose bridges and railways were built to last for centuries. The ninety-year lease on number 15 was granted to Sir Alexander's son, a barrister. The first occupant of number 17 was Ernest Debenham. He was so impressed by living in a Ricardo house that in 1905 he commissioned his own, the palatial Peacock House, to be built in Addison Road.

In 1896 Robertson met a young artist, Arthur Melville, in Shannon's house. 'He and I became friends almost at once, no doubt owing to our many points of dissimilarity. He was a tremendously vital and athletic man, breezy, strong and adventurous; I was –

The Holland Park Circle

well, none of these things.'[31]

Melville had trained in Edinburgh, then at the Académie Julian in Paris where he was particularly influenced by Bastien-Lepage's rural works and the French orientalists. Between 1880 and 1882 he travelled in Egypt and Persia, developing a personal use of watercolour, a 'synthesis of realism and impressionism'.[32] He would use his collection of sketches for the rest of his life as the source for popular paintings. His *Arab Interior* of 1882, for example, which recreated 'in a fresh and radical form the long-standing fascination with the abstract patterning of shutters, light, architecture and carpets, as well as the drama and ritual of Arab life', was shown at the Royal Scottish Academy at exactly the same time as Leighton was re-creating such an interior in his own house.[33]

Melville also developed links with the so-called Glasgow Boys, including James Guthrie and John Lavery, who 'synthesized Bastien-Lepage's concern for fresh outdoor observation with Whistler's interest in harmonious patterns on a surface'.[34] But at the same time he pushed his own cosmopolitan, symbolist vein: *Audrey and Her Goats* (1884–9) reveals connections with the work of Puvis de Chavannes and Phoebe Traquair in Edinburgh.

Melville moved to London in 1889, taking a studio in Stratford Avenue, Kensington. Already an Associate of the Royal Scottish Academy and the Royal Society of Painters in Water-Colours, he maintained the 'popular front of his Oriental work, while at the same time pursuing the apparently far more radical interest in the aesthetic movement'.[35] In his studio he hung tapestries on the walls, placed rugs, brought back from Baghdad, on the wooden floor and displayed copies after Velázquez. His furniture was strikingly eclectic, 'an antique Scottish bureau bookcase, an English dower chest and a divan bed; a French Empire escritoire, a painting table and two large easels. Sketches and canvases were grouped all round with their faces to the wall.'[36] For reading, he chose Rudyard Kipling and Robert Louis Stevenson. He may also have made contact with Colin Hunter in Melbury Road, not only as a fellow Scot, but because Hunter hosted a sketching club bringing together Scottish artists.

In 1890, Melville joined Clausen and Orchardson on the Hanging Committee for the Grosvenor Gallery's 'Scottish Grosvenor', the last exhibition before its closure. The art critic of the *Saturday Review* was generally impressed (though he disliked *Audrey and her Goats*):

> The Grosvenor Gallery has asserted its right to exist by producing a decidedly original and, in some respects, a very interesting exhibition this year. It is given up to Scotch art; but not merely to that rather greasy Academic Scotch art showing the lines of the brush in the long smears of paint with which we were already only too well acquainted. On the contrary, what is most noticeable at the Grosvenor Gallery this year is the work of a group of young Glasgow painters whose names are entirely unknown in the South, and who, if we are not mistaken, have never exhibited their pictures in London before. These Glasgow painters give freshness and importance to the show, and add that element of novelty which we have seen to be wanting at the Royal Academy and at the New Gallery.[37]

Soon after Melville was invited with Whistler to hang an exhibition for the Walker Art Gallery in Liverpool (fig. 113). When Melville and Robertson were introduced, the Scotsman had become embroiled in a disastrous and mysterious financial investment. Robertson gave him financial assistance, invited him to use his studio in Holland Park and at Sandhills, Surrey, and also found him work designing costumes and scenery for

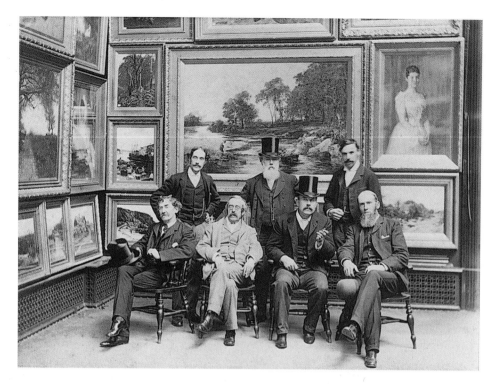

113. The Hanging Committee at the 1891 Liverpool Autumn Exhibition. Whistler is seated in the front row on the left; Melville is seated second from the right.

George Alexander's production of *Much Ado About Nothing* at the St James's Theatre. By this time Robertson had established a reputation for himself as a costume designer; his closest friends included leading actors and actresses; he painted portraits of Ellen Terry and Sarah Bernhardt.

The stage was of absorbing interest to many of the Holland Park artists. In 1879 Prinsep's plays *Cousin Dick* and *Monsieur Le Duc* had been produced and acted in by John Hare at the Royal Court and the St James's. Prinsep also painted Hare and Mrs Kendal; Leighton, Watts and Prinsep all painted Lily Langtry. Fildes was approached by George Alexander, the actor-manager of the St James's, to paint his portrait; Linley Sambourne's editor at *Punch*, Francis Burnand, wrote over a hundred plays including *The Colonel*, the first play to make fun of the Aesthetic style to be followed, shortly after, by W.S. Gilbert's *Patience*. Joseph Comyns Carr wrote *King Arthur*, which was performed at the Lyceum in 1895 with Ellen Terry as Guinevere and Johnston Forbes-Robertson as Launcelot, wearing costumes designed by Burne-Jones.

Between 1898 and 1899 Melville worked in Robertson's studio on two versions of *King Cophetua and the Beggar Maid* (fig. 114), the subject matter already interpreted by Tennyson and Burne-Jones. He was courting Ethel Croal and after their marriage, Robertson rented the couple a farmhouse adjoining his own property in Surrey; he also offered himself as an apprentice to Melville, working on a series of religious paintings. These remained unfinished. In 1904 Melville died of typhoid caught on a trip to Spain. Holland Park had lost

a unique figure who bridged the gulf between the Realism of the 1850s and the Symbolism which announced the birth of modern art . . . a major talent, an influential trailblazer important to the development not only of the Glasgow School and English Post-Impressionism, but

114. Arthur Melville, *King Cophetua and the Beggar Maid*, 1898. National Gallery of Scotland, Edinburgh.

also to that of the German painters of the Munich Secession and possibly . . . to the French. He was in tune with the most forward-thinking developments in modern art.[38]

The only other *avant-garde* artist of the late nineteenth century to work in Holland Park was Albert Moore, who had died in 1893. A. Lys Baldry paid tribute in the Studio:

He was not an archaeologist striving fatuously to reconstruct the life and characteristics of centuries long past, nor a painter of pretty pruriences angling for the patronage of the man

of the world with the bait of half-draped femininity. He was, on the contrary, an artist of to-day suggesting the art of to-morrow; a designer of pictures without passions and without emotions. . . . He showed that beauty of form, colour, design, and draughtsmanship, exquisite balance of line arrangement, and consummate skill of handling, are all possible in a canvas that tells no story, records no gossip, nor teaches any moral.[39]

Whistler was more forceful: 'Albert Moore – Poor fellow! The greatest artist that, in the century, England might have cared for and called her own – how sad for him to live there – how mad to die in that land of important ignorance and Beadledom.'[40]

The Holland Park Circle

17

Artists in Residence

Studios! – even as we write the word studio doors fly open to admit for once in the year
shoals of eager visitors. Outsiders are always curious about artists and their surroundings; to
them the sanctum sanctorum of the painter's house is a mysterious place, draped in tapestry
. . . it is the sacred meeting ground of a secret society, whose talk is a masonic puzzle to the
uninitiated – a laboratory in which ideas are melted down and boiled up, and turned out on
canvas by magic, the paint-pot and brushes being the wizard's apparatus.[1]

When the silk mercer Arthur Lewis of Moray Lodge (see chapter 5) accompanied his
family each year around the neighbouring artists' studios on Show Sunday, he was
spoilt for choice. By the mid-1880s Kensington was heaving with artists, for the
Lewises, 'only a few beyond walking distance'.[2] Leighton's house remained the grand-
est, though it was not the favourite of Lewis' daughter Kate:

we went down Holland Walke, shaded then by great elm trees with rooks cawing noisily from
their nest overhead, and through the branches we looked into the beautiful grounds of
Holland House. A few yards along the High Street brought us to Sir Frederick [sic] Leighton's
wonderful house and studio: marble pillars, an indoor pool with water-lilies and a slender
fountain, frescoes, mosaics and wonderful hangings. But it didn't seem to be 'lived in', or
homelike, like those of Luke Fildes and Colin Hunter, nor like the library in which a quite
young painter, Graham Robertson worked.

Turning in the opposite direction, up Campden Hill, Kate recalled,

Rudolph Lehmann would have portraits to show us in the studio built out behind the house
we children knew well . . . George Boughton kept up a running commentary of travel talks
while he showed his pictures, suggesting a dozen trips to my Father among the Dutch canals
and tulip-fields he constantly visited – and he told amusing little anecdotes about the peo-
ple. Frank Dicksee opened his own door and made one very welcome – I liked both him and
his pictures, and so I did the wonderful apple-trees in blossom and the Berkshire lanes on
Alfred Parson's easel in Bedford Gardens. Mr Abbey in the adjoining studio was far more aca-
demic, and his American accent and American wit did not appeal to me.[3]

Linley and Marion Sambourne's itinerary was even more crowded: Sambourne was
visiting friends but also researching for *Punch*, in whose pages the pretensions of artists
were regularly punctured.[4] On Sunday, 6 April 1884 the couple set off from their home
on Campden Hill, 18 Stafford Terrace, calling in the morning on Fildes, Hunter and
Prinsep in Holland Park, then Millais a short carriage journey away at Palace Gate. After
lunch they visited Boughton and Henry T. Wells on Campden Hill, William Powell

Frith, just north of the Bayswater Road, then on to St John's Wood to see Briton Rivière, Edwin Long, John Pettie, Frank Holl, Philip Morris, Henry Davis and Henry Stacy Marks, returning home 'sleepy & seedy'. On Sunday, 8 April 1888 snow, sleet and hail delayed their visits until after lunch when they managed Stone, Thornycroft, Prinsep, Leighton, William Orchardson and, in St John's Wood, Frederick Goodall, Pettie, Holl, Davis, Stacy Marks and Vicat Cole. They reached home at 7.30 for dinner.[5]

There were two Show Sundays, one for members of the Royal Academy, the other for 'outsiders'; they took place just before work had to be sent in to the Academy. The occasion had become part of the London season: artists and their families, art collectors and dealers jostled with the general public curious to see the homes of rich and famous artists.

For most of the artists and their families, each Show Sunday came at the end of a year of hard work. Edwin Abbey voiced the relief of his colleagues: 'everybody is taking a long breath now that the agony of Show-Sunday is over and the pictures are gone in'.[6] But Marcus Stone expressed the disappointment and sense of failure which he suffered on the completion of every one of his paintings. 'To exhibit a picture is like publishing evidence of incapacity. I rarely look at any of my works at an exhibition. It gives me more pain than pleasure. Orchardson once said 'we are always beginning our good pictures. We only finish our bad ones.''[7]

Artists' letters are littered with references to the awful London weather, few more so than those of Henry James. 'The weather is hideous, the heaven being perpetually instained with a sort of dirty fog-paste, like Thames-mud in solution. At 11 a.m. I have to light my candles to read!' '[London] seemed *all* foul fog, sordid mud, vile low black brick, impenetrable English density & irrecoverably brutal & miserable lower classes!'[8]

The timing of the openings of the Academy, the Grosvenor and the New Gallery meant artists were struggling to complete work during the coldest and darkest months of the year, a nightmare for those who relied on light flooding their studios. Linley Sambourne (fig. 115), working solely in black and white, was able to work through the night (which he frequently did), in the light of a portable gas lamp, with an engraver's globe throwing a beam of bright light on to his board. Those artists who could afford it built winter studios.

Stone's house was one of the first to include such a facility. He had written from Paris to the collector Sir Henry Thompson in January 1875 while his house was still being designed by Shaw: 'I have been in Paris for three months and shall be here for another five weeks . . . I hope you will think my picture for the R.A. which I am doing here is better than it would have been, if it had been produced in the midst of London Winter fogs.'[9]

Fildes' letters to Woods (living in Venice) present an endless tale of woe. On 1 January 1880:

> We have endured and still endure the most awfully dark and hopeless winter that has ever been known in London, consequently the civilised globe. We had uninterrupted heavy fog for 5 consecutive days last week . . . it is too dark for painting and so dense that we have had to burn gas to get our meals by. . . . Nobody is doing any work except a few at Hampstead.[10]

And on 18 October 1880 he noted that 'All through the next 4 months I doubt if there will be 15 hours a week of light fit to paint by'.[11] In 1881 he decided to engage

115. Linley Sambourne, photographed in his home, 18 Stafford Terrace.

Mervyn MacCartney to enlarge his studio window (Shaw was ill), writing to Woods on 17 September: 'My window is started and I think it will be a most satisfactory alteration though a costly one – It will cost nearly £150. Isn't that a shame?' He was able to start work in December but 'what is the good for now that I have a fine window there's no light to come in!'[12]

He remained dissatisfied, and on 19 January 1885 wrote: 'it is absurd to think of finishing any bit – We have had two days only when there was a few hours of feeble sickly sunshine since you left – The winters in London are decidedly getting worse & worse for painters.' He finally decided to build a glass studio.

> It gets worse every year and the dark season lasts about 6 months. My hope now is the glass house which, by the way, I have not got yet! But it comforts me to know that it will soon be ready . . . I find the change too great there being no shadow whatever in the model with the white walls, glass all round & the mosaic floor which is intensely bright, and I believe a mistake for it sends up reflections like snow would – I also find the hot water pipes around it are quite ineffectual during the present severe weather we are having so tomorrow I go to buy a stove.[13]

Meanwhile Leighton was having similar problems. He made a public speech about London fog, reported in the *Builder* on 25 March 1882:

> the crushing curse under which the inhabitants of our great city groan during the better part of the year . . . among the melancholy millions who grope their darkling way through our English winters none suffer so much under this smoke pest as the members of the community to which I belong . . . we are further and especially attacked and paralysed in the heart

116. George Aitchison, design for Frederic Leighton's winter studio at 2 Holland Park Road, 1889. London Metropolitan Archive, London.

and centre of our intellectual activity, for we live by the suggestive imitation and presentment of that which is revealed to us by light, – and by light alone, – and made lovely by its splendour.

Artists were right in their belief that London fogs were getting worse: the average number of days in the year affected by 'ordinary fog' between 1811 and 1820 was 18.7; between 1881 and 1890 it rose to 54.8, almost eight weeks of painting time.[14] Leighton engaged Aitchison to construct his glass studio in 1889, an enormous, balconied glass annexe, supported on iron columns, to the east of his studio (fig. 116). Fildes, taking credit for the idea, reported progress to Woods on 7 February 1890:

Leighton, at last, has got into his glass-house but I have not seen him since – I have some interest in the subject because it was I who induced him to build one – I understand his contract was £1600 for it. Pretty stiff! But that's because of Aitchison who has made a base for it sufficient to support the Eiffel Tower.[15]

Even such a construction was unable to beat the fogs; all the artists' houses were heated with coal fires, which contributed to the problem. The solution for Leighton and most of his neighbours was to go abroad.

In his speech on the pernicious weather, Leighton commented on fog-bound artists recalling times spent in sunnier climes overseas:

many a brother painter must regret with me the interminable hours, days, and weeks of enforced idleness spent in the continuous contemplation of the ubiquitous yellow fog, depressing the spirits all the more for recalling the memories of distant lands, where the sun shines in the sky, and sheds its gold over all things, where the fragrance of a thousand blossoms, not the soot of a thousand chimneys, is wafted in through open windows, and where grime does not blot out the heavenly face of nature.[16]

He usually travelled abroad in the late autumn and early winter, in search of the precious light, painting landscapes which would frequently reappear in the backgrounds of paintings 'finished' the following spring for the Academy.[17]

Few of his neighbours travelled as much. Italy was the most popular destination, in particular Florence and Venice. It was fortuitous that Watts' old pupil Roddam Spencer

Stanhope was established in a villa at Bellosguardo, just outside Florence; Woods lived in Venice, and in the late 1880s Prinsep acquired an apartment in a *palazzo* overlooking the Grand Canal.

Those unable to leave England expressed irritation and jealousy in their letters. Burne-Jones tried irony when he wrote to his friend Spencer Stanhope:

> My dear Gholes [Spencer Stanhope's nickname]. . . . Its a lovely London November day – how you would enjoy it – none of your intolerable blazing suns – a sweet soft drizzle over everything and that mist peculiar to England which throws a glamour over objects till they are scarcely discernible. It is an effect I have long wished to paint – after all we ought to live in our own times – and may I add without offence, amongst our own people – It is not that I should not enjoy Florence enormously but I feel my duty is here – some men can reconcile it with their ideas of virtue to leave friends and country, and be off to some over luxurious sunny clime where in the pleasures of the senses they lose all remembrance of higher aspirations – it is not so with me – I love the English character, I like to watch it in its more serious and religious moments on the cricket field – and in the ecstatic rapture on the bicycle.[18]

Shaw, struggling with the foundations of Fildes' house, was more straightforward when he wrote in June 1876 from a cold and rainy London: 'I wish you would not write about Venice and your happiness – it is very unkind of you – for it makes me entirely discontented – and I feel disposed to go down and quarrel with my wife.'[19]

Fildes had first visited Venice in 1874 with Marcus Stone and discovered a paradise for the artist. 'You can go out for a walk or a row, and spot at least half a dozen pictures, beautiful ones, in an hour and every time you go out. The shipping is splendid, too, such colour. You can have a gondola which is bigger than a punt and splendid to paint from as it is so beautifully fitted up, for a day and a man for 5 Lire – 4/2 d of our money – and 6 d for himself.'[20] After a second visit in 1876, he wrote to Woods, who had remained behind in Venice, 'Since my return I have sold 3 more small pictures to McLean for £150 and the Venetian Canal pictures to Virtue for £2,100 – these, with the 2 large Venetian subjects to McLean for £1050, is the extent of my trading so far.'[21] He could afford to be confident. For a successful artist, European travel was as cheap as, or cheaper than, staying at home. One thousand pounds paid for George and Rosalind Howard, their seven children and six servants to enjoy half a year in Italy.

Woods returned to Venice in 1878, after seeing Carl van Haanen's painting of Venetian *Bead Stringers* in Paris. The painting inspired him to depict Venice's 'loggias, canal-banks and shaded doorways, gaily clad girls and ragged children contrasted against the crumbling walls, grime and squalor'.[22] He took a studio close to Van Haanen and began a lifetime's devotion to the city, expressed through paintings he sent annually to the Royal Academy until his death in 1921. He also found himself part of a lively circle of artists and writers, writing to Fildes on 19 October 1878:

> I am next door to the Church close by S. Trovaso . . . quite in the thick of the studios . . . I met Mark Twain and have had a walk with him in the evening . . . Van Haanen is painting a fluffy red-haired girl in a pale green bodice; you would make a hit with her. He is designing a subject picture, he goes to work exactly as you do, the full size at once, altering every day, painting over and over thinly whilst designing.[23]

Whistler and Sargent arrived in Venice soon after, Whistler as a result of being bankrupted by his libel action against Ruskin; Woods was also friends with the Anglo-Italian

Montalba family, Anthony Rubens, Emeline Montalba and their four artist daughters Clara, Ellen, Henrietta and Hilda.

Fildes used Woods' studio during his visits to Venice; Woods' London friends helped to sell his work while he was abroad. Fildes wrote to him in November 1879: 'your picture is sold [for £150] to a Mr Messell, a friend of Stones who it seems had seen one or two little things of yours & had said he would like to have one'.[24] Ludwig Messell was a wealthy stockbroker; his son Leonard married the Sambournes' daughter Maud. When Woods came over with his paintings in 1882 he found buyers for *Bargaining for an Old Master* (Holbrook Gaskell) and *A Venetian Fanseller* (Agnews); as a confirmed bachelor, the fees, totalling £1,200, set him up for the following year.[25]

Writing to Woods about the awfulness of the London weather in October 1880, Fildes explained: 'I am anxious to do an important picture this year but I have almost come to the conclusion it is out of the question and such being the case I am think- ing most seriously of going to Venice for a few months – I may be able to do *something* there if only Pot-boilers for I *cannot hope to do anything more in a strange place*.'[26] Woods found him a studio for two months early the following year. The results proved more than pot-boilers; Fildes found a ready market for his Venetian paintings for the next decade: as the *Art Annual* noted, they were 'well suited to lighten the houses of dull London'.

Fildes' son has recalled the experience of the family when they all spent the early summer months in Venice:

> The day's work began early and by mid-afternoon my father and my uncle were ready to take the steamer out to the Lido. The Lido was then a very sparsely built upon and thinly popu- lated spot, with no sign of a building on the Adriatic side of it except the *Stabilimento* for sea- bathing. Waiting on the sands at the *Stabilimento* would be my mother, myself and my nanny, who had spent most of the day there, picnicking. My father and my uncle would usually be accompanied by Thoren, or Ruben or Count Thun or others of the circle. It was then the turn of my mother to come into her own, sitting there under her parasol in the midst of a circle of sun-bathing courtiers over whose prostrate forms I clambered.[27]

Fildes' *Venetian Life* and *A Venetian Flower Girl* were popular successes at the Royal Academy of 1884 though William Morris thought the mass of flowers in *Venetian Flower Girl* displayed 'repulsive skill' and the whole piece 'downright' ugly.[28] Commissions fol- lowed for more of the same, including *Flower Girl* for G.C. Schwabe, a founder of the Harland and Wolff shipbuilding company who lived at 19 Kensington Palace Gardens and Henley-upon-Thames. Schwabe had been particularly taken by the flowers Morris hated:

> For the sake of regularity, I state the price I am willing to pay say 'One thousand pounds' – as regards subject, altho' I do not wish to fetter you, allow me to say I should like very much to have something like the Flower Girl you had in the exhibition of 1884. I never saw flowers better painted nor a more charming figure.[29]

Fildes was forced to forgo the offer of a further £200 from a firm of colour printers for the reproduction rights as Schwabe wished to send the painting to Hamburg immediately after the Academy exhibition in 1886.[30]

By 1889, when Fildes showed *An Alfresco Toilet* (fig. 117), criticism of the Venetian sub- ject matter was mounting even among the popular press: 'his tact and facility cannot prevent us from being heartily tired of the buxom wenches who have so often

117. Luke Fildes, *An Alfresco Toilet*, 1889. Lady Lever Art Gallery, Liverpool. Fanny Fildes is the central figure having her hair dressed.

appeared in his pictures as well as those of Herr van Haanen and Mr Henry Woods'.[31] Fildes himself admitted to Woods, in reference to *An Alfresco Toilet*, 'I begin to think I have stuck and will never do anything more. Certainly this is the worst thing I have ever done and with an agony of labour. Nothing done but what is taken out the next day.'[32] There followed a dramatic and wholly successful switch to portraiture.

Early in the 1870s Roddam Spencer Stanhope (fig. 118) sold Sandroyd, the house Philip Webb designed for him in Surrey, and established his permanent home in Florence. He and his wife Lilla were already living in Florence when Holman Hunt stayed in the city in the autumn of 1866 *en route* to the Holy Land. They offered what help they could when Hunt's wife Fanny died of military fever (typhus) shortly after the birth of a son, Cyril; the Spencer Stanhopes' only child died the following year.

After the death of his parents in 1873, Spencer Stanhope bought the Villa Nuti at Bellosguardo just outside Florence. Burne-Jones and William Morris were among the first visitors,[33] Burne-Jones writing to his son Philip:

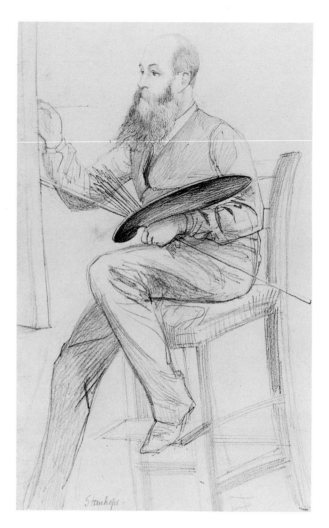

118. George Howard, *Roddam Spencer Stanhope*. Castle Howard, Yorkshire.

> Yesterday I walked up a hill to see Mr Stanhope who has a pretty house that looks all over Florence, and you go up to it by a long wall of roses in full flower showing over the top, and trees that you have never seen the like of all over the country, and there are Apennine mountains at the back.[34]

The Villa Nuti was formerly part of the estate of Prince Strozzi, 'who had sold it to the family of Nuti to defray heavy gambling debts'. It was transformed into the

> villa Stan-hoo-pee . . . a spacious, mediaeval building, encircling a courtyard where grew massive creepers, and orange and lemon trees laden with fruit. From the terrace, amid the roses, one looked out over Florence drowning in the sunlight, cut by the silver line of the shining Arno. In the loggia, which my uncle fashioned into a delightful room, the wide windows commanded a panorama of the Vallombrosan hills . . . everywhere the walls glowed with my uncle's own paintings in rare Italian frames, from which his calm, passionless angels or gay little Loves looked out amid the tones of pink and rose or gold and amethyst which he loved.[35]

Spencer Stanhope had established himself in the city in which his master, Watts, had

enjoyed the hospitality of the Hollands thirty years earlier. His work was similarly inspired by the Florentine art of the Renaissance; his style was closest to Burne-Jones although his interest in wall-decoration and use of tempera as a medium in his painting can be traced back to the influence of Watts at Little Holland House. The architect George Bodley stencilled the walls of the Villa Nuti; Spencer Stanhope stencilled the walls of the Anglo-Catholic Church of St Mark in the Via Maggio. When Bodley designed Holy Trinity, a second, larger Anglican church in Florence, Spencer Stanhope painted a triptych for the altar and *The Resurrection*, in memory of his daughter Mary, for the Memorial Chapel. Spencer Stanhope and Bodley were also involved in the building and design of Marlborough College Chapel.

His villa became a favourite destination for artists and writers, as well as for some of the collectors he had known through Watts and the Prinseps at Little Holland House: Arthur Balfour, for example, and his architect brother Eustace who had married the sister of the Marquess of Lorne and settled in Addison Road, Holland Park. They approached Florence not as a 'modern' city, but through Dante and Botticelli, the poetry of the Brownings, the fiction of Henry James and George Eliot's *Romola* illustrated by Leighton. (George Eliot had written of Leighton's commission, 'He is an invaluable man to have because he knows Florence by heart.'[36]) Spencer Stanhope's paintings, like Burne-Jones', appealed to people 'who look at the world and at life not directly, as it were, and in all its accidental reality, but in the reflection and ornamental portrait of it furnished by art itself in other manifestations; furnished by literature, by poetry, by history, by erudition'.[37] From 1887, his niece Evelyn and her husband William de Morgan spent almost every winter at Bellosguardo (De Morgan's health making such visit's necessary).

When Henry James stayed at a neighbouring villa to work on *The Aspern Papers* he was intoxicated by the view, the situation and also by the knowledge that Browning had visited the house immediately after the death of his wife.

> I feel again the sun of Florence in the morning walk out of Porta Romana and up the long winding hill; I catch again, in the great softness, the 'accent' of the straight, black cypresses; I lose myself again in the sense of the large, cool villa, already then a centre of histories, memories, echoes, all generations deep; I face the Val d'Arno, vast and delicate, as if it were a painted picture.[38]

He also used the setting in *The Portrait of a Lady*: 'it looked somehow as if, once you were in, you would need an act of energy to get out'.[39]

Italy was ideal for light and warmth during the autumn and winter. However, the English countryside provided sufficient attractions during the summer months, particularly for artists with growing families. Also there was a steady demand for English or Scottish subjects shown at the Academy.

Fildes returned to villages along the Thames, 'six or seven miles of country which takes in the two Stokes, Aston Tirrold and Blewbury',[40] for three of his largest paintings, *The Widower*, *The Return of the Penitent* and *The Village Wedding*. His letter to Woods dated 24 August 1881 from the Chequers Inn, Aston Tirrold, conveys the pleasures of working in the countryside with his family, though the costumes of the labourers could not match those he had discovered in Venice:

119. Luke Fildes, *The Village Wedding*, 1883. Christopher Wood Gallery, London.

The lot of us came here on Monday. . . . You know this old village – we walked through it that Sunday going to Blewbury. At this little inn – the only place I could find for miles around – we are very comfortable.

I left London with the idea of painting this 'Village Wedding' quite in modern costume, but I really think it will be utterly beyond me to do so. It is so ugly and *nasty* I cannot bring myself to do it. I don't mean the people in their every day clothes – they are just passable – but I mean those in their wedding attire, all Reading and Wallingford slop goods degrading in every respect. . . .

It is very pleasant in many respects here. We have the run of a lot of large orchards belonging to the Inn, and they are nice pleasant people (He an old Indian Mutiny man and she a good cook). They have never had anyone staying with them before. . . I have got a splendid large barn for a studio and we have a pony and carriage for four which I tool about the lanes. Lots of fruit and excellent living, and three young pups for Val to play with, pretty flower garden separating the road from the house, and a private sitting-room – in fact all is well in the midst of the most beautiful scenery and villages with rustics who dress pictorially worse than the denizens of Scotland Road and Vauxhall Road in Liverpool! And I think when I say *that* I have exhausted my contempt for them as an artist. It's like eating stones and sawdust after my fare in Venice.[41]

One of the models, for the bridegroom, was a recently married shepherd who announced he had previously sat for Fildes' *Return of the Penitent*. *The Village Wedding* (fig. 119) was a popular success when it was shown at the Academy in 1883; Agnews bought it for 2,500 guineas before the exhibition opened. The *Art Annual* commented: '[the engraving, by Agnews] has found its way to all parts of the world, and many a colonist can trace likenesses to friends in the Old Land amongst those assembled so picturesquely in "The Village Wedding".'

Working holidays by the sea had long been popular with Victorian artists. The colonisation of the Isle of Wight in the 1860s and 1870s by Tennyson, Julia Margaret Cameron and Watts turned Freshwater into 'Little Holland House-by-the-sea'; Burne-Jones acquired a seaside retreat at Rottingdean in Sussex in 1880. In 1894 Fildes

bought a property by the sea, Holland House, at Kingsgate, near Broadstairs on the Isle of Thanet. The house had been built in the 1760s by Henry Fox, first Lord Holland, as a reproduction of Tully's Formian villa; it was divided into five separate dwellings and a coastguard station early in the nineteenth century. 'It was the central portion that had kept the name of Holland House, and it was that which my father had bought.'[42] The area had recently become fashionable: Val Prinsep's father-in-law spent his last year living nearby with his mistress; Linley Sambourne had a house at Thanet, and the Herapaths, his parents-in-law, lived near Ramsgate. Westgate on Sea, nothing but fields and sand-dunes until the mid-1860s, had filled up with Queen Anne seaside properties.[43] Fildes found it easy to let his own house to members of the aristocracy when he was unable to take time away from the studio.

Val Prinsep meanwhile acquired a studio by the sea at Pevensey, Sussex, where other members of his family had bought land and property. He transformed a 'hut' into accommodation for his family and friends. It was called Santa Claus, and the Prinseps liked it so much, they found it hard to return to Kensington. Florence was given the honour of naming streets in Pevensey after their artist friends, Poynter and Leighton. Prinsep wrote to Woods on 1 February 1899:

> We have been away from Kensington since August! Of course an occasional visit has been made but virtually we have been at Pevensey. Our house – a mere cottage has proved a success and the studio though small has enabled me to paint a picture so we are all well – parents and boys. There will be an outcry when we return for the kids infinitely prefer the country to town – yet return we must and shall in early March.[44]

Prinsep was at an advantage, however, over his friends and neighbours in Holland Park: since marrying Florence his business interests and her private income ensured he never had to struggle to complete a work for Show Sunday – although he always did his best to submit something.

For the artists who were married – the majority who settled in Holland Park from the mid-1870s – domestic life could offer support and protection. The arrival of babies, however, inevitably created interruption and distraction. Fildes' youthful appearance was noted when he was visited by *Strand Magazine*: 'Perhaps the helpful aid of wife and the pleasures of childhood, allowed a free and unfettered course, have something to do with the fact that Mr Fildes looks ten years younger than he really is!'[45] Fanny, while offering 'her [valuable] advice and criticism on an important detail of work',[46] virtually gave up her own painting to devote herself to his career and raising their six children (fig. 120); as a result, Fildes' income and social status steadily increased.

After Hamo Thornycroft married Agatha Cox in 1884, his working life grew more complicated. He left his parents and sisters in the family studio-home in Melbury Road to live in a small flat nearby (Agatha was assisted by a cook and a nurse for their baby), continuing to rent the studio from his father and, after his death in 1885, from his brother John. By 1891, with two children and a third expected, Thornycroft and Agatha needed a larger home. Their youngest daughter Elfrida wrote: 'They were torn between a desire to live in the country and Thornycroft's need to be near his studio. Oliver [their son] needed more outlet for his ebullient energy than the small studio garden could afford, yet Thornycroft wondered if he would ever do any "serious" work while living away from his studio.'[47] They acquired a house in the countryside,

120. Luke Fildes' son at work in the school-room, 11 Melbury Road. 'The two youngest boys and the girls are still at home, and lead a life of homely happiness' (*Strand Magazine*, 1893).

Frimley Green, Surrey, but Thornycroft remained in London during the week staying either in Melbury Road or with his sister Helen in Avonmore Mansions close by. As a sculptor he needed the extensive workshop space available in Melbury Road, and the studio assistants employed by the family. According to the *Strand Magazine*, by the early 1890s his average working week was eighty hours. The journey to Frimley Green took three hours each way.

The creation by John Belcher in 1892 of a small flat above the stable block of Moreton House provided Thornycroft with a *pied-à-terre* next to his studio and Agatha with somewhere to stay if she visited her husband during the week (fig. 121), but he continued to miss his family. He enjoyed their company; they were also the subjects of his work.

> I am just now having the new experience of my daughter [Joan, born 1888] staying in town with me in my bachelor apartments here; and although she is only just turned seven I find her a sweet little companion, chattering away as she models in clay beside me, extols her own work and finds it 'done' in her opinion before I fancy she can have fairly started; still my speedy correction of her effort is no surprise to her and she has finished it again in another ten minutes. She has modelled three works today and polished six of my bronze statuettes with great vigour and has indeed worked well from 9 till 7.[48]

121. John Belcher, design for additional accommodation, 2 Melbury Road, 1892. London Metropolitan Archive, London.

In 1899 the Thornycrofts gave up their Surrey house, moving to Hampstead. Their daughters' education was the primary reason – they were sent to the newly founded King Alfred's, a coeducational day school – but Thornycroft also explained that 'our separation for part of each week when living there became at last unbearable.' His daughter Rosalind described their new routine; Thornycroft travelled to work by railway:

> The North London Railway, from his daily journey on it to Addison Road, became very much his personal possession and in order to beautify it a little he would take packets of flower seeds and scatter them out of the window along the more dreary stretches of line through Kensal Rise and Willesden.[49]

The studio in Melbury Road continued to be run by a team of assistants. In 1885 they consisted of George Hardie, chief carver; Harry Pegram, modelling and carving; Jim Smith, pointing and casting the plaster models; and Noah, a general man doing odd job work.[50] Weekly wages amounted to £15. By 1900 Thornycroft employed Hardie, Jim Smith and his son Nixon, also Anderson, his houseman, and his wife, who lived on the premises.

Memoirs of the artists' children suggest theirs was an idyllic upbringing around the leafy parkland of Holland House. Leighton was godfather to one of Prinsep's sons and a daughter of Giovanni Costa; Fildes and Prinsep were godparents to Sambourne's children. Fildes held annual Christmas parties in his studio, renamed the 'Theatre Royal, Melbury Road'; here the children produced plays using the winter studio for their stage.

> This was a venture by myself [L.V. Fildes], my brother Paul, and my sister Kitty for the production of plays in rhymed couplets of my own composition. The venture which lasted for several years, met – as I sensed at the time – with success. The glass studio was all one could wish for as a stage; the arch and the curtains between the two studios were an ideal proscenium. Audiences might consist of as many as a dozen. In addition to the 'Little Hunters' from across the road and our parents, our chief supporters were Uncle Harry [Woods], Gordon Thomson, Henry T. Wells and my godfather Val Prinsep.[51]

Louisa Starr's daughter Estella Canziani recalled Sundays at the Prinseps': 'There were many tea-parties in the garden, and while we children played by the pool of water and fed the geese and made rainbows with the garden hose, artists dropped in for a chat. We shot water from the hose over Leighton's wall, and I don't think he ever complained about us.' (fig. 122).[52] Leighton did protest, however, when Shannon's daughter Kitty climbed up the wall dividing their properties and fell over. Kitty, in her own memoirs, recalled seeing Leighton take his after-dinner coffee out of doors as she went to bed; her bedroom overlooked his garden.[53]

The tennis courts in the Prinseps' garden and at Moray Lodge were popular with children and adults and there were musical parties at Moray Lodge, at the homes of Rudolph Lehmann and George Boughton on Campden Hill, at the Kensington home of the artist and collector J.P. Heseltine, and at the Cranes', at 13 Holland Street:

> The Walter Cranes also gave amusing parties. Every one we had ever known or heard of, went to those New Year's Eve gatherings. We [the Canzianis] wore fancy dress or sometimes disguise, and we guessed who we each were at 12 o'clock midnight. The Walter Cranes were

like two grown-up children; they loved titles, pageantry, and play of all sorts. On the disguise occasion . . . Crane became a crane with long bill, red legs, and floppy wings. When he spoke he opened his bill with his hands. Dame Crane's little dog became a dog-rose with a large pink wild-rose collar sticking up round his head.[54]

Fildes' son Val recalled visits to the house of the collector G.C. Schwabe:

Because he took an interest in small children he still lives in the memory of one of them after all these years. On the way home from walks in Kensington Gardens a detour would be made to the Schwabe mansion in Kensington Palace Gardens – 'Millionaires' Row' – where the largest musical-box I have seen would be set in motion, and a toy singing-bird in a gilt cage perform. The concert would conclude with a dish of German sweet-meats being handed round.[55]

Schwabe had already cultivated close relationships with the artists he patronised. Prinsep wrote to him in 1884: 'I shall be delighted to pay you a visit on the 23rd . . . I've just returned from Paris so billiards have been neglected but at Henley [Schwabe's country house] provided you have some heavy ones I will play you for as many new hats as you care to lose.'[56]

The diaries of Linley and Marion Sambourne provide glimpses of the busy social life of the artists' wives, sometimes accompanied by their husbands. Their own circle appears to have included the Fildes, the Hunters and the Stones but neither Leighton, Watts, Schmalz nor Solomon. However the wives' social circles did not necessarily mirror the artists' professional friendships. Leighton regularly sent models along to his neighbours, writing to Stone, for example, on 29 April 1888, 'let me present to you a young lady with a charming face, Miss Livings . . . she would I think be valuable to you – will you kindly introduce her also to Fildes'.[57] And William Burges criss-crossed Holland Park in the few years he lived in Melbury Road, calling on Leighton, Watts, Prinsep, Hunter, members of the Messels and Ionides families and Christopher Dresser.[58]

Marion Sambourne's 'at home' was every Tuesday, Laura Stone's was Sunday. In 1882 the Sambournes gave dinners for the Fildes (thick soup, red mullet, kidneys and bacon, roast leg mutton, cabinet pudding, herring) and for the Burnands (Sambourne's editor at *Punch*), the Macdonalds and the Fildes (clear soup, salmon, cucumber, sheep brain, lobster patties, *chaudfroid* of pigeons, forequarter of lamb, new potatoes, cauliflower, asparagus, quails, salad, Baba of rhum, compôte of fruit, anchovies and cream cheese).

A 'gentlemen only' dinner in 1893 comprised caviare; clear soup, cold salmon, *chaudfroid* of pigeons, tomato salad; roast lamb, peas, *haricots verts*; roast chicken, salad, Russian salad; jelly, macédoine of fruit; anchovy savoury cream cheese; ices – pineapple cream, raspberry water; grapes, cherries, greengages. Marion spent £2 14s. 6d. at the stores in the morning. The gentlemen, served by two specially hired waiters plus 'Mrs Birley & girl', stayed until 2a.m. drinking twelve bottles of Ayala 1880, five Geister 1874, two Sauternes and three Burgundy. Sambourne noted in his diary 'Very good dinner, 15 bottles champagne drunk. Slight bilious headache which lasted all day.'[59]

They attended dinner at the Stones', 'very good'; the Boehms'; the Joachims'; the Lewises' and the Messels'. The latter was 'capital', a 'very jolly dinner'; the guests included the Cassavettis, the Gilberts (W.S. Gilbert the dramatist), the Boughtons, two

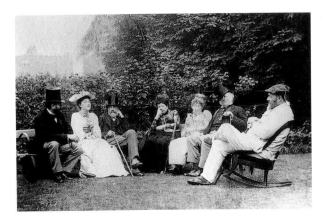

122. In Val Prinsep's garden, 1 Holland Park Road. Luke Fildes is on the far left; next to him are Florence Prinsep and Philip Calderon. Val Prinsep is sitting in the rocking chair on the far right; next to him is William Powell Frith.

Miss Montalbas over from Venice and the Ionides: artists mixed in with the banking friends of Marion's father Spencer Herapath.

Although the social engagements of the artists' wives continued throughout the year, broken only by trips to the country or abroad, as Easter approached and the deadline of 'sending-in day' the artists spent more and more time within their studios. Kitty Shannon, writing of the change to her father's usual jovial personality, could have been describing the situation for all their artist-neighbours: 'when the Academy sending-in day drew near my father became very much depressed and detached'.[60] For the majority of the Holland Park artists, an entire year's income was determined by success or failure at the Academy.

Few of the Holland Park artists would have agreed with the *Builder* of 5 May 1877, which commented with dismay on the change to the artist's status: no longer a bohemian but one 'who communicates by private telegraph with his broker in the City between the intervals of waiting for a change of model'. The journal was even more concerned about the inflated prices being paid for pictures:

> The ugly feature connected with these high prices consists in the bad feeling that it creates in the minds of many people who have a very natural desire to possess pretty things, but who do not exactly see their way to the sacrifice of a considerable portion of their capital to the possession of a Millais or a Meissonier . . . those who purchase pictures for the love alone of the picture, cannot afford to compete with purchasers whose view is to sell some day at a profit.

In 1882 the *Builder* again expressed concern, this time about the changes to Show Sunday:

> Of late years in London . . . the great artists have opened towards the close of March their splendid studio doors more or less freely to their admiring and opulent friends, for the purpose of showing the pictures that are expected to be exhibited at Burlington House in May. To many persons those visits have afforded a very great pleasure; and certainly, years ago, it was difficult for a lover of art to find a more agreeable way of passing an afternoon. But of late these picture-receptions have assumed a somewhat different character; they have become crowded exhibitions of social celebrities, the people visiting the studios, and the studio itself appearing to rival the attraction of the pictures exhibited.[61]

Journals such as the *Builder* had helped to create the 'celebrity' status of artists and,

inevitably, boost the value of their works. From the early 1880s magazines and journals featured 'peeps' into the homes of artists. Maurice Adams' series for the *Building News* (1880–1) concentrated on architectural features. F.G. Stephens' series 'Artists at Home' was first published in the *Athenaeum*, then in a single volume (1884);[62] its main feature was a photograph of the artist in his studio (Stephens was typical in including no women artists) surrounded by works completed and in progress. Mrs Haweis' effusive articles 'Beautiful Houses' for the society magazine *Queen* (published in book form in 1882) bathed her subjects in purple prose; in Leighton's studio, for example, 'loveliness . . . breathes upon the easels, and carries us into an *Arcadia* where the music of the free hills and streams was in the shepherd's pipe, the freedom of the birds and the flowers in the maiden's hearts.'[63] The *Studio*, founded in 1893, featured Leighton in its opening issue and could state, with confidence, 'The interior of the fine Studio, that has an air of home rather than of a mere showplace, is familiar to thousands who have never crossed its threshold.'[64]

The Holland Park studios of Leighton, Val Prinsep, Fildes, Stone, Thornycroft, Hunter, Watts and Shannon were regularly featured, and their proximity to one another remarked upon, thus helping to create the impression of a 'colony', even though the works produced by the artists were very different in style and content. Mrs Haweis, looking out of Leighton's drawing-room, remarked that 'the big trees veil without concealing the red-brick domiciles of several brother artists who are crowding round their president'.[65] The interviews conducted for the *Strand Magazine* (Leighton 1892, Thornycroft and Fildes 1893, Prinsep 1896, Stone 1899, Woods 1901), and special book-length features in the *Art Annual* (Leighton 1884, Fildes 1895, Stone 1896) included biographical details about the artists and their families, and descriptions of their houses (with photographs), including rooms not normally open to the public. Fildes wrote to Henry Woods of the 'sickening rot' which was about to appear in the *Strand*, hoping he would not see it, but 'the warning came too late':

> 'I had not been at the hotel two hours', my uncle [Woods] wrote back – he was on a holiday in Switzerland – 'before the parson put it into my hands. Certainly every person in the hotel had read it. It is true that some parts have a sickly flavour, perhaps only to us! I heard many remarks such as, "Oh! how interesting!" The rapture was general concerning your house. Such a place could scarcely have been imagined in London.'[66]

Though protesting to Woods, Fildes, like the other Holland Park artists, was all too willing to receive free and flattering publicity.

The articles contained numerous illustrations of the artists' work. These reproductive engravings provided by firms such as Agnew's and the Berlin Photographic Company, could be snapped up by studio visitors unable to afford original work. Advertisements in the journals also offered photographs of paintings. Frederick Hollyer's studio – selling 'permanent photographs' of works by Burne-Jones, Watts, Rossetti and Albert Moore – was conveniently situated in Pembroke Square, just across Kensington High Street from Melbury Road and 'open to visitors daily'.

Even Linley Sambourne, whose Show Sundays attracted only a few dozen visitors, was featured in the *World* in 1886, the article entitled 'Celebrities at Home'. There were many follow-up articles inviting artists to pronounce on issues of the day. Watts supported the Royal School of Art Needlework with a long piece published in *Nineteenth Century* (he was also President of the Anti-Tight Lacing Society). In the *Strand*, in 1891,

artists commented on contemporary fashion. Leighton declared, diplomatically, 'Whatever may be the criticisms to which the dress of a lady in our day is open, there is a vast amount of nonsense talked about it. Titian and Velásquez would probably have been very happy to paint it.'[67]

The magazines also carried advertisements which offered readers access, in London, to furniture, furnishings and *objets d'art* supposedly similar to the contents of the artists' studios: Japanese leather-paper at Liberty's, 'durable, inexpensive and uncommon'; Japanese works of art, modern and antique lacquers, bronzes, sword guards and colour prints at S. Kato in Mortimer Street; '25,000 peacock feathers, over 4 feet long, just arrived from Japan, post free ls 9d per bundle of 100, not less than a bundle sold' at Edward Bella's Japanese Gallery in Soho Square.[68] As Henry James remarked, 'on what a scale the consumption has always gone on!'[69]

The artists of Holland Park were themselves intensely aware of the benefits (and pitfalls) of the interest of the press. To live like a gentleman required an annual income of several thousand pounds; it was essential their works attracted buyers – individual collectors or dealers – willing to pay high prices for the originals and for reproduction rights. Royal patronage of Leighton, Prinsep, the Thornycrofts, Fildes and Shannon distinguished the colony. But recognition by the Royal Academy – hanging 'on the line', election as Associates, then full Academicians (there were only forty at any one time) – ensured regular, ever-increasing incomes and was consequently eagerly sought. Moore was an exception, a few loyal patrons providing sufficient means to support his extremely modest lifestyle.

Considerable irritation was expressed by several artists when Burne-Jones, the star of the rival Grosvenor Gallery, was elected an Associate of the Academy in 1885, ahead of candidates who actually supported the institution. Fildes wrote to Woods on 7 June:

> I have no doubt it was a surprise to you I mean the Burne Jones incident – as you will see by the voting there was a dead set for him – I have not the slightest objection to him being in the RA – I only feel there has been an indecent haste in rushing him in & a very slavish bowing down to him as soon as he graciously consented to allow himself to be selected. . . . Had there been any body at all strong I don't think Jones would have got in but as you see there are only a lot of poor things as portraitists just now *so that* was his chance.[70]

Burne-Jones was himself reluctant to be elected, as he had little intention of showing work at the Academy. He had bowed to pressure from Leighton and Watts, the latter writing to him on 5 June: 'I wish I might venture to hope you would accept the recognition the Academy has done itself the honour to show by becoming one of us. I believe you could help the cause of Art more effectually by doing so than by remaining outside.' Burne-Jones replied the same day: 'I love solitude & peace & isolation & I give these up reluctantly – as I gave them up to exhibit at all: but I cant have my way – and since you & Leighton are so affectionately kind about this I am bound to be glad too.'[71] But in 1893 he resigned, explaining to Watts on 13 February 'I'm like a man who has been asked into a house as he was passing by, and being beckoned to, he came in good naturedly & without much thought – & has been on the hall mat ever since.'[72] His only painting to be hung at the Academy, in 1886, was the erotically charged *The Depths of the Sea*, displayed in the same gallery as Prinsep's domestic scene *Five O'Clock Tea*.

Supported by a small coterie of admirers including George Howard, William Graham and the Ionides family, who had remained faithful since the 1860s and who

paid whatever he asked for his work, Burne-Jones had no need of Academy recognition. For artists such as Fildes, Stone and Hunter, the situation was very different; their works appealed to middle-class collectors most of whom required the reassurance of the Academy's 'stamp of approval'. Many went to the Academy before venturing to the studios of the artists whose work they liked. Election to the Academy guaranteed sales.

Already an Associate, Fildes was keen to support Woods' election. In 1880 he wrote to him:

> We have an election on at the R.A. . . . I scarcely know who'll get in. Dicksee, of course, but who the others are to be it is hard to think. Possibly Bodley, architect, and some men talk of Thornycroft as sculptor. The other two places may go to the many who are trying. Who they are I don't care a damn excepting yourself, but I don't think you have any chance this time, though there are many who are most favourably inclined to you. You see both Stone and I, who would have stood by you, will be away.[73]

Woods became an Associate in 1882. Fildes, meanwhile, recognised that he would have to wait to be a full Academician until after Stone was elected:

> I stood no chance at all nor will I as long as Stone is not elected – people that would vote for me won't because – 'My God! What a slap in the face it would before Stone!' they say – and then 'Ol! Fildes – he's sure of it – He can afford to wait – whereas if Stone is passed over now he'll never get it' and so on.[74]

As it happened, both Fildes and Stone became Academicians in 1893 (their diploma works were *A Schoolgirl* and *Good Friends*). The same year Prinsep wrote to Fildes from Paris about his and Woods' chances:

> I rejoice to hear that Harry Woods has acquired a domicile in London as he has a very good chance of election . . . I shall be glad to congratulate him if he succeeds & back him up if his election is deferred yet another time. If I don't succeed this time I shall take myself out of opportunity for I am rather tired of it. This please keep to yourself.[75]

Prinsep became an Academician in 1894, Woods the year after.

Under the presidency of Leighton, the Academy Summer Exhibitions attracted the highest numbers of paying visitors in the century, an average total attendance between 1878 and 1896 of 355,000. The numbers of works sent to the Academy for consideration also rose, from 6,415 in 1878 to 12,408 in 1896; there were sometimes 2,000 exhibits.[76] When Leighton's Liverpool patron Andrew Kurtz attended his first Academy dinner in 1881 he noted in his diary:

> In the courtyard of Burlington House were assembled the Artists Volunteer Corp under the command of Val Princep [sic], they were dressed in either a grey or fawn colour suit & looked a very soldierlike looking body. No one would have taken them for artists. . . . Sir Fredk. Leighton at the head of the stairs to receive his guests added to the magnificence of the scene. His appearance is quite 'Presidential' & he receives with much cordiality even friendliness of manner.[77]

> A business-man who is a picture-buyer – and for the last half-century almost all our picture-buyers have been business-men – has his weak side, and, so far as his relation to art goes, he feels it a privilege to be made free of the art-precincts, and promoted into the intimacy of a great or a distinguished painter. He is apt to find the world of art much more entertaining than the world of commerce; and, while pluming himself upon having converse with persons

whose names are in all men's mouths, he can still feel, in a certain sense, he himself 'rules the roost', as all these fine performances would collapse without a purchaser to sustain them.[78]

The businessman picture-buyer described by William Michael Rossetti could find almost all that he desired in the studios in Melbury Road and Holland Park Road. Though there is no evidence that the artists consciously conspired with one another to catch a client, their collective wares added up to a formidable store-house of temptations. They presented a microcosm of Victorian art and consequently proved attractive to late nineteenth-century collectors interested in acquiring a quantity of works representative of the age rather than, like Frederick Leyland and William Graham, for example, building up a homogeneous collection in which works were linked by the common ideals of the artists.

There was, literally, something for everyone, in terms of scale, subject matter and medium, from large symbolist oils by Watts to society portraits by Shannon and Fildes; from the seascapes of Hunter to Stone's garden lovers. Leighton, Watts, Schmalz, Rae, Normand and Solomon J. Solomon painted classical and biblical themes, often containing nudes; Moore concentrated on perfecting his aesthetically draped and timeless women. Prinsep painted almost anything: classical subjects, costume drama, scenes of contemporary Venice and portraits. Only the 'anecdotical [sic]' or story-pictures despised by Henry James were few and far between: apart from portraiture, the artists in Holland Park rarely tackled contemporary life, either realistically or sentimentally. Fildes, for example, abandoned social realism for pretty girls in Venice; Thornycroft was unusual in producing some sculptures of contemporary subjects as well as portrait busts and classical statues.

Older patrons remained faithful to the artists of the Little Holland House circle; several, including the Howards, were engaged throughout the 1880s in perfecting the aesthetic appearance of their houses. Watts painted Constantine Ionides, his wife and three of their children in 1880–1, writing to Constantine after receiving his cheque, 'Such pleasure as you express gives me the most real pleasure in my turn. Such things make "a life worth living".' In 1883 he painted Aglaia Coronio, writing before the work was quite finished: 'It strikes me that perhaps it would be as well to let you have it as it is that I may be able to put the last touches in from advice, for I confess I like it better as it is than I shall probably do when more worked upon so I wish to shift the responsibility.'[79]

Watts also painted portraits for Percy and Madeline Wyndham of their sons Guy and George. Although he was never persuaded to visit their country houses, the Wyndhams called regularly at 'new' Little Holland House in Melbury Road. Mary Wyndham noted a visit to see his new gallery (fig. 123), opened to the public in 1881: Watts surpassed himself as the visionary.

> There we saw his pictures and the statue of Hugh Loupus [sic], its awfully fine. Mr Watts says he feels he has got on lately, since he had a vision one morning in bed that Titian & Reynolds came to him & gave him a lesson, painted before his eyes; he feels quite a fresh courage since the event, and is trying to put to practice what he learnt from them feeling that now for the first time in his life the veil between him & really doing something was withdrawn.[80]

Before his marriage, Prinsep frequently accepted the Wyndhams' hospitality at their

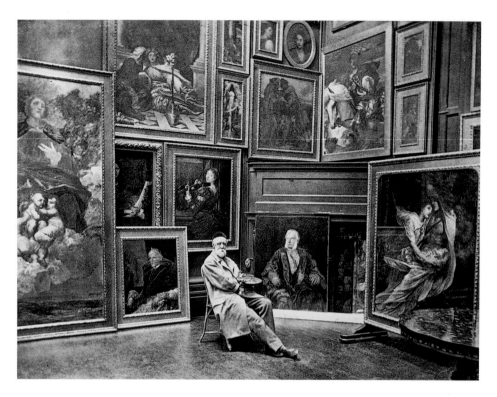

123. George Frederic
Watts seated in the
gallery designed by
George Aitchison at 6
Melbury Road. The
photograph was taken by
J.P. Mayall for F.G.
Stephens, *Artists at Home*
(1884).

country houses, painting Mary and George, playing tennis, cricket and whist, helping
to entertain schoolchildren from the village, in short the perfect artist in residence.
From the late 1880s, however, the Wyndhams were concentrating on their £80,000
country house Clouds, designed by Webb, its interior decorated by Morris and
Company with the advice of Burne-Jones. Hanging their pictures in appropriate set-
tings took precedence over further purchases.

The statue of Hugh Lupus astride a horse spotted by Mary Wyndham at Watts' stu-
dio had been commissioned in 1870 by the Wyndhams' close friend Hugh Grosvenor,
third Marquess of Westminster. He also bought one of George Mason's finest paintings,
Evening, Matlock – The Harvest Moon. *Hugh Lupus* was hardly started when Watts moved to
Melbury Road. Grosvenor, who in 1874 had become the first Duke of Westminster, lent
him a Percheron mare to model from (it was stabled at Cliveden when 'off duty'), but
the statue was not ready for casting until 1882. The following year all seven and a half
tons were erected in front of the Duke's new Eaton Hall near Chester.[81]

Meanwhile, the Duke's attention was drawn by Alfred Waterhouse, the architect of
Eaton, to the work of Hamo Thornycroft. (Waterhouse had designed a studio-house in
1876 on Campden Hill for Marcus Stone's brother-in-law, Edward Sterling). The Duke
was struck by a clay model of *Artemis* and commissioned a full-size version in marble.
Thornycroft, in a state of great excitement, wrote to his friend Edmund Gosse describ-
ing the arrival in Melbury Road of a four-ton block of marble:

> My baby, from Serravezza, arrived today, such a lovely fair fine maid, weighs four tons already,
> and is ten feet long; the unappreciating British public could not but stop to crowd around
> the gate while the beautiful but impassive infant was slowly borne across the threshold into
> the mysterious recesses of the studio.

256

I gave it a good bath the first thing. I think this was right, being a bachelor I was not certain what was the right thing to do. This only exposed its beauty all the more and I was very loth to go away from the pure one for a minute. It is charming at this age, but its childhood will probably be very wearying and tiresome and its adolescence very interesting.

All this is very stupid, but I can think of nothing to say, and the idea of making only a moderately good figure out of so lovely a block of marble seems uppermost in my mind. Just think what a lot of grand figures the block contains! If only one knew how to cut them out – To be a giant of a sculptor would be a grand existence.[82]

When *Artemis* was shown at the Academy in 1880 it was a resounding success; Thornycroft was elected Associate the following year. The Duke continued to patronise Holland Park artists, commissioning two paintings from William Blake Richmond who was installed in his studio next to Prinsep and Leighton: *Hermes* completed in 1886, *Icarus* in 1887. The following year Richmond painted the Duke's daughter-in-law Sibell, Countess Grosvenor.

Arthur Lewis was not the only silk mercer living on Campden Hill. By 1880 William Rawlinson had taken Hill Lodge on the south side of Campden Hill Square and Stephen Winkworth had moved into Airlie Lodge. Rawlinson and Winkworth, like Lewis, were far from typifying the 'unimaginative and unaesthetic order . . . the British merchant and paterfamilias and his excellently regulated family' abused by Henry James for liking subject pictures of the 'anecdotical class'.[83]

Winkworth's father Henry was a Manchester silk merchant; his brother-in-law the solicitor William Shaen had commissioned one of the first red-brick houses on Campden Hill (see fig. 20), from Rossetti's friend Benjamin Woodward. (In 1894, Philip Webb was commissioned to design an oak cabinet for the Shaens' house). Rawlinson was a partner in James Pearsall and Company which helped to create the English embroidery-silk trade; he also worked, like William Morris, with Thomas Wardle of Leek to reintroduce old methods of dyeing silk using natural dyes from the East. At the same time he became a distinguished Turner expert, building up an unrivalled collection of drawings and engraved work; he collected blue and white Chinese porcelain and owned a Whistler *Nocturne*, tastes he shared with the Quaker banker William Cleverley Alexander who in 1874 acquired Aubrey House next door to Lewis and commissioned Whistler to paint his daughter Cicely.[84] William Blake Richmond painted Rawlinson and his wife, their son Hugh and daughter Mary.

At Holly Lodge (the name was restored by the Winkworths), Stephen and his wife attempted to create an artistic house worthy of their paintings and sculpture and to which neighbours like Leighton could be invited for musical evenings. Morris and Company provided wallpapers; panels of birds filled the upper walls of the drawing-room, and elsewhere there were decorations similar to Poynter's work at the South Kensington Museum. The Winkworths were particularly interested in sculpture, allowing Edmund Gosse to use photographs of rooms in Holly Lodge for his article, 'The Place of Sculpture in Daily Life', published in the *Magazine of Art* in 1894. Small versions of Thornycroft's *Mower*, *John Bright* and *General Gordon*; Leighton's *Sluggard* and Onslow Ford's *Peace* were placed among the books and pictures, an effect Gosse hoped to encourage among collectors who lacked the confidence to buy large oils or full-size sculpture.

Some very rich people indulge themselves with long classical entablatures, as large as the wall of a ballroom, by Sir Frederic Leighton or Mr Poynter; others, whose incomes for five years would scarcely buy one of these pictures, yet make themselves very happy with a few precious little water-colour drawings . . . I should like to see the same variety of taste and range of capacity exercised in the field of sculpture.[85]

Bronze statuettes, Gosse insists, are perfect for a 'reasonably well-to-do person, who would naturally buy pictures' and who possesses 'one of the dark harmonious drawing-rooms or libraries which are now in vogue, rooms which Mr William Morris first put into our power to arrange. The woodwork, I suppose, is sombre; the wall-papers glaucous green or dusky red, the furniture, as far as possible, in the taste of the last century.'[86] Gosse could have been describing the colours of the Winkworths' rooms.

The contractor Sir John Aird who acquired a house in Kensington in 1874 (14 Hyde Park Gate) befriended some of the artists whose work he collected, in particular Fildes. He was also, like so many of the artists, a keen member of the Volunteer movement, becoming Major and honorary Lieutenant-Colonel of the Engineer and Railway Staff Corps. The content of his collection, mostly bought from artists in their studios, reveals a characteristic new to late nineteenth-century collectors – the desire to possess works representative of all the styles and subject matter tackled by Victorian artists. Among the Holland Park artists, Aird owned work by Leighton, Prinsep, Stone, Clara Montalba, J. Hanson Walker, Woods and Fildes. The artists called him 'St John Aird of the Large Heart'; he appears to have bought paintings on the spur of the moment, simply because he liked them.[87]

He came to Fildes' studio after seeing *The Village Wedding* at the Academy in 1883. Its purchase by Agnew's for 2,500 guineas had been a well-publicised phenomenon which brought hundreds of visitors to Melbury Road.

> 'Show Sunday' fell that year [1883] on the 8th of April. My mother had instituted a system by which the parlourmaid, stationed on the landing outside the studio door, dropped a coffee bean into a brass bowl for every visitor who came up the Triumphal Staircase. This year the tally was little short of seven hundred.[88]

Aird immediately commissioned *Venetian Life* for 2,000 guineas, returning on Show Sunday the following year to see his completed painting. 'So great was the impression the picture made, that [he] . . . was completely carried away and bought Woods "Il mio Traghetto", which was in my father's studio, on the spot, and still not content he must cross the road to No. 8 and buy Marcus Stone's two pictures.'[89] He also bought Leighton's *Sun-Gleams* (*The Arab Hall*).

The Fildes spent Christmas 1886 with the Airds at their country house, East Sutton Park near Staplehurst. When Fildes painted Aird's portrait in 1898, the engineer was engaged in his greatest work, building the Assuan and Assyût Dams across the Nile with Benjamin Baker. In 1904 the Fildes travelled up the Nile, 'their travels . . . smoothed by John Aird . . . by that time a baronet, whose word went a long way in Egypt'.[90] Kitty Fildes married Whitaker Ellis, Aird's grandson.

Fildes appears, among all the Holland Park artists, to have found it easy to develop social relations with his patrons, from members of the royal family (he painted state portraits of Edward VII, Queen Alexandra and George V) to those, like himself, who made their fortune through their own hard work. He exuded a manliness which

appealed to the industrialists and manufacturers who were unable to resist his paintings of Venetian girls. In 1895 the dealer David Croal Thomson wrote up a visit to Fildes' house for the *Art Annual*. He arrived immediately after a fire had broken out in the studio.

> I dwell in this detail on what turned out to be but a trifling material loss because it shows the character of Mr Fildes, the pertinacity and fearlessness of the man, who fought, single-handed and successfully, to extinguish the fire. His is no character to look on and let others work; when danger or difficulty approaches him he does not shrink from duty, but gamely goes for the enemy, and even when others deem the task too heavy, he manfully sticks to the post and comes out the victor – he is, in fact, a manly man, and, at the same time, a genial friend and a generous opponent.[91]

Croal Thomson was not only editor of the *Art Journal*, in charge of the Goupil Gallery in New Bond Street and from 1898 a director of Agnew's; he also advised the millionaire George McCulloch, who began to build up his collection of contemporary English and French art after retiring to England in 1893. McCulloch had made a fortune in Australia, where his uncle was premier of Victoria. McCulloch became manager of his Mount Gipps sheep station, near Broken Hill and when silver was discovered he formed the Broken Hill Property Company. On the walls of his home in Australia he had hung colour reproductions of well known modern masterpieces from the Christmas annuals; on his arrival in London he bought 184 Queen's Gate, Kensington and began to buy the originals.[92] He also commissioned stained-glass windows from Morris and Company, his own Hammersmith carpet, the 'McCulloch', and bought a partial set of Burne-Jones' 'Holy Grail' tapestries.[93] By the time of his death he had spent over a quarter of a million pounds and owned some 300 paintings. With Thomson's advice, he bought at auction, from dealers, at the Academy and occasionally from the artists themselves.

Fildes' *An Alfresco Toilet* (fig. 117) had been commissioned by Arthur Anderson of Wimpole Street in 1887. Fildes began the painting in Venice, using Woods' studio as the background, but progress was slow:

> contrary to his usual practice, he had painted the background first! When he came to putting in his figures he had not liked his background and had scraped it all out on his visit to Venice in 1888. The central figure, the young woman whose Titian hair is being dressed, was painted from my mother.[94]

McCulloch acquired the painting from Tooth's in 1894 for £1,365, then sought a meeting with the artist. Photographs in the Fildes family collection reveal the artist and his wife with the McCullochs at Queen's Gate, *An Alfresco Toilet* hanging on the wall behind them (fig. 124). McCulloch also bought paintings by Woods, *The Ca d'Oro, Venice* and *La Friulanella*; by Shannon, *Fairy Tales*, and *Magnolia*; by Marcus Stone, *A Gambler's Wife*; and by Solomon J. Solomon, *Judgment of Paris*.[95]

Henrietta Rae's dealings with McCulloch were somewhat different to Fildes'. She had begun her largest painting, *Psyche before the Throne of Venus*, in 1892, before leaving the Holland Park Road studio. Richmond lent her his studio for additional space, since the canvas measured 10 feet by 6 feet 4 inches. At Norwood she carried on painting in a special glass-house, transporting the completed work back to Holland Park Road for Show Sunday 1894. Leighton was critical: 'it had a tendency to prettiness of which he

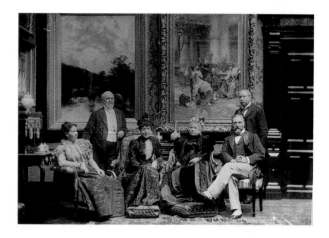

124. 184 Queen's Gate,
Kensington. Luke and Fanny
Fildes with Mr and Mrs George
McCulloch, c. 1897.

could not approve'. When McCulloch called with the intention of buying and asked what Leighton thought of the work, she blithely repeated his criticisms. Leighton, horrified, wrote to McCulloch:

> Let me seize this opportunity of saying how sincerely pleased I am to hear that you have bought Mrs Normand's charming picture. Mrs N. is full of talent, and a most enthusiastic artist – but she is given to self-depreciation (a very rare attribute) – and the purchase of so important an effort is a great and merited encouragement to her.[96]

Tooth's, recognising the significance afforded the work by McCulloch's decision to buy, produced a photogravure reproduction. Some of the critics, however, agreed with Leighton, finding little emotion in the prostrate figure of Psyche. Rae responded in 1895 by producing her unique interpretation of the 'Apollo and Daphne' myth which, unlike all the versions by her male colleagues, appears to signal a recognition of the violence of the scene, indicating the distress and defiance of Daphne.[97]

McCulloch also commissioned *The Loves of the Winds and the Seasons* from Albert Moore, an elaborate allegory which was to be his last picture.

> He shut himself up, refusing himself to friends and seeing hardly anyone save a former pupil, a kind and charming woman, who now came to him, ostensibly for some final lessons, but I think really that she might bring him some help and sympathy. And he worked ceaselessly at his picture. As it grew he faded. It was killing him, but as his life passed into the fair young limbs of the Winds and the Seasons he was happy . . . It was a beautiful and brave ending and well be-fitting this most perfect knight of the Lady Beauty, to whose service all his life had been dedicated and to whom in death he was still faithful.[98]

Moore died in 1893; McCulloch's painting was hung in the Academy the following year.

Leighton's *Daphnephoria*, commissioned by his friend Stewart Hodgson, was bought at the 1893 sale of Hodgson's collection by Tooth's, then sold on to McCulloch for almost £4,000. He also acquired one of Leighton's last great works, *The Garden of the Hesperides*, exhibited at the Academy in 1892. The contrast between these classical works and Edwin Abbey's representation of a scene from Shakespeare, *Richard Duke of Gloucester and the Lady Anne*, which McCulloch bought from the artist in 1896, could not be more extreme.

The Holland Park Circle

Fildes' greatest social and artistic triumph as far as his friend the dealer Lockett Agnew was concerned was to charm William Hesketh Lever, the soap millionaire from Port Sunlight. Fildes painted Mrs Lever first, writing to Woods on 30 June 1896, 'I am doing several things here – one of Mrs Lever of "Sunlight" fame which will be an awful job'.[99] The following year Agnew wrote to him:

> I have at last come to the conclusion that your charm of manner completely eclipses your artistic talent, and you know the high opinion we all have of the latter. It is a fatal charm and promises in the future to make your life unbearable in your studio. Only yesterday, for instance, a client of ours told Morey [Agnew] that he wanted his portrait painted, and you had been so consistently nice, so warmly appreciative of his wife's character, and so painstaking that really he must offer you the commission. Now when I tell you that the client whom you have charmed is one Lever of Soap fame you will clearly understand the rocks ahead.[100]

Lever began collecting paintings from 1887, attending the Academy in search of images for his soap advertisements.[101] He defended the transformation of original works into advertising reproductions by insisting he was performing a service to society:

> The view I take . . . is this, that works of art are in great demand for Cottage homes, and one sees some pictures being hawked about from door to door that are anything but works of art. I have a desire to reproduce none but the best works by the best men, and although they may be reproduced by the tens of thousands to be given in exchange for Soap Wrappers, I cannot help but think they must have a good effect in raising the artistic taste of the Cottager.[102]

His taste had been formed as a young man and had changed little by the 1890s; he preferred Leighton, Albert Moore, Burne-Jones, Waterhouse and Millais. He regularly attended the summer exhibitions at the Academy and each year entertained Academicians and Associates to dinner at his London home, first near Hyde Park, then, from 1904, at the Hill, Hampstead. However, he rarely commissioned work, instead buying at auction and through dealers. He acquired Leighton's *Psamanthe*, his first major purchase, for £315, in Liverpool in 1893. It had been exhibited at the Academy in 1880, then at the Liverpool Autumn Exhibition and bought by a Liverpool collector, Benson Rathbone. *Fatidica* was bought from Leighton by Agnew's in 1894, then sold to Lever for £1,050 the following year.

Fildes received £735 for his painting of Lever, who invited the whole Fildes family to watch the Diamond Jubilee Day celebrations from a balcony in Pall Mall. In 1902, Lever held an art exhibition at Port Sunlight to coincide with the Coronation and asked Fildes to persuade Poynter, President of the Academy to open the show. Poynter was unable to oblige, so Fildes stepped in, making a speech on 'The Mission of Art Collectors' in which he pleaded for the elevating role of public art galleries in an industrial community. Fildes' words as much as the exhibition itself may have influenced Lever to found the Lady Lever Gallery as a memorial to his wife, thereby extending the 'good effect' of the reproductions obtained from his company in exchange for soap wrappers. The family's links with Lever remained strong, Val Fildes becoming Secretary of Lever Brothers.

The concept of founding public galleries, or at least buying works with the explicit intention of donating them to public galleries, had emerged in the 1870s, following the creation of a number of galleries throughout Britain.[103]

Exeter was one of the first to open, in 1868. Birmingham's Public Picture Gallery was opened in 1871; the Brighton Museum and Art Gallery, in 1873. In 1876 Thomas Holloway founded the Royal Holloway College at Egham, Surrey for the higher education of women, then proceeded to build up a collection appropriate for the students by bidding at Christie's over a two-year period and acquiring seventy-seven paintings. He was criticised for paying record prices and thus falsely inflating the art market. Fildes' *Applicants for Admission to a Casual Ward*, for example, for which Thomas Taylor had paid the artist £1,250 in 1874, cost Holloway £2,100 in 1883.[104]

The Walker Art Gallery opened in Liverpool in 1877. It was named after Andrew Barclay Walker, brewer and mayor of the city, who gave £20,000 towards the building in 1873.[105] Andrew Kurtz commissioned Leighton to paint a subject of his own choice − *Elijah in the Wilderness* − for the gallery. During the 1880s galleries were founded in Derby (1883), in Sheffield, the Mappin Art Gallery (1887), in Leeds, the City Art Gallery (1888), and the Harris Museum and Art Gallery was opened in Preston in 1895. Manchester City Art Gallery commissioned *The Last Watch of Hero* from Leighton in 1887 and also paid him £6,000 for *Captive Andromache*, the highest price he received for a work. Manchester was forced to outbid the banker Alexander Henderson who had just acquired the collection of the disgraced MP, Eustace Smith.

While some artists in Holland Park benefited from the additional publicity as their works were shown to the public beyond London, Watts played an active part in the promotion of his own works by opening his gallery in 1881. Watts found the confidence to display his many unsold paintings after the success of an exhibition of his work at the Manchester Institution the previous year. The Manchester businessman Charles Rickards had acquired nearly sixty of his paintings since the late 1860s; Watts advised on their hanging, though he never travelled north to see the collection. The Manchester experiment led to an invitaton from Coutts Lindsay to hold a major retrospective of his work at the Grosvenor Gallery in 1881−2. Critics were mostly favourable; Watts was recognised as the 'grand old man' of Victorian art:

> We are standing here in the presence of a thinker saddened by the insoluble problems of this weary world, yet not cast down; of a poet whose imagination is equal to high flight; of an artist capable of giving form and colour to the creations of his thought and fancy; of a man possessing the large tolerance of culture: we are in the presence, too, of one full of high disinterested purpose and aspirations, and not easily satisfied.[106]

The Grosvenor Gallery exhibition lasted only two months, but thereafter the public were able to visit his private gallery. The sale of Rickards' collection in 1887 realised £16,000 at Christie's; Watts had become a 'sound investment'.

Watts was considering leaving a representative number of his works to the nation. In 1886 he wrote to his old friend Lord Elcho, since 1883 the tenth Earl of Wemyss,

> I want your advice & perhaps your aid in carrying out a project I have long had. [I want to give] my series of portraits & the most important of my *suggestive* efforts to the nation . . . I shall make this gift not so much considering the things of any real value as for the sake of precedent. The portraits having an historical interest irrespective of any artistic merit they may or may not possess will be so far worth the nation's acceptance.[107]

Both Watts and Leighton were actively involved in the founding of the South London Art Gallery and the Whitechapel Gallery (opened in 1901), lending works to elevate

the 'unsatisfactory moral tone' of 'largely criminal parishioners',[108] and welcoming the poor to their own studios. Leighton became President of the Council of the South London Art Gallery in 1887; as a trustee he donated forty-one works of art. Watts painted Canon Samuel Barnett, rector of St Jude's, Whitechapel; he and Leighton lent work in 1881 to an exhibition at St Jude's. Emilia Barrington's description of a visit to Watts' gallery by the 'deserving poor' may be 'over the top' but the idea that art made people better was still widely accepted:

> There, crowded together, were a number of poor people, living habitually with nothing but the most squalid ugliness in their surroundings, looking with eager eyes at the visions of his creation, and listening most earnestly to the explanation of the ideas and meanings in them. The art which to many among the richer classes was but a source of aesthetic culture, gave to these visitors an inlet to a world of visionary beauty and noble thought which they might all inhabit, however poor and miserable they might be. They were offered food for their spirits, which was above mere culture and education.[109]

Lever's views were exactly the same: 'Art and the beautiful raise up in mind and soul an association of ideas and experiences suggesting prophecies of the ideal and the beautiful in conduct or character. . . . Art and the beautiful civilize and elevate because they enlighten and ennoble.'[110]

In 1890 both Leighton and Fildes were approached by the Liverpool millionaire Henry Tate to paint works for the collection he intended to give to the nation. Tate had created his own picture gallery at Park Hill, Streatham with the fortune he made using the Langen cube process to produce neat white cubes of sugar. His refinery in London was at Silvertown in the East End. Tate's taste in art was dominated by the Royal Academy. He acquired a range of works, late Pre-Raphaelites, narrative, animal paintings, landscapes, 'decent, unaffecting, uncontentious pictures which also brought him an incidental pleasure – the friendship of artists'.[111] Every year before the Academy show he entertained artists at his house, providing strawberries from his own hothouse.

According to Millais, his plan to give his collection to the nation was talked through in Millais' house in Kensington: Leighton, President of the Academy, was present, also George Howard, by now Earl of Carlisle and a trustee of the National Gallery.[112] Tate first wrote to the National Gallery on 23 October 1889 offering over sixty pictures valued at £75,000 provided an appropriate space would be created for them to be hung together. Sir Frederic Burton, Director of the National Gallery, was forced to decline the offer because of lack of space. Tate renewed the offer, this time to the government, but in the press his motives and his taste were beginning to attract criticism, particularly his preference for sentimental paintings.

An article in the *Pall Mall Gazette* in 1890 suggested that Leighton's commission would considerably enhance the quality of Tate's collection. 'With a view to enlarging his collection and making it more worthy of acceptance by the nation, by reason of making it fully representative of English art at the latter end of the nineteenth century, Mr Tate has commissioned Sir Frederick [sic] Leighton to paint a picture that will be a typical example of his mature powers.'[113] Leighton took the commission seriously, writing to Tate on 27 February 1891:

> I am anxious to consult you on the subject of the commission you have given me to paint a picture to be presented to the nation. The matter has of course been much on my mind and

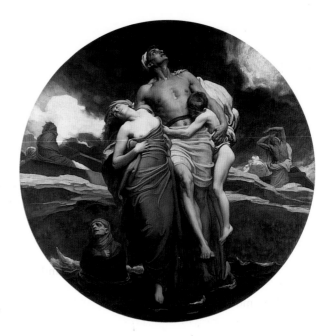

125. Frederic Leighton, *And the Sea Gave up the Dead Which Were in It*, 1891–2. Tate Gallery, London.

I should desire, in view of the destination of the work & of your munificent public spirit to make it the . . . most important painting I have produced.

Although he realised the public expected him to paint a female nude, he deliberately chose a very different subject, which he regarded as of greater significance (fig. 125); it was, after all, to be his choice for the nation.

I made a large circular design from Revelations of the Sea giving its dead at the last Judgement . . . this design being in the opinion of my Artist friends the best I have made, and dealing with matter of grand & elevated character not much treated in our school I am about to paint it as a picture. . . . *Now this is the work which I should wish to be remembered by in our Nat. Gallery* – but I do not know what your feeling would be.[114]

There is no record of Tate's 'feeling', though visitors to the collection when it opened on Millbank in 1897 pronounced Leighton's painting gloomy and morbid. The biblical subject had originally been intended for St Paul's; it exhibited bravura painting of the nude (male, female and child) but also Leighton's personal vision of the Day of Judgment, an appropriate topic for the end of the century.

Fildes' approach to the choice of subject was totally different, though he also dealt with death and rebirth. Responding to Tate's preference for sentiment, Fildes returned to the harrowing death of his first-born child Philip over ten years earlier, and painted *The Doctor*, to become one of the most enduring of Victorian popular images. After Tate agreed to pay a fee of £3,000, Fildes was concerned to obtain his approval for the initial idea and sketch. He wrote in June 1890:

It has just occurred to me that you did not say that Mrs Tate would accompany you to my studio tomorrow but I hope she will if agreeable to her. I should like it very much and I know you would. I need scarcely say, in coming to see the very slight sketch I will show you, you will not expect to find anything beyond what refers to the *idea* or *subject* of the picture. But, that will be definitely shown. You will see precisely what it is about, and the idea I wish to

The Holland Park Circle

carry out, just like as if I *wrote* it down – only more clearly and definitely.[115]

Like his earlier genre paintings *The Doctor* involved much research. Fildes wrote to Woods:

> Last night I saw Prinsep who gave me a most rapturous description of a delightful fishing village called Hope near Salcombe on the Devonshire Coast which from what he says of the interiors quite fulfils my expectations for my picture – He also knows we could stay in the place – if not, at Salcombe – Hook [James Clark Hook, formerly resident of Tor Villa, Campden Hill, and painter of coastal scenes] has painted & stayed there.
>
> There is also the advantage to me and no disadvantage to you that it is a new country.
>
> I have often wished to go to Devon but never had a definite reason for doing so – It is within a mile or two the same distance from London as Whitby – only perhaps rather more difficult to get at as I think some part of the journey, the latter from Kingsbridge Road Station to Salcombe is by coach. Prinsep says it is delightfully primitive & beautiful & strongly recommends it.[116]

After sketching cottages in Devon and in Scotland, Fildes constructed in his studio a life-size mock-up, a composite of several fishermen's cottages. Though several doctors offered to model for the central figure, Fildes himself acted the part, taking photographs of the position, so that it could be adopted by his professional model.

Woods arrived, as usual, from Venice the day before Show Sunday 1891 (fig. 126):

> I arrived at Melbury Road soon after six o'clock and in good time to see Luke's picture of *The Doctor* by day-light. I was greatly struck by the completeness of the picture in every way. The story is admirably told, I was prepared for this, but not for the consummate skill with which he has told it. I have never seen painting that pleased me better than the Doctor and the Child.[117]

The Doctor was a triumph at the Academy, so many people crowding round that Fanny was unable to get near. The photogravure published by Agnew's became the single most

126. Luke Fildes, *The Doctor*, 1891. Tate Gallery, London.

popular print ever issued by the firm.[118] The copyright was also pirated in America where the picture appeared on a postage stamp.

Whereas Leighton's commission was regarded as an opportunity for Tate to improve the quality of his collection, Fildes' commission was considered to have encouraged the artist to return to earlier, more significant subject matter: 'the painter might have gone on with his facile and fascinating Venetian subjects – they never failed to please the public whom a painter must respect, the public who buy. But Mr Tate's commission enabled the artist to do work more worthy of his old reputation.'[119]

The Doctor was even used by the medical profession as an inspiration to newly qualified doctors.

> A library of books written in your honour would not do what this picture has done and will do for the medical profession in making the hearts of our fellow men warm to us with confidence and affection. . . . Above everything, whatever may be the rank in your profession to which you may attain, remember always to hold before you the ideal figure of Luke Fildes' picture, and be at once gentle men and gentle doctors.[120]

Meanwhile Leighton and Howard continued to be involved in the negotiations with Tate over his offer to the nation. When it became clear the government would provide neither the space nor a building, Tate wrote to Howard on 21 November 1890:

> I should like to know whether, if you were assured that an anonymous gentleman, whose bona fides I would guarantee, is ready to build a new gallery provided the Government will give the land & maintain the Galleries, would you recommend the Government to accept the offer?

Tate was, of course, the 'anonymous gentleman'. But Howard was not persuaded, replying, 'I continue however to think that your friend would be doing far more to further the interest of a British Gallery by spending £100,000 on pictures instead of sinking them in bricks & mortar'.[121]

The 'anonymous' donor still made the offer – £80,000 – moving Leighton to point out, in his annual speech at the Royal Academy in 1891, the significance of this for British culture:

> I ventured last year, on a like occasion, to express an earnest hope that before long a great reproach might be removed from this country and that at last we might cease to stand alone among the great nations of the civilised world in having no special, central and worthy home for the permanent display of the works of contemporary native artists, the property of the people; no recognition, in fact, on the part of the State that contemporary art in its higher forms has a national significance at all.

But when the identity of the donor was revealed, there was adverse criticism in the press:

> Tate's sugar is getting a better advertisement now than ever any soap secured, and the proprietor must chuckle at the success of his boom. But the public should discriminate between sugar and art. Because a gentleman has purveyed 'crystal loaf' with success for many years it does not follow that he knows anything about pictures. Yet we are asked to accept some sixty canvases from Mr Tate, build for them a palatial gallery, and presumably reward the generous donor with a peerage. . . . And now the sixty pictures go begging, and can find no roof to hide their shame under. For which the art world offers many and fervent thanks, for indeed the pictures are sad examples of the worst style of the worst R.A.s.[122]

In March 1892 Tate withdrew his offer, though he continued to add to his collection, purchasing Millais' *Ophelia*.

In November, the Liberals came to power; the new Chancellor of the Exchequer was Sir William Harcourt, one-time resident of Campden Hill, an acquaintance of Watts and model for his vast mural of the lawgivers in Lincoln's Inn Hall, completed thirty-five years earlier. Tate was quickly mollified and a site for the new gallery was found, the old Millbank prison beside the Thames. The *Graphic* welcomed the arrangements, but also pointed to the gulf between the opinion of the public, the abuse of art critics and the antipathy of the government:

> It is given to few men to endow their country with an institution of national importance and of enormous value. But to fewer still is it the appointed lot to confer their benefits on a grateful public amid a noisy though insignificant chorus of a hand-ful of abusive writers, and in the face of the indifference of Ministers, whose half-contemptuous discourtesy is more cutting than the irresponsible insults and vulgar vilification of Gallicised critics.[123]

Watts was the third Holland Park artist to play a major part in the project. He first wrote to Tate on Christmas Day 1892 to enquire on behalf of a young friend whether there would be a porter's position vacant when the gallery opened. He followed this with a letter inviting Tate to visit his gallery in Melbury Road:

> I shall be most gratified by a visit to my studio & myself when we return to town some time in April, meantime if you do not know my Gallery at Little Holland House it might amuse you to spend an idle half hour (meantime) some day when you go to see Sir Frederic Leighton. You might be interested by some of the things I destine to become national property by Gift. These form almost all my life's work going on still.
>
> Though I am far from wealthy as may be seen from the number of unsold pictures in my gallery (I never had any thing I did not work for) & though it is useful to one to sell something occasionally, I do not now work for income.[124]

Watts could not help but present himself to the Liverpool millionaire businessman as an artist who painted for more than mere 'income' – though his lucrative portrait commissions had paid for houses on the Isle of Wight and in Melbury Road. But he was quick to recognise that Tate's gallery would provide him with the perfect home for a selection of his imaginative works.

In the privileged position of donor, Watts was unable to resist dictating the hanging of his own pictures.

> That my own contributions should be placed in your gallery I had never for a moment contemplated. I cannot tell you what satisfaction it gives me to think that the objects of my life's work should find a resting place together during my lifetime. Of course it is not for me to make conditions & I do not presume to do so, but I hope as they embody a single idea & have reference to one & the same object they will be placed together, I feel also it would be a fine thing to have one room made magnificent in itself by means of a splendid colour say the deepest & noblest red that can be got! . . . so that the general effect on entering the room would be that of a grand strain of music.

The 'noblest' red was, not surprisingly, already covering the walls of his gallery in Melbury Road, 'the most positive & violent vermillion that could be obtained'.[125]

Mammon (fig. 127), one of the eighteen pictures Watts presented to the new National Gallery of British Art in 1897 (he gave more between 1899 and 1902) was hung in

127. George Frederic Watts, oil sketch for *Mammon: Dedicated to his Worhipper*, c. 1884–5. Watts Gallery, Compton, Surrey.

the special Watts Room. It came with its own catalogue entry, written by the artist for his major retrospective at the New Gallery, held in 1896:

> The god, his face expressive of avarice, cruelty and insolence, and his head flanked with ass's ears, seated towards right, and decked in gorgeous but ill-fitting draperies; his right hand rests heavily on the head of a crouching woman, and his left foot is placed on the prostrate figure of a man; in his lap are money bags.[126]

It is tempting to see this as Watts' commenting on a decade which had brought the Holland Park artists unrivalled wealth and popular acclaim but also increasing criticism.

18

Death and Decline

The annual musical party which Leighton held in March 1895 was to be his last. Emilia Barrington recalled the occasion,

> when *Lachrymae* and *Flaming June* stood on the easels, and for the first time the silk room was open, hung with the work of Leighton's friends; how, through all the beautiful strains from Joachim and the rest, a tragic note rang out to tell, as it seemed, of the waning life at the centre of it all . . . A voice sang with emotion Charles Kingsley's soul-stirring verse – 'when all the world is old, lad, and all the trees are brown'.[1]

On 1 January 1896, Leighton was raised to the peerage, the first and only artist to be thus honoured.[2] He chose as his title Lord Leighton, Baron of Stretton in Shropshire; the village was on the estate of Sir Baldwyn Leighton, a distant relation.

He died on 25 January. He had suffered for years from angina pectoris (the same disease killed Burne-Jones), and his final hours were racked with terrible pain. His sisters were with him at his death, also his close friends and executors Val Prinsep and Samuel Pepys Cockerell. His last reported words were 'Give my love to all at the Academy'. He died owing the Home Office £360 17s. for the letters patent creating him a baron; for his parliamentary robe, he owed Messrs Wilkinson and Son, Robe Makers, £39 18s.

Leighton lay in state first in his studio, surrounded by his latest pictures decorated with flowers, then at the Royal Academy. The funeral took place on 3 February at St Paul's Cathedral (fig. 128), the arrangements made by Prinsep, Fildes, Henry T. Wells and Richard Norman Shaw.[3] A detachment of the Artists' Rifles led the funeral cortège; his palette, brushes and malstick were placed on the coffin. A reporter for the *Scarborough Evening News* (Leighton's home town) was among the crowds. He noted people lined the whole length of the route from Piccadilly to St Paul's: 'flags were at half-mast on many public buildings, and as the solemn procession passed slowly along, the remains were reverently saluted by the crowd'.[4] Julia Cartwright received her invitation to the funeral from the Council of the Royal Academy:

> I got a good place among the authors, close to the Artists Corps who lined the nave. . . . It was all strangely moving and an impressive sight, the great door opening and letting in a blaze of sunshine and one ambassador or deputation after another arriving in uniform with splendid wreaths, and over all that the great organ music rolling out Chopin's Funeral March . . . I heard two artists saying how beautiful it all was and how he would have loved it.[5]

Walter Crane wrote a sonnet which began:

128. Frederic Leighton's funeral, 1896. His coffin is carried into St Paul's Cathedral, past a guard of honour formed by the Artists' Rifles.

Beneath Great London's dome to his last rest,
The princely painter have ye borne away.[6]

Hamo Thornycroft wrote to his wife Agatha the impact on the artists of Holland Park:

The only thing about this artistic neigbourhood in which I see advance is in the beauty and growth of the plane trees in this Melbury Road! Steadily they progress and are vigorous adolescents; but the work of the artists who have made the road famous is in, well, a less progressive period. Happily we all think our best work is still perhaps in front: *somehow* we shall achieve it.[7]

Members of the public visited Leighton's memorial exhibition at the Academy in 1897.[8] Prinsep and Marcus Stone organised the hanging, with the assistance, for the first time at the Academy, of electric light.[9] A committee was formed to preserve his house and its contents as 'a centre for Art in the Parish of Kensington'; Emilia Barrington, his neighbour and biographer, worked tirelessly as secretary.[10] But Burne-Jones was unimpressed with the concept, writing to Thomas Rooke on 9 May 1896,

What possible enthusiasm or interest could one get up about a house by Aitchison. . . . There couldn't be any gain in making public property of it and to have all those splendid things from the East built up in such a silly way couldn't please me, could it? And they could not be moved without endangering them. It's a great shame.[11]

Henry James observed the reluctance of the nation to honour Leighton now he was dead, by subscribing to such a venture:

Lord Leighton's beautiful house, almost immediately after his funeral, was offered as a memorial to the nation if the nation would subscribe to buy it. The nation, scarce up from its genuflections at St. Paul's, buttoned its pocket without so much as scratching its head. Since then his two sisters . . . have generously made known that they will present the house as a museum for relics of their brother if the public, in its commemorative enthusiasm, will

The Holland Park Circle

collect the relics and keep up the establishment. Nothing is more presumable than that the public will do nothing of the sort.[12]

Negotiations dragged on for several years. Anne Thackeray Ritchie called in about 1904, to be greeted by Emilia Barrington 'in a hat and feathers . . . at the top of the stairs'. The elderly novelist, a guest of Leighton's for almost half a century, was struck by his drawing of Adelaide Sartoris.

> I remember her coming into a room once, when I was a girl, looking like this very picture. She had 'great blobs' as ornaments (so my father called them); she looked very noble and stately and alarming. Leighton laughed and beamed in admiration. 'How beautiful', he said, and hurried to meet her.
>
> It is horrid, being old and remembering all these vanished visions . . . I am glad he [Leighton] never failed, glad his charming looks never left us.[13]

The house was finally purchased by the Royal Borough of Kensington in 1926, freehold, for £2,750, a fraction of what it cost Leighton to build.

William Holman Hunt had moved back to Kensington in 1902 after his house in Fulham, Draycott Lodge, was compulsory-purchased. He took 18 Melbury Road (fig. 129), which had a studio in the garden erected by a previous resident. He was going blind, so recruited Edward Hughes to work with him on an enlarged version of The Light of the World which he intended for Tate's Gallery.[14] Charles Booth bought the painting, agreeing to exhibit it in South Africa, 'to preach its message to the Boers' and in Australia and New Zealand, before leaving it to the gallery.

A contemporary of Hunt, D.J. Furnivall, eulogised the work: 'I claim that this new Light of the World is the culmination and crown of Victorian English Art – nay, the greatest that our country has ever produced, and fit to range with the most glorious creations that the world has ever seen.'[15] The Tate Gallery disagreed (their benefactor Henry Tate was dead); the painting was 'wilfully and outrageously anachronistic'.[16] A more appropriate place was found in St Paul's Cathedral, where Hunt's ashes would be buried in 1910.

The young Virginia Woolf, great-niece of Thoby and Sara Prinsep, visited Hunt in Melbury Road before the painting went off on tour. Mrs Hunt

> was giving a large evening party. Melbury Road was lined with hansoms, four-wheelers, hired flies, and an occasional carriage drawn by a couple of respectable family horses . . . all our old family friends were gathered together in the Moorish Hall. . . . The effect of the Moorish Hall . . . was garish, a little eccentric, and certainly very dowdy. The ladies were intense and untidy; the gentlemen had fine foreheads and short evening trousers, in some cases revealing a pair of bright red Pre-Raphaelite socks . . . [in the studio] we found old Holman Hunt himself dressed in a long Jaeger dressing gown, holding forth to a large gathering about the ideas which inspired him in painting The Light of the World, a copy of which stood on the easel. He sipped cocoa and studied his flowing beard as he talked, and we sipped cocoa and shifted our shawls – the room was chilly – and we listened.[17]

With the advent of a new century, Hunt, born in 1827, seemed very old indeed, his works, ideals and personality all anachronisms, out of place and somehow dowdy to the up-and-coming Bloomsburyite.

129. 16 and 18 Melbury Road.
The empty plot to the right of
no. 16 was occupied by Colin
Hunter's house, destroyed in the
Second World War.

Watts spent an increasing amount of time at Limnerslease, his country home in Surrey, with his wife Mary and their adopted daughter Lily. Only admirers ventured into the countryside to visit the 'grand old man' of Victorian art. He had refused the offer of a baronetcy, apparently fearing that Ellen Terry's son by Edward Godwin might have a right to the title after his death; instead, in 1902, he joined the first group of twelve civilians to receive the Order of Merit. After his death Hunt took his place in the distinguished club.

A few weeks before he died in 1904, Watts spent several hours talking about contemporary art to Charles Hallé, founder with Joseph Comyns Carr of the New Gallery. Watts had been to see the exhibition at the New Gallery of the International Society of Painters, Sculptors and Gravers, including work by Whistler, Pissarro, Monet, Renoir, Rodin, William Nicholson and Charles Ricketts; 'nothing even mildly provocative', as Wilfrid Blunt remarks.

> He begged me [recalled Hallé] to close, sell, or burn down the New Gallery sooner than allow it to become a centre for everything he held to be most degrading in art . . . his grief and rage that such things could not only be tolerated, but senselessly applauded, in a country where he, Burne-Jones, Leighton, Millais, and others had worked so hard to revive the sense of what was noble and beautiful, was a sad experience.[18]

Hallé had a similar conversation with Burne-Jones in 1898, only days before the painter's death: 'It was like a summing up of his whole life and as we sat in the dusk, his white face and the solemnity of his voice gave me a feeling of awe.'[19] As Hallé commented, when writing up the conversation in his *Notes from a Painter's Life*, Watts and Burne-Jones 'died with despair in their hearts about the art they loved so much, and the headlong pace at which it was hastening to become a corrupting influence in the world, instead of what men had always hitherto striven to make it, an influence for good'.[20]

Prinsep died suddenly on 11 November 1904, the same year as his sometime teacher, after a prostate operation, and was buried in Brompton Cemetery in the vault designed by Burne-Jones for his father-in-law Frederick Leyland, 'not so much a great artist as a popular one; not so much a great painter as a good all-round man'.[21] Colin Hunter also died in 1904.

The Holland Park Circle

Their contemporaries in Holland Park, Fildes, Stone, Woods, Thornycroft, Shannon, Schmalz, Normand and Rae all survived the First World War. Fildes was knighted in 1906 and received the KCVO in 1918; Thornycroft was knighted in 1917, Shannon in 1922.

According to his son and biographer, Fildes was less affected by changing taste than some of his younger contemporaries whose reputations and incomes suffered under the attack of critics such as Roger Fry, who had replaced Leighton's friend F.G. Stephens on the *Athenaeum* in 1901, and D.S. McColl. Fry regularly denounced their contribution to the nineteenth century's 'veritable debauch of trivial anecdotic picture-making such as the world has never seen before'.[22]

Fildes did not escape criticism. While *The Doctor*, popular with visitors to Tate's gallery, was acknowledged to be a fine work, a critic in the *Westminster Gazette* compared it to the portraits Fildes sent to the Academy: 'one wonders what can have happened to the painter that he should now be showing the kind of rubbish that hangs in his name in Burlington House'.[23] Fildes' Venetian paintings were included in the attacks launched at the collection of the millionaire George McCulloch, shown at the Academy following his death in 1909:

> What attitude of mind has inspired the great majority of works in the McCulloch collection, put forward by the Academy as a representative collection of modern English art? Again and again it is triviality, commonness, a false anxiety to please a large public.[24]

The *Burlington Magazine* compared the Academy which, under Poynter's presidency, had agreed to put on the exhibition, to 'a well managed and successful sixpenny magazine'.[25] At the sale of the collection, in 1913, McCulloch's widow received only slightly more than half the original investment.

However, conservative collectors such as Lever snapped up paintings they had always coveted. He spent £17,000, acquiring amongst other works Leighton's *Daphnephoria*[26] for £2,850 (McCulloch had given £3,937 10s.; Stewart Hodgson £1,500) and *The Garden of the Hesperides* for £2,690; also Fildes' *An Alfresco Toilet* for £1,614.

Royal patronage ensured that Fildes' income and reputation, at least with the general public, remained considerable up until his death. His problems as a painter remained unchanged. In 1912, when asked by the Lord Chamberlain how his portrait of the King was proceeding, he replied:

> I am sorry I have not got on at all with the King's picture – The winter darkness has been too much for me – I had little expectation in Novr, when I had the first opportunity of beginning it, of completing it in time for the coming R.A. but the exceptional gloom & darkness in London ever since entirely took away any chance I had.[27]

He may have agreed with Walford Graham Robertson commenting on the 'new age' post-1914, 'to which I do not belong and do not understand. I and a few of my friends have accidentally slopped over into it (the verb is inelegant but expressive) and perhaps the best thing we can do is to hold our tongues and efface ourselves.'[28]

By the time Shannon was elected, in 1909, to full membership of the Royal Academy, the relevance of such status was increasingly marginal; sadly his elevation marked the beginning of his own physical decline. A riding accident appears to have caused painful and progressive paralysis of his legs; by 1918 he was confined to a wheelchair and in

the care of a nurse-companion. He died in a Kensington nursing home little over a year after receiving his knighthood.[29]

Commissions continued to pour in to Thornycroft up until his death in 1925, many commemorating the reign of Victoria and the achievements of the British Empire. When he made a speech in February 1925 at the twenty-first birthday of the Royal Society of British Sculptors he expressed, in public, his disgust at 'modern' sculpture (he was thinking, in particular, of Jacob Epstein's *Rima* which was placed in Kensington Gardens):

> There are no doubt some works now produced which, though modern in execution are almost prehistoric in style, and leave too much to the imagination, I venture to think. I will back the treatment of nature employed by the Greek Sculptors and by men of the Italian Renaissance to survive this pseudo-barbaric phase.[30]

He had approved of Sir Frank Dicksee, aged seventy-two, being made President of the Royal Academy the previous year, since 'there is no-one of the Leighton or Millais calibre among us now'.[31] As an old Artists' rifleman, he would also, no doubt, have enjoyed Dicksee's rallying speeches, replete with Arthurian imagery, made to students at the Academy Schools:

> It is for you to equip yourselves that when the history of your times is written it may be seen that your heritage has not been wasted, and that your labour has been faithful and sincere. . . . Old traditions and former standards are ignored and have again to go through the ordeal by battle. . . . Your equipment must be as that of the Happy Warrior who seeks the Holy Grail whose armour is so well worn that it troubles him not at all, who is so complete a horseman that his horse is at one with himself, and in this wise with weapons that will not fail him, he can concentrate all his efforts on the quest that it is his ardent hope to attain.[32]

Lord Ilchester completed his chronicles of Holland House in March 1937. 'Whatever fate be in store for the old mansion – and what certainty, we repeat, can there be in the future, at least some humble record will remain of its existence, and of some few of the scenes which have been enacted close at hand or within its 'dear old russet brick walls'.'[33] During the Second World War German bombers set Holland House alight. This time there were no artists to rush across the park to assist the fire-fighters and the house was badly damaged (fig. 130).

Much of the contents had been removed to safety at the beginning of the war (though not Watts' wall-decorations), but the decision was taken by the Ilchester estate not to rebuild. In 1951, the remains of the house and 52 acres of parkland were sold to the council for £250,000, the grounds to be opened to the public. Most of the damaged part of the house was demolished, apart from the east wing which was opened as a youth hostel in 1959. A proposal in 1989 to rebuild Holland House emphasised the effect demolition had had not just on the layout of the gardens and park but on the whole area:

> At present the visitor following the paths and axis comes upon the fragmented parts of Holland House and its landscape features, without being enabled to understand their connections, sense and purposes.
>
> The house, which is the centrepiece and the *raison d'être* for the gardens, outbuildings, park and township, stands broken as an unhappy, artificially demolished ruin, made sadder and

130. The library of Holland House after German bombers set the house alight.

more perplexing by temporary fencing and well meaning attempts to tidy the remains, and rebuild one side of its lower storey.

Without the house, the converging paths and vistas have lost their point and meaning. Without the house, the place will always have a disappointment at its centre.[34]

Other houses were badly damaged during the war. Colin Hunter's in Melbury Road was destroyed; also 1 Holland Park (the Ionides') and Christopher Dresser's home, Tower Cressy. The larger houses on Campden Hill requisitioned by the army all suffered internal damage caused by their tenants rather than the enemy.

During the post-war period, houses all over London were demolished for commercial reasons, their sites more valuable for blocks of flats (more residents per square foot) and offices. On Campden Hill Moray Lodge and Argyll Lodge were swallowed up by Holland Park School; Thorpe Lodge became the school library. Thornwood Lodge and Holly Lodge were demolished to make way for Queen Elizabeth College. Only Aubrey House remained, the home of the Alexander family and their descendants.

The Howards' house, 1 Palace Green, was converted into flats by the Crown Commissioners, after all the fittings had been removed and the original decorations painted over. Prinsep's house was also divided into flats. During the war, his treasures had been removed by his youngest son to a warehouse for safe keeping, only to be destroyed when a bomb hit the depository.

Protected by its status as a museum, Leighton's house remained untouched (apart from minor bomb damage), unaffected even by the plummeting value of Victorian art. In 1962 *Flaming June* was for sale, with frame, in a Battersea junk shop, for £60.[35] Watts' house, number 6 Melbury Road, was not so fortunate. In 1961 the London County Council (LCC) proposed to place building preservation orders on Leighton's house and on numbers 6, 8, 9, 11, 15 and 17 Melbury Road (the houses of Watts, Stone, Burges,

Fildes, Rendel and Debenham). The LCC claimed the houses were 'the nucleus of an area which was the home of many of the most celebrated artists of that time'. Parway Estates had applied to build houses and a block of thirty flats on the site of number 6 (the lease expired in 1963). Their architect Austin Blomfield attacked the LCC's claim:

> I don't believe that G.F. Watts and his community are of sufficient importance to justify the houses being preserved. . . . The modern artist would have called Watts an 'old square'. He was involved entirely with the photographic appearance of his subject but his contemporaries might have hailed him as a genius because of the exactness of his paintings. In my view Watts was not a man of such stature as to justify the retention of No. 6 as a memorial to him.[36]

Blomfield was repeating views expressed by respected art historians. Reginald Turnor, in his 1950 study of nineteenth-century architecture in Britain, had dismissed all the artists' houses apart from Shaw's:

> There is Burges' own Kensington house, gabled and turreted and Gothicised; Stevenson's unpleasant Lugar Lodge for Colin Hunter . . . George Aitchison's horrible solution of the house-cum-studio problem for Sir Frederick Leighton, with its fantastic Arab Hall; a surprisingly dismal design by Philip Webb for Val Prinsep . . . G.F. Watts' house and studio by Aitchison and Frederick Pepys Cockerell (the latter here quite unworthy of his father).[37]

Watts' house was finally demolished in 1964. In its place is a block of flats called Kingfisher House. Watts had joined several campaigns, one against the wanton destruction of birds for their plumage. In 1899 he had painted *A Dedication* in which an angel weeps over a handful of plucked kingfishers laid on an altar, inscribed 'to all who love the beautiful and mourn over the senseless and cruel destruction of bird life and beauty'.[38]

The houses of Fildes and Stone were more fortunate. Though both were subdivided after the war, and consequently considerably altered inside, their external appearance remained little changed. Stone's studio was occupied by a portrait painter, the film director Michael Powell occupied the ground floor in the 1950s, shooting parts of *Peeping Tom* in the garden; Fildes' house was restored by the film-director Michael Winner. Burges' Tower House was vandalised in the early 1960s but was bought in 1968 by the film star Richard Harris. Campbell Smith & Company Ltd, the London firm responsible for the original decorations, carried out extensive restoration work on the interior. The house was later sold to a member of the rock band Led Zeppelin (fig. 131).

The restoration and re-evaluation continues, though many art historians still debunk the period. *Flaming June*, the 'Mona Lisa of the Western Hemisphere', is one of the most popular exhibits in the Museo de Arte de Ponce in Puerto Rico and is currently valued at several million pounds. At the Tate Gallery, with sponsorship from British Petroleum, more Victorian paintings in the collection are being exposed to public gaze, examples of all the styles and subject matter which appealed to collectors like Lever and Tate: animal portraits, sentimental genre scenes, historical scenes, landscapes. The Victorian room is a favourite destination for visitors; postcard sales are highest for the images which have remained in the popular consciousness even though the names of the artists may have been forgotten.

The resurgence of interest is reflected elsewhere in popular culture: Victorian novels continue to be serialised on television (Wilkie Collins as well as Dickens); Hollywood

131. Michael Winner and Jimmy Page standing in front of their houses in Melbury Road, 1981.

has discovered Henry James and Edith Wharton. Victorian architecture is appreciated: George Gilbert Scott's hotel fronting St Pancras station is no longer threatened with demolition; the Albert Memorial has been restored at a cost of £10 million. Leighton House has featured in advertisements and fashion shoots; Linley Sambourne's house, also a museum, is a favourite 'authentic' location for films set in the Victorian and Edwardian periods. At the end of the twentieth century the studio-houses which come up for sale in Holland Park command high prices; once more they are desirable residences, and many have been acquired by artists working not with paint and marble but with sound and light.

Notes

Introduction

1 Wilkie Collins, *A Rogue's Life* (London, 1879), pp.46–7.
2 See Jeremy Maas, *Victorian Painters* (London, 1969).
3 George Dunlop Leslie, *The Inner Life of the Royal Academy* (London, 1914), p.273.
4 Personal communication from John Christian.
5 *Building News*, 14 November 1862.
6 See Giles Walkley, *Artists' Houses in London 1764–1914* (Aldershot, 1994), in particular the maps locating RAs in London in 1819 (p.27) and in 1869 (p.57).
7 See John Physick, *The Victoria and Albert Museum* (London, 1982).
8 Roy Porter, *London: A Social History* (Harmondsworth, 1996), pp.188, 205.
9 *Building News*, 29 September 1876.
10 Halsey Ricardo designed a pair of semi-detached houses in Melbury Road, though not for artists. If Edward Godwin, the architect of Whistler's White House, had been able to realise the designs he drew up for houses in Holland Park Road, this small area would have boasted work by every radical architect of the day. Godwin's studio for Princess Louise was completed, nearby, in Kensington Palace.
11 See 'New Houses in Holland Park Kensington', *Building News*, 29 September 1876.
12 Mrs Russell Barrington, *The Life, Letters and Work of Frederic Leighton* (London, 1906), volume 1, p.6.
13 Harry How, 'Mr Hamo Thornycroft, R.A.', *Strand Magazine*, 6, 1893.
14 William Holman Hunt, *Pre-Raphaelitism and the Pre-Raphaelite Brotherhood* (London, 1905), volume 1, pp.140–1.
15 See Paula Gillett, *The Victorian Painter's World* (Gloucester, 1990), Introduction and Chapter 1 for discussion of the status of the artist in the nineteenth century.
16 Henry James, 'The Picture Season in London 1877', reprinted in John L. Sweeney (ed.), *The Painter's Eye* (Wisconsin, 1989).
17 But see Paul Saville, 'Valentine Cameron Prinsep in relation to the practice and theory of academic painting in late 19th century England', B.Litt. thesis, University of Oxford, 1970; Joseph Frank Lamb, 'Lions in their dens. Lord Leighton and late Victorian studio life', Ph.D, University of California, 1987; Jenny Pury, *Solomon J. Solomon R.A.* (London, 1990), catalogue for exhibition held at Ben Uri Art Gallery; Malcolm Warner, *The Victorians. British Painting 1837–1901* (Connecticut, 1997), p.12.
18 In particular three curated by Mary Bennett, 'Ford Madox Brown' and 'Holman Hunt' at the Walker Art Gallery in 1964 and 1969 and 'Millais' at the Royal Academy in 1967; 'Dante Gabriel Rossetti' at the Royal Academy in 1967; 'Burne-Jones' curated by John Christian at the Hayward in 1975; 'Victorian High Renaissance', curated by Allen Staley et al. at Manchester City Art Gallery, Minneapolis and Brooklyn in 1978.
19 See Tim Barringer and Elisabeth Prettejohn (eds), *Frederic Leighton Antiquity, Renaissance, Modernity* (New Haven and London, 1999).
20 [Frederick Leyland] Osborn and Mercer, 'Sale particulars of 49 Prince's Gate', 17 June 1892.

1 Watts and his Early Patrons: the 1840s

1 Dannreuther Papers, Hastings Museum. Mary Watts writes that a Mr E. Riley brought Ionides to Watts' studio, M.S. Watts, *George Frederic Watts: The Annals of an Artist's Life* (London, 1912), volume 1, p.32.
2 Ibid., p.25.
3 See Giles Walkley, *Artists' Houses in London 1764–1914* (Aldershot, 1994).
4 Watts Papers, Tate Gallery Archive, G.F. Watts to C.A. Ionides, 20 October 1893.
5 L.M. Lamont (ed.), *Thomas Armstrong, C.B. – A Memoir 1852–1911* (London, 1912), p.195.
6 M.S. Watts, *G.F. Watts*, volume 1, p.32. This contradicts Alexander C. Ionides, *Ion: A Grandfather's Tale* (Dublin, 1927), p.6. Ionides claims the copy was intended for the University of Athens.
7 M.H. Spielmann, 'The Works of Mr G.F. Watts, RA', *Pall Mall Gazette*, 22, 1886.
8 Wilfrid Blunt, *England's Michelangelo: A Biography of G.F. Watts, OM, RA* (London, 1989), p.12.
9 A.C. Ionides, *Ion*.
10 David Kynaston, *The City of London Volume 1: A World of its Own 1815–1890* (London, 1994), pp.169–70.
11 Emma Niendorf, *Aus London* (Berlin, 1855), quoted in Timotheos Catsiyannis, *Constantine Ionidis-Ipliktzis 1775–1852 and the Ionidi Family* (London, 1988), p.45.
12 One of the Greek costumes is in the Victoria and Albert Museum, London.
13 Luke Ionides, *Memories* (Ludlow, 1996), p.42. First published in 1925.
14 *Punch* ridiculed the competition: 'the Poor ask for Bread, and the Philanthropy of the State awards – an Exhibition': see M.H. Spielmann, *The History of 'Punch'* (London, 1895), p.187.
15 See Allen Staley, *Victorian High Renaissance* (Minneapolis, 1978), p.58.
16 L. Ionides, *Memories*, pp.56–7.
17 The Earl of Ilchester, *Chronicles of Holland House 1820–1900* (London, 1937), p.320.
18 Blunt, *England's Michelangelo*, p.29.
19 M.S. Watts, *G.F. Watts*, volume 1, p.48.
20 Blunt, *England's Michelangelo*, p.32.
21 Ronald Chapman, *The Laurel and the Thorn* (London, 1945), p.24.
22 See Ilchester, *Chronicles*, p.325. Watts' subjects included General Sir Frederick Adam who had served in the Peninsular War and

at Waterloo; Constantine Phipps, Marquess of Normanby, British Minister before Lord Holland; Mrs Fitzpatrick (later Lady Castletown); Jerome Bonaparte and his daughter Princess Mathilde de Demidoff; Richard Cottrell, chamberlain to the Duke of Lucca, who carefully preserved fragments of Watts' frescos; Don Neri Corsini, daughter of Guiseppe Binda, American Consul in Livorno; George Petre, secretary to Lord Holland; the lawyer George Bowyer; George Hamilton Seymour, Minister in Florence 1831–6; John Stuart-Wortley, the Earl of Wharncliffe; and the three daughters of General Ellice who had been responsible in the first place for Watts' comfortable residency.

23 Ilchester, Chronicles, p.325.
24 Holland Papers, British Library, BM Add. MS 51775. Lord Holland to his mother, 5 April 1841, refers to 'the awful one [plan] you have so often spoken of respecting the frontage to the Hammersmith Road'.
25 Blunt, England's Michelangelo, p.30.
26 At least this is the impression given in Lord Ilchester's family history, which provides only edited snippets from his ancestors' letters.
27 Blunt, England's Michelangelo, pp.30–1. Also see Katerine Gaja, G.F. Watts in Italy (Florence, 1995), p.30: 'the very absence of a robust or fixed "identity" might make it easier for an artist to give his patrons the slip and quietly go on doing what he wants to do . . . Watts faded chameleon-like into the background, becoming almost part of the furniture. Nothingness could also be convenient.'
28 Ilchester, Chronicles, p.325.
29 Ibid., p.324.
30 Ibid., pp.335–6.
31 Ibid., p.338.
32 Gaja, G.F. Watts, p.32.
33 Ilchester, Chronicles, p.336.
34 Gaja, G.F. Watts, p.20.
35 Watts Papers, Watts to Alexander Ionides, 15 June 1846.
36 Ilchester, Chronicles, p.336.
37 M.S. Watts, G.F. Watts, volume 1, p. 56.
38 Holland Papers, BM Add. MS 52034, 8 July 1845.
39 Watts Papers, Watts to Alexander Ionides, 15 June 1846.
40 Ibid.
41 Ibid.
42 M.S. Watts, G.F. Watts, volume 1, p.76.
43 Blunt, England's Michelangelo, p.42.
44 Chapman, The Laurel and the Thorn, p.31: 'They were very much together. Watching him as he argued, being close to him as he bent over her drawing board, she gave way as much as she dared to the exciting feelings the young painter aroused in her.' Gaja, G.F. Watts, pp.90–1 also suggests a serious relationship.
45 Watts Papers, Watts to Alexander Ionides, 7 September 1846.
46 Ibid.
47 Ibid.
48 Blunt, England's Michelangelo, p.43.
49 Chapman, The Laurel and the Thorn, pp.32–3.
50 Watts Papers, Watts to Alexander Ionides, 2 January 1847.
51 Gaja, G.F. Watts, p.96.

2 Watts at Little Holland House; the Genesis of the Holland Park Circle: the 1850s

1 Watts had introduced Holford to Lord Ossulton, whose Giorgiones the collector coveted, M.S. Watts, George Frederic Watts: The Annals of an Artist's Life (London, 1912), volume 1, p.86. Holford married Coutts Lindsay's sister May.
2 The Earl of Ilchester, Chronicles of Holland House 1820–1900 (London, 1937), p.365.
3 M.S. Watts, G.F. Watts, volume 1, p.100.
4 Ilchester, Chronicles, p.375.
5 Watts Papers, Tate Gallery Archive, Eastlake to Watts, 12 July 1847.
6 W.M. Thackeray, 'Our Street' , The Christmas Books of Mr M.A. Titmarsh (London, 1857), volume 1, p.61.
7 Wilfrid Blunt, England's Michelangelo: A Biography of G.F. Watts, OM, RA (London, 1989), p.53.
8 Ibid., p.54.
9 M.S. Watts, G.F. Watts volume 1, p.106.
10 Luke Ionides, Memories (Ludlow, 1996), p.57.
11 William Holman Hunt, Pre-Raphaelitism and the Pre-Raphaelite Brotherhood (London, 1905), volume 1, p.345.
12 Blunt, England's Michelangelo, p.63 quotes from The Stones of Venice: 'We have as far as I know at present among us, only one painter G.F. Watts who is capable of design in colour on a large scale. He stands alone among our artists of the old school in his perception of the value of breadth in distant masses and in the vigour of invention by which such breadth must be sustained; and his power of expression and depth of thought are not less remarkable than his bold conception of colour effect.'
13 Anthony Trollope, Phineas Redux (Oxford, 1974), p.308. First published in 2 volumes in 1873.
14 Sir Algernon West, Recollections 1832–86 (London, 1910), p.297.
15 A.M.W. Stirling, The Letter-bag of Lady Elizabeth Spencer-Stanhope (London, 1913), volume 2, p.258, 8 July 1850.
16 Ibid., p.259.
17 Blunt, England's Michelangelo, p.72.
18 M.S. Watts, G.F. Watts, volume 1, p.125.
19 Paul Saville, 'Valentine Cameron Prinsep in Relation to the Practice and Theory of Academic Painting in Late 19th Century England', unpublished B. Litt. thesis, University of Oxford, 1970, p.16.
20 For accounts of the Prinsep and Pattle families, see manuscript material in possession of Sir Hew Hamilton-Dalrymple including Sir Hugh Orange, 'The Chevalier de L'Etang' (1937) and Elizabeth Boyd, 'The Pattle Sisters' (1976). Also see Colin Ford (ed.), The Cameron Collection (Rugby, 1975); Nagham Jarrah, 'Valentine Cameron Prinsep', MA thesis, Courtauld Institute, London, 1983.
21 Brian Hill, Julia Margaret Cameron (London, 1973), p.86.
22 M.S. Watts, G.F. Watts, volume 1, p.124.
23 Virginia Woolf and Roger Fry (eds), Victorian Photographs of Famous Men and Fair Women (New York, 1926), p.1.
24 The grandmother died in 1866 at the age of ninety-eight. Watts met her when she visited the Prinseps in Chesterfield Street, 'upwards of eighty, down on her knees in a passage . . . keenly interested in playing a game of chuck-halfpenny with her great-grandsons': M.S. Watts, G.F. Watts, volume 1, p.129.
25 Gordon N. Ray (ed.), The Letters and Private Papers of William Makepeace Thackeray (London, 1945), volume 1, p.267.
26 Ibid., p.391.
27 Elizabeth Boyd, 'The Pattle Sisters', p.3.
28 Ibid.
29 Osbert Wyndham Hewett (ed.), A Selection from the Diaries from 1851–1862 of Chichester Fortescue, Lord Carlingford, KP (London, 1958), quoted by Blunt in England's Michelangelo, p.74.
30 See Thackeray, 'On a Good-Looking Young Lady', published in Punch, 8 June 1850: 'when she comes into the room, it is like a beautiful air of Mozart breaking upon you; when she passes through a ball-room, everybody turns and asks who is that Princess, that fairy lady'.
31 Virginia Surtees, Coutts Lindsay 1824–1913 (Norwich, 1993), pp.62–3.
32 Ibid., p.60.

33 Kathleen Fitzpatrick, *Lady Henry Somerset* (London, 1923), p.18.

34 Ray, *Thackeray*, volume 2, p.704.

35 Ilchester, *Chronicles*, pp.396–7.

36 M.S. Watts, *G.F. Watts*, volume 1, pp.128–9.

37 Anon. [member of Pattle-Prinsep family], extract from article in possession of Watts Gallery, Compton [c. 1900], p.181.

38 A.M.W. Stirling, *A Painter of Dreams* (London, 1916), pp.278–9.

39 Laura Troubridge, *Memories and Reflections* (London, 1925), p.23.

40 Ilchester, *Chronicles*, p.498. Nightingale Lane was an old name given to the southern part of Green Lane, a broad pathway of turf, with trees and bushes on either side, created by the Hollands to run parallel to but some distance from the east of Addison Road.

41 Georgiana Burne-Jones, *Memorials of Edward Burne-Jones* (London, 1993), volume 1, p.183. First published in 1904.

42 Ilchester, *Chronicles*, p.329.

43 Ibid., p.331.

44 Anne Thackeray Ritchie, *Old Kensington* (Bristol, 1995), p.14. First published in 1873.

45 Ibid., pp.132–8. The farmhouse in the distance was eventually rented by Thoby Prinsep.

46 Virginia Surtees, *The Ludovisi Goddess: The Life of Louisa Lady Ashburton* (Salisbury, 1984), p.50.

47 W.R. Lethaby, *Philip Webb and His Work* (London, 1979). First published in 1935.

48 Gertrude Jekyll, *Old West Surrey* (London, 1904), pp.5–6. Also see Sally Festing, *Gertrude Jekyll* (Harmondsworth, 1993), p.56.

49 [Hon. Mrs Edward Twisleton], *Letters of the Hon. Mrs Edward Twisleton Written to her Family 1852–1862* (London, 1928), p.104.

50 M.S. Watts, *G.F. Watts*, volume 1, p.140.

51 Hunt, *Pre-Raphaelitism*, volume 2, p.122.

52 Troubridge, *Memories*, p.19, 9.

53 G. Burne-Jones, *Memorials*, volume 1, p.186.

54 Anon. Watts Gallery p.185

55 Stirling, *Painter of Dreams*, p.304.

56 Coutts Lindsay, for example, was inspired to design a scheme of wall-decorations for Dorchester House in the late 1850s for his brother-in-law and Watts' old friend, Robert Holford.

57 [Twisleton], *Letters*, pp.107–8.

58 Taylor Papers, Bodleian Library, Ms Eng. Letters d.14.

59 Anon. Watts Gallery, p.184.

60 Fitzpatrick, *Lady Henry Somerset*, pp.14–15.

61 Surtees, *The Ludovisi Goddess*, p.61.

62 Geoffrey Squire, 'Clothed in Our Right Minds', in Geoffrey Squire (ed.), *Simply Stunning: The Pre-Raphaelite Art of Dressing* (Cheltenham, 1996), p.42.

63 Anne Thackeray Ritchie, *Alfred, Lord Tennyson and his Friends* (London, 1893). Quoted by Charlotte Gere in 'The Art of Dress, Victorian Artists and the Aesthetic Style', *Simply Stunning*, p.17.

64 Fitzpatrick, *Lady Henry Somerset*, p.15.

65 [Twisleton], *Letters* pp.96–7.

66 Anon. Watts Gallery, p.184.

67 Stirling, *Painter of Dreams*, p.299.

68 Sidney Colvin, *Memories and Notes of Persons and Places* (London, 1921), p.94.

69 L. Huxley (ed.), *Letters of Elizabeth Barratt Browning to her Sister* (London, 1929).

70 Hunt, *Pre-Raphaelitism*, volume 2, pp.167–8.

71 Henri Murger, *Scènes de la vie de bohème* (1848). Murger claimed in his preface 'Bohemia only exists, and is only possible in Paris', but see Nigel Cross, *The Common Writer* (Cambridge, 1985), on literary bohemia in London.

72 Stirling, *Painter of Dreams*, p.299.

73 Cross, *The Common Writer*, p.110.

74 T.H.S. Escott, *Anthony Trollope* (London, 1913), pp.139–50. Prinsep provided Trollope with stories about his own frustrated attempts to win a parliamentary seat. After finally securing Harwich, Prinsep was unseated after a petition, material which re-emerged in *Phineas Finn*.

75 Trollope, *Phineas Finn* (Oxford, 1974), p.315. First published in 2 volumes in 1869.

76 Stirling, *Painter of Dreams*, p.299.

77 Trollope, *Phineas Finn*, volume 2, p.314.

78 Blunt, *England's Michelangelo*, p.79.

79 Troubridge, *Memories*, p.23.

80 Colvin, *Memories and Notes of Persons and Places*, p.94.

81 Ritchie, *Old Kensington*, p.140.

82 G. Burne-Jones, *Memorials*, volume 1, p.186.

83 M.S. Watts, *G.F. Watts*, volume 1, p.160.

84 Wilfrid Ward, *Aubrey de Vere: A Memoir* (London, 1904), p.162.

85 Troubridge, *Memories*, p.24: 'He lived entirely by rule to preserve his delicate health, practising a strict diet that anticipated many of the regimes of the present day. Revalenta Arabica was, I think, the name of one of the dishes concocted for him.'

86 Ronald Chapman, *The Laurel and the Thorn* (London, 1945), p.60.

87 Hunt, *Pre-Raphaelitism*, volume 2, p.122.

88 F.G. Stephens Papers, Bodleian Library, Ms Don e. 67, Hunt to F.G. Stephens from Jerusalem, 21 November 1877.

89 Colvin, *Memories of Persons and Places*, p.95.

90 Blunt, *England's Michelangelo*, p.96.

91 M.S. Watts, *G.F. Watts*, volume 3, p.92.

92 Ibid., p.136.

93 Watts Papers, Watts to Jeannie Nassau Senior from 7 Carlton House Terrace, 1855.

94 M.S. Watts, *G.F. Watts*, volume 1, p.178.

95 Watts Papers, Sir Charles Eastlake to Watts, [1859].

96 Oswald Doughty and J.R. Wahl (eds), *Letters of Dante Gabriel Rossetti* (Oxford, 1967), volume 1, pp.356–7.

97 G. Burne-Jones, *Memorials*, volume 1, p.159.

98 Valentine Prinsep, 'A Chapter from a Painter's Reminiscence. The Oxford Circle: Rossetti, Burne-Jones, and William Morris', *Magazine of Art*, 1904, p.167.

99 G. Burne-Jones, *Memorials*, volume 1, p.159. Val Prinsep described the occasion in a letter to Sarah Acland, 16 January 1903, Acland Papers, Bodleian Library, Ms Acland d.160.

100 Valentine Prinsep, 'A Chapter' p.167.

101 Ruskin Papers, Bodleian Library, MSS Eng. Lett. c.50, Ruskin to Watts, 18 October 1858.

102 Dalrymple Papers, private collection, Ruskin to Val Prinsep [1858].

103 Hunt, *Pre-Raphaelitism*, volume 2, p.123.

104 Blunt, *England's Michelangelo*, p.88; M.S. Watts, *G.F. Watts*, volume 1, p.172.

105 M.S. Watts, *G.F. Watts*, volume 1, p.173.

106 Others saw Arthur Prinsep in this way. Anne Thackeray Ritchie's journal, March 1859: 'Arthur Prinsep looking like a little knight out of Spenser with violets in his button hole', in Hester Ritchie (ed.), *Letters of Anne Thackeray Ritchie* (London, 1924), p.169.

107 See Mark Girouard, *The Return to Camelot* (New Haven, 1981), pp.150–4.

108 M.S. Watts, *G.F. Watts*, volume 3, p.188.

109 Ibid., volume 1, p.289. Mary Tytler married Watts in 1886 after his divorce from Ellen Terry.

110 Tennyson, 'Lancelot and Elaine', *Idylls of the King* (London, 1894), p.401. First published in 1859.

111 G. Burne-Jones, *Memorials*, volume 1, p.183.

112 Penelope Fitzgerald, *Edward Burne-Jones* (Stroud, 1997), p.65.

113 John Christian, *Burne-Jones: The Paintings, Graphic and Decorative Work of Sir Edward Burne-Jones 1833–98* (London, 1975), p.20.

114 See John Christian (ed.), *The Little Holland House Album* (North

Berwick, 1981).

115 Watts Papers, Watts to Jeannie Nassau Senior from Bowood [1858].

116 Martin Harrison and Bill Waters, *Burne-Jones* (London, 1979), p.33; G. Burne-Jones, *Memorials*, volume 1, p.140.

117 M.S. Watts, *G.F. Watts*, volume 1, pp.156–7.

3 Building for Art in Kensington

1 Goddard's 800 houses took twenty-five years to complete; Hall went bankrupt in 1864; the last of the Radfords' houses in Holland Park were begun in 1877. See *Survey of London, Northern Kensington, Volume XXXVII* (London, 1973).

2 'London was more excavated, more cut about, more rebuilt and more extended [in the 1860s] than at any time in its previous history': John Summerson, *The London Building World of the Eighteen-sixties* (London, 1973), p.7. In 1868, nearly 7 per cent of all new buildings in metropolitan London were erected in North Kensington: *Survey of London*, pp.6–7.

3 Wilkie Collins, *Hide and Seek* (London, 1873), p.16.

4 *Building News*, 5, 1859, p.36.

5 Walter Crane, *An Artist's Reminiscences* (London, 1907), p.35.

6 Derek Hudson (ed.), *Munby: Man of Two Worlds* (London, 1974), p.115. First published in 1972.

7 'Quondam', *Builder*, 21, 1863, p.85.

8 *Ibid.*, 24, 1866, p.951.

9 *Building News*, 14 November 1862, pp.376–7.

10 Andrew Kurtz Papers, Liverpool Record Office, Diary, 1871.

11 *Building News*, 5, 1859, p.36.

12 Collins, *Hide and Seek*, pp.16–17.

13 *Illustrated London News*, 31 January 1846.

14 Charles Eastlake, *A History of the Gothic Revival* (1872), quoted in *Survey of London*, p.64.

15 See Margaret Shaen (ed.), *Memorials of Two Sisters, Susanna and Catherine Winkworth* (London, 1908), also *Dictionary of National Biography* under Winkworth, Catherine. The sculptor Thomas Woolner wrote to Emily Tennyson in 1861, 'I have just finished a marble bust for W. Shaen, he is the happy man who possesses the only complete dwelling house built by poor Woodward whose death I suppose you have heard of': Amy Woolner, *T. Woolner, his Life in Letters* (London, 1917), p.205.

16 Hester Thackeray Fuller and Violet Hammersley, *Thackeray's Daughter, Some Recollections of Anne Thackeray Ritchie* (Dublin, 1951), p.88.

17 *Ibid.*, p.89.

18 Winifred Gerin, *Anne Thackeray Ritchie: A Biography* (Oxford, 1981), p.120.

19 Mark Girouard, *Sweetness and Light* (New Haven, 1990), p.11.

20 *Survey of London*, p.189.

21 *Ibid.*

22 Fiona McCarthy, *William Morris* (Oxford, 1994), p.184.

23 Gerin, *Anne Thackeray Ritchie*, p.124.

24 Gordon N. Ray (ed.), *The Letters and Private Papers of William Makepeace Thackeray* (London, 1945), volume 4, p.264.

25 Gerin, *Anne Thackeray Ritchie*, p.125.

26 Sheila Kirk, 'Philip Webb 1831–1915: Domestic Architecture', PhD thesis, University of Newcastle-upon-Tyne, 1990, p.239. Also see Holland Estate Papers, London Metropolitan Archive, Cherkenwell, London.

27 *Survey of London*, p.141. Original drawings at Department of Prints and Drawings, Royal Institute of British Architects, Portman Square, London. Additional material in the Holland Estate Papers, London Metropolitan Archive.

28 William Holman Hunt, *Pre-Raphaelitism and the Pre-Raphaelite Brotherhood* (London, 1905), volume 2, p.143.

29 January and Summer 1859, February 1860, Spring 1861.

30 For membership see W.M. Rossetti (ed.), *Ruskin: Rossetti: Pre-Raphaelitism* (London, 1899); Leonee and Richard Ormond, *Lord Leighton* (New Haven, 1975), p.52; Deborah Cherry, 'The Hogarth Club', *Burlington Magazine*, April 1980, pp.237–44.

31 Georgiana Burne-Jones, *Memorials* (London, 1993), volume 1, p.190.

32 Stephen Jones et al., *Frederic Leighton 1830–1896* (London, 1996), p.103.

33 Mrs Russell Barrington, *The Life, Letters and Work of Frederic Leighton* (London, 1906), volume 2, p.52.

34 G. Burne-Jones, *Memorials*, volume 1, p.277.

35 W.R. Lethaby, *Philip Webb and His Work* (London, 1979), p.27. First published in book form in 1935.

36 See Kirk, 'Philip Webb'. Building work began in August 1860. The builder was John Tyerman of Kennington. The offices were enlarged in 1864, and the accommodation was enlarged in 1870 just before the house was sold and the Spencer Stanhopes settled semi-permanently in Italy.

37 Martin Harrison and Bill Waters, *Burne-Jones* (London, 1979), pp.72–3.

38 Charles Roberts, *The Radical Countess* (Carlisle, 1962), p.36.

39 F.G. Stephens, *Artists at Home* (London, 1884), p.13.

40 By 1871 Prinsep employed a couple, Henry and Elizabeth Bowen, and a young housemaid, Elizabeth Pegg.

41 Maurice B. Adams, 'Artist's Homes No 8', *Building News*, 29 October 1880.

42 *Ibid.*

43 J. Bryson and J.C. Troxell (eds), *Dante Gabriel Rossetti and Jane Morris: Their Correspondence* (Oxford, 1976), p.12.

44 Watts Papers, Tate Gallery Archive, Watts to Madeline Wyndham, 8 December 1885.

45 G. Burne-Jones, *Memorials*, volume 1, p.284.

46 McCarthy, *William Morris*, pp.194–5.

47 Daphne du Maurier (ed.), *The Young George du Maurier: A Selection of his Letters 1860–67* (London, 1951), p.249.

48 G. Burne-Jones, *Memorials*, volume 1, pp.286–7.

49 *Ibid.*

50 Penelope Fitzgerald, *Edward Burne-Jones* (Stroud, 1997), p.96.

51 G. Burne-Jones, *Memorials*, volume 1, p.286.

52 *Ibid.*, pp.288, 289.

53 A.W. Baldwin, *The Macdonald Sisters* (London, 1960), p.101.

54 *Ibid.*, p.97.

55 *Ibid.*, pp.83–90.

56 G. Burne-Jones, *Memorials*, volume 1, p.292.

57 Luke Ionides, *Memories* (Ludlow, 1996), p.74. First published in 1925.

58 In 1865 Burne-Jones displayed Spencer Stanhope's *Beauty and the Beast* in the front studio of 41 Kensington Square for the public to view.

59 Fanny Hunt never reached the East; she died in Florence after giving birth to a son.

4 Leighton, Aitchison and 2 Holland Park Road

1 Leonee and Richard Ormond, *Lord Leighton* (New Haven, 1975), p.26. Trollope, a fellow guest at Little Holland House, received a total of £727 11s. 3d. for *The Warden* and *Barchester Towers* over twenty years: R. Patten, *Dickens and his Publishers* (Oxford, 1978), p.228.

2 Oswald Doughty and J.R. Wahl (eds), *Letters of Dante Gabriel Rossetti* (Oxford, 1967), volume 1, p.252, 11 May 1855.

3 A.G. Temple, *Guildhall Memories* (London, 1918), p.119.

4 Mrs Russell Barrington, *The Life, Letters and Work of Frederic Leighton*, (London, 1906), volume 1, p.246.

5 *Ibid.*

6 Except in 1857.
7 See Louise Campbell, 'Decoration, Display, Disguise: Leighton House Reconsidered', Tim Barringer and Elizabeth Prettejohn (eds), *Frederic Leighton: Antiquity, Renaissance, Modernity* (New Haven and London, 1999), p.274 on Leighton keeping his distance from other artists settling in South Kensington.
8 M.S. Watts, *George Frederic Watts: The Annals of an Artist's Life* (London, 1912), volume 1, p.200.
9 Barrington, *Leighton*, volume 1, pp.230–1.
10 M.S. Watts, *G.F. Watts*, volume 1, p.198.
11 Barrington, *Leighton*, volume 1, p.224.
12 The novelist's first meeting with Leighton in Italy in 1853–4 provided material for Clive's sojourn in Rome. Thackeray made the prediction to Millais that Leighton would one day be President of the Royal Academy. See J. Comyns Carr, *Some Eminent Victorians* (London, 1908), p.95.
13 M.S. Watts, *G.F. Watts*, volume 1, p.199.
14 Ibid.
15 Ibid.
16 Barrington, *Leighton*, volume 1, p.231.
17 See Michael Musgrave, 'Leighton and Music', Barringer and Prettejohn, *Frederic Leighton*, pp.295–314, for a full account of musical context and Leighton's special role.
18 Edgcumbe Staley, *Lord Leighton of Stretton, P.R.A.* (London, 1906), p.189.
19 Barrington, *Leighton*, volume 1, p.233.
20 Gordon N. Ray (ed.), *The Letters and Private Papers of William Makepeace Thackeray* (London, 1945), volume 3, p.230. Thackeray, 8 March 1853 to Mrs Procter: 'Sartoris – (who misses Cremorne Gardens and the company there) – is coming to England for the Season – leaving his wife in Rome.'
21 Anne Thackeray Ritchie, *Records of Tennyson, Ruskin and Browning* (London, 1892), pp.193–4.
22 Virginia Surtees, *Coutts Lindsay 1824–1913* (Norwich, 1993), pp.68–9.
23 Watts Papers, Tate Gallery Archive, Watts to Jeannie Nassau Senior, January 1856.
24 Ibid. [1857].
25 Barrington, *Leighton*, volume 1, p.278.
26 Alain Decaux, *La Castiglione: Dame de coeur de l'Europe* (Paris, 1959), p.151. See also Abigail Solomon-Godeau, 'The Legs of the Countess', in Emily Apter and Wilhelm Pietz (eds), *Fetishism as Cultural Discourse* (Ithaca, NY, 1993).
27 F. Elliott, *Roman Gossip* (1894), p.291.
28 Solomon-Godeau, 'Legs of the Countess'.
29 Barrington, *Leighton*, volume 2, p.47.
30 Ormond and Ormond, *Leighton*, p.62.
31 Ibid.
32 Barrington, *Leighton*, volume 2, p.114. £1,000 from Gambart was immediately invested in Eastern Counties Railway debentures at 4.5 per cent on the advice of Coutts Bank. See Jeremy Maas, *Gambart, Prince of the Victorian Art World* (London, 1975).
33 F.G. Stephens Papers, Bodleian Library MS Don. e.69, Leighton to F.G. Stephens, 3 February 1864.
34 Barrington, *Leighton*, volume 2, p.115.
35 Margaret Richardson, *George Aitchison: Lord Leighton's Architect*, (London, 1980), Royal Institute of British Architects, Heinz Gallery exhibition catalogue.
36 J. Mordaunt Crook, *William Burges and the High Victorian Dream* (London, 1981) p.46.
37 Ibid.
38 Clive Aslet, 'George Aitchison: Lord Leighton's Architect', *Country Life*, 1980.
39 Ibid.
40 One of the few buildings Aitchison designed was the Royal Exchange Assurance Offices in Pall Mall (1863).
41 *Survey of London, Northern Kensington, Volume XXXVII* (London, 1973), p.136.
42 Louise Campbell, 'The Design of Leighton House', *Apollo*, February 1996, p.11, and Campbell, 'Decoration', pp.270–72.
43 Ibid.
44 Staley, *Leighton*, pp.69–70.
45 G. Costa, 'Notes on Lord Leighton', *Cornhill Magazine*, 1897, p.383.
46 Castle Howard Archives, Castle Howard, F. Leighton to G. Howard [1866].
47 Campbell, 'The Design', p.16.
48 See Stuart Durant, *Christopher Dresser* (London, 1993) p.6, and see Campbell 'Decoration', p.281.
49 *Building News*, 9 November 1866.
50 Leighton Papers, Royal Academy, Notebook XXVI, c.1866.
51 *Building News*, 9 November 1866.
52 *Survey of London*, p.71: Tisdall married Amelia Tunks, daughter of a South Kensington dairy farmer, in 1847, and went into partnership with Amelia's sister Elisabeth. By 1871 Tunks and Tisdall employed ten men and four boys. Tisdall played a significant role as an agriculturalist, helping to found the Metropolitan Dairymen's Association in 1872, and the British Dairy Farmers' Association, 1876.
53 Ibid., p.128.
54 See Musgrave, 'Leighton and Music', p.299. Musgrave dates the first party 25 May 1867.
55 Benjamin Disraeli, *Lothair* (London, 1870), volume 3, pp.122–3.

5 Artist Comrades: Guns and Glees

1 Sir William Macpherson, Commander, SAS 1963–6: lecture given at Leighton House Museum, 1996.
2 Women in the circle donned medieval attire to be photographed by other women, including Julia Margaret Cameron and Lady Alice Kerr, sister of Lord Lothian.
3 B.A. Young, *The Artists and the S.A.S.* (London, 1960). Sterling, shortly before his death, commissioned a house from Alfred Waterhouse which was built on Campden Hill. He was related by marriage to Marcus Stone.
4 Sir Algernon West, *Recollections 1832–86* (London, 1910), p.203.
5 Derek Hudson (ed.), *Munby: Man of Two Worlds* (London, 1974), p.49. First published in 1972.
6 Walter Crane, *An Artist's Reminiscences* (London, 1907), pp.58–9.
7 J.G. Millais, *The Life and Letters of Sir John Everett Millais* (London, 1899), volume 1, p.259.
8 Joseph Comyns Carr, *Coasting Bohemia* (London, 1914), p.13.
9 'Effie . . . was certainly in distress; and Millais came to her rescue by falling in love with her': Mark Girouard, *The Return to Camelot* (New Haven, 1981), p.158.
10 Millais used the discarded head for *The Martyr of the Solway* (1870–2): see Alison Smith, *The Victorian Nude, Sexuality, Morality and Art* (Manchester, 1996), pp.155–6.
11 F.G. Stephens, *Athenaeum*, 30 April 1870, p.585, quoted by Smith, p.151.
12 V. Surtees (ed.), *The Diaries of George Price Boyce* (Norwich, 1980), p.24.
13 Ibid., p.85.
14 Leonee and Richard Ormond, *Lord Leighton* (New Haven, 1975), p.53.
15 Macpherson, 1996 lecture at Leighton House Museum.
16 Anne Clark Amor, *William Holman Hunt: The True Pre-Raphaelite* (London, 1995), p.174.
17 G.A. Sala, *Life and Adventures* (London, 1895), volume 1, p.424.
18 Watts Papers, Tate Gallery Archive, Watts to Jeannie Nassau Senior, n.d., c.1859.

19 I. Jenkins, 'G.F. Watts' Teacher; G.F. Watts and the Elgin Marbles', *Apollo*, September 1984.
20 See Joseph Kestner, *Masculinities in Victorian Painting* (Aldershot, 1995), p.97, for debate about armour and the erect penis: 'In the iconography of chivalry in the nineteenth century, this inscription of maleness and dominance is marked by armour, which transforms the male body into the supreme signifier of masculinity, the permanent erection.'
21 See ibid., p.107.
22 David F. Cheshire, *Portrait of Ellen Terry* (Charlbury, Oxon, 1989), pp.25–6.
23 Duff-Gordon Papers, private collection, Diary of Lady Duff-Gordon, 19 January 1864.
24 See Kestner for further discussion of the theme of chivalry in Victorian paintings.
25 Peter Stearns, *Be a Man! Males in Modern Society* (New York, 1990), p.68.
26 Mrs Russell Barrington, *The Life, Letters and Work of Frederic Leighton*, (London, 1906), volume 1, p.306.
27 See J. Llewelyn Davies (ed.), *The Working Men's College 1854–1904* (London, 1904); Girouard, *Return to Camelot*.
28 F.G. Stephens Papers, Bodleian Library MS Don e. 66, Holman Hunt to Stephens, 25 January 1861.
29 Watts Papers, Watts to Madeline Wyndham, 4 April 1885. And see Caroline Dakers, *Clouds* (New Haven and London, 1993).
30 Wemyss Papers, Gosford House Aberlady.
31 Earl of Wemyss and March, *Memories 1898–1912* (Edinburgh, 1912), p.295.
32 Hudson, *Munby*, p.49.
33 Wemyss, *Memories*, p.302.
34 M.S. Watts, *George Frederic Watts: The Annals of an Artist's Life*, volume 1, p.197.
35 Ibid., p.198.
36 M.S. Watts, *G.F. Watts*, volume 2, pp.198–9. Lord Elcho was given an electro copy of the Elcho Shield when he resigned in 1880 from active command of the London Scottish regiment. The shield was placed over the dining-room sideboard at Gosford: Wemyss Papers: Wemyss, *Memories*, p.302.
37 Brian Hill, *Julia Margaret Cameron* (London, 1973), p.73.
38 Wemyss, *Memories*, pp.299–300.
39 Simon Reynolds, *William Blake Richmond* (Norwich, 1995), p.165.
40 Barrington, *Leighton*, volume 1, p.14.
41 Ibid., volume 2, p.55.
42 Stephen Calloway, *Liberty of London: Masters of Style and Decoration* (London, 1992), p.27.
43 Kate Terry Gielgud, *An Autobiography* (London, 1953), p.14.
44 H. Stacy Marks, *Pen and Pencil Sketches* (London, 1894), volume 1, pp.184–6.
45 Members of the Junior Etching Club also met at Lewis' own rooms in Jermyn Street to discuss publications. See Paul Saville 'Valentine Cameron Prinsep in relation to the practice and theory of painting in late 19th century England', B.Litt. thesis, University of Oxford, 1970 p.98. In 1858, through the dealer Gambart, the group illustrated a volume of Hood's poetry; in 1859 they illustrated *Passages from Modern English Poets*; 'after this venture, the Club disintegrated'.
46 Stacy Marks, *Pen and Pencil*, volume 1, p.186; Lamont (ed.), *Thomas Armstrong, C.B. A Memoir 1832–1911* (London 1912), pp.18–21.
47 David Wilkie Wynfield, Philip Calderon, W.F. Yeames, George Dunlop Leslie, Henry Stacy Marks, John E. Hodgson and George E. Storey. Honorary members included Arthur Lewis, George du Maurier, Eyre Crowe, Frederick Walker and Val Prinsep. They were subject painters with a preference for domestic, pathetic or frivolous situations; most lived in and around St John's Wood.
48 M.H. Spielmann, *The History of 'Punch'* (London, 1895), p.92.

49 Stacy Marks, *Pen and Pencil*, volume 1, p.192.
50 Stone Papers, Dickens House Museum, Doughty Street, London, J60, notes for speech given by Marcus Stone at the Boz Club Dinner, 1910.
51 Henry Silver, 'The Home-Life of John Leech', *Magazine of Art*, 16, 1893, p.166. Also see Simon Houfe, *John Leech and the Victorian Scene* (Woodbridge, 1984).
52 M.H. Spielmann, *The History of 'Punch'*, p.559.
53 See George and Edward Dalziel, *The Brothers Dalziel: A Record 1840–1890* (London, 1978), first published 1901.
54 Lamont, *Thomas Armstrong*, p.19.
55 Daphne du Maurier (ed.), *The Young George du Maurier: A Selection of his Letters 1860–67* (London, 1951), p.121.
56 Stacy Marks, *Pen and Pencil*, volume 1, p.186.
57 Daphne du Maurier (ed.), *Young George du Maurier*, p.210.
58 W.W. Fenn, 'Recollections of Sir Frederick Leighton', *Chamber's Journal*, 80, 6th series, 14 November 1903, p.792.
59 H. Stacy Marks, *The Life and Letters of Frederick Walker RA* (London, 1896), pp.68, 97.
60 Ibid., p.55.
61 Millais, *The Life and Letters of Sir John Everett Millais*, volume 2, p.8.
62 Stacy Marks, *Pen and Pencil*, volume 1, pp.190–1.
63 Gielgud, *An Autobiography*, p.18.
64 Ibid., p.17.
65 T.H. Escott, *Society in London* (London, 1886), pp.164–5.

6 Art and Society on Campden Hill

1 Kensington Palace continued to be used as apartments for minor royals and courtiers following the defeat of a plan initiated early in the 1850s to make it the site for the National Gallery. Lord Elcho was in favour of the idea, which was opposed by both Queen Victoria and Prince Albert. 'I hear that the Bill for the site of the new National Gallery is to be violently contested & that Ld. Elcho hopes to gather a sufficient number of votes for his "Times" proposal to take Kensington Palace from the Crown for the purpose & to throw away the site which we have acquired': Prince Albert to Lord John Russell, quoted in Derek Hudson, *Kensington Palace* (London, 1968), pp.95–6.
2 H.G. Massey, *Campden Hill: its Historic Houses and their Inhabitants* (London, 1951), p.10; information also from Carolyn Starran, Kensington Local Studies, Central Library, R.B.K.&C.
3 Press cutting (no source), 10 July 1846, Kensington Local Studies.
4 Duke of Argyll, *Autobiography and Memoirs* (London, 1906), volume 1, pp.391–2.
5 G.W.E. Russell, *Portraits of the Seventies* (London, 1916), pp.73–4.
6 William Holman Hunt, *Pre-Raphaelitism and the Pre-Raphaelite Brotherhood* (London, 1905), volume 1, p.191.
7 Simon Reynolds, *William Blake Richmond* (Norwich, 1995), pp.58–60.
8 Richard J. Hutchings and Brian Hinton (eds), *The Farringford Journal of Emily Tennyson 1853–1864* (Newport, Isle of Wight, 1986), p.119.
9 Macaulay received letters in January 1856 from Dean Milman and the Duke of Argyll telling him the lease of Holly Lodge was on the market: see George Trevelyan (ed.), *The Life and Letters of Lord Macaulay* (London, 1899), p.626.
10 Ibid., p.628.
11 Ibid., p.648.
12 Lady Stanley to Lord Stanley, 11 February 1860, in N. Mitford (ed.), *The Stanleys of Alderley* (London, 1968), p.236.
13 Jonathan Guinness with Catherine Guinness, *The House of Mitford* (London, 1985), p.96.
14 Ibid., p.82.

15 Gordon N. Ray (ed.), *The Letters and Private Papers of William Makepeace Thackeray* (London, 1945), volume 2, p.805.
16 Airlie Papers, private collection, Blanche, Countess of Airlie to Lady Stanley, 27 March 1861.
17 Castle Howard Archives, Castle Howard, Rosalind, Countess of Carlisle's diary, 26 June 1863.
18 Ibid., 18 April 1863.
19 Airlie Papers, Watts to Blanche Airlie, 29 April 1863.
20 Ibid., Blanche Airlie to Lady Stanley, 31 December 1865.
21 Ibid., 6 April 1861.
22 Ibid., Blanche Airlie to Lady Stanley, from Warnford Court, Bishop's Waltham, Hampshire.
23 Ibid., Adelaide Sartoris to Blanche Airlie, n.d.
24 Ibid., Blanche Airlie to Lady Stanley, 1869.
25 Framley Steelcroft, 'Mr Val C. Prinsep, R.A.', *Strand Magazine*, 12, 1896.
26 Airlie Papers, Blanche Airlie to Lady Stanley, 27 September 1866.
27 Ibid., n.d.
28 Ibid., Watts to Blanche Airlie, 4 August 1866.
29 Ibid., n.d.
30 Ibid., Watts to Blanche Airlie, 20 April 1872.
31 Ibid., n.d.
32 Watts Papers, Tate Gallery Archive, B. Disraeli to Watts, 5 July 1871.
33 Ibid., December 1871.
34 Airlie Papers, Watts to Blanche Airlie, 1 January 1875.
35 Ibid., 1867.
36 Ibid., Watts to Blanche Airlie, 7 July 1865: 'Many thanks for the loan of the fair one with the golden locks who was charming.'
37 Ibid., Watts to Blanche Airlie, 1 January 1875.
38 See Diane Sachko Macleod, *Art and the Victorian Middle Class* (Cambridge, 1996), p.277 for a definition of 'patron' as opposed to 'collector': one who is 'privy to the thoughts of the artists and architects who established the movement'.
39 Castle Howard Archives, J23, Rosalind Howard to Blanche Airlie, n.d.
40 Ibid., Rosalind Howard's diary, 16 June 1863.
41 Airlie Papers, Thomas Woolner to Blanche Airlie, 16 February 1864.
42 V. Surtees, *The Artist and the Autocrat* (Salisbury, 1988), p.30.
43 Castle Howard Archives, Rosalind Howard's diary, 29 September 1863.
44 Ibid. J23, George Howard to Blanche Airlie, 16 October 1864.
45 Georgiana Burne-Jones, *Memorials* (London, 1993), volume 1, p.303. First published in 1904.
46 Castle Howard Archives, Georgiana Burne-Jones to Rosalind Howard, 30 November 1866.
47 Ibid., Rosalind Howard's diary, 19 January 1867.
48 Mitford, *Stanleys of Alderley*, p.299. Lady Stanley to Lord Stanley, 26 June 1864, 'George Howard proposed yesterday. . . . He will have 800 when he comes of age & the savings will make 200 or more – not much'.
49 Weigall (1829–1925) married Lady Rose Fane, sister of the twelfth Earl of Westmorland, in 1866. By 1876 he was living in Kensington at 1 Eldon Road, with a rooftop painting room and a garden pavilion. In the 1880s, the Weigalls holidayed at Westgate-on -Sea, Kent with the Airlies' daughters Lady Clementine Mitford and Lady Blanche Hozier.
50 Castle Howard Archives, Lord Airlie to George Howard, 4 March 1868.
51 Ibid., Rosalind Howard's diary, 5 March 1868.
52 Ibid., Blanche Airlie to Rosalind Howard, 8 August 1870; Rosalind Howard to Blanche Airlie, 10 August 1870.
53 Airlie Papers, George Howard to Blanche Airlie, n.d.
54 Ibid., Blanche Airlie to Lady Stanley, 17 March 1875.
55 Castle Howard Archives, Edward Burne-Jones to George Howard [1875].
56 G. Burne-Jones, *Memorials*, volume 2, p.60.
57 Airlie Papers, Blanche Airlie to Lady Stanley, 6 August 1868.
58 Castle Howard Archives, J23, Blanche Airlie to Rosalind Howard, 7 August 1868.
59 Ibid., Philip Webb to George and Rosalind Howard, 10 August 1868.
60 Ibid., Rosalind Howard's diary, 9 December 1869.
61 Ibid., J23, Blanche Airlie to Rosalind Howard, n.d.
62 Leon Edel and Lyall H. Powers (eds), *The Complete Notebooks of Henry James* (Oxford, 1987), p.225, 26 December 1881.

7 Howard, Webb and 1 Palace Green

1 Sidney Colvin, *Memories and Notes of Persons and Places* (London, 1921), pp.22–3.
2 Isobel Spencer, *Walter Crane* (London, 1975), p.65.
3 Castle Howard Archives, Castle Howard, Rosalind Howard's diary, 16 January 1868.
4 Ibid.
5 Airlie Papers, private collection, George Howard to Blanche Airlie, 15 September 1867.
6 Castle Howard Archives, Philip Webb to George Howard, 7 September 1867.
7 Geoffrey Tyack, *Sir James Pennethorne and the Making of Victorian London* (Cambridge, 1992), p.305.
8 V. Surtees, *The Artist and the Autocrat* (Salisbury, 1988), pp.52–3; see also the *Survey of London, Northern Kensington, Volume XXXVII* (London, 1973) and Sheila Kirk, 'Philip Webb 1831–1915: Domestic Architecture', PhD thesis, University of Newcastle-upon-Tyne, 1990.
9 Kirk, 'Philip Webb', p.163.
10 Mark Girouard, *Sweetness and Light* (New Haven, 1990), p.1.
11 W.R. Lethaby, *Philip Webb and His Work* (London, 1979) p.88. First published in book form in 1935.
12 Castle Howard Archives, Georgiana Burne-Jones to Rosalind Howard, 5 July 1868.
13 Ibid., Rosalind Howard's diary, 5 March 1869.
14 Ibid., 15 April 1869.
15 Ibid., 24 November 1868.
16 Ibid., George Howard to Charles Howard, [9] December 1869.
17 Ibid., Rosalind Howard's diary, [15] January 1868.
18 Ibid., Burne-Jones to George Howard, n.d., c.1878.
19 Ibid., Rosalind Howard's diary, 4 April 1868.
20 Ibid., 21 May 1868.
21 Ibid., 4 May 1869.
22 Ibid., Burne-Jones to George Howard, n.d.
23 Ibid., Georgiana Burne-Jones to Rosalind Howard, 18 August 1867.
24 Ibid.
25 Georgiana Burne-Jones, *Memorials* (London, 1993) volume 1, p.306. First published in 1904.
26 Ibid., p.307.
27 Castle Howard Archives, Georgiana Burne-Jones to Rosalind Howard, 15 October 1867.
28 Ibid., Burne-Jones to George Howard, 22 October 1867.
29 Ibid., Georgiana Burne-Jones to Rosalind Howard, n.d.
30 Ibid., Burne-Jones to George Howard, September 1867: 'here I am quite desolate . . . I have felt intensely melancholy and depressed – the result of a good couple of years pondering about something and have been a nuisance to everyone . . . I have been intolerable even to Georgie.'
31 Ibid., Rosalind Howard's diary, 26 January 1869.
32 Ibid., 23 March 1869.

33 Ibid., Georgiana Burne-Jones to Rosalind Howard, 18 February 1869.
34 Ibid., Rosalind Howard's diary, 12 July 1869.
35 Ibid., 3 May 1869. See also Henry James, *The Tragic Muse* (1890) for the dilemma of Nick Dormer, who wishes to be an artist but whose family, and the woman who loves him, wish to be a politician.
36 Castle Howard Archives, J22, Georgiana Burne-Jones to Rosalind Howard, 3 November 1871.
37 *Studio*, 15, October 1898.
38 *Castle Howard*, Sotheby's sale catalogue, 11–13 November 1991.
39 There is some debate as to exactly when, if ever, Burne-Jones' liaison with Maria Zambaco ended. In the 1880s she was using a studio on Campden Hill close to his.
40 Walter Crane, *An Artist's Reminiscences* (London, 1907), pp.167–70.
41 Castle Howard Archives, J22, Walter Crane to George Howard, 13 November 1878.
42 Castle Howard Archives, J22, Morris to Rosalind Howard, 13 December [1879].
43 Castle Howard Archives, J22, Burne-Jones to George Howard, n.d.
44 Though an attempt to give an impression of the room was made during the 1998–9 Burne-Jones exhibition at the Metropolitan Museum of Art in New York and at the City Art Gallery, Birmingham.
45 *Studio*, 15, October 1898.
46 Lethaby, *Philip Webb*, p.33.
47 Howard Papers, Philip Webb to George Howard, 14 August 1871.
48 Castle Howard Archives, Rosalind Howard's diary, 28 October 1872. The incorrect identification of the man playing the organ as St Cecilia was repeated in Sotheby's sale catalogue of 15 June 1988 (lot 220).
49 Derek Hudson, (ed.), *Munby: Man of Two Worlds* (London, 1974), p.279.
50 Moncure D. Conway, *Travels in South Kensington* (London, 1882), p.201.
51 Castle Howard Archives, J22, Georgiana Burne-Jones to Rosalind Howard, 8 February 1875.
52 Ibid., same to same, 28 September 1869.
53 Ibid., Webb to George and Rosalind Howard, 3 June 1869.
54 Ibid., Webb to George Howard, 6 September 1869.
55 Ibid., Morris to George and Rosalind Howard, 9 September 1881.
56 Ibid., Morris to Rosalind Howard, 4 November 1881.
57 Ibid., same to same, 13 December 1879.
58 Ibid., 15 December 1879.
59 Ibid., Burne-Jones to Rosalind Howard, n.d.
60 Webb Papers, private collection, Rosalind Howard to Webb, 3 January 1880.
61 Castle Howard Archives, Webb to George Howard, 12 November 1881.
62 Ibid., same to same 16 January 1882.
63 Castle Howard Archives, Rosalind Howard's diary, 28 May 1883.
64 See Christopher Newall, *Painters of the Italian Landscape 1850–1900* (Newcastle under Lyme, 1989).
65 Castle Howard Archives, Philip Webb to George Howard, n.d.
66 Castle Howard Archives, Burne-Jones to Rosalind Howard, n.d. Webb meanwhile completed other major commissions for the Howards, at Brampton and Naworth, at Castle Howard and Lanercost Priory.
67 Surtees, *The Artist and the Autocrat*, p.145.
68 Ibid., p.167.
69 Ibid., p.172.

8 *The Ionides – Patrons in Holland Park*

1 Luke Ionides, *Memories* (Ludlow, 1996), p.29. First published in 1925.
2 George du Maurier, *Trilby* (London, 1994), p.108. First published in 1894.
3 Ibid., p.4.
4 Ibid., pp.112–13.
5 Daphne du Maurier (ed.), *The Young George du Maurier: A Selection of his Letters 1860–67* (London, 1951), p.21.
6 Ionides, *Memories*, p.45.
7 Du Maurier (ed.), *Young George du Maurier*, p.137.
8 Georgiana Burne-Jones, *Memorials*, (London, 1993), volume 2, p.43. First published in 1904.
9 Du Maurier (ed.), *Young George du Maurier*, pp.30–1.
10 Timotheos Catsiyannis, *Constantine Ionidis-Ipliktzis 1775–1852 and the Ionidi Family* (London, 1988), p.45.
11 Fiona McCarthy, *William Morris* (Oxford, 1994), p.270.
12 Du Maurier (ed.), *Young George du Maurier*, p.20.
13 L.M. Lamont (ed.), *Thomas Armstrong, C.B. – A Memoir 1852–1911* (London, 1912), pp.195–6.
14 W.G. Robertson, *Time Was* (London, 1945), p.13.
15 Oswald Doughty and J.R. Wahl (eds), *Letters of Dante Gabriel Rossetti* (Oxford, 1967), volume 2, p.505, 29 April 1864.
16 Ionides, *Memories*, p.9. *At the Piano* was bought by John 'Spanish' Phillip, a neighbour of Holman Hunt on Campden Hill. 'Phillip, the R.A. back from Spain with, well, you know, Spanish notions about things, asked who painted the picture, and they told him a youth no one knew about, who had appeared from no one knew where', Andrew McLaren Young, Margaret MacDonald, Robin Spencer, Hamish Miles, *The Paintings of James McNeill Whistler* (New Haven and London, 1980), volume 1, p.9.
17 Du Maurier (ed.), *Young George du Maurier*, p.197.
18 Roy McMullen, *Victorian Outsider: A Biography of J.A.M. Whistler* (London, 1973), p.109.
19 Ionides, *Memories*, p.9.
20 Leonee Ormond, *George du Maurier* (London, 1969), p.111.
21 Dannreuther Papers, Hastings Museum, unpublished MS of Chariclea Dannreuther.
22 Ionides, *Memories*, p.64. 'Indeed, it has been claimed that this patronage at a crucial moment in his early career encouraged him to develop that genre for which he became universally known and admired': see Tim Wilcox, *Alphonse Legros 1837–1911: catalogue de l'exposition présentée au Musée des beaux-arts de Dijon* (Dijon, 1988).
23 Walter Crane, *An Artist's Reminiscences* (London, 1907), p.218, quoting Webb.
24 Ibid., p.218.
25 T.H. Escott, *Society in London* (London, 1886), p.166.
26 Catsiyannis, *C. Ionidis-Ipliktzis*, p.62.
27 Ionides, *Memories*, p.80.
28 Crane, *An Artist's Reminiscences*, p.219.
29 Ionides Papers, National Art Library, Victoria and Albert Museum, London, D.G. Rossetti to C. Ionides, [May] 1880.
30 J. Bryson and Janet Camp Troxell (eds), *Dante Gabriel Rossetti and Jane Morris: Their Correspondence* (Oxford, 1976), p.152.
31 Ibid., p.120.
32 Ionides Papers, D.S. Rossetti to C. Ionides, 18 March 1880.
33 Ibid., D.G. Rossetti to C. Ionides, 18 March 1880.
34 Bryson and Troxell (eds), *Rossetti and Morris*, p.160.
35 Ionides Papers, Burne-Jones to C. Ionides, n.d. [1881].
36 See Julia Ionides, Afterword to Ionides, *Memories* on Luke's marital separation and financial ruin.
37 Ibid., p.85.
38 Ibid., pp.86–7.

39 Ibid., p.15.

40 Charles Harvey and Jon Press, 'The Ionides Family and 1 Holland Park', *Journal of the Decorative Arts Society*, 18, 1994.

41 Lewis Day, 'A Kensington Interior', *Art Journal*, May 1893. Leighton's studio mantelpiece (in situ) was inlaid with oriental saucers.

42 G.C. Williamson, *Murray Marks and his Friends* (London, 1919), p.3.

43 Ibid., p.13.

44 Sheila Kirk, 'Philip Webb 1831–1915: Domestic Architecture', PhD thesis, University of Newcastle-upon-Tyne, 1990, p.375.

45 Webb Papers, private collection, Webb to A. Cassavetti, 23 February 1878.

46 Caroline Dakers, *Clouds: The Biography of a Country House* (New Haven and London, 1993), p.64.

47 The Richters were friends of the Beales who lived opposite 1 Holland Park and commissioned Standen in West Sussex from Webb.

48 Moncure D. Conway, *Travels in South Kensington* (London, 1882), p.203.

49 Webb Papers, private collection, Joseph Ebner to Philip Webb, 31 October 1879.

50 Crane, *An Artist's Reminiscences*, pp.218–19.

51 A. Lys Baldry, *Modern Mural Decoration* (London, 1902), p.96.

52 Day, 'Kensington Interior'.

53 Gleeson White, 'An Epoch-Making House', *Studio*, 14, 1898.

54 Day, 'Kensington Interior'.

55 White, 'Epoch-Making House'.

56 Linda Parry (ed.), *William Morris* (London, 1996), p.152.

57 F.G. Stephens Papers, Bodleian Library Ms Don. e. 62, Burne-Jones to Stephens, 8 October 1888. Burne-Jones wrote to Kate Faulkner, in September 1880, after being commissioned to decorate a piano for William Graham's son-in-law Mr Mackenzie: 'I feel as if one might start a new industry in painting them – or rather a revived industry – only it is important that people shall not be frightened at the outset, and think that nothing can be done under 2 or 3 hundred pounds. I can't say how much the Graham piano wouldn't cost to reproduce – a horrible big sum – but I should like Broadwood to be venturesome and have a few made on speculation': Burne-Jones Papers, Fitzwilliam Museum, Cambridge.

58 G.L. Morris, 'On Mr Philip Webb's Town Work', *Architectural Review*, 2, 1897, p.206.

59 Day, 'Kensington Interior'.

60 Alexander C. Ionides Junior, *Ion: A Grandfather's Tale* (Dublin, 1927), volume 2, p.25.

61 Day, 'Kensington Interior'.

62 Dannreuther Papers; plans for Windycroft. And see Victoria Williams, 'Windycroft: an arts and crafts house', *Pre-Raphaelite Society Review*, volume III, number 3, Autumn 1994.

63 A.C. Ionides, *Ion*, volume 1, p.5.

64 Alan Wykes, *Snake Man: The Story of C.J.P. Ionides* (London, 1960), pp.26–7.

65 Kirk, 'Philip Webb', p.525.

66 See Christies' sale catalogue, April 1887, for extent of Rickards collection.

67 Extract from the will of Constantine Ionides, 31 August 1899, included in Basil S. Long, *Catalogue of the Constantine Alexander Ionides Collection* (London, 1915), volume 1.

9 The Aesthetic Interior

1 Moncure D. Conway, *Travels in South Kensington* (London, 1882), p.165.

2 Leon Edel (ed.), *Henry James Letters* (London, 1974–84), volume 2, p.118.

3 Ibid., p.124.

4 Fred Kaplan, *Henry James* (London, 1993), pp.180–1.

5 Walter Crane, *An Artist's Reminiscences* (London, 1907), p.170.

6 *The Architect*, 17, 1877, p.26.

7 A. Swinburne, *Notes on the Royal Academy Exhibition 1868* (London, 1868), p.51.

8 See Helen Smith, *Decorative Painting in the Domestic Interior in England and Wales c. 1850–1890* (New York, 1984), pp.144–6.

9 Ibid., p.144.

10 Stuart Durant, *Christopher Dresser* (London, 1993), p.27.

11 Ibid., p. 34, quoting Dresser, from the Furniture *Gazette*, 3 January 1880. Dresser's home from 1869 to 1882 was Tower Cressy on Campden Hill, a 'vulgarly Italianate' house topped with a large tower with bulbous pinnacles.

12 Mrs Haweis, *The Art of Decoration* (London, 1881), p.10.

13 Margaret Richardson, *George Aitchison: Lord Leighton's Architect*, RIBA Heinz gallery exhibition catalogue 1980.

14 See Caroline Dakers, *Clouds: The Biography of a Country House* (New Haven and London, 1993), p.34.

15 Henry James, 'The Picture Season in London 1877', reprinted in John L. Sweeney (ed.), *The Painter's Eye* (Wisconsin, 1989), pp.142–3.

16 Watts Papers, Tate Gallery Archive, Watts to Madeline Wyndham, 12 September 1879.

17 The house had been begun by Anthony Salvin, who had worked on Petworth House.

18 George Aitchison, *Journal of the Royal Institute of British Architects*, 1894–5, pp.401–17.

19 Wyndham Papers, private collection, Mary Wyndham's diary, 4 March 1883.

20 Leonee and Richard Ormond, *Lord Leighton* (New Haven, 1975), pp.116–17.

21 See Dakers, *Clouds*.

22 Castle Howard Archives, Castle Howard, George Howard to Charles Howard [late 1870]. And see T.H. Escott, *Society in London* (London, 1886), on the Marquess of Lorne, 'never made one of the family by his royal brothers-in-law. It was regarded as a *mésalliance*. His appointment to the Viceroyship of Canada was a temporary release from a position not merely difficult, but impracticable.'

23 R. Dorment, *Alfred Gilbert Sculptor and Goldsmith* (London, 1986), p.18. Royal Academy exhibition catalogue.

24 See Dakers, *Clouds*; Barbara Morris, *Victorian Embroidery* (London, 1962); Anthea Callen, *Angel in the Studio. Women in the Arts and Crafts Movement 1870–1914* (London, 1979).

25 *Building News*, 7 March 1879, 36, pp.261–2.

26 Simon Reynolds, *William Blake Richmond* (Norwich, 1995), p.138.

27 Not by Elizabeth Longford, *Darling Loosy, Letters to Princess Louise 1856–1939* (London, 1991). She is unconvinced of Lorne's homosexuality or that there was a physical relationship between Louise and Boehm.

28 Dorment, *Alfred Gilbert*, p.106.

29 Timothy Wilcox, 'The Aesthete Expunged. The Career and Collection of T. Eustace Smith, MP', *Journal of History of Collections*, 5, no. 1, 1993, pp.43–57.

30 Wilfrid Blunt, *England's Michelangelo: A Biography of G.F. Watts, OM, RA* (London, 1989), p.111.

31 F.G. Stephens Papers, Bodleian Library, MS Don. e. 69, Leighton to F.G. Stephens, 1871.

32 L.M. Lamont (ed.), *Thomas Armstrong, C.B. – A Memoir 1852–1911* (London, 1912), p.16.

33 Eustacia Smith and Charles Dilke bought some of his drawings, Crane, *An Artist's Reminiscences*, pp.166–7.

34 See Alison Smith, *The Victorian Nude: Sexuality, Morality and Art* (Manchester, 1996), p.117, quoting F.G. Stephens.

35 Julian Hawthorne, *Shapes That Pass* (London, 1928), pp.135–6.

36 See Roy Jenkins, *Dilke: A Victorian Tragedy* (London, 1965).

37 Leon Edel (ed.), *Henry James Selected Letters* (Cambridge, 1987), p.210, 23 August 1885.

38 F.G. Stephens, *Athenaeum*, 15 February 1862.

39 Anon [member of Pattle-Prinsep family], extract from article in possession of Watts Gallery, Compton [*c.* 1900], p.183.

40 B. Curle (ed.), 'Lord Leighton: a catalogue of letters to various correspondents in the possession of the Royal Borough of Kensington & Chelsea', 1983, MSS 12620, letter 146, 8 November [1875].

41 Ibid., MSS 12623, letter 152, n.d.

42 Ibid., MSS 12635, letter 153, n.d.

43 Crane, *An Artist's Reminiscences*, p.217.

44 Unpublished autobiography of Mrs Constance Hugh Smith, volume 3, p.118, in Philip Ziegler, *The Sixth Great Power: Baring's 1762–1929* (London, 1988), pp.261–2.

45 Ormond and Ormond, *Leighton*, p.20.

46 John Lehmann, *Ancestors and Friends* (London, 1962), p.173.

47 Peter Ackroyd, *Dickens* (London, 1990), pp.874–5, 974–5.

48 Kate Terry Gielgud, *An Autobiography* (London, 1953), p.75.

49 See Amelia Pain, *Saint Eva* (London, 1897), frontispiece by Burne-Jones.

50 Lehmann, *Ancestors*, p.194, including Edward Baring, First Lord Revelstoke and head of Baring's before the 1890 crisis.

51 Rudolf Lehmann, *An Artist's Reminiscences* (London, 1894), p.222.

52 J. Lehmann, *Ancestors*, p.219.

53 Ibid.

54 Ibid., p.220.

55 Conway, *Travels*, pp.164–5.

56 Ibid., p.159.

57 Henry James, 'The Author of Beltraffio', in Frank Kermode (ed.), *The Figure in the Carpet* (Harmondsworth, 1986), p.61. First published 1884.

58 Henry James, *The Spoils of Poynton* (Harmondsworth, 1964), p.7. First published 1897.

59 Anthony Trollope, *The Way We Live Now* (Harmondsworth, 1993), p.33. First published 1875.

60 Ibid., p.319.

61 See Dianne Sachko Macleod, *Art and the Victorian Middle Class* (Cambridge, 1996), pp.223–7.

62 *Builder*, 34, 8 July 1876.

63 W.J. Loftie, *Kensington Picturesque & Historical* (London, 1888), p.124.

64 Ibid.

65 Macleod, *Art and the Victorian Middle Class*, p.224.

66 H. Osborne O'Hagan, *Leaves from My Life* (London, 1929), volume 1, p.32.

67 Oswald Doughty and J.R. Wahl (eds), *Letters of Dante Gabriel Rossetti* (Oxford, 1961), volume 4, p.1391, 22 December 1875. Howell, 'the half-Portuguese artistic adventurer . . . became successively Ruskin's secretary, Burne-Jones' close friend and Rossetti's agent', Jan Marsh, *Pre-Raphaelite Sisterhood* (London, 1985), p.238.

68 *Builder*, 34, 8 July 1876.

69 *London Journal*, 17 August 1876.

70 G.C. Williamson, *Murray Marks and his Friends* (London, 1919), Val Prinsep, p.84.

71 M. Susan Duval, 'F.R. Leyland: A Maecenas from Liverpool', *Apollo*, 124, August 1986, pp.113–14. For a full account of Leyland, Whistler, and their relationship see Linda Merrill, *The Peacock Room: A Cultural Biography* (New Haven and London, 1999).

72 Francis L. Fennell, *The Rossetti-Leyland Letters* (Athens, Ohio, 1978), p.35.

73 His son-in-law Val Prinsep gave a softer version in his article for the *Art Journal*, 1892: 'Before he was thirty he had quite transformed that business, and having made the fortunes of his

principals, was himself a wealthy man. Soon the name of the original firm was altered, and since then, Messrs. F.R. Leyland have been one of the leading, as well as most successful, steamship owners of Liverpool.'

74 See Duval, 'F.R. Leyland', p.111.

75 Williamson, *Murray Marks*, p.85. 49 Prince's Gate was previously the home of Lord and Lady Somers.

76 Andrew McLaren Young, Margaret MacDonald, Robin Spencer, Hamish Miles, *The Paintings of James McNeill Whistler* (Yale, 1980), volume 1, p.101.

77 Alan Bowness, *The Pre-Raphaelites* (London, 1984), Tate Gallery exhibition catalogue, p.234.

78 Lamont, *Thomas Armstrong*, pp.206–7.

79 Alexander Papers, Kensington Local Studies, Central Library R.B.K. & C. See Merrill, *Peacock Room*, p. 224.

80 Williamson, *Murray Marks*, pp.94–5.

81 Young, *Paintings of Whistler*, p.103.

82 Whistler Papers, Glasgow University Library, Leyland to Whistler, 6 July 1877.

83 J. Bryson and J.C. Troxell (eds), *Dante Gabriel Rossetti and Jane Morris: Their Correspondence* (Oxford, 1976), p.116.

84 Ibid., p.147.

85 Ibid., p.149.

86 Williamson, *Murray Marks*, p.88.

87 Theodore Child, 'A Pre-Raphaelite Mansion', *Harper's*, 82, December 1890, p.91.

88 Angela Emanuel, *A Bright Remembrance: The Diaries of Julia Cartwright 1851–1924* (London, 1981), p.127.

89 Whistler Papers, Glasgow University Library, Whistler to Leyland, 31 October 1876.

10 The Creation of Melbury Road: 1875

1 The Earl of Ilchester, *Chronicles of Holland House 1820–1900* (London, 1937), p.430.

2 Watts Papers, Tate Gallery Archive, Watts to Lady Holland, 30 January 1871.

3 Ilchester, *Chronicles*, p.444.

4 John Bateman, *The Great Landowners of Great Britain and Ireland* (Leicester, 1971). First published 1876.

5 Ilchester, *Chronicles*, p.443.

6 Ibid., p.444.

7 M.S. Watts, *George Frederic Watts: The Annals of an Artist's Life* (London, 1912), volume 1, p.251.

8 Anne Thackeray Ritchie, *From Friend to Friend* (London, 1919), p. 20.

9 Richard J. Hutchings and Brian Hinton (eds), *The Farringford Journal of Emily Tennyson 1853–1864* (Newport, Isle of Wight, 1986), p.109.

10 Watts Papers, Julia Margaret Cameron to Charles Cameron, 25 May 1860.

11 Ibid., Watts to Emily Tennyson, 25 February 1865.

12 H.J. Fuller & V. Hammersley (eds), *Thackeray's Daughter. Some Recollections of Anne Thackeray Ritchie* (Dublin, 1952), pp.125–7.

13 Winifred Gerin, *Anne Thackeray Ritchie* (Oxford, 1981), p.153.

14 John George Marks, *Life and Letters of Frederick Walker R.A.* (London, 1896) pp.154–5.

15 Brian Hill, *Julia Margaret Cameron* (London, 1973), p.127, quoting the *Photographic News*, March 1868.

16 M.S. Watts, *G.F. Watts*, volume 1, p.255.

17 Watts Papers, Watts to Madeline Wyndham, n.d.

18 Ruskin Papers, Bodleian Library, MSS Eng. Lett. c. 50, Ruskin to Watts, 1 February 1873.

19 M.S. Watts, *G.F. Watts*, volume 1, p.266.

20 Sheila Kirk, 'Philip Webb 1831–1915: Domestic Architecture',

PhD thesis, University of New Castle-Upon-Tyne, 1990.

21 Laura Troubridge, *Memories and Reflections* (London, 1925), p.20.
22 Fuller & Hammersley, *Thackeray's Daughter*, p.25.
23 Watts Papers, Tennyson to Watts, 27 December 1872.
24 Castle Howard Archives, J20, Castle Howard, George Howard to Charles Howard, 25 February 1875.
25 Webb Papers, private collection, Webb to Watts, 8 July 1874.
26 Ibid., same to same, 17 July 1874.
27 Castle Howard Archives, J20, George Howard to Charles Howard, 25 February 1875.
28 Castle Howard Archives, Burne-Jones to Rosalind Howard, n.d.
29 Leonee Ormond, *George du Maurier* (London, 1969), p.225.
30 M.S. Watts, *G.F. Watts*, volume 1, pp.298–9.
31 Ibid., pp.299–300.
32 Ilchester, *Chronicles*, pp.445–6.
33 Ibid.
34 Watts Papers, Burne-Jones to Watts [1874].
35 M.S. Watts, *G.F. Watts*, volume 1, p.279.
36 Holland Papers, London Metropolitan Archive, Clerkenwell, agreement between Ilchester and Val Prinsep, 15 February 1875; mortgage with Lombardian Benefit Building Society, 3 November 1875; further details of leasehold arrangements in papers relating to alterations to 6 Melbury Road in the twentieth century, when the lease of the property had passed to Prinsep's widow, Mrs Ball-Green.
37 Giles Walkley, *Artists' Houses in London 1764–1914* (Aldershot, 1994), pp.40–1.
38 Mrs Russell Barrington, *G.F. Watts, Reminiscences* (London, 1905), pp.99–100.
39 Watts Papers, Watts to Jeannie Nassau Senior, 23 November 1875, 16 January 1876.
40 Barrington, *Watts*, p.49.
41 Mary Lago (ed.), *Burne-Jones Talking* (London, 1982), p.30.
42 M.S. Watts, *G.F. Watts*, volume 1, p.305.
43 Troubridge, *Memories*, p.23.
44 Sidney Colvin, *Memories and Notes of Persons and Places* (London, 1921), p.97.
45 Dalrymple Papers, private collection.

11 Stone, Fildes and Shaw: 11 and 8 Melbury Road

1 Harry How, 'Hamo Thornycroft', *Strand Magazine*, 6, 1893.
2 According to the architect Reginald Bloomfield. See N. Pevsner, 'Richard Norman Shaw', in P. Ferriday (ed.), *Victorian Architecture* (London, 1953), p.245.
3 Frederick Leyland and Wickham Flower, both of whom engaged Shaw, were exceptions in their preference for aesthetic painters, Morris and Company, etc.
4 T.H. Escott, *Personal Forces of the Period* (London, 1898), quoted by Paula Gillett, in *The Victorian Painter's World* (Gloucester, 1990), p.34.
5 W.R. Lethaby, *Philip Webb and His Work* (London 1979). p.75. First published in book form 1935.
6 Pevsner, 'Richard Norman Shaw', p.241.
7 Redgrave lived in Hyde Park Gate in the 1840s, then moved to Abinger, Surrey in 1851. Hook, whose house on Campden Hill was taken over by Holman Hunt, also moved to Abinger in 1855, then Churt in 1865. Horsley was part of the 'Cranbrook Colony' of artists: see *The Cranbrook Colony*, Wolverhampton Art Gallery, 1977.
8 Andrew Saint, *Richard Norman Shaw* (New Haven and London, 1976). Horsley strove to 'ape the old communal customes and hospitality' of old England, though his particular picturesque school of painting was losing its popularity at the same time as architects were reviving the 'rural, romantic tradition'
(pp.34–5).
9 Cooke lived at the Ferns, Eldon Road, Kensington, c.1850; Hyde Park Gate, 1855.
10 Other artist-clients included Frederick Goodall, RA, who commissioned Grims Dyke in the Harrow Weald, in 1870; Thomas Sidney Cooper, RA, who commissioned a studio in the garden of his house in Chepstow Villas, London W11, in 1874.
11 Mark Girouard, *Sweetness and Light* (New Haven, 1990), p.100.
12 Lowther Papers, Royal Geographical Society, Kensington.
13 Fildes Papers, National Art Library, Victoria and Albert Museum, London, Fildes to Henry Woods, November 1876.
14 Anon., 'Mr Marcus Stone, R.A.', *Strand Magazine*, 18 August 1899, pp.122–33.
15 Stone Papers, Dickens House Museum, Autobiographical notes.
16 Peter Ackroyd, *Dickens* (London, 1990), p.639.
17 Stone Papers, Autobiographical notes.
18 L.S. Baldry, 'The Life and Work of Marcus Stone R.A.', *Art Annual*, Christmas 1896.
19 Stone Papers, notes for lecture given by Stone, 1910.
20 Robert L. Patten, *Dickens and his Publishers* (London, 1978), p.305.
21 F.G. Kitton, *Dickens and his Illustrators* (London, 1899), p.113. See N. John Hall, *Trollope and his Illustrators* (London, 1980) and John Harvey, *Victorian Novelists and their Illustrators* (London, 1970).
22 Harvey, *Victorian Novelists*, p.165. Ackroyd, *Dickens*, p.942, quotes Dickens' advice to Stone: 'Give a vague idea'.
23 Patten, *Dickens and his Publishers*, p.306.
24 Anon., 'Mr Marcus Stone R.A.'
25 N.J. Hall *Trollope and his Illustrators* regards the illustrations as 'in the first rank' after Millais', p.124.
26 Baldry, 'Stone'.
27 National Art Library, Victoria and Albert Museum, London, Stone to Gimpel [1860].
28 Baldry, 'Stone'.
29 Castle Howard Papers, Castle Howard, Rosalind Howard's diary, 5 May 1863.
30 Anon., 'Mr Marcus Stone R.A.'
31 David Croal Thomson, 'Fildes', *Art Annual*, 1895.
32 See Malcolm Warner, *The Victorians, British Painting 1837–1901* (Connecticut, 1997).
33 L.V. Fildes, *Luke Fildes* (London, 1968), pp.12–13.
34 Harry How, 'Mr Luke Fildes, R.A.', *Strand Magazine*, 6, 1893.
35 Warner, *The Victorians*, p.148.
36 Patten, *Dickens and his Publishers*, p.732.
37 Fildes, *Luke Fildes*, p.14.
38 Thomson, 'Fildes'.
39 Ibid.
40 How, 'Mr Luke Fildes, R.A.'
41 Thomson, 'Fildes'.
42 How, 'Mr Luke Fildes, R.A.'
43 Jeannie Chapel, *Victorian Taste* (London, 1982), p.85.
44 *Saturday Review*, 2 May 1874, p.562.
45 Chapel, *Victorian Taste*, p.86.
46 Fildes, *Luke Fildes*, p.24.
47 Taylor owned works by several of Shaw's clients, including Fildes, Stone and Horsley: see Dianne Sachko Macleod, *Art and the Victorian Middle Class* (Cambridge, 1996), p.478. Several of his paintings were later acquired by Thomas Holloway, see Chapel, *Victorian Taste*, p.87.
48 Trollope, by comparison, received £2,800 in 1866–7, at the height of his popularity, for *The Claverings*, 'the highest rate of pay that was ever accorded to me'. Trollope, *An Autobiography*, (Oxford, 1980), p.164. First published in 1883.
49 Fildes Papers, Fildes to Woods, 8 November 1874.
50 Fildes, *Luke Fildes*, p.34.

51 Ibid., p.35.
52 Anon., 'Mr Marcus Stone, R.A.'
53 Baldry, 'Stone'.
54 Anon., 'Mr Marcus Stone, R.A.'
55 'His pictures are popular because they unite daintiness of sentiment with attractiveness of setting and arrangement. They are painted not to appeal to any craving for sensationalism, but to present in as fascinating a form as possible those events in which all classes are interested because of their common possession of a certain range of human emotions' (Baldry, 'Stone'). p.4.
56 T.H. Escott, *Society in London*, (London, 1886), pp.313–14.
57 Baldry, 'Stone'.
58 Ibid.
59 Holland Estate Papers, London Metropolitan Archive, Clerkenwell, leasehold agreement between Earl of Ilchester and Marcus Stone, 24 December 1877.
60 Baldry, 'Stone'.
61 Maurice Adams, 'Mr Marcus Stone's House, Kensington', *Building News*, 38, 30 April 1880, pp.522–7.
62 Anon., 'Mr Marcus Stone, R.A.'
63 Edward Tarver, 'Artists' Studios', *Art Annual*, 19, 1880, p.250.
64 Adams, 'Mr Marcus Stone's House, Kensington'.
65 Fildes Papers, Shaw to Fildes, June 1876.
66 Fildes, *Luke Fildes*, p.46.
67 Fildes Papers, Shaw to Fildes, 23 March 1876.
68 Thomson, 'Fildes'.
69 How, 'Mr Luke Fildes, R.A.'
70 Fildes Papers. He sold *The Widower* for £1,890, *Large Roses* for £300, *Small Roses* for £150, *Girl against Sky* for £200, a watercolour of *Girl against Sky* for £45, *Waiting* for £150, another version of *Waiting* for £85, *Simpletons* for £210, another version for £105, and a third version for £50.
71 See Shirley Nicholson, *A Victorian Household* (Stroud, 1988).
72 Fildes Papers, Shaw to Fildes, June 1876.
73 Ibid., Fildes to Woods, 28 October 1876.
74 Ibid.
75 Ibid., Shaw to Fildes, 19 October 1877.
76 Fildes, *Luke Fildes*, p.91.
77 Maurice Adams, 'Mr S. Luke Fildes' House', *Building News*, 39, 17 December 1880, pp.702, 707.
78 How, 'Mr Luke Fildes, R.A.'

12 The Thornycrofts, Burges, Hunter and Moore: 2, 9 and 14 Melbury Road and 1 Holland Lane

1 Fildes Papers, National Art Library, Victoria and Albert Museum, London, Fildes to Woods, October 1876.
2 Walter Armstrong, 'Colin Hunter, ARA', *Art Annual*, 1885.
3 Ibid.
4 Ibid.
5 Numbers 10 and 12 Melbury Road built by William Turner of Chelsea, large 'pretentiously-built mansions' (*Building News*, 13 April 1877). Turner also built the semi-detached pair on the other side of Hunter, numbers 16 and 18 (Holman Hunt moved into 18 in 1902).
6 Mark Girouard, *Sweetness and Light* (New Haven, 1990), p.39.
7 Mrs Haweis, *Beautiful Houses* (London, 1882), p.91.
8 Girouard, *Sweetness and Light*, p.41.
9 Maurice Adams, 'Mr Colin Hunter's House, Kensington', *Building News* 38, 25 June 1880, pp.781–82.
10 *Building News* 38, 23 April 1880, p.497.
11 Edward Godwin, 'The Home of an English Architect', *Art Journal*, 1886, pp.170–3, 301–5.
12 J. Mordaunt Crook, *William Burges and the High Victorian Dream* (London, 1981), p.307.
13 See Matthew Williams, 'Burges House', *Cardiff Civic Society Review*, 1996.
14 F.G. Stephens Papers, Bodleian Library Ms Don. e. 81, Aitchison to F.G. Stephens, 27 April 1881.
15 *Builder*, 34, 1876, p.18.
16 Ibid.
17 *Building News*, 26, 1874, p.690.
18 Mordaunt Crook, *William Burges*, p.16.
19 *Builder*, 33, 1875, p.1146.
20 Mordaunt Crook, *William Burges*, p.89. Burges left £40,000.
21 Ibid., p.78.
22 Evan Charteris, *Life and Letters of Edmund Gosse* (London, 1931), p.149.
23 *The Architect*, 15, 1881, p.213.
24 Godwin, 'The Home of an English Architect'.
25 Burges Papers, National Art Library, Victoria and Albert Museum, summary of diary.
26 Anon., 'Illustrations of Works by the Late William Burges, A.R.A.', *The Architect*, 27, 15 April 1882, p.235.
27 Holland Estate Papers, London Metropolitan Archive, Clerkenwell.
28 *Building News*, 5, 13 April 1877, pp.375–6.
29 Haweis, *Beautiful Houses*, p.22.
30 Ibid., p.19.
31 Godwin, 'The Home of an English Architect'.
32 Haweis, *Beautiful Houses*, p.15.
33 Godwin, 'The Home of an English Architect'.
34 Haweis, *Beautiful Houses*, p.16.
35 Godwin, 'The Home of an English Architect'.
36 Mordaunt Crook, *William Burges*, p.319.
37 Haweis, *Beautiful Houses*, p.19.
38 Ibid.
39 Mordaunt Crook, *William Burges*, p.325.
40 W.R. Lethaby, *Philip Webb and His Work* (London, 1979), p.73. First published in book form 1935.
41 Simon Reynolds, *William Blake Richmond* (Norwich, 1995), p.100.
42 Elfrida Manning, *Marble and Bronze* (London, 1982), p.47.
43 Ibid., p.49.
44 Mrs Russell Barrington, *The Life, Letters and Work of Frederic Leighton* (London, 1906), volume 2, p.6.
45 Ibid.
46 Manning, *Marble and Bronze*, p.60.
47 Harry How, 'Mr Hamo Thornycroft, R.A.', *Strand Magazine*, 6, 1893.
48 L.V. Fildes, *Luke Fildes* (London, 1968), p.65.
49 Susan Beattie, *The New Sculpture* (New Haven, 1983), p.32.
50 Manning, *Marble and Bronze*, p.65.
51 Ibid., p.67.
52 *Survey of London, Northern Kensington, Volume XXXVII* (London, 1973), p.142.
53 How, 'Mr Hamo Thornycroft, R.A.'
54 Manning, *Marble and Bronze*, p.67.
55 How, 'Mr Hamo Thornycroft, R.A.'
56 Ibid.
57 Manning, *Marble and Bronze*, p.67.
58 Ibid.
59 Ibid.
60 How, 'Mr Hamo Thornycroft, R.A.'
61 Manning, *Marble and Bronze*, p.67.
62 Angela Emanuel, *A Bright Remembrance: The Diaries of Julia Cartwright 1851–1924* (London, 1981), p.111.
63 Beattie, *The New Sculpture*, p.165.
64 Manning, *Marble and Bronze*, p.67.
65 Beattie, *The New Sculpture*, p.147. 'Both portray their subjects in a

state of isolation from the physical world, imprisoned by anguished thought.'

66 Ibid.
67 Fildes, *Luke Fildes*, p.46.
68 W.G. Robertson, *Time Was* (London, 1945), p.60.
69 Ibid., p.57.
70 Walter Crane, *An Artist's Reminiscences* (London, 1907), p.177.
71 C.Y. Lang (ed.), *The Swinburne Letters* (New Haven, 1959–62), volume 2, pp.32–3.
72 Mark Girouard, *The Victorian Country House* (New Haven, 1979), p.67.
73 A.C. Swinburne, *Notes on the Royal Academy Exhibition 1868* (London, 1868).
74 Oswald Doughty and J.R. Wahl (eds), *Letters of Dante Gabriel Rossetti* (Oxford, 1967), volume 2, p.497, [1864].
75 Whistler Papers, Glasgow University Library, Whistler to Moore [1870].
76 *Building News*, 36, 7 March 1879, pp.261–2.
77 Robertson, *Time Was*, pp.58–9.

13 The Leighton Ascendancy

1 Benjamin Disraeli, *Lothair* (London, 1870).
2 L.V. Fildes, *Luke Fildes* (London, 1968), p.65, comment by Whistler.
3 The translation of 'Zisa', the inspiration for Leighton's Arab Hall.
4 Margaret Richardson, *George Aitchison: Lord Leighton's Architect*, 1980, RIBA Heinz Gallery exhibition catalogue. p.6.
5 F.G. Stephens Papers, Bodleian Library, MS Don e. 69, Leighton to Stephens, 3 July 1868.
6 Mrs Andrew Lang, 'Sir Frederick [sic] Leighton his Life and Work', *Art Annual*, 1884.
7 Harry How, 'Sir Frederick [sic] Leighton, P.R.A', *Strand Magazine*, 14, 1892, p.128.
8 Mrs Haweis, *Beautiful Houses* (London, 1882), p.2.
9 How, 'Sir Frederick Leighton'.
10 J. Price, *My Bohemian Days in London*, quoted in Kate Bailey 'Leighton's Public and Private Lives', *Apollo*, February 1996, p.24.
11 Haweis, *Beautiful Houses*.
12 Julian Hawthorne, *Shapes That Pass* (London, 1928), p.138.
13 Alice Corkran, *Frederic, Lord Leighton* (London, 1904), p.168.
14 Mrs Russell Barrington, *The Life, Letters and Work of Frederic Leighton* (London, 1906), volume 2, p.129.
15 Ibid., p.217, quoting Aitchison.
16 Ibid., p.148.
17 Leonee and Richard Ormond, *Lord Leighton* (New Haven, 1975), p.96.
18 Barrington, *Leighton*, volume 2, p.136.
19 C.Y. Lang (ed.), *The Swinburne Letters* (New Haven, 1959–62), volume 2, p.25.
20 Robert Irwin, *The Arabian Nights, A Companion* (London, 1994), p.28.
21 Ibid., pp.32–3.
22 Barrington, *Leighton*, volume 2, pp.218–19.
23 Ormond and Ormond, *Lord Leighton*, p.99.
24 Barrington, *Leighton*, volume 2, p.219.
25 Ibid., p.218.
26 Julie Lawson, 'The Painter's Vision,' in *Visions of the Ottoman Empire* (Edinburgh, 1994), p.32.
27 Mrs Andrew Lang, 'Sir Frederick Leighton'.
28 William de Morgan was paid £227 between 1880 and 1882: see Leighton Accounts, Coutts Bank, London.
29 Haweis, *Beautiful Houses*, p.4.
30 B. Curle (ed.), *Lord Leighton: a catalogue of letters to various correspondents in the possession of the Royal Borough of Kensington & Chelsea* (1983),

31 Leighton to Crane, MSS. 12609, letter 95, n.d.
31 Walter Crane, *An Artist's Reminiscences* (London, 1907), p.216.
32 Mary Anne Stevens (ed.), *The Orientalists: Delacroix to Matisse* (London, 1984), p.202.
33 I. Cooper-Willis, *Vernon Lee's Letters* (privately printed, 1937) p.123, quoted by Ormond and Ormond, *Lord Leighton*, pp.100–1.
34 T.H. Escott, *Society in London* (London, 1886), p.153.
35 Quoted in Barrington, *Leighton*, volume 2, p.6.
36 Wyndham Papers, private collection, Mary Elcho's (later Countess of Wemyss) diary. See Musgrave, 'Leighton and Music', Barringter and Prettejohn (eds), *Frederic Leighton Antiquity, Renaissance, Modernity* (New Haven, 1999), pp.295–314.
37 Wyndham Papers, Mary Elcho's diary. Musgrave, 'Leighton and Music' writes of Joachim, 'No English performer or composer was of comparable artistic rank', and of Piatti, 'the most influential cellist in 19th century England', pp.302–3.
38 Barrington, *Leighton*, volume 2, pp.216–17.
39 B. Curle (ed.), *Lord Leighton*, Leighton to Joachim, 20 March 1875.
40 Watts Papers, Tate Gallery Archive, Burne-Jones to Watts, spring 1888.
41 Haweis, *Beautiful Houses* p.3.
42 Ibid., p.10.
43 Lang, 'Sir Frederick Leighton'.
44 How, 'Sir Frederick Leighton, P.R.A.'
45 Crane, *An Artist's Reminiscences*, p.127.
46 Angela Emanuel, *A Bright Remembrance: The Diaries of Julia Cartwright 1851–1924* (London, 1981), p.127.
47 National Art Library, Victoria and Albert Museum, MS.L. 86 WWI. John Hanson Walker to F. Newburne, 7 September 1873. The 'friend' was Mr Shaw of Capelthorpe who bought *Out of Luck*, as well as *In Luck*.
48 Belinda Morse, *John Hanson Walker: The Life and Times of a Victorian Artist* (Gloucester, 1987), p.77.
49 Ibid., p.45.
50 Ibid., p.93.
51 Richard Dorment, *Alfred Gilbert* (New Haven, 1985), p.45.
52 Allen Staley, *Victorian High Renaissance* (Minneapolis, 1978), p.177.
53 Dorment, *Alfred Gilbert* p.45.
54 F.G. Stephens Papers, Bodleian Library, MS Don e. 67.
55 Dorment, *Alfred Gilbert* p.53.
56 Susan Beattie, *The New Sculpture* (New Haven 1983), p.157.
57 Dorment, *Alfred Gilbert* p.57.
58 See Anna Greutzner Robins, 'Leighton: A promoter of the New Painting', Barringer and Prettejohn (eds), *Frederic Leighton*, pp.315–30, for discussion of Leighton's interest in contemporary art, in particular Clausen and the New English Art Club.
59 Louise Campbell, 'The Design of Leighton House', *Apollo*, February 1996, p.14.
60 *Builder*, September 1895.
61 Campbell, 'The Design', p.16.
62 Ormond and Ormond, *Lord Leighton*, p.75.
63 Leon Edel and Lyall H. Powers, *The Complete Notebooks of Henry James* (Oxford, 1987), pp.60–1.
64 Fred Kaplan, *Henry James* (London, 1993), p.271.
65 Ernest Rhys, *Frederic, Lord Leighton* (London, 1900), p.98.
66 F. Goodall, *Reminiscences* (London, 1902), p.206.
67 How, 'Sir Frederick Leighton, P.R.A'.
68 Watts Papers, Tate Gallery Archives, Augusta Matthews to Mary Watts.
69 Castle Howard Archives, Castle Howard, Blanche Airlie to Rosalind Howard, 22 May 1877 after announcement of the marriage of Anne Thackeray to the much younger Mr Ritchie: 'I feel with you that there are a few women who are delightful thro' all time & I hope her young husband will find her so. The strain on the woman is however very great & I have seen them

very anxious – Lady Pembroke & Lady Down are happy examples – as yet. To be the friend of an older woman for many years as Leighton is does not prove any thing it is not being the husband.'

70 J. Harlaw, *The Charm of Leighton* (London, 1913), quoted in Christopher Newall, *The Art of Lord Leighton* (London, 1993), p.122.

71 Barrington, *Leighton*, volume 2, p.273.

72 Ibid., p.267.

73 Ibid., p.273.

74 His birthday can be calculated from his own marriage and death certificates and a dated letter from his younger brother Charles. His birth was not registered in England or Wales. For a fuller story of the Mason family see Caroline Dakers, 'Leighton: The Truth? Frederic, Lord Leighton, and his Relationship with Lily and Fred Mason', *Apollo*, December 1996.

75 Mason Papers, private collection.

14 *Prinsep, Webb and 1 Holland Park Road*

1 Obituary notice of Val Prinsep, *Morning Post*, 17 November 1904.

2 Val Prinsep, *Six Lectures Delivered to the Students of the Royal Academy of London, January 1901* (London, 1901), p.178.

3 M. Sterling Mackinlay, 'Random Recollections of a Bohemian', *Strand Magazine*, 29, 1905, p.576.

4 Oliver Millar, *The Victorian Pictures in the Collection of Her Majesty the Queen* (Cambridge, 1992), p.212.

5 On one visit, 27 March 1876, he may have bought *Two Ladies on a Staircase*.

6 Val Prinsep, *Imperial India: An Artist's Journals* (London, 1879), p.1.

7 F.G. Stephens, *Artists at Home* (London 1882).

8 Fildes Papers, National Art Library, Victoria and Albert Museum, Fildes to Woods, 28 October 1876.

9 Framley Steelcroft, 'Mr Val C. Prinsep R.A.' *Strand Magazine*, 12, 1896.

10 Prinsep, *Imperial India*, p.20

11 Webb Papers, private collection, Webb to Val Prinsep, 7 November 1876.

12 Ibid.

13 Steelcroft, 'Mr Val C. Prinsep.'

14 Millar, *Victorian Pictures*, p.214.

15 *Vanity Fair*, 23, 1880.

16 Kurtz Papers, Liverpool Record Office.

17 Millar, *Victorian Pictures*, p.214.

18 Wyndham Papers, Private collection.

19 Ibid., Madeline Wyndham to Mary Elcho, 6 September 1884.

20 Obituary notice, *Financial Times*, 14 November 1904.

21 Fildes Papers, Woods to Fildes, 12 October 1890.

22 Webb Papers.

23 Sheila Kirk, 'Philip Webb 1831–1915: Domestic Architecture', PhD thesis, University of Newcastle-upon-Tyne, 1990. p.241.

24 Fildes Papers, Val Prinsep to Fildes, Paris [n.d.].

25 *Morning Post*, 14 November 1904.

26 Steelcroft, 'Mr Val C. Prinsep.'

27 Webb Drawings, Royal Institute of British Architects, V16 [65]

28 *Morning Post*, 14 November 1904.

29 Webb Papers, Notebook entry, 28 April 1893.

30 J.G. Millais, *The Life and Letters of Sir John Everett Millais* (London, 1899) volume 1, p.374. Val's son Anthony Prinsep sold the painting in 1923 for £1,575.

31 *Morning Post*, 14 November 1904.

15 *The Studios of Holland Park*

1 See Joseph Frank Lamb, 'Lions in their dens. Lord Leighton and late Victorian Studio life', PH.D, University of California, 1987,

p.189: 'the potential advantages of living near such a personage were not lost upon young, ambitious artists bent upon becoming successful R.A.s.'

2 Estelle Canziani, *Round about Three Palace Green* (London, 1939), p.99.

3 Holland Estate Papers, London Metropolitan Archive, Clerkenwell.

4 Details of Solomon's life are from Jenny Pury, *Solomon J. Solomon R.A.* (London, 1990), an exhibition held at the Ben Uri Art Gallery.

5 See Giles Walkley, *Artists' Houses in London 1764–1914* (London, 1994) for details of further purpose-built blocks in Kensington.

6 *Survey of London, Northern Kensington, Volume XXXVII* (London, 1973), p.128.

7 Private source. John Singer Sargent moved into his Tite Street studio in Chelsea in 1884. He acquired a lease for £140 per annum for two rooms with a dressing-room. For an extra £35 per annum a housekeeper answered the door, took messages and he had use of the kitchen fire: Stanley Olsen, *John Singer Sargent* (London, 1986), p.128.

8 Trevor Blakemore, *The Art of Herbert Schmalz* (London, 1911), p.33.

9 Ibid., p.122.

10 See Richard Jenkyns, *Dignity and Decadence: Victorian Art and the Classical Inheritance* (London, 1992).

11 *Strand Magazine*, 24, 1888.

12 Herbert Schmalz, 'A Painter's Pilgrimage', *Art Journal*, 1893, p.97.

13 Blakemore, *Herbert Schmalz*, p.109.

14 Jacqueline Collis Harvey, research presented at Leighton House Museum, 1996. Harvey proposes that Schmalz was Dorothy Dene's lover and the cause of her pregnancy, subsequent abortion and death.

15 Simon Reynolds, *William Blake Richmond* (Norwich, 1995), p.262.

16 Bodleian Library Oxford, Ms Eng Letters d 275, Richmond to Watts, 10 December 1888.

17 Ibid.

18 Lecture at Leighton House Museum by Simon Reynolds, January 1999.

19 Arthur Fish, *Henrietta Rae* (London, 1905), p.13.

20 Jan Marsh and Pamela Gerrish Nunn, *Pre-Raphaelite Women Artists* (Manchester, 1997), p.12.

21 Fish, *Henrietta Rae*, pp.35–7.

22 Ibid., p.38.

23 Ibid., p.45. Pamela Gerrish Nunn, *Pre-Raphaelite Women Artists* comments that women were beginning to paint nudes at the point at which men were moving away from the subject.

24 Alison Smith, *The Victorian Nude, Sexuality, Morality and Art* (Manchester, 1996), p.173.

25 Paul Saville, 'Valentine Cameron Prinsep in relation to the practice and theory of academic painting in late 19th century England', B. Litt. thesis, University of Oxford, 1970.

26 Fish, *Henrietta Rae*, p.39.

27 Ibid.

28 Ibid., pp.54–5.

29 M. Stirling Mackinlay, 'Random Recollections of a Bohemian I – Some Studio Stories', *Strand Magazine*, 29 May 1905, p.581.

30 Anon., 'Sir Frederick [sic] Leighton at Home', *Pall Mall Budget*, 3 July 1890, quoted in Anna Greutzner Robins, 'Leighton: A Promoter of the New Painting', Tim Barringer and Elizabeth Prettejohn (eds), *Frederic Leighton: Antiquity, Renaissance, Modernity* (New Haven, 1999), p.322.

31 Fish, *Henrietta Rae*, p.77.

32 Mackinlay, 'Random Recollections'.

33 Saville, 'Prinsep', p.206.

34 Fish, *Henrietta Rae*, p.48.

35 Rosemary Treble, *Great Victorian Pictures* (London, 1978), p.95.

36 *The Times*, 24 May 1875.
37 Canziani, *Round about Three Palace Green*, p.60.
38 Ibid., pp.61, 85.
39 Ibid., p.73.
40 Ibid., p.59.

16 The Last Victorian Artists' Houses in Holland Park

1 The Earl of Ilchester, *Chronicles of Holland House 1820–1900* (London, 1937), p.450.
2 Ibid.
3 Ibid., p.451.
4 Watts Papers, Tate Gallery Archive, Watts to Lady Ilchester, 29 July 1894.
5 See Barbara Dayer Gallati, 'Portraits of Artistry and Artifice: the Career of Sir James Jebusa Shannon 1862–1923', PhD, City University of New York, 1988.
6 Barbara Dayer Gallati, 'James Jebusa Shannon', *Antiques*, November 1988, p.1134.
7 Ibid., p.1135.
8 Gallati, 'Portraits of Artistry', p.16.
9 G.P. Jacomb-Hood, *With Brush and Pencil* (London, 1925), pp.68, 69.
10 Gallati, 'Portraits of Artistry', p.19.
11 Jane Ridley and Clayre Percy (eds), *The Letters of Arthur Balfour and Lady Elcho 1885–1917* (London, 1992), pp.49–50.
12 Diana Cooper, *The Rainbow Comes and Goes* (London, 1958), p.54.
13 Kitty Shannon, *For My Children* (London, 1933), p.65.
14 Ibid., p.66.
15 Ibid.
16 Karl Anderson, 'Anderson's Impressions: An American Artist Relates his Experiences in Europe', *The Bellman*, 8 (5 March 1910), pp.293–4, quoted in Gallati, 'Portraits of Artistry', p.23.
17 M.H. Spielmann, 'The Royal Academy Elections', *The Graphic*, 23 January 1897, p.92, quoted ibid., p.186.
18 Gallati, 'Portraits of Artistry', p.86.
19 Lewis Hind, 'The Work of J.J. Shannon', *The Studio*, 8 July 1896, p.67.
20 Shannon, *For My Children*, p.168.
21 Jacomb-Hood, *With Brush and Pencil*, pp.70–1.
22 Shannon, *For My Children*, p.15.
23 'The Royal Academy', *Athenaeum*, 24 May 1902, pp.664–5.
24 Jacomb-Hood, *With Brush and Pencil*, p.86.
25 D.S. McColl, 'The Academy', *Saturday Review*, 10 May 1902, pp.594–5.
26 See Annabel Watts, *Charles Edward Wilson & W. Graham Robertson Contrasts: An exhibition of paintings contrasting the work of two late Victorian Surrey artists 19 September–31 October 1998* (Haslemere, 1998).
27 W.G. Robertson, *Time Was* (London, 1945), p.38.
28 Whistler Papers, Glasgow University Library, W. Graham Robertson to Whistler, 1893, 1894.
29 Holland Estate Papers, London Metropolitan Archive, Clerkenwell. Additions by Basil Procter in 1911 for J.E. Mounsey reveal the odd layout of the original building.
30 The house was then occupied by the Benzons (see chapter 9).
31 Robertson, *Time Was*, pp.298–9.
32 Iain Gale, *Arthur Melville* (Edinburgh, 1996), p.23.
33 John Mackenzie, *Orientalism, History, Theory and the Arts* (Manchester, 1995), p.66. Mackenzie identifies Melville as part of a particular phase of orientalism in the last decades of the nineteenth century: 'The Orient becomes less glamorised, more varied, with a greater range of subjects and moods, often more reflective, in some ways more concerned with mutual understanding' (ibid., p.50).

34 Susan P. Casteras and Colleen Benney (eds), *The Grosvenor Gallery: A Palace of Art in Victorian England* (New Haven, 1996), p.7.
35 Gale, *Arthur Melville*, p.51.
36 Agnes E. Mackay, *Arthur Melville* (London, 1951), p.73.
37 D.S. McColl, 'The Academy'.
38 Gale, *Arthur Melville*, p.88.
39 A. Lys Baldry, 'Albert Moore' *The Studio*, 3 April 1894.
40 Linda Merrill, *A Pot of Paint: Aesthetics on Trial in Whistler v. Ruskin* (Washington, 1992), p.159.

17 Artists in Residence

1 *The Architect*, 28 March 1874.
2 Kate Terry Gielgud, *An Autobiography* (London, 1953), p.75.
3 Ibid.
4 Sambourne wrote to Whistler on 1 December 1878: 'I trust you will not feel offended by my little bit of nonsense wh will appear in the no of "Punch" for this week. I am in a manner *obliged* to take up any subject the editor points out . . . I have *every* sympathy with you in what must be a most trying & irritating time [i.e. the libel case against Ruskin]', Whistler Papers, Glasgow University Library.
5 Sambourne Papers, Leighton House Museum, Kensington.
6 E.V. Lucas, *Edwin Austin Abbey: the record of his life and work* (London, 1921), volume 2, p.111.
7 Stone Papers, Dickens House Museum, London, autobiographical notes.
8 Fred Kaplan, *Henry James* (London, 1993), pp.177, 328.
9 National Art Library, Victoria and Albert Museum, Stone to Thompson, January 1875, Ms 8 WW1 STA–SWAN.
10 Fildes Papers, National Art Library, Fildes to Woods, 1 January 1880.
11 Ibid., same to same, 18 October 1880.
12 Ibid., same to same, 13 December 1881.
13 Ibid., same to same, 7 February 1886. After acquiring his second house, 17 Grove End Road, in 1885, Lawrence Alma-Tadema increased light in his studio by coating the ceiling with aluminium leaf; Giles Walkley, *Artists' Houses in London* (Aldershot, 1994), p.131.
14 Henry T. Bernstein, 'The Mysterious Disappearance of Edwardian London Fog', *London Journal*, 1, no. 2, 1975.
15 Fildes Papers, National Art Library, Fildes to Woods, 7 February 1890.
16 'An artist's view of the smoke question', *Builder*, 25 March 1882.
17 His absence also provided his servants with the opportunity to thoroughly clean his studio.
18 Burne-Jones Papers, Fitzwilliam Museum, Cambridge, XXVI [1897].
19 Fildes Papers, National Art Library, R.N. Shaw to L. Fildes, June 1876.
20 L.V. Fildes, *Luke Fildes* (London, 1968), pp.30–1.
21 Fildes Papers, National Art Library, Fildes to Woods, 28 October 1876.
22 Rudolph de Cordova, 'Mr Henry Woods, R.A.', *Strand Magazine*, 2, March 1897.
23 Fildes, *Luke Fildes*, p.53.
24 Fildes Papers, Fildes to Woods, 17 November 1879.
25 Fildes, *Luke Fildes*, p.80.
26 Fildes Papers, Fildes to Woods, 18 October 1880.
27 Fildes, *Luke Fildes*, p.71.
28 Ibid., p.93.
29 Fildes Papers, Schwabe to Fildes, 3 June 1885.
30 Schwabe bought two paintings by Henry Woods, *At the Foot of the Rialto* and *The Gondolier's Courtship*, on visiting Melbury Road in 1881; he also bought work by the St John's Wood Clique and Val

Prinsep's *A Bientôt* (1876). He left his collection to the city of Hamburg.

31 *Athenaeum*, 18 May 1889.

32 Fildes Papers, Fildes to Woods, 6 February 1889.

33 See Burne-Jones Papers, XXVI, book of letters typed by Georgiana Burne-Jones, February 1902, Burne-Jones to C. Fairfax Murray, 11 April 1873.

34 A.M.W. Stirling, *A Painter of Dreams* (London, 1916), p.338.

35 A.M.W. Stirling, *Life's Little Day* (London, 1925), pp.145–6.

36 Rosemary Ashton, *George Eliot* (Harmondsworth, 1997), p.260.

37 Henry James, 'The Picture Season in London 1877', reprinted in John L. Sweeney (ed.), *The Painter's Eye* (Wisconsin, 1989), p.144.

38 Leon Edel (ed.), *Henry James Letters* (London 1974–84), volume 2, pp.94–5.

39 Henry James, *The Portrait of a Lady* (Harmondsworth, 1986), p.304. First published 1881.

40 Fildes, *Luke Fildes*, p.32.

41 Ibid., p.72.

42 Ibid., p.135.

43 See Mark Girouard, *Sweetness and Light* (New Haven, 1990), pp.186–9. Lady Airlie's daughter Clementine and son-in-law Bertie Mitford commissioned a house from Ernest George; another daughter Blanche and her errant husband Captain Hozier were also regular visitors, together with Lady Rose Weigall and her artist husband (who painted the Airlies).

44 Fildes Papers, Prinsep to Woods, 1 February 1899.

45 Harry How, 'Luke Fildes, R.A.', *Strand Magazine*, 6, 1893.

46 Ibid.

47 Elfrida Manning, *Marble and Bronze* (London, 1982), p.117.

48 Ibid., p.133.

49 Ibid., p.141.

50 Ibid., p.101.

51 Fildes, *Luke Fildes*, p.133.

52 Estelle Canziani, *Round about Three Palace Green* (London, 1939), p.66.

53 Kitty Shannon, *For My Children* (London, 1933), p.66.

54 Canziani, *Round about Three Palace Green*, p.80.

55 Fildes, *Luke Fildes*, pp.69–70.

56 Fildes Papers, Prinsep to Schwabe, [1884].

57 B. Curle (ed.) *Lord Leighton a catalogue of letters to various correspondents in the possession of The Royal Borough of Kensington & Chelsea* (1983), MSS 12454, letter 247, Leighton to Stone, 29 April 1888.

58 See Burges Papers, National Art Library, Victoria and Albert Museum, London.

59 Shirley Nicholson, *A Victorian Household* (Stroud, 1988), p.125. Also see Sambourne Papers, diaries of Linley and Marion Sambourne.

60 Shannon, *For My Children*, p.87.

61 'The Kensington Artists', *Builder*, April 1882, p.382.

62 F.G. Stephens, *Artists at Home* (London, 1884), photographed by J.P. Mayall and reproduced in facsimile by photo-engraving on copper plates.

63 Mrs Haweis, *Beautiful Houses* (London, 1882) , p.11.

64 Anon., 'Artists as Craftsmen no. 1, Sir Frederic Leighton, Bart, PRA, as a Modeller in Clay', *The Studio*, 1 April 1893.

65 Haweis, *Beautiful Houses*, p.8.

66 Fildes, *Luke Fildes*, p.132.

67 'Letters from Artists on Ladies' Dress', *Strand Magazine*, 1891, p.162.

68 See *The Studio*, I, 1893, 15, 1898, et passim.

69 James, 'Picture Season in London 1877', p.136.

70 Fildes Papers, Fildes to Woods, 7 June 1885.

71 Watts Papers, Tate Gallery Archives, Watts to Burne-Jones, 5 June 1885; Burne-Jones to Watts, 5 June 1885.

72 Ibid., Burne-Jones to Watts, 13 February 1893. Leighton

probably also tried to get Albert Moore elected but received virtually no support from the rest of the council, see Anna Greutzner Robins, 'Leighton: A Promoter of New Painting', Barringer and Prettejohn (eds) *Frederic Leighton: Antiquity, Renaissance, Modernity* (New Haven and London, 1999), p.315.

73 Fildes, *Luke Fildes*, p.68.

74 Fildes Papers, Fildes to Woods, 7 June 1885.

75 Ibid., Prinsep to Fildes, [1893].

76 Sidney C. Hutchinson, *The History of the Royal Academy 1768–1986* (London, 1984).

77 Kurtz Papers, Liverpool Record Office, diary, 1 May 1881.

78 W.M. Rossetti (ed.), *Dante Gabriel Rossetti: his Family Letters* (London, 1895), volume 1, pp.249–50.

79 Watts Papers, Watts to Constantine Ionides, 14 December 1880; Watts to Aglaia Coronio, 30 November 1883.

80 Wyndham Papers, private collection, Mary Wyndham's diary.

81 The designer Gertrude Jekyll assisted in supervising the interior decorations of Eaton Hall.

82 Manning, *Marble and Bronze*, p.79.

83 James, 'Picture Season in London 1877', p.148.

84 According to Violet Hunt, her father the painter Alfred William Hunt, Alexander and Rawlinson all enjoyed the services of the same barber, who made a living perambulating Campden Hill: see V. H. Hunt, *Flurried Years* (London, 1926), p.64.

85 Edmund Gosse, 'The Place of Sculpture in Daily Life', *Magazine of Art*, 1894.

86 Ibid., p.368–9.

87 Dianne Sachko Macleod, 'Art Collecting and Victorian Middle-Class Taste', *Art History*, 10, no. 3, September 1987, characterises the later generation of 'upwardly mobile' middle-class collectors as sharing a 'reverence' for art.

88 Fildes, *Luke Fildes*, p.86.

89 Ibid., p.92. He eventually owned Stone's *Asleep, Fallen Out* and *Reconciled*. See Henry Blackburn, *Collection of Pictures and Statuary (Mr John Aird)* (London, 1884).

90 Fildes, *Luke Fildes*, p.170.

91 David Croal Thomson, 'Luke Fildes', *Art Annual*, 1895.

92 Edward Morris, *Lord Leverhulme, founder of the Lady Lever Art Gallery* (Liverpool, 1980) catalogue of exhibition at Lady Lever Art Gallery, p.30.

93 McCulloch was probably introduced to Morris & Co by his friend and fellow Australian W.K. D'Arcy of Stanmore Hall, Middlesex, whose house was decorated by the firm. McCulloch commissioned eight stained-glass windows for 184 Queen's Gate in 1902, one of the designs by Burne-Jones dating from 1878. His set of the 'Holy Grail' tapestries were originally designed for D'Arcy at Stanmore.

94 Fildes, *Luke Fildes*, p.113.

95 Christie's 23–30 May 1913, sale of McCulloch's collection.

96 Arthur Fish, *Henrietta Rae* (London, 1905), pp.81–2.

97 See Joseph Kestner, *Masculinities in Victorian Painting* (Aldershot, 1995), p.77.

98 W.G. Robertson, *Time Was* (London, 1945), p.275.

99 Fildes Papers, Fildes to Woods, 30 June 1896.

100 Fildes, *Luke Fildes*, p.144.

101 Lever was deliberately competing with Pear's, a company he eventually took over (he bought Millais' *Bubbles* in 1886). See Edward Morris, 'Paintings and Sculpture', in Morris, *Lord Leverhulme*, p.14.

102 See Dianne Sachko Macleod, *Art and the Victorian Middle Class* (Cambridge, 1996) p.342.

103 Giles Waterfield, 'Art Galleries and the Public', in *Art Treasures of England. The Regional Collections* (London, 1998), p.17.

104 See Jeremy Maas' foreword to Chapel, *Victorian Taste* (London, 1982), p.7: 'It was as though he had lowered a net into the sea

of High Victorian art and the collection was his catch from what was available for purchase at the time.'

105 Edward Morris, *The Walker Art Gallery* (London, 1994), p.10.
106 *London Quarterly Review*, 58, 1882.
107 Wemyss Papers, private collection, Watts to Earl of Wemyss, 14 January 1886.
108 Wilfrid Blunt, *England's Michelangelo: A Biography of G.F. Watts, OM, RA* (London, 1989), And see Giles Waterfield (ed.), *Art for the People: Culture in the Slums of Late-Victorian Britain* (London, 1994); also Raface Cardosu Denis, 'From Burlington House to the Peckham Road: Leighton and Art and Design Education,' Barringer & Prettejohn (eds.), *Frederick Leighton*.
109 Mrs Russell Barrington, *G.F. Watts: Reminiscences* (London, 1905), p.91.
110 Edward Morris, *Victorian and Edwardian Paintings in the Lady Lever Art Gallery* (London, 1994), p.xviii.
111 Frances Spalding, *The Tate: A History* (London, 1998), p.12.
112 J.G. Millais, *The Life and Letters of Sir John Everett Millais* (London, 1899), volume 2, p.369.
113 Tate Papers, Tate Gallery Archive, London, collection of press cuttings relating to Tate, *Pall Mall Gazette*, 1890.
114 Ibid., Leighton to Tate, 27 February 1891.
115 Ibid., Fildes to Tate, 22 June 1890.
116 Fildes Papers, Fildes to Woods, 19 May 1890.
117 Fildes, *Luke Fildes*, p.121.
118 Rosemary Treble, *Great Victorian Pictures* (London, 1978), p.36.
119 Tate Papers, *Daily News*, 30 November 1892.
120 Fildes, *Luke Fildes*, p.118.
121 Tate Papers, Howard to Tate, 1 December 1890.
122 Ibid., *Society*, 20 February 1892.
123 Ibid., *The Graphic*, 18 February 1893.
124 Ibid., Watts to Tate, 1 January 1893.
125 Ibid., same to same, 7 July 1897.
126 Blunt, *England's Michelangelo*, p.211.

18 Death and Decline

1 Mrs Russell Barrington, *The Life, Letters and Work of Frederic Leighton* (London, 1906), volume 2, p.335.
2 He had been made a baronet in 1886. Millais and Burne-Jones received baronetcies in 1885 and 1894.
3 L.V. Fildes, *Luke Fildes* (London, 1968), p.140.
4 Barrington, *Leighton*, volume 2, p.337.
5 Angela Emanuel (ed.), *A Bright Remembrance: The Diaries of Julia Cartwright 1851–1924* (London, 1981), p.199.
6 Crane also wrote a sonnet on the death of Watts, beginning 'Lo! Regal death hath set his seal': Bodleian Library Ms Eng. d.275, Crane to Mary Watts, 3 July 1904.
7 Elfrida Manning, *Marble and Bronze* (London, 1982), pp.133–4.
8 See Sidney C. Hutchinson. *The History of the Royal Academy 1768–1986* (London, 1984), Over 80,000 visited Millais'
memorial exhibition in 1897 and over 60,000 visited Watts' memorial exhibition in 1905–6.
9 Fildes, *Luke Fildes*, p.143.
10 Barrington, *Leighton*, volume 2, p.378.
11 Mary Lago (ed.), *Burne-Jones Talking* (London, 1981), p.102.
12 Henry James, 'Lord Leighton and Ford Madox Brown 1897', reprinted in John L. Sweeney (ed.), *The Painter's Eye* (Wisconsin, 1989), p.248.
13 Hester Ritchie (ed.), *Letters of Anne Thackeray Ritchie* (London, 1924), pp.266–7.
14 Jeremy Maas, *Holman Hunt and the Light of the World* (London, 1984).
15 Furnivall Papers, University of London Library MS 797 91/1 f.43.
16 Maas, *Holman Hunt*, p.110.
17 Virginia Woolf, *Moments of Being* (London, 1976), pp.153–4.
18 Wilfrid Blunt, *England's Michelangelo: A Biography of G.F. Watts, OM, RA* (London, 1989), p.220.
19 Georgiana Burne-Jones, *Memorials* (London, 1993) volume 2, p.345.
20 Blunt, *England's Michelangelo*, p.220.
21 See Paul Saville, 'Valentine Cameron Prinsep in relation to the practice and theory of academic painting in late 19th century England', B. Litt. thesis, University of Oxford, 1970, p.292.
22 Fildes, *Luke Fildes*, p.157.
23 Tate Papers, Tate Gallery Archive, London, *Westminster Gazette*, 15 July 1897.
24 *Saturday Review*, 27 February 1909.
25 *Burlington Magazine*, March 1909; also see Dianne Sachkco Macleod, *Art and the Victorian Middle Class* (Cambridge, 1996), p.363.
26 Lever chose to be laid in state beneath this painting when he died in 1925: see Morris, p.xvi in Lady Lever catalogue.
27 Fildes Papers, National Art Library, Victoria and Albert Museum, London, Fildes to Sir Douglas Dawson, 11 February 1912.
28 W.G. Robertson, *Time Was* (London, 1945), p.324.
29 Barbara Dayer Gallati, 'James Jebusa Shannon', *Antiques*, November 1988, p.31.
30 Manning, *Marble and Bronze*, p.190.
31 Ibid.
32 See Joseph Kestner, *Masculinities in Victorian Painting* (Aldershot, 1995), p.109.
33 The Earl of Ilchester, *Chronicles of Holland House 1820–1900* (London, 1937), p.452.
34 Chapman Taylor Partners, *Holland Conservation Area Proposals Statement (Draft)* (London, 1989), p.20.
35 J. Maas, 'From Outcast to Icon', *RA Magazine*, 49, Winter 1995.
36 Newspaper cuttings collection, Kensington Local Studies, Central Library, R.B.K. & C.
37 Reginald Turnor, *Nineteenth Century Architecture in Britain* (London, 1950).
38 Blunt, *England's Michelangelo*, p.215.

Index

Photographic Acknowledgements

The cost of making photographs and paying permissions for *The Holland Park Circle* fell to the author and the choice of illustrations has, to some extent, been dictated by the amount of reproduction and rights fees charged by museums, galleries, libraries and private owners. Some copyright holders priced images beyond the economics of this book whilst some graciously waived fees altogether. Grants towards the cost of illustrations have been essential and I would like to thank Central Saint Martins College of Art and Design, the Paul Mellon Foundation and the Scouloudi Foundation for their support.

Birmingham Museums and Art Gallery: 45; Blackburn Museum and Art Gallery: 72; Bradford Art Galleries and Museums: 106; Bridgeman Art Library: 51, 52, 72, 73, 80, 87, 88, 105, 106, 109, 119, 127; British Architectural Library, RIBA, London: 24, 25, 29, 59, 61, 75, 82, 93, 101; British Library, London: 44, 104; Dickens House Museum, London: 62; Forbes Magazine Collection, New York: 73, 105; Freer Gallery of Art, Smithsonian Institute, Washington DC, 64; Guildhall Art Library, London: 80; The Honourable Simon Howard, Castle Howard, Yorkshire: 13, 22, 39, 41, 42, 43, 57, 118; London Metropolitan Archive, Clerkenwell, London: 70, 116, 121; Manchester City Art Galleries: 23, 87, 88, 100; Museum of London: 89, 108; National Gallery of Scotland, Edinburgh: 114; National Museum of Wales, Cardiff: 95; Board of Trustees of the National Museums and Galleries on Merseyside: 47, 48, 102, 113, 117; National Portrait Gallery, London: frontispiece, 28, 58, 85, 86, 90, 92, 123; Photographic Records Limited: 18; Private collections: 3, 4, 5, 9, 12, 14, 15, 16, 18, 27, 30, 32, 35, 36, 37, 38, 66, 77, 78, 97, 98, 119, 120, 122, 124; © Royal Academy of Arts: 30; Royal Borough of Kensington and Chelsea Libraries and Arts Service: endpapers, 1, 10, 19, 20, 21, 33, 34, 50, 54, 63, 67, 74, 76, 79, 81, 83, 84, 91, 94, 103, 107, 110, 111, 112, 115, 128, 129; The Royal Collection © 1999 Her Majesty Queen Elizabeth II: 99; RCHME © Crown Copyright: 2, 40, 53, 55, 65, 71, 130; Royal Photographic Society Picture Library, Bath: 26, 49, 68; Sotheby's, London: 46, 60; South African National Gallery, Cape Town: 109; © Tate Gallery, London 1999: 31, 96, 125, 126; Trustees of the Watts Gallery, Compton, Surrey: front cover, 6, 7, 8, 11, 17, 56, 69; Victoria and Albert Museum (Ionides Bequest): 51, 52; Michael Winner: 131